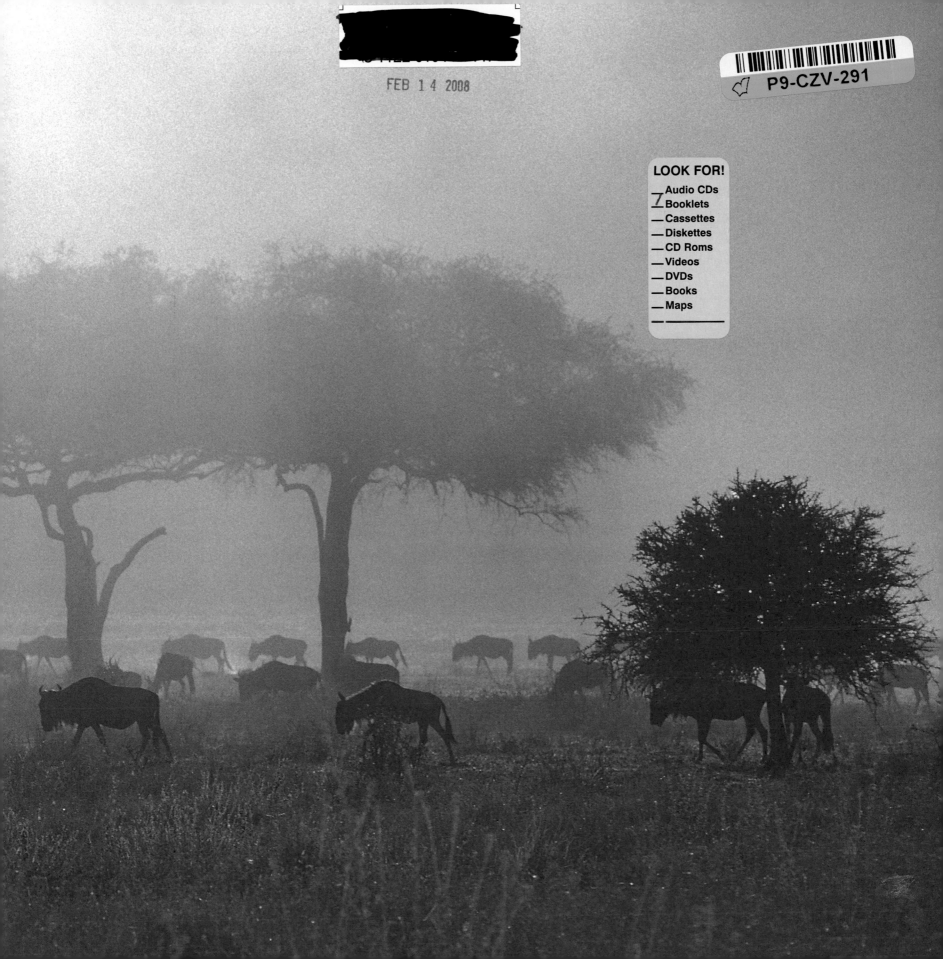

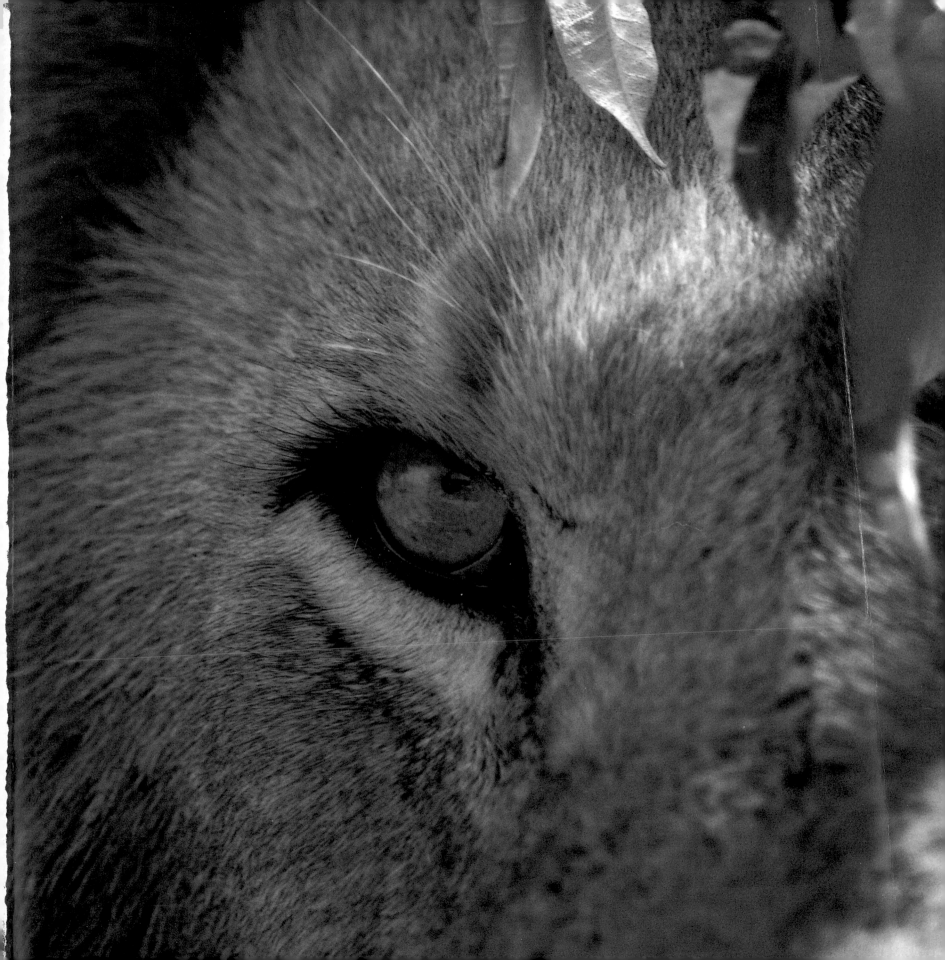

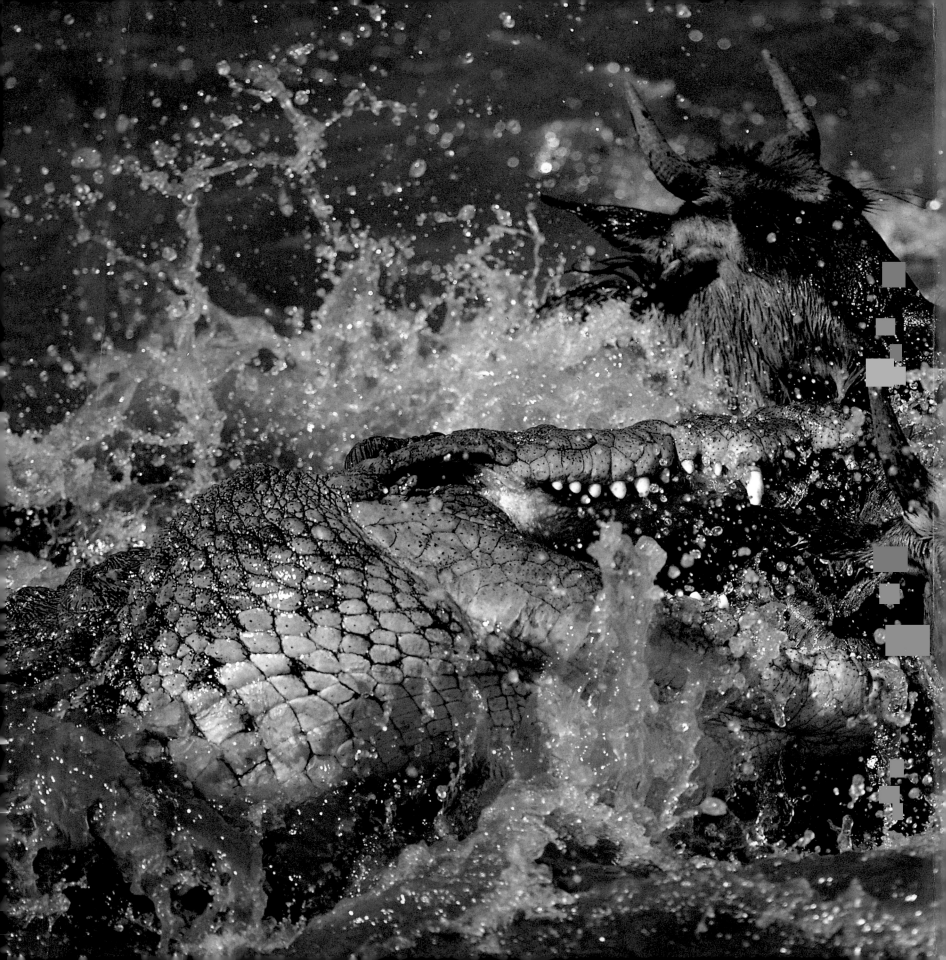

PREDATOR

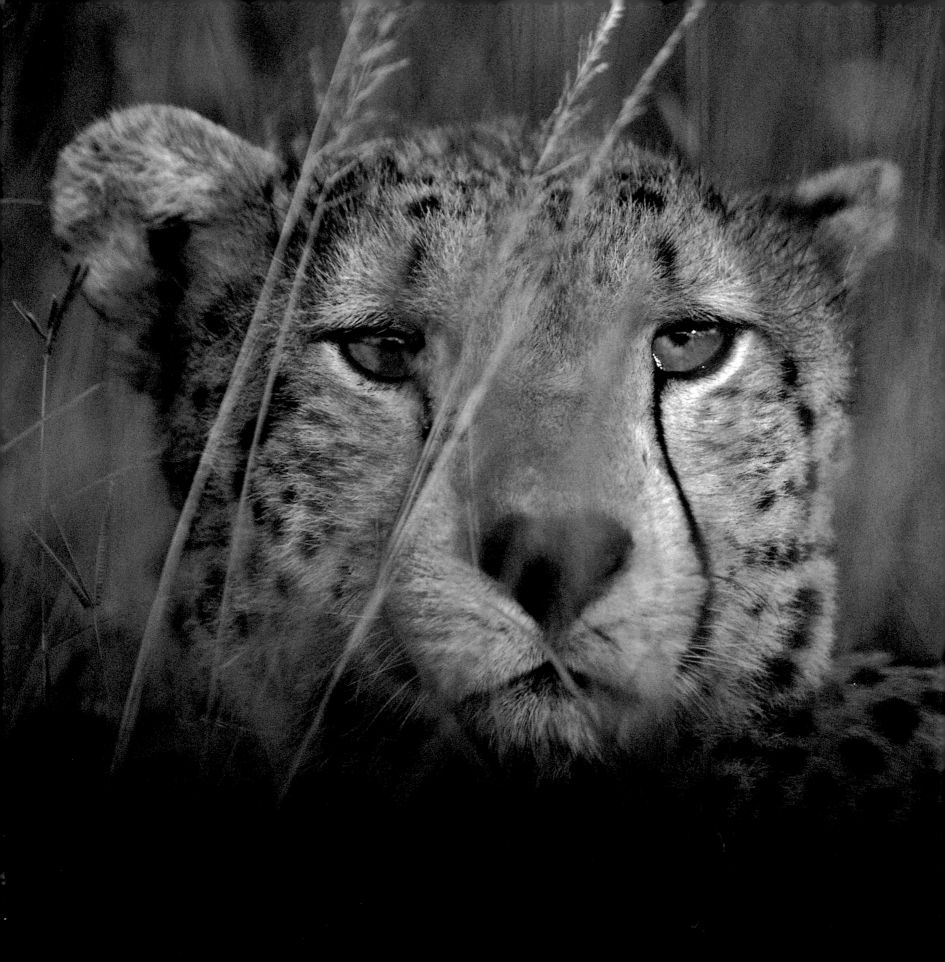

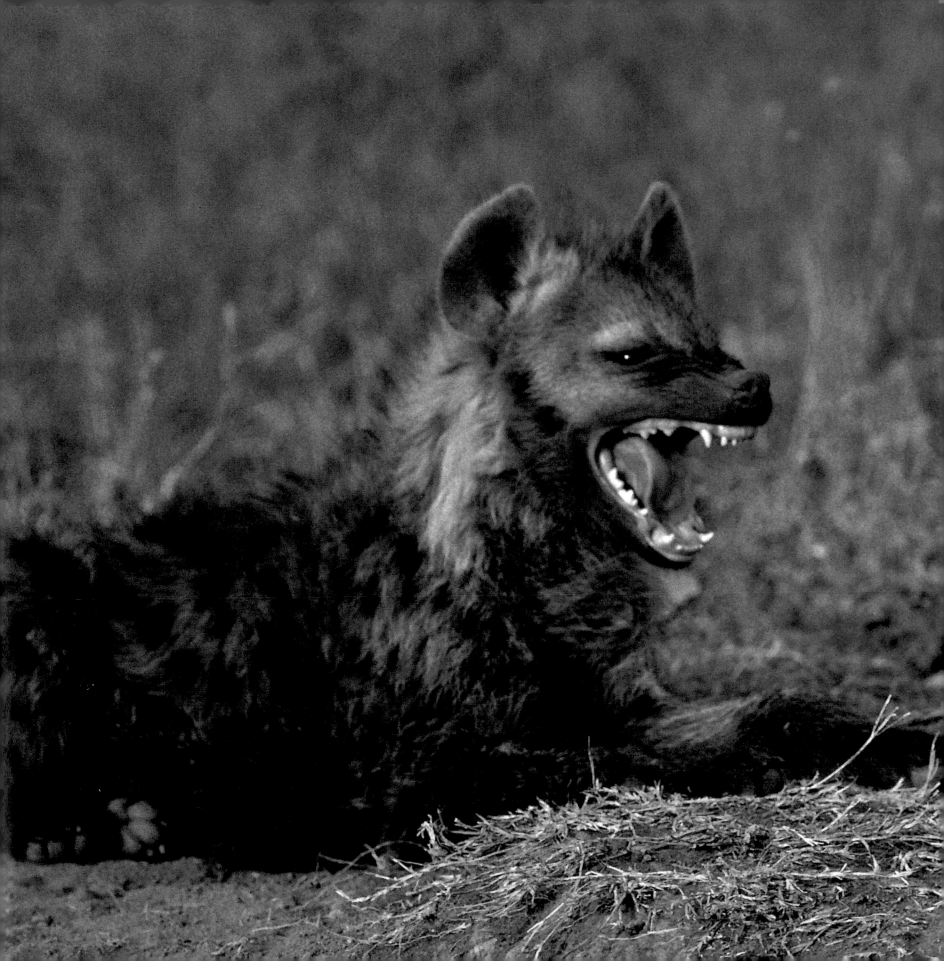

PREDATOR

LIFE AND DEATH IN THE AFRICAN BUSH

Mark C. Ross and David Reesor

ABRAMS, NEW YORK

For the softly falling rain in my life, my Baby Murit. —MCR

To my best friend, my traveling partner, my wife Diane. —DR

EDITOR: Andrea Danese
DESIGNER: Brady McNamara
PRODUCTION MANAGER: Jane Searle

LIBRARY OF CONGRESS CATALOGING-IN-PUBLICATION DATA
Ross, Mark C.
 Predator : life and death in the African bush / Mark C. Ross and
David Reesor.
 p. cm.
 Includes bibliographical references and index.
 ISBN 13: 978-0-8109-9301-3
 ISBN 10: 0-8109-9301-5
 1. Carnivora—Africa. 2. Crocodiles—Africa. 3. Predation (Biology)—
Africa. 4. Carnivora—Africa—Pictorial works. 5. Crocodiles— Africa—
Pictorial works. 6. Predation (Biology)—Africa—Pictorial works.
I. Reesor, David. II. Title.

 QL737.C2R674 2007
 599.7096—dc22 2006036127

PRINTED AND BOUND IN CHINA
10 9 8 7 6 5 4 3 2 1

harry n. abrams, inc.
a subsidiary of La Martinière Groupe
115 West 18th Street
New York, NY 10011
www.hnabooks.com

Feel free to contact the author with your comments, questions,
or suggestions at markross@africaonline.co.ke

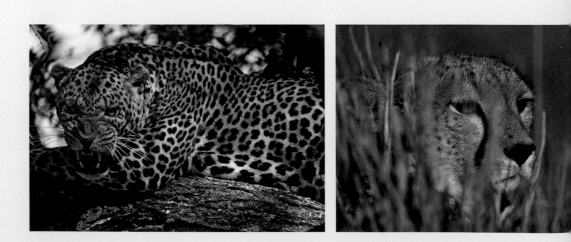

CONTENTS

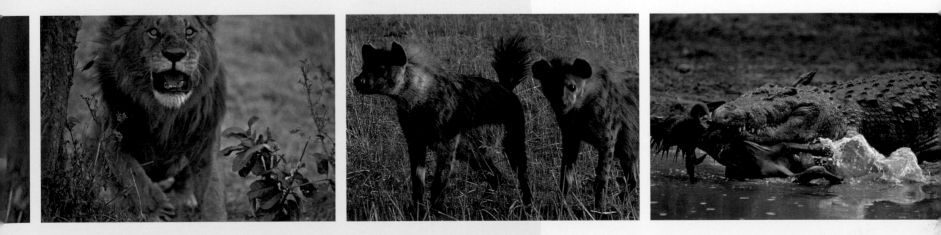

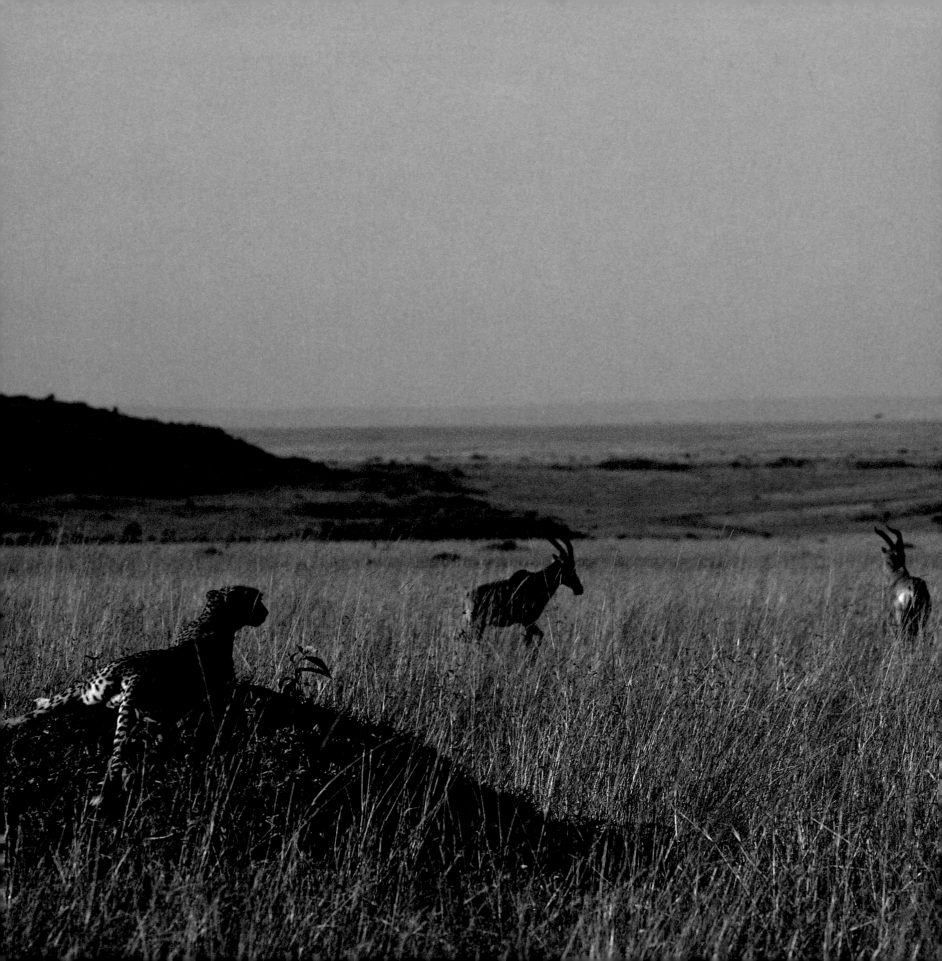

PREFACE

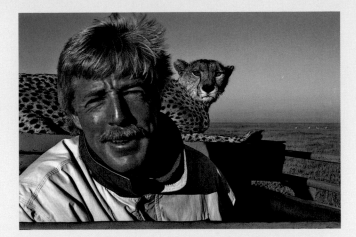

Carnivores are politically incorrect animals—they kill for a living. Yet everyone I have ever taken out into the African bush, vegans included, can't resist spending hours watching the large carnivores, hoping to witness the drama of a kill. Physically and mentally, far more excitement is involved when a cheetah pursues and kills a speeding Thomson's gazelle than when a male wildebeest stalks in on a clump of grass and successfully ingests it. So perhaps it's not surprising that so many of us would rather watch the big cats hunt than a zebra graze.

The carnivores that we selected for this book were chosen simply because they are the ones that people on safari will most likely encounter. We opted to address their behavior photographically because we humans are such a visually oriented animal and because hopefully this book will be taken into the field (on safari), where one can see predator behavior taking place.

Africa is a huge, diverse continent so it is dangerous to generalize too much about high-level predators. Leopards in the northern Serengeti make a living killing oribi while the same species in Botswana commonly fishes. Lions on the rim of Ngorongoro Crater survive by taking down full-sized Cape buffalo, yet on the crater floor only a few miles away, they are the dominant scavenger, even more so than hyenas.

The data in this book is taken mostly from doctoral theses done primarily in East Africa, where I live, photograph, and study. I have carefully refrained from cloaking scientific research under the guise of personal observations. Such observations, quite often those of wildlife film crews, are wildly off the mark, and without solid research a "half-truth" can be completely misleading. For example, for decades it was a "fact" that hyenas were filthy scavengers and lions were the king of beasts. It was also a "fact" that lions hunted in coordinated, premeditated groups, sending out decoys and herding prey into various traps. These so-called facts have long since been dismissed as false, fractional observations carried out most haphazardly.

I have been observing, researching, photographing, and teaching about African wildlife for almost thirty years. One of the few things I know for sure is that generalizing about complex and evolved predators will certainly get one into trouble. All the large cats and hyenas are highly adaptable, living in such diverse habitats that writing anything about them opens oneself up for criticism. Even such basic facts as body weight, attack distance, success ratio, and number of offspring vary tremendously from habitat to habitat, even within the same country. I strongly urge you to study up before coming on safari, make your own observations and conclusions, and see if they hold up. The more you know and understand, the more interesting that observing becomes.

As you look through this book, feel free to correct me where needed, add more details where required, and don't believe everything that is in print, my own print included!

Have a great safari and tell me what you saw!

Mark C. Ross

OPPOSITE In long grass, a cheetah is too low to see its surroundings and any potential prey in the area. The termite mound offers a terrific platform from which to scan. This female has been spotted by a group of Coke's hartebeests, so she will not attack.

ABOVE A wild cheetah lies on the author's Land Rover roofhatch to gain an elevated view of the surrounding plains.

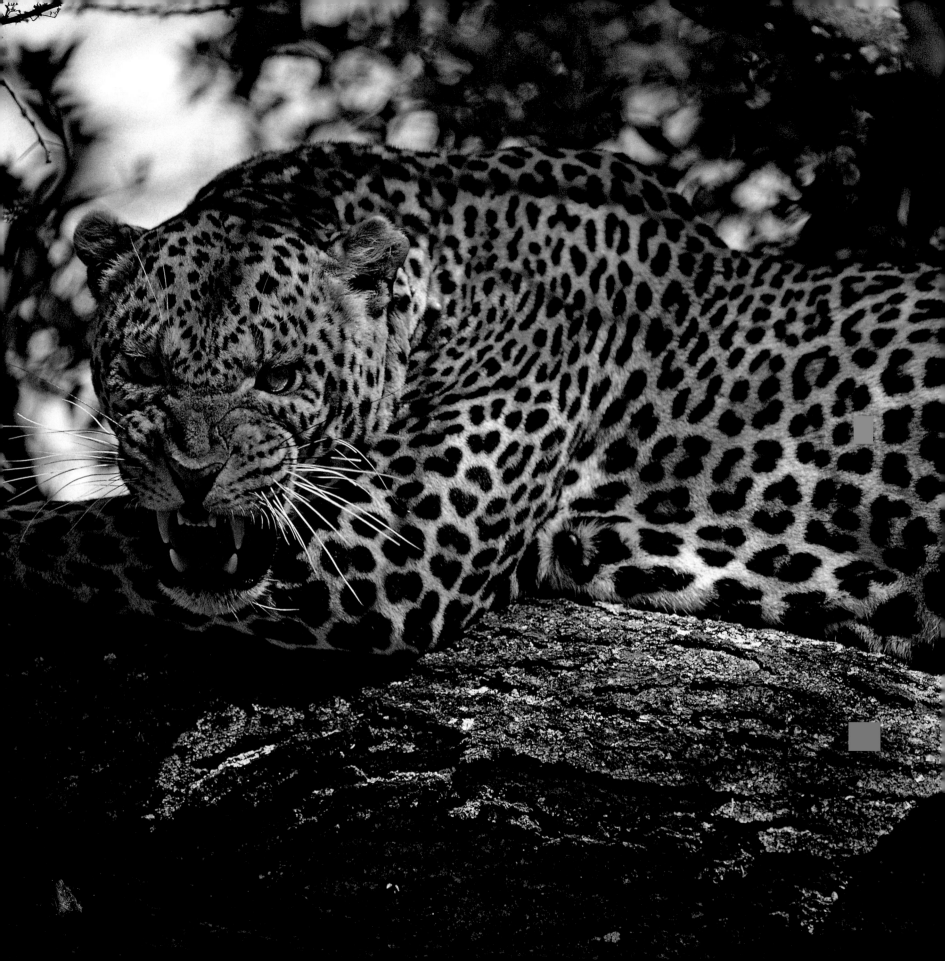

LEOPARD

A DAY IN THE LIFE

The drying impala leg moved imperceptibly in the dawn's gathering breeze, as if there was life still in it. It wobbled again and held still. Eight feet below the carcass, the leopard's leg twitched as well. Perhaps she was dreaming of a successful chase as she lay straddled across the wide acacia tree branch.

The day's heat was building rapidly and though it had been far from a strenuous night for the leopard, she was already deep in sleep, content in the shady wind along the river, her stomach full.

Somewhere downstream, within her territory but out of sight and out of mind, the leopard's seven-month-old son was probably in a similar situation—up a tree, horizontal, and oblivious to the world below. For these nocturnal hunters day was night and only the coming of darkness would naturally rouse them from their sleep.

The impala kill, a pregnant female, had been a typically easy snatch for the leopard, though the dappled cat had made five failed attacks the previous night before she managed to jump this antelope and slap it to the ground.

The leopard had been ambling along the bank of the wide and shallow river, slaloming slowly between the *Acacia elatior* trees as she worked her way eastward along the northern boundary of her twelve-square-mile territory. The moonless night posed no difficulty for her as she cruised; rather, it aided her, cloaking her as she glided along.

The cat had moved swiftly and silently in the total darkness, her long whiskers and eyebrow hairs spanning wider than her shoulder width, touching lightly against the vegetation as she moved, allowing her to avoid the shrubs, rocks, and trees she passed through. Her paws, surrounded by hair with additional tufts between the toes, made her footfalls silent. Her male cub followed in equal silence—at least, most of the time. Occasionally, the youngster would pointlessly rush at a dik-dik or, out of impatience, sneak ahead only to hide and charge his own mother as she paced steadily forward in the night. Patience is usually a predator's long suit, and the leopard never reacted negatively to her son's mock attacks. She let him bounce into her and slide off, seldom even dropping a shoulder to take the hit, much less raising a paw in defense. Mostly, the inexperienced male just tagged along, his patience strained despite his well-fed, healthy appearance.

The first of the female's attacks had been directed at a young eland, part of a nursery group of five. The eland calves, already standing almost five feet tall, had been surrounded by their massive mothers. The leopard had slipped up to within six yards of the herd before exploding out halfheartedly. Her only hope with this group lay in the possibility of an eland calf bolting clear of the herd in its panic. At the sound and shadowy sight of the leopard's charge, the mother elands had instinctively run, but they kept themselves between their calves and the danger hurtling at them. The twelve-hundred-pound adult eland made attacking a foal way too risky. The young male leopard, crouched and hidden but alert, had seen his mother burst forward only about ten feet and then pull to a full stop and watch the herd as it crashed through the brambles and acacia deadfall. The eland trampled noisily on for more than a hundred yards before they settled into a fast single-foot gait and finally came to a halt a safe distance away.

The cub rose from his hiding place behind a log and bounced up to his mother, cuffing her on the rump. She sat, licked a paw, and set off walking once more. The hunt was far from over.

The next potential prey the leopards bumped into was a small herd of impalas, a bachelor group of five immature males. Three of the impalas had been up and feeding, even though it was midnight when the leopards

An old male leopard snarls a very serious warning just prior to exploding out in a fake charge at a safari traveler who became too exposed in the vehicle's roof hatch.

A leopard stands frozen on a branch and extremely alert as a herd of impalas passes underneath. Leopards do not leap from trees onto the back of their victim. Instead, they land on the ground beside their targets and immediately launch into them.

happened upon them, and only one of the sitting impalas was asleep; the other was occupied with chewing its cud.

The leopard cub's tail tip began to quiver uncontrollably, the last two furry inches flicking up and down, up and down, as both cats slid forward. The mother leopard used a fallen and tangled sausage tree to shield her approach with the cub dutifully following her. As the leopard slunk forward and paused under the branch, the cub pulled up and stood against it, planting his furry feet side by side as he positioned himself to watch and learn from the sidelines once again.

It took the leopard ten minutes to edge in the last sixteen yards, putting her at only eight yards away from one of the sitting impalas. The mother leopard's tail was also vibrating at this point, but no other motion, and certainly no sound, came from her direction. The cub waited, ears instinctively flattened against the short fur on his skull. The mother gathered herself then launched toward the sitting impala, spewing sand from her rear feet as she propelled herself forward. As fast as she was, the impala was quicker. Even as one of the feeding impalas snorted an alarm and rocketed skyward, the sitting impala was exploding away, never fully gaining its feet before it was moving, with lightning-bolt speed, away from the oncoming cat. Another miss.

The cub bounded forward, arching elegantly up over the fallen branch as he burst out. He broadsided his mother, falling to the ground at her feet. He gathered himself, stood, and walked in a slow circle, sniffing the ground where the impala had been sitting so peacefully only seconds before. In the near distance, one of the impalas snorted yet another alarm call—though meant as a warning to other impalas, all prey species recognize this sound.

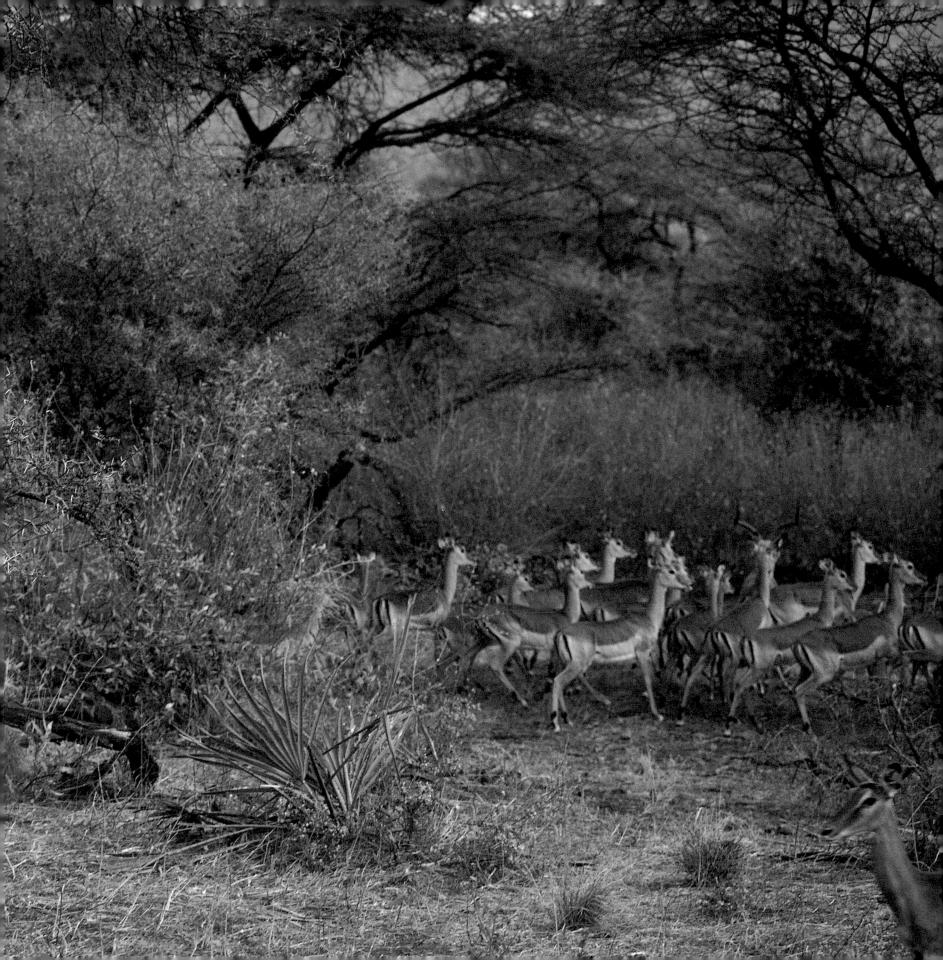

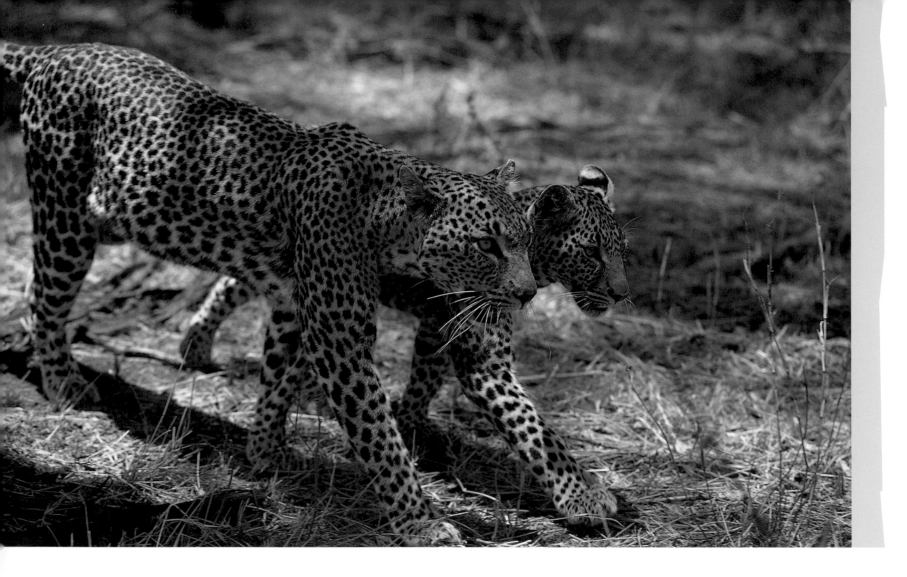

The leopard lowered her boxy head and sniffed the sand beside her son's head, and the two cats, shoulder to shoulder, moved out again. After twenty more minutes, mother and son slid up onto the low branch of an *Acacia tortillas* and rested, stretched full length, for more than half an hour before coming down again, headfirst, and continuing downriver toward the east.

Hunting was not on the adult leopard's mind when she rounded a wide acacia trunk and happened upon the solitary impala. But in a fraction of a second she burst from strolling to flying speed, and hit the standing impala across the rump. The leopard's sheer weight threw the slim impala sideways and before the antelope had even started to gather itself, the leopard had one claw-bared paw in its shoulder and her teeth buried into its white

throat. The cat's other front foot found purchase on the doomed antelope's leg. The cat pushed off with its back feet and kicked them into the impala's hip, sending it crashing to the sand. The grip on the throat never lessened, the canines sinking in farther while the cat cradled the impala with its front legs.

The cub ran forward and darted excitedly back and forth beside the two animals but touched neither. Even when the impala ceased moving only seconds later, the young leopard stayed clear of it. Finally, fully two minutes after hitting the impala, the mother leopard released its neck, withdrew her paws, and slowly stood beside the heap. Her cub was possessed, suddenly unable to control himself. The youngster attacked the dead animal, biting its throat, head, and the back of its neck while he

kicked and slashed with his back legs. The mother sat by, keeping herself upright, swiveling her head to search the surrounding darkness for intruders. Nothing was moving but her crazed cub. He quickly wore himself out and looked toward his guardian as if to ask, "What now?" She answered by moving to the impala's hip.

The carcass rolled easily under her paw, and the leopard crouched down and bit mouthfuls of fur from the antelope's stomach. Her feline incisors nipped the skin as she pulled away the white belly hair. Blood trickled from the hide and the leopard licked the familiar fluid. The cat drove a canine and premolar through the impala's thin hide. She pulled up with a jerk, ripping open the carcass. The cub was now beside her, and he mimicked his mother precisely.

But no sooner had he joined her than he received a violent thwack upside the head. He jumped back in shock. While he was recovering from the blow, the leopard dropped her head and resumed where she had left off. Frustrated but helpless, the cub could only sit and softly howl while he watched his mother feed. He would have to wait his turn. Yet the cub could no longer contain himself and risked another attempt. This time, since the entire belly of the impala was now torn wide open, the cub could

feed without disturbing his mother. The two felines fed steadily, their faces becoming flecked with blood and bits of flesh.

Twenty minutes later the impala had been hollowed out; the stomach, still intact, was pulled out and pushed to one side, while the liver, kidneys, intestines, and even lungs had been consumed. When the cub lay down, taking a break from the tiring job of ingesting, the mother grasped the impala by the throat again and this time dragged it to the base of the nearest tree, a towering river acacia. Straddling the carcass and gripping its twisted neck, the leopard stood at the base of the tree and gazed upward. After a moment's rest, the leopard, using the full power of her shoulders and front legs, pulled herself and the impala a few feet up the tree. Pausing only to reposition her back legs to get a better grip, she lunged up again, and then again. Two more muscle-rippling lunges and she was standing in the lowest fork of the tree, gasping for breath while she tightly held the impala. With another jump she gained the next fork higher. The carcass was now fifteen feet up, and the leopard walked out on a huge horizontal limb. Her motions were fluid and almost casual despite the fact that she was dragging more than a hundred pounds of dead weight. Twelve feet out on the branch she deposited the impala, letting the head flop onto a web of branches.

By the time the leopard looked back down through the branches, her cub was gone. She scanned the area, but nothing could be seen or heard of him. The cub would come back when he became lonely or hungry. In the meantime, he was undoubtedly safely sleeping in another tree.

Twice, the leopard tugged on the impala, repositioning it so that it was more securely wedged in the forked branches. She then settled on her chest and gnawed on the impala's shoulders. After twenty-five more minutes of feeding she grew tired, turned away from the carcass, and flopped down again, legs straddled and hanging down. Within minutes she was asleep.

OPPOSITE The close bond between mother leopards and their cubs is reflected in the symmetry of these two striding together shoulder to shoulder. Walking very close, side by side, is common behavior between leopard mothers and cubs.

BELOW A young leopard feeds on a pregnant impala that it killed during the day, a rare event since leopards do almost all their hunting at night.

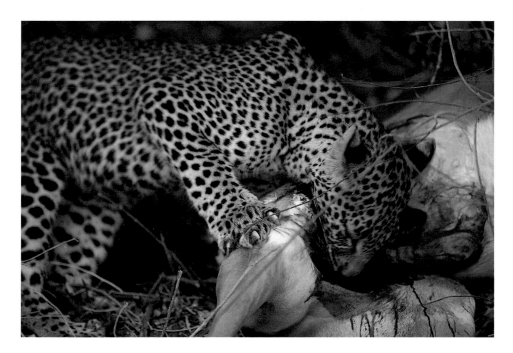

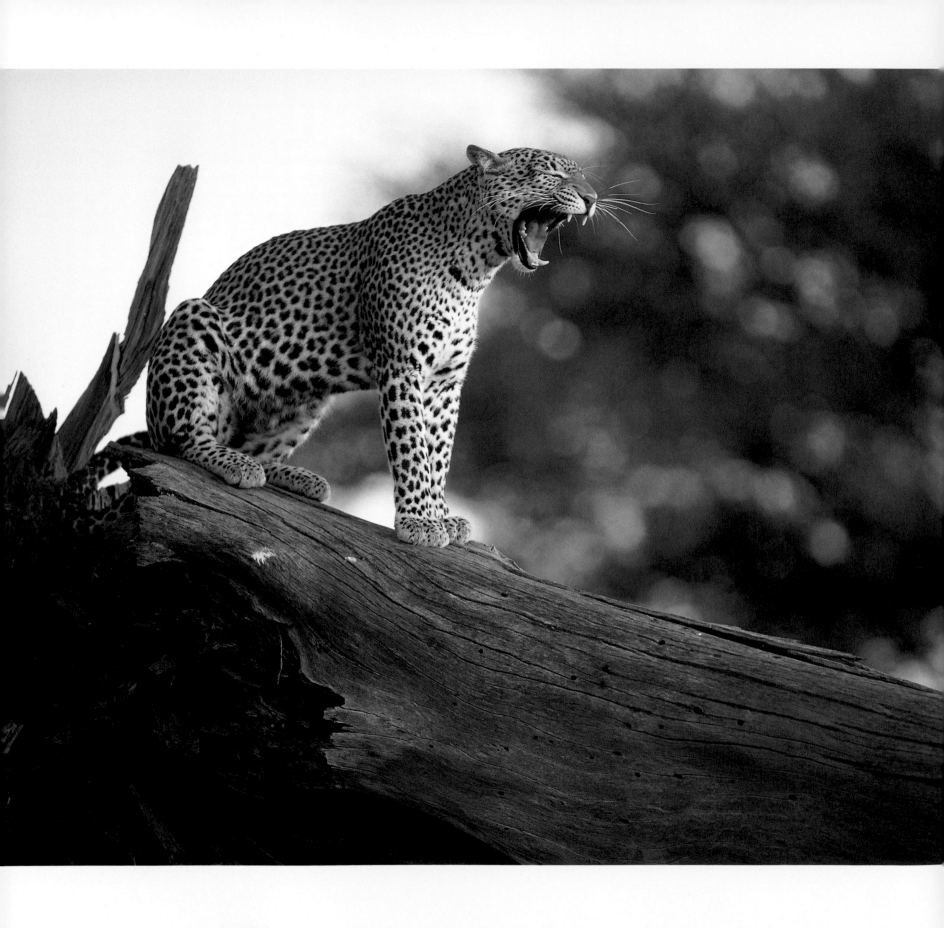

The leopard slept through the remainder of the night and half the following morning, waking only twice, both times to feed on the impala. By the middle of the day she could barely be bothered to budge. Only a passing group of nomadic lions, which circled the area briefly when they detected the odor of the dead impala, caused her to raise her heavy head. Otherwise, she slept as if drugged, with only her paws twitching occasionally.

The sun's rays lost their heat in the late afternoon and at five o'clock, when the glowing orb kissed the edge of the clouded horizon, the leopard finally woke. She raised her head a few inches, gazed around, and eventually pulled herself to her feet, yawning broadly. She turned her head toward the carcass once, looked away, and sauntered across the wide branch toward the tree's trunk.

She descended quickly, headfirst, leaping the last six feet to the ground, yet landing softly in spite of her significant body weight. Without pausing, she set off for the river. Emerging on the sandy shoreline, she walked forward until her front feet were in the cool current. Crouching, she lapped up the water for three solid minutes before turning and pulling back onto the embankment. Smoothly and effortlessly, she ascended the bank in a series of quick bounds. Equally fast, she virtually ran up an acacia that had been pushed over by elephants two months previously. She strolled out on the tilted trunk and flopped down, her rear legs hanging over the sides, her fluffy front feet positioned under her chin. For seven minutes she watched and listened before finally rising, pivoting. She jumped to the ground and sauntered off in search of her son just as the anemic clouds turned from pink to mauve and night began its march across the woodlands.

As the equatorial sun sinks into the branches of the baobab trees, the roaring of lions and leopards mixes with the whooping of hyenas.

BIOLOGY AND BEHAVIOR

Leopard Anatomy A leopard's skull is blunt and heavy, heavier than a cheetah's head and blunter than a lion's cranium. This is one indication of a leopard's hunting style. This cat is incredibly powerful and blindingly swift. It also has the jaw power to easily crush its victims, striking a great balance between speed and strength. Leopards are lightning quick, but only over a very short distance, hence their heads don't need to be as streamlined or as lightly built as those of cheetahs. Power is more valuable than speed to a hunting leopard.

The heavy skull and jaw also anchor muscles that are so strong that a leopard can drag more than its own body weight up a tree—no easy feat. The teeth match the jaw muscles in robustness. Without these heavy canines, a leopard could not drag its prey up a tree, much less kill a warthog or a young wildebeest.

Typical of all the felines, the leopard has a neat row of six incisors between the heavy canine teeth, and only one sharp, not flat, premolar next to them. The molars, as one would expect, are shaped for cutting and the upper and lower molars form a carnassial shear, an overlapping cutting surface, making it possible for the leopard to neatly slice meat from a carcass.

The most amazing features of a leopard's head are its whiskers. They are the longest whiskers of any cat, spanning slightly wider than the leopard's shoulders. There are also long whiskers in the eyebrows and high on a leopard's cheeks. All of these hairs work in unison allow this cat to maneuver safely in total darkness, one of the keys to a leopard's unique hunting method.

Leopards, like lions and cheetahs, have a layer of reflective cells on the back of the retina, the *tapetum lucidum*, which bounces light off the back of the eye and directs it forward to stimulate the retinal cells a second time. This drastically improves a leopard's night vision. The *tapetum lucidum* is the second physical characteristic that allows a leopard to hunt well at night.

Third, a leopard's paws aid the cat in killing. Its paws are completely surrounded by hairs, with almost twice as many hair follicles between the toes, thus cushioning and silencing its feet as it walks.

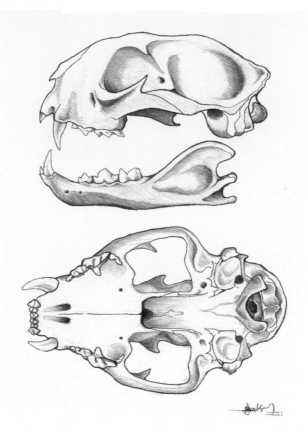

Drawing of a leopard's skull, showing the side and bottom views.

A leopard has also evolved a wide and powerful paw with deeply curved and retractable claws. The retracted claws stay sharp because they are not exposed like a cheetah's, which makes a leopard's claws perfectly suited for climbing and killing. A leopard's dewclaw, or fifth toe, neither shows in its footprint nor aids in climbing. It is, however, a useful tool in controlling struggling prey, and thus helps prevent a leopard from being injured by its downed but struggling prey.

The skeleton of a leopard—low, wide, and heavy—is another reflection of this hunter's killing style. A leopard's skeleton does not have the slightness, height, or length of a fast-running cheetah's, but neither does it have the heaviness of a lion's. A leopard's skeleton, like a leopard's life, is in-between those of a cheetah's and a lion's. A leopard is a "jack of all trades, master of none." The fact that this feline can adapt to almost any habitat and prey species is one of its keys to survival.

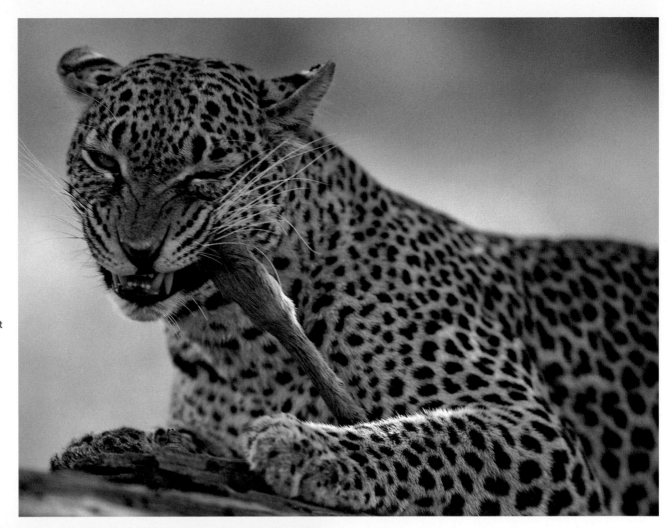

RIGHT Paws are not nearly as adept at grasping as they are at killing. This leopard struggles to grip a leg bone as it finishes off a kill.

BELOW A leopard's cushioney paw pads enveloped in thick, velvety fur.

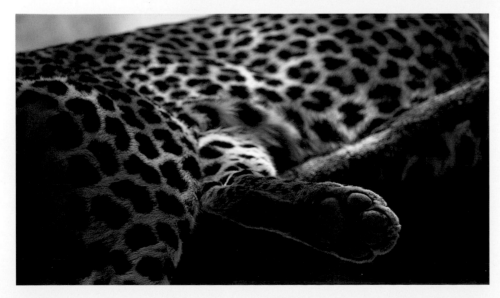

SAFARI TIP
Study a leopard's tracks. The hairs on the paws and between the toes can be seen in its tracks.

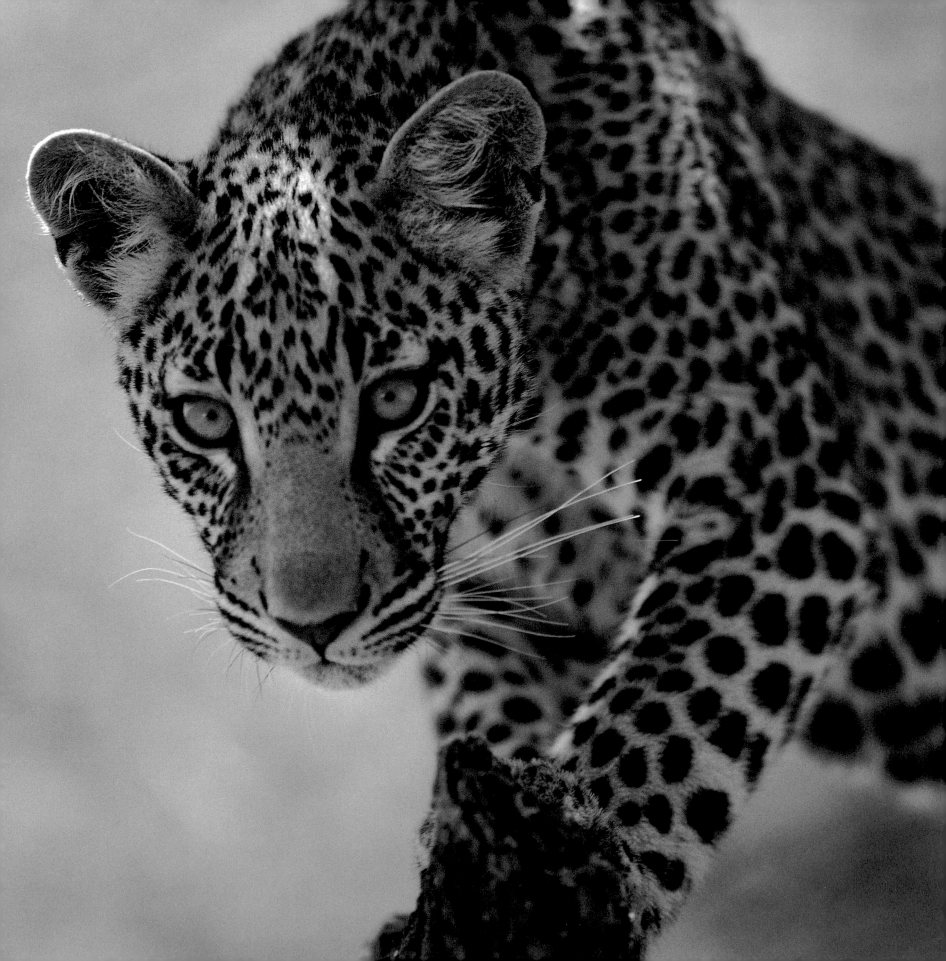

OPPOSITE A young male leopard stares, mesmerized by a flock of Helmeted Guineafowl.

RIGHT Leopards have extremely long tails, which they seem to forget about when they're up a tree. This leopard's tail hangs ram-rod straight down, making it easier for safari guides to spot.

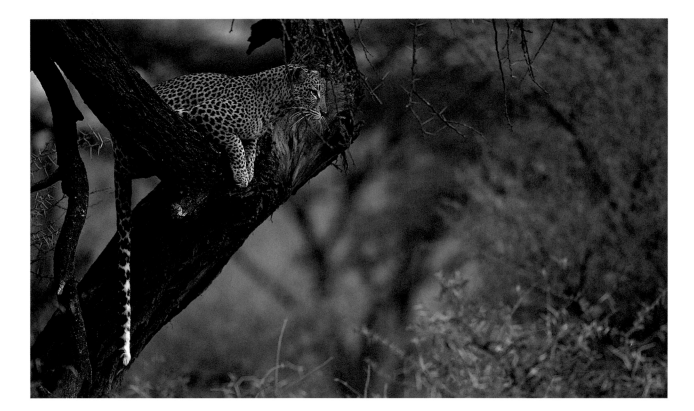

SAFARI TIP

Look at a leopard's facial hairs when you are next watching one of these cats. Notice the whisker length and locations.

A phenomenal burst of power is required for a leopard to pull its prey, often weighing more than its own body weight, up a tree and store it away from marauding lions or hyenas. This strength is in its claws, jaws, and muscles, particularly the muscles of the shoulders and neck. Imagine yourself trying to lift more than your body weight with your mouth.

Even the tail of a leopard is an aid in killing. Leopards hunt by pouncing on their prey before the prey has a chance to flee. They will sneak up to within fifteen feet of their target before exploding forward in a blur of deadly speed. The chosen prey will undoubtedly try to run, jinking and turning as it builds up speed. A leopard's tail, which is longer than half its body, helps the racing cat to match the escaping animal's every turn by serving as a counterweight and balance as the leopard charges.

One of the enduring myths about leopards is that the females turn up their tail tips, exposing the white underneath, in order to lead their cubs when walking. It is also said that this white area is used as a signal to prey that they are *not* being hunted at the time. However, both male and female leopards have a white patch underneath the ends of their tails, and all leopards, including cubs, walk with the tips of their tails turned up. Furthermore, virtually all leopards that I have observed hunting do twitch the last few inches of their tails just prior to attacking their prey, but they are certainly not warning the prey of their presence. This would be an utterly self-defeating behavior. This vibrating tail is merely an uncontrollably excited, nervous response to the tension prior to attacking.

These same tails, ironically enough, help safari guides locate leopards. A leopard, no matter how beautifully hidden in a tree, ignores its tail, leaving it hanging gun barrel–straight down from the branch on which the cat is lying. These exposed tails are too uniform in thickness and hang too perfectly straight to be mistaken for a vine or a broken branch. Nothing drapes down with the perfect symmetry of a leopard's tail.

Leopards are mysterious creatures, often just suddenly "there," appearing magically and silently beside you

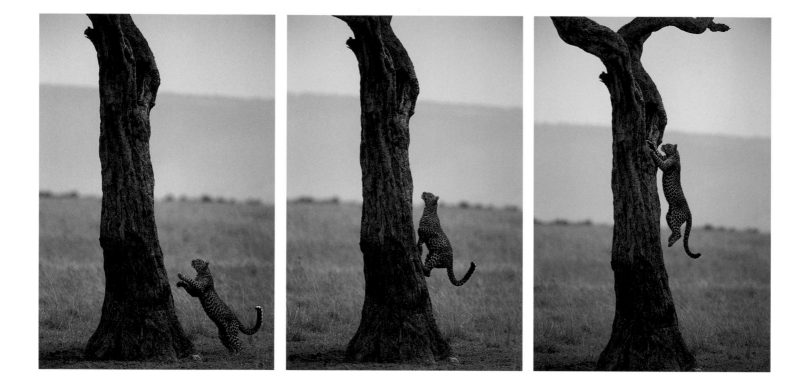

like an apparition. A leopard's coat of dappled fur is the perfect camouflage, allowing it to move and remain virtually unseen, even under the harsh light of an equatorial afternoon. A leopard has the most amazing collage of spots, blotches, necklaces, and rosettes combining to form a magnificent cryptic scheme. The colors in this diverse pattern range from snow-white to pitch-black, with golden honey, tawny browns, and yellows predominating. (Conversely, a cheetah's coat is composed of many solid black spots of various sizes against a fairly uniform light background.) Black leopards do occur, though these melanistic individuals are usually confined to mountain habitats where dark vegetation is dominant. Even on these melanistic leopards, the rosette and necklace patterns can be detected. Leopards are so well camouflaged, I have seen both impalas and dik-diks walk right up to them as they were sitting under the shade of an acacia tree. I've seen Grant's gazelles and gerenuk amble to within fifteen feet of a leopard that was sleeping in the thin shade of a salt brush. Simply put, no cat can meld with its surroundings like a leopard.

Leopards, like cheetahs and lions, also exhibit "appeasement behavior" to avoid conflict or defuse a potentially tense encounter with another leopard. Leopards have evolved white throats and underparts that can be submissively exposed in these situations. Leopards take it a step further by having a contrasting black necklace or two of connecting black blotches that ring the bases of their white necks. This contrast makes the white throat stand out even more when it is exposed. These necklaces are like fingerprints—their patterns are unique to every leopard. We guides use them to identify individual leopards.

ABOVE Leopards are exposed and vulnerable on the open plains. Any tree, even a small boscia, is better than nothing when looking for cover. In three quick bounds this male has vanished from the open grass.

OPPOSITE Where's the leopard? In broad daylight, a leopard sits bolt upright on a log behind a pair of dik-diks. The tiny ungulates are aware that some danger is nearby but do not see the motionless leopard.

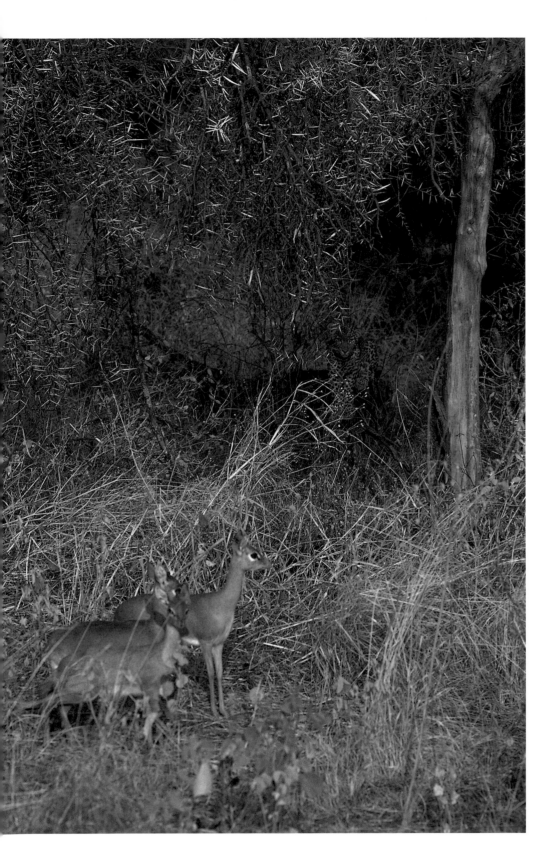

When you are near a leopard,
maneuver your vehicle to the
downwind side and see if you
can smell it.

Territoriality and Habitat Leopards are territorial cats,
with male territories averaging fourteen square miles,
while females typically hold twelve square miles of land.
These territories are somewhat flexible and often overlap;
male territories tend to overlap more with female ter-
ritories than with those of other males.

Leopards are found in all environments in Africa,
including vast open grasslands and deserts. One of the
keys to their success and adaptability is that they can
eat almost anything, from frogs and fish to birds, rats,
lizards, insects, snakes, and eggs. They do not confine
their palates to medium-sized mammals—far from it.

Leopards require secure daytime resting places that are
safe from lions, hyenas, and baboons. Trees work well,
as do cliff faces, caves, and small valleys. The right food,
of course, must be present within a leopard's habitat, but
because they can adapt to such a wide range of prey, it
is possible that safe locations for daytime resting could
be the more important factor in determining a leopard's
territory.

Another factor is the fact that leopards hunt by attack-
ing with very short, swift sprints. They cannot maintain
even a medium-distance chase, which eliminates open
grasslands.

Leopards maintain their territories by patrolling them,
leaving urine markings on prominent trees and rocks,
defecating along the borders, establishing scratching
posts, and vocalizing to advertise that the area is occupied.
Both sexes "roar" throughout the year, though females
tend to roar much more when they are in heat. A
leopard's roar consists of a series of rasping grunts that
sound a great deal like someone sawing through a piece

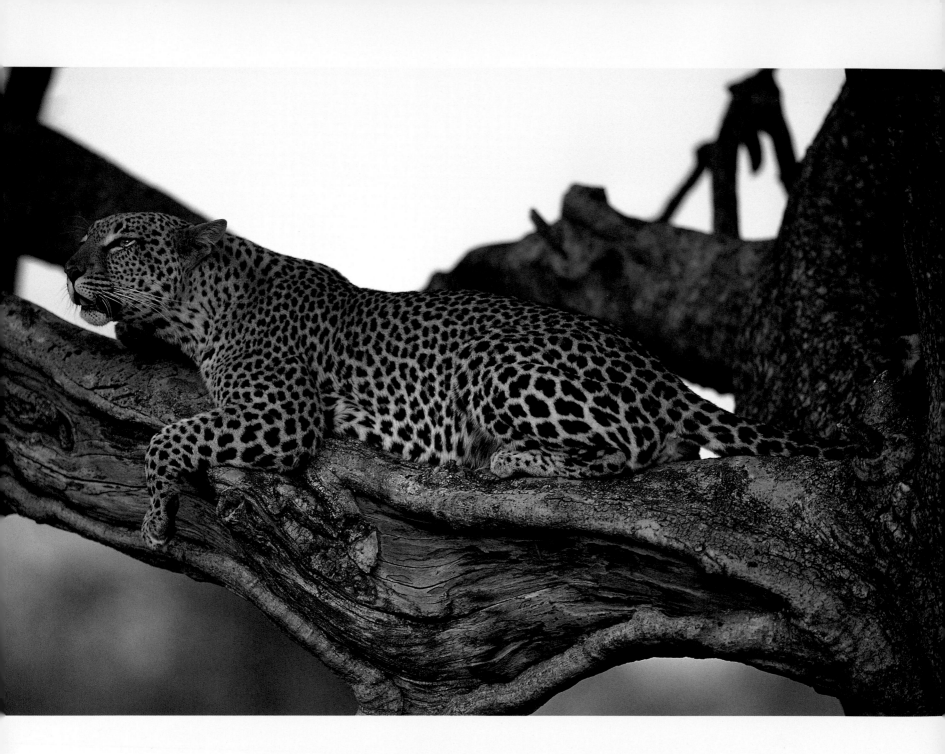

ABOVE Msikio, an old female leopard I've studied for years, calls out for a male. She has just come into heat, and she will patrol the edges of her territory, marking its perimeter with urine and feces, and vocalizing continuously, letting the males in the territories bordering hers know that she is ready to mate.

OPPOSITE Msikio mates with the male that borders her territory to the east. It is extremely rare to find leopards mating in daylight, and I'm not sure why these two chose to make themselves so vulnerable. We returned 130 days later to find Msikio with her tiny cub still so new that only one eye had opened (see page 30).

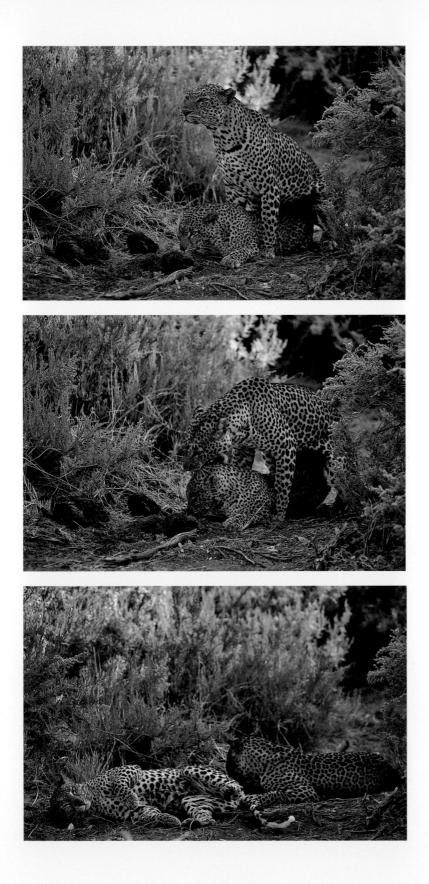

of lumber. Eight to ten exhaling sawing sounds comprise a typical leopard territorial call. All these techniques warn away competing leopards and leopards of the same sex, but can attract leopards of the opposite sex. Fights between the same sex occur only when all other avoidance methods have failed.

Since both sexes mark their territories, it's easy for a male to tell when a female in an adjacent territory is in heat by smelling her urine deposits. Hence leopards are not in heat as often or for as long as nonterritorial cheetahs. Every forty-five days a leopard will come into heat for approximately sixteen days. That allows enough time for a male to detect that she is in heat, track her down within her territory, and mate with her. A female leopard leaves little to chance and drastically increases the odds of being found during her estrus cycle by vocalizing continually and loudly as she moves through her territory during these periods.

I have never seen photographs of wild leopards mating and have only witnessed it myself on three occasions. Two of these matings occurred at night, so the only evidence was the sound of them as they frolicked under the cover of darkness. I have seen leopards mate during the day only once in the twenty-five years I've been running safaris, which gives you an idea of the rarity of diurnal couplings.

Leopards, unlike lions and cheetahs, are very playful and frisky when they pair off. The couples often zip around, jumping over each another, even playing in elephant and rhino dung by rolling in it, tossing it in the air, and batting it back and forth. The actual coupling is typical of cats: the female sidles up to the male, turns and faces away from him, squats down, and presents herself to him. He straddles her, enters her, growls, and often gently bites and holds her neck. The instant he withdraws the female flops over on her side or back and remains lying down for some minutes. The pair will stay together for only a few days, a much shorter span of time than lions. Leopards also do not mate as often per hour as lions do, coupling every twenty minutes on average as compared to a peak of every five minutes for mating lions.

Leopards are solitary cats so only one male will be in consort with an estrus female. This is markedly different from most lion (and some cheetah) matings, at which

there is most often more than one male in attendance. As with cheetahs, once the estrus cycle is over the male leopard leaves the female and returns to his own territory, and the daily rhythm of life continues for the solitary felines. The female gives birth one hundred to one hundred and five days later.

Leopard cubs are born in safe seclusion, the mother usually selecting a small rocky cave or, more often, a hollow log in which to bear her litter of two tiny young (litters up to five have been recorded). Leopard kittens are born with their eyes shut and are tiny, weighing only twenty-two ounces. Even though the kittens are odorless, they are still extremely vulnerable to predation by both lions and hyenas. Infanticide by male leopards has also been well documented so this postnatal period is a very tenuous time for the cubs.

A mother leopard does a number of things besides nursing, cleaning, and keeping her cubs warm to improve their chances of survival. She moves the cubs every few days, carrying them in her mouth one at a time, from the old lair to a new one. This may aid in foiling any predator that has noticed her consistent movements to and from the den, and it may well prevent infecting parasites from accumulating where the cubs have been lying.

Somewhat surprisingly, mother leopards spend long periods apart from their young, thus drawing attention away from them. She will not bring her kills back to the lair, kills that other predators could smell and search out. Finally, mother leopards also cease their territorial calling during this postpartum period. Again, they do not want to draw attention to themselves, even from a neighboring male leopard.

Msikio's new cub.

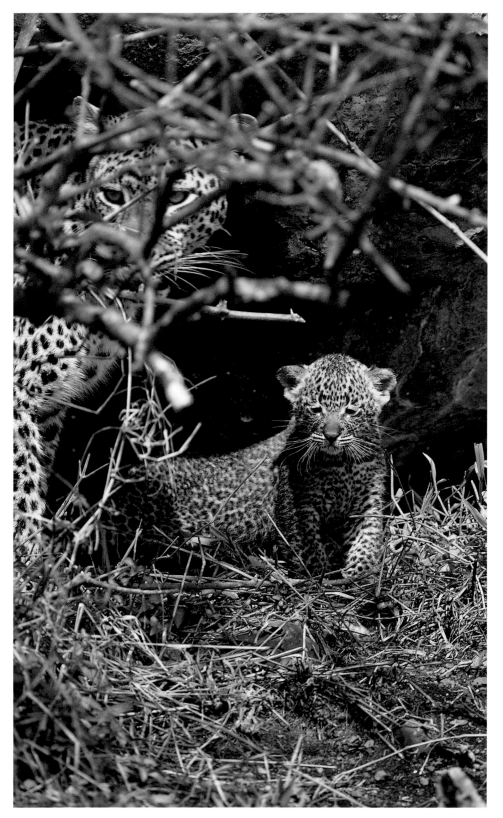

Leopard cubs' eyes open when they are four to nine days old, but they are still completely helpless and don't dare venture out from the lair. The kittens' coloration, similar to though slightly grayer than an adult leopard's due to the rosette patterns compressed on their small bodies, offers them no real advantage.

By two months of age the little ones are bouncing balls of fur that venture about when their mother is at the den. Fat, fuzzy, and gray-eyed, the cubs climb and crawl, tussle and fight, and begin to follow their mother farther and farther away from the den, although they are never so far from safety that, startled by the slightest sound, they can't run safely back to cover. Even at six months of age they are still highly vulnerable to predation from lions and hyenas, predation against which the mother is either unable or unwilling to fight. If the mother were to become seriously injured or killed, the cubs would soon die without her. Genetic survival dictates that such a risky fight is not worth it to a mother leopard.

Youth and Growth Due in part to their shy and solitary natures, surprisingly little is known about wild leopard young, and even such basics as the duration of their suckling period remains a mystery. Research on captive leopards says they are weaned by the time they are three months old. Wild leopard cubs are certainly eating meat by this age so this time frame may be accurate for them too. Leopards regurgitate meat for their cubs when they are quite small. This behavior is unique among the African cats.

Leopards with cubs hunt often, probably nightly, as they need an estimated four to six pounds of meat every twenty-four hours. Lactation requires a lot of energy and thus calories. At four to five months of age, the cubs

A young male leopard peers out, bleary-eyed, into the morning light. This individual eventually became extremely popular with tourists, but unfortunately his fame killed him. One day he became trapped up a tree with a pride of lions beneath him, but the pressure of so many safari vehicles surrounding him forced him to jump down and make a run for it. He was overtaken by the lions and killed almost instantly.

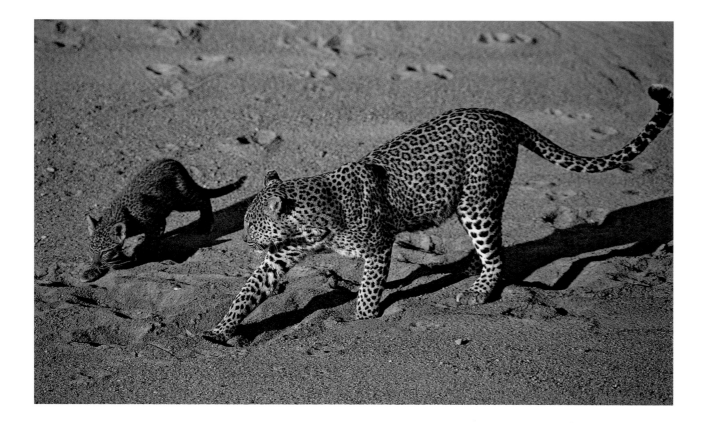

ABOVE This mother came out of her lair, defecated, and scraped sand over the droppings. Her young son imitated her actions, though he himself did not defecate—leopards learn by watching their mother in action. A minute later his sister joined them on the sand (right).

OPPOSITE A near-grown leopard (at left) is not quite ready to leave his mother (right) even though he is of age. He tries to play with her, but she rebuffs him again and again in an attempt to drive him out of her territory.

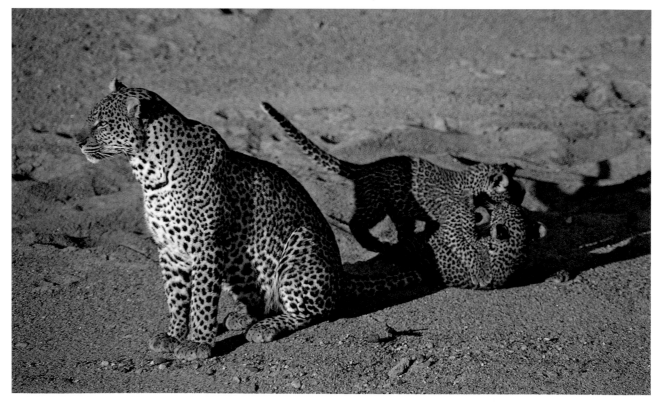

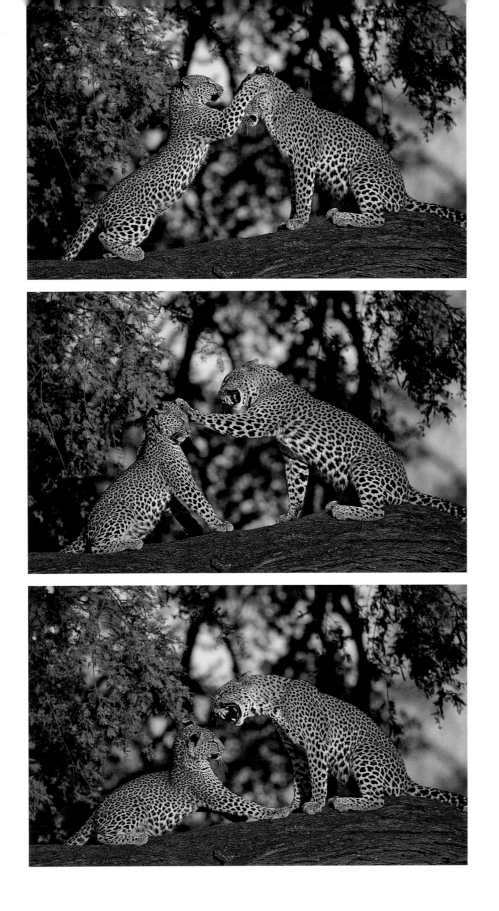

are consistently following their mother when she goes hunting. A leopard's hunt is a casual affair as compared to a cheetah's or lion's hunt, so it isn't difficult for the short-legged cubs to keep up as the mother, resting frequently, wanders her area in search of prey.

Leopard cubs, like all cats, learn to hunt by watching their mother stalk, attack, and kill her prey. In this way they learn what to hunt, where to hunt, and how to stalk it. But it's a slower way to develop as a hunter so there is a trade-off.

At four to six months of age young leopards develop two interesting traits: they steal from their mothers, and push them off of fresh kills, kills that may still be alive. I have never seen a mother retaliate or even attempt to repossess the meat. Very young leopard cubs are both attracted to and terrified of still-kicking or freshly killed prey. Genetically they must know it could be dangerous, and yet genetically they are also aware that it's their life-sustaining food. A quandary then develops. As the cubs reach five or six months of age they become bolder, gradually drawing nearer and nearer and standing just behind their mother as she subdues the fighting prey. The moment all is calm, a cub may slide its head in, gripping the prey in exactly the same way and in almost the same spot as the more experienced adult. Once the prey is dead, the cub will move to where the adult is feeding and start eating there as well, thus learning where to break into a fresh kill and what to eat.

Play Play for leopard cubs is generally a one-sided affair—the mothers certainly tolerate being attacked, climbed on, knocked over, and strangled, but mothers very seldom initiate interaction with their offspring. If the litter consists of more than one cub, the little ones generally keep themselves occupied with play. The mother then just acts as a guardian babysitter, usually sitting nearby and just keeping an eye on things. Adult leopards are much less tolerant of play when they are up in trees, regardless of the time of day. Perhaps they inherently do not want to draw attention to themselves when they are so visible. For whatever the reason, adult females have virtually no patience for horseplay up high.

Adolescence Leopard cubs stay with their mother until they are more than a year old. Though adult females are territorial, they don't seem strongly motivated to force the cubs out on their own. For a leopard cub, leaving their natal territory is a very gradual process.

A female cub invariably stays with her mother longer, some eighteen months, and sets up a territory either adjacent to or near her mother's. These two territories can even overlap considerably and have no firmly defined boundaries. If the mother leopard happens to be old and dies soon after a female cub reaches adolescence, that cub will stay on and inherit her mother's territory.

For male leopard cubs, it's a different story. From the age of eight or nine months they have been wandering, often spending whole days and even the occasional night away from their mothers. The male cub's playing at this age often becomes rather short-tempered and rough, and

the mother becomes rapidly less tolerant of it, thus serving as an impetus for these growing cubs to spend less and less time with their mothers.

Adolescent males establish their territories farther away from their mother's than the females—if they were adjacent, there would be the risk that they would mate. Thus, they wander, though for a much shorter period than nomadic lions roam. If a wandering adolescent male chances on a territorial male leopard, he will simply be chased out of the area. Male leopards do not typically fight, and certainly no fights to the death have been recorded (at least, as far as my research has shown).

Male leopards reach sexual maturity before they are three years old, and will have established a territory by that age. Female cubs are able to breed by the time they are two and a half years old and will have their first litter by the time they are three.

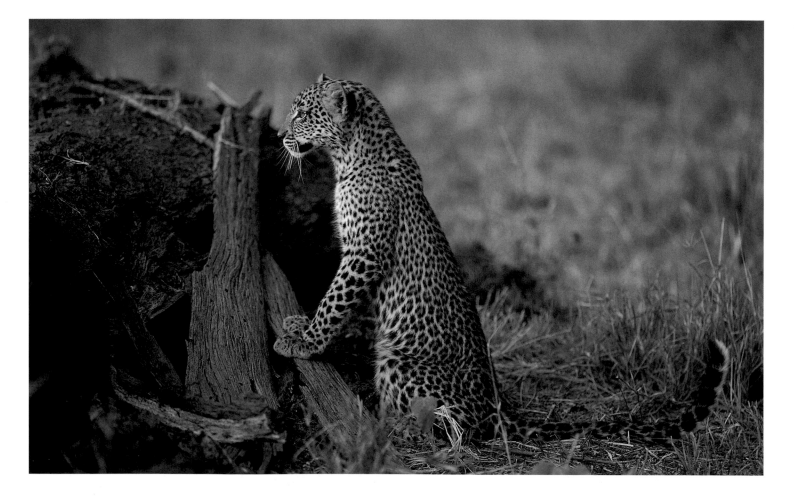

SAFARI TIP
Sketch the necklace pattern of a leopard. Use it as an identifier—you may see this one again.

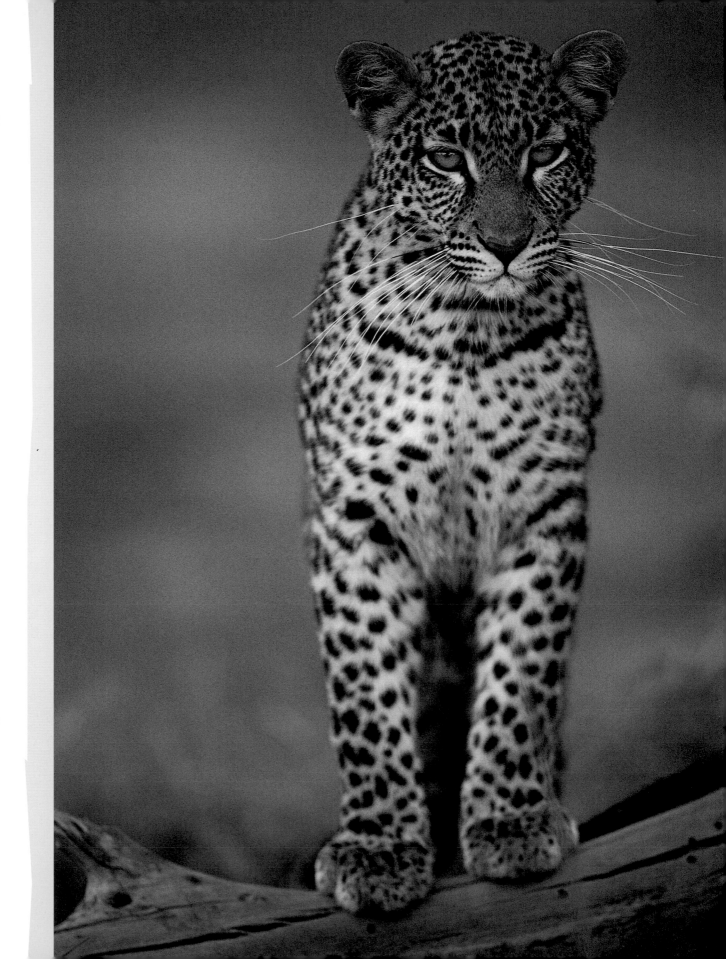

OPPOSITE Five-year-old Jicho, the third-generation female of a leopard family I've been following in Samburu, already exhibits her unique habit of periscoping up over fallen logs. Neither her mother nor grandmother searched for prey this way.

RIGHT Jicho gazing at a herd of impalas after first periscoping up over the log. She seems to have originated the periscoping behavior, which she will more than likely pass on to her offspring.

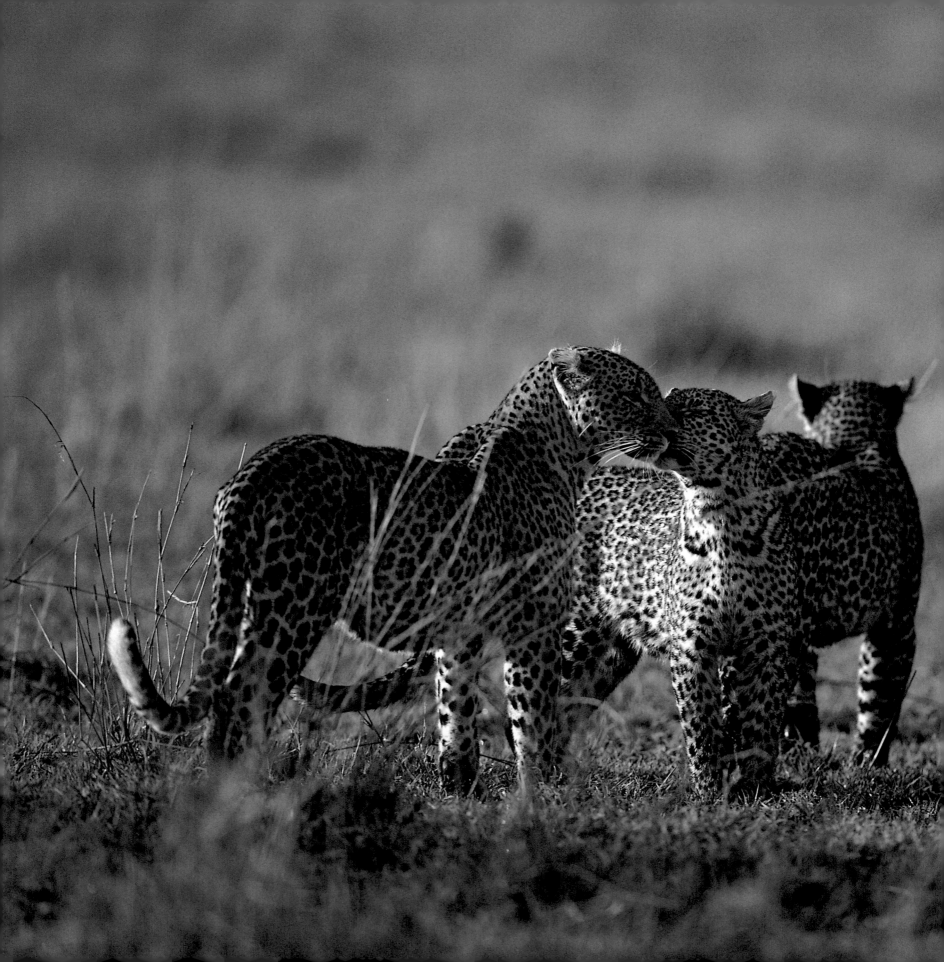

A mother leopard walks across the open plains with two near-grown cubs.

Hunting Leopards are lousy hunters and have to be overly optimistic when it comes to killing. In other words, they stalk and attack far more prey then they expect to capture. Leopards only succeed in 5 percent of the attacks that they initiate, but with a strike distance of sixteen feet and a pursuit distance that averages only fifty feet, they expend very little energy; therefore, their investment in each attack is small.

It is a leopard's physique that aids it greatly in this casual, energy-saving approach to hunting: a leopard's long whiskers allow it to move easily in complete darkness; the cat's silent, hair-muffled feet hide any clues to its proximity; and a rosette-patterned coat is difficult enough to see during the day, and at night, even under a bright moon, it cloaks the leopard perfectly. Combined, these attributes allow a leopard to get very close to unsuspecting prey, time and time again. Instead of engaging in a long, calorie-consuming, high-risk chase, a leopard uses the element of surprise and attempts to capture its prey *before* the prey flees. If the selected target manages to get up and make a run for it, the leopard will almost always let it go, preferring to try again and again.

The fact that leopards will eat just about anything is a terrific advantage for them. It allows them to exploit almost any habitat and gives them the ability to change food sources from month to month as prey availability fluctuates. Thus they can remain in the same territory throughout the year. Their eclectic tastes, therefore, make it very difficult to generalize about how leopards hunt, except to say that the way they hunt varies almost as much as what they hunt. Leopards will sit by a pool along a river and swat fish onto the shore; they will climb into trees

SAFARI TIP

If you come across a leopard while you're on a night game drive, stay with it (preferably well to the side of it or well ahead), and watch it hunt. This is much easier than you might think, but it does require patience.

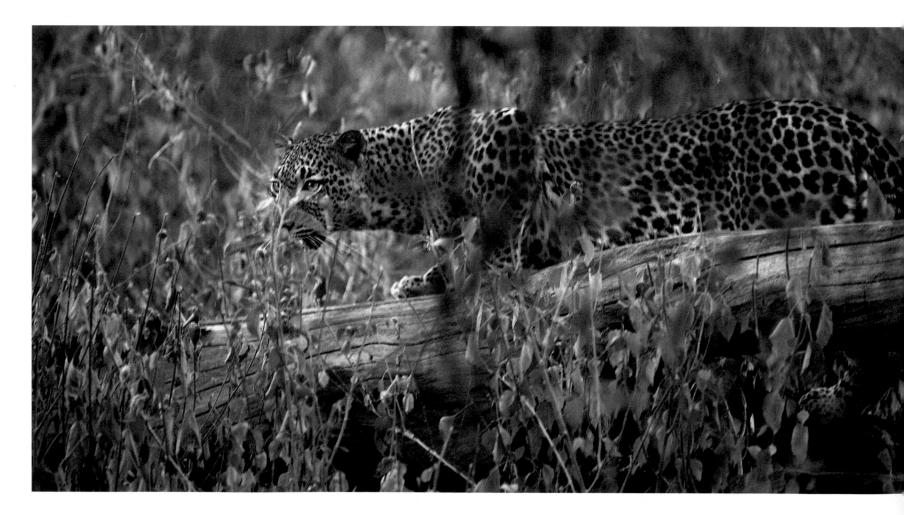

OPPOSITE Leopards are the ultimate in stealth and are able to stalk much closer to their prey than either lions or cheetahs. However, they pursue their quarry for only about fifteen yards, a much shorter distance than lions or cheetahs.

RIGHT Unable to carry this large impala carcass up the tree, the young leopard tries to cover it up instead.

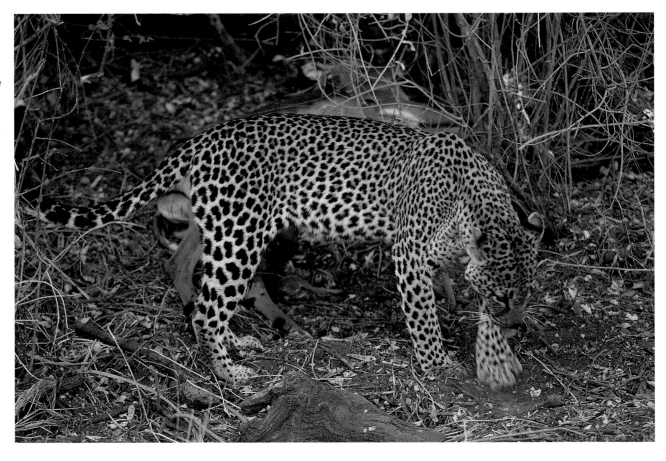

SAFARI TIP

Learn a vervet monkey alarm call, and use them as leopard spotters.

and grab sleeping guinea fowl. Leopards quite commonly take domestic dogs as well, dogs who make the mistake of barking, thus giving away their exact location. Even a Rhodesian ridgeback is no match for a hunting leopard.

Leopards, given a choice, will hunt medium-sized prey, such as impalas, young wildebeests, and immature topi (tsessebe), Grant's and Thomson's gazelles, and warthogs. They do not, contrary to popular belief, specialize in hunting old, weakened, or newborn animals. They do kill more male antelopes than females, but that is only because most solitary antelopes are male and solitary targets are more vulnerable to predation.

Leopards kill antelopes by swatting their rumps, knocking them down, and then either biting through the prey's neck or skull, or grasping the victim by the throat and strangling it. It is not infrequent that one sees claw marks across the rump of an impala or Grant's gazelle, indicating a near miss by a leopard.

I've spent hours watching leopards hunt warthogs, these hunts always occurring at dusk. Warthogs are formidable fighters, armed with four self-sharpening tusks. Because leopards are solitary cats and have no pride to hunt for them, they cannot risk being injured, for that could mean starvation. When a leopard catches a warthog (in East Africa) it will wrestle the pig onto its back and actually bite through the chest, eventually piercing the heart. It's a slow way to kill a warthog, but safer than grabbing the pig's throat and getting slashed by one of the tusks.

Lions defend their kills, as do hyenas, by their sheer numbers in their prides or clans. Cheetahs defend their kills by eating it very quickly, thus lessening the chance that it will be stolen. Leopards, quite cleverly, protect their kills by simply dragging the meat up a tree and out of reach of the competition. These powerful cats will disembowel their prey, eating the vital organs first, and then, with the enormous strength in their teeth, jaws,

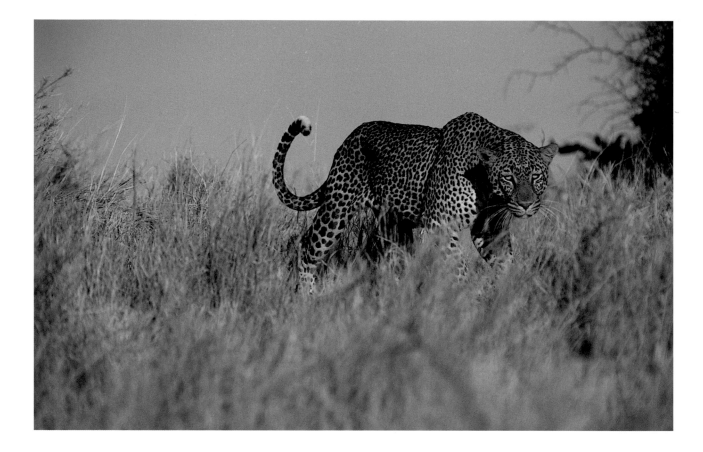

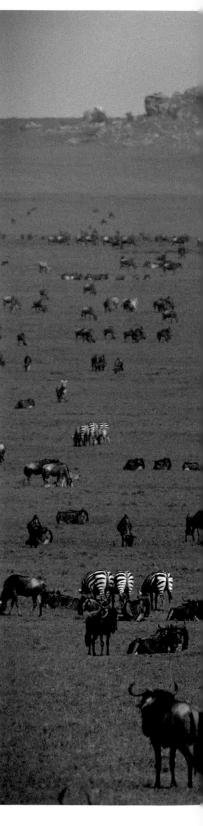

claws, legs, and shoulders, drag their prey straight up a vertical tree trunk. The leopard will then drape the kill over a branch or wedge the carcass into a fork where it can continue feeding at its leisure. Hyenas cannot climb trees and lions can only clumsily manage the largest or lower branches, and since cheetahs won't even attempt to ascend a standing tree, the leopard's kill is safe. Vultures, too, are unable to access a kill stashed in a tree, because it's impossible for them to maneuver their huge wings within the tight confines of a tree's branches.

No African predators kill for the fun of it—that is strictly a human trait. But leopards will hang more than one kill in a tree, if prey is plentiful. The urge to kill is hardwired, and if easy prey is abundant, during calving times for example, a leopard will often have the temporary luxury of multiple kills on which to feed.

Leopards are, without a doubt, the most successful of Africa's large cats. They are capable of inhabiting virtually

all environments; can live in proximity to people without mishap; and can cohabit an area with lions, hyenas, and cheetahs (though they will kill cheetahs, if given a chance). Leopards, in spite of their omnipresence, have little impact on an environment. In the Serengeti/Mara ecosystem, cheetahs kill twice the biomass per year that leopards kill, which is a reflection on leopard population densities, not on a leopard's hunting skills.

ABOVE A very large yet shy male slinks down toward a river to drink.

RIGHT The Serengeti Plains in February are crammed full of wildebeests, common zebras, and Grant's and Thomson's gazelles, not to mention all the other resident ungulates and predators. This is a rich ecosystem, the world's largest collection of terrestrial mammals.

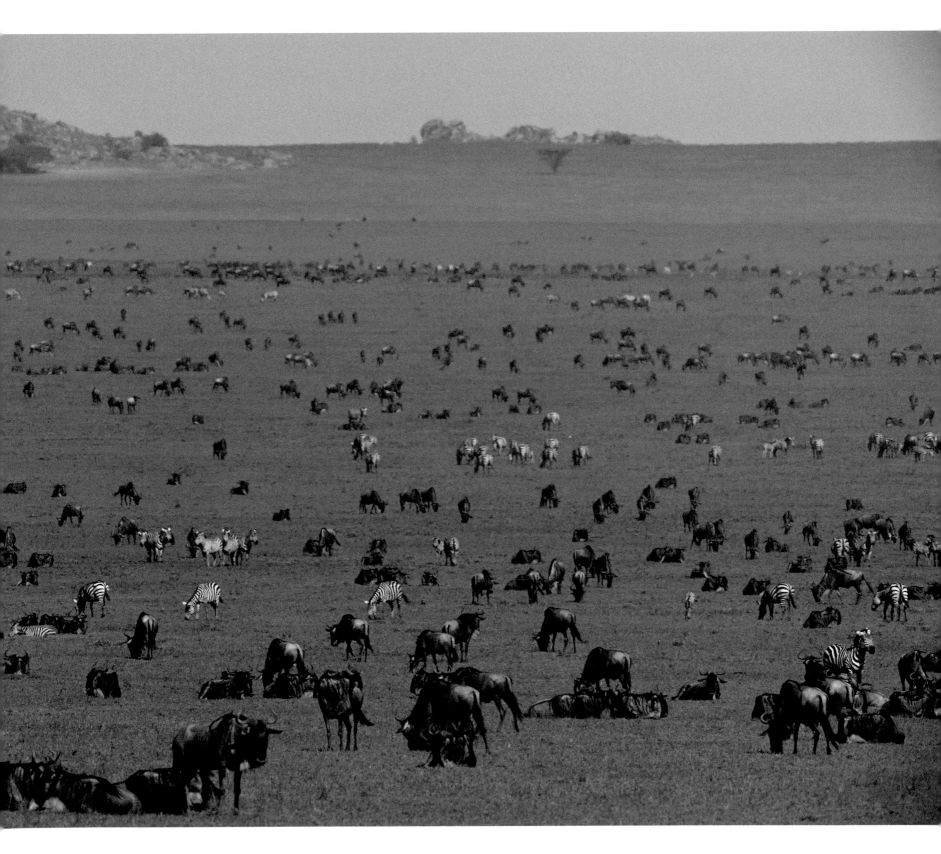

Prey Defense Most medium-sized antelopes live in social herds, whether female/breeding herds or male bachelor herds. A herd provides many eyes and ears for defense against feline predators. Because leopards are odorless, an antelope's nose, no matter how well developed, offers it no greater protection. Even dik-diks, which have the keenest sense of smell of any of the antelopes, cannot detect leopard odors. Elephants have been observed walking directly under a branch with a leopard lazing on it, completely unaware of its presence. Yet when they see a leopard they will react every time, charging the cat just as they do with lions.

Prey species develop daily rhythms that minimize their time in dense habitats at night. In semiarid or seasonally dry country, prey animals will most often come to the rivers during the day, thus avoiding being concentrated along the banks at night, when the leopard could use the cover of a riparian forest to make his hunting easier.

Many prey species have developed aural warnings, which they give when they have detected a leopard. In habitats where vervet monkeys live, I locate most of the leopards I find by listening for this primate's barking alarm call; I find the monkey, look where it's looking, and search there for a leopard.

Dik-diks, impalas, Grant's and Thomson's gazelles, gerenuk, oryx, and zebras all snort alarm calls when they spot leopards. Their vocalizations warn not only their own, but other ungulates of a predator's proximity. These calls can alert you too once you recognize them.

Baboons and vervet monkeys will also sleep in trees or on cliff faces at night to lessen their chances of exposure to hunting leopards. At night baboons are vulnerable, but during the day they stay in tightly knit and highly organized troops that are a superb defense against leopards. During the day the tables are turned and a troop of baboons won't hesitate to attack and kill a leopard if they happen upon one on the ground.

SAFARI TIP

Observe any given antelope and study its coloration pattern to determine how it might be helpful in prey defense. The rump pattern and heel "flashes" on an impala are not accidental. The stripes on a zebra did not evolve because they look pretty. Notice how the horizontal stripes on the plains antelopes and the vertical stripes on the woodland antelopes help break up these animals' silhouettes.

A mother Grant's gazelle, after having given birth to her fawn, will eat the fetal sac, lick the fawn clean, and, about two minutes later, the fawn will stagger to its feet.

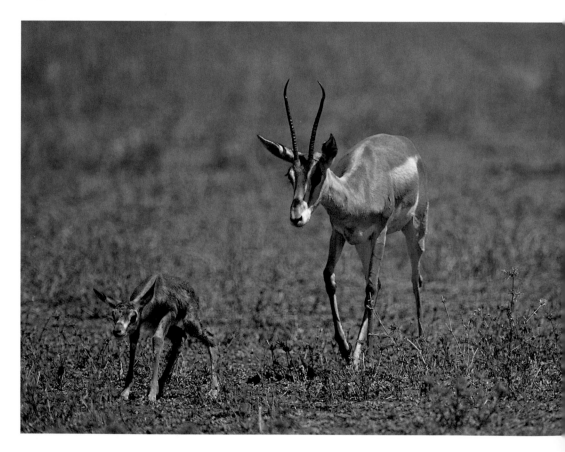

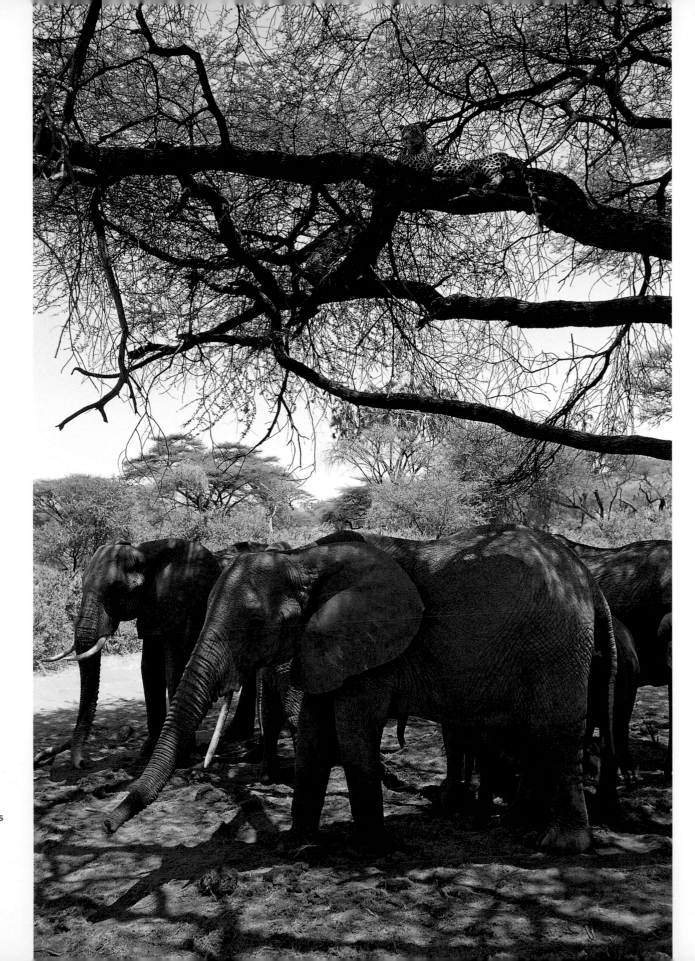

A leopard, odorless, lounges on a branch over a herd of elephants who are unaware of him.

Debunking Leopard Myths

MYTH: Leopards use the white underside of their tail tips to lead their cubs.

FACT: If this were true cubs and all males would not have white tail tips as well.

MYTH: Leopards use the white underside of their tail tips to signal prey as to whether they are hunting or not.

FACT: Signaling to prey in any way would be self-defeating to a leopard, and nature doesn't evolve that way. The element of surprise is crucial to a leopard when it is hunting.

MYTH: Leopards are great hunters.

FACT: Leopards only succeed in 5 percent of their attacks. They miss far more often than any other cat, as well as hyenas and wild dogs, but they compensate by hunting often and using little energy, a method that works well for them.

MYTH: Leopards hate water.

FACT: Leopards are strong swimmers and can kill prey in water, even fish.

How to Observe Leopards

1. Leopards are almost exclusively nocturnal hunters so you need to observe them as close to the night as possible. Leave your camp or lodge before first light if you can, and stay out as late as possible. Go on night drives when you can.

2. I find more leopards by listening than looking. Learn the alarm snorts of impalas and dik-diks in particular, though all the ungulates will have a snorting alarm call for cats. Also learn the alarm calls of both baboons and vervet monkeys.

3. When you want to find a leopard in a tree, spend your time looking at the ground for its tracks. Leopards do not cover much ground during the day, so if you discover even relatively fresh tracks, the leopard is probably in the area.

4. If you find a kill in a tree that still has meat on it, come back at dusk or dawn; stay at a bit of a distance and wait for the leopard to return.

5. During the crepuscular hours, search fallen logs and low, exposed tree branches for leopards. These cats are seldom up high at this time of day.

6. During the middle of the day look for a telltale tail hanging down from a high tree branch.

7. **Never** sit down inside your vehicle and wait for your driver or guide to find a leopard for you. Get involved in your own safari—the more eyes searching for the desired creature, the better your chances of finding it.

LEFT AND BELOW A male leopard, detecting the scent of a cheetah that had marked on the car earlier that day, slaps the vehicle before climbing onto it.

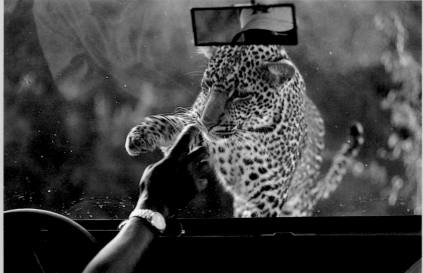

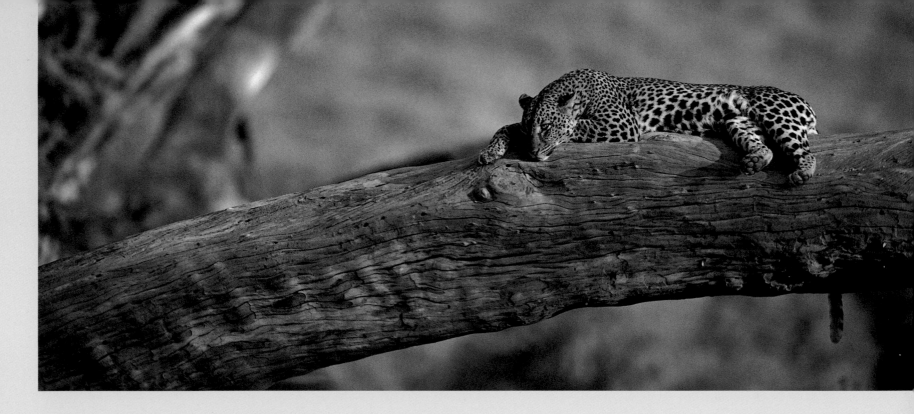

Facts on File

1. Dr. Richard Estes justifiably calls the leopard the "Prince of Stealth."

2. Leopards are the most widespread and most adaptable of all African cats.

3. Leopards are the least specialized of all African cats, able to live on anything from insects to fish to mammals three times their own size.

4. Leopards have body weights of 60–130 pounds average for females and 80–150 pounds average for males.

5. Male territory sizes average fourteen square miles; female territory sizes average twelve square miles.

6. Both sexes mark territories with urine, feces, claw-sharpening posts, and by vocalizing.

7. Leopards are almost purely nocturnal hunters, spending their days up in trees or in cover.

8. Litters of two to three cubs are born throughout the year.

9. Gestation is typically one hundred days.

10. Cubs are born blind, but their eyes open after six to ten days.

11. Cubs are weaned at two to three months and start eating meat at six to eight weeks.

12. Leopards become sexually mature and independent at two to four years of age.

13. Leopards hunt predominantly by sight, but scent can play a roll as well.

14. Vervets and baboons will mob leopards during the daytime, and baboon troops have been known to kill leopards.

15. The extremely long whiskers of a leopard allow it to maneuver with great skill in total darkness.

16. A leopard's average attack distance is only five yards.

17. Leopards succeed in killing 5 percent of the time they attack.

18. A leopard kills small prey by biting through the neck and severing vertebrae, larger prey by strangulation.

19. Leopards can carry far more than their own body weight up a tree.

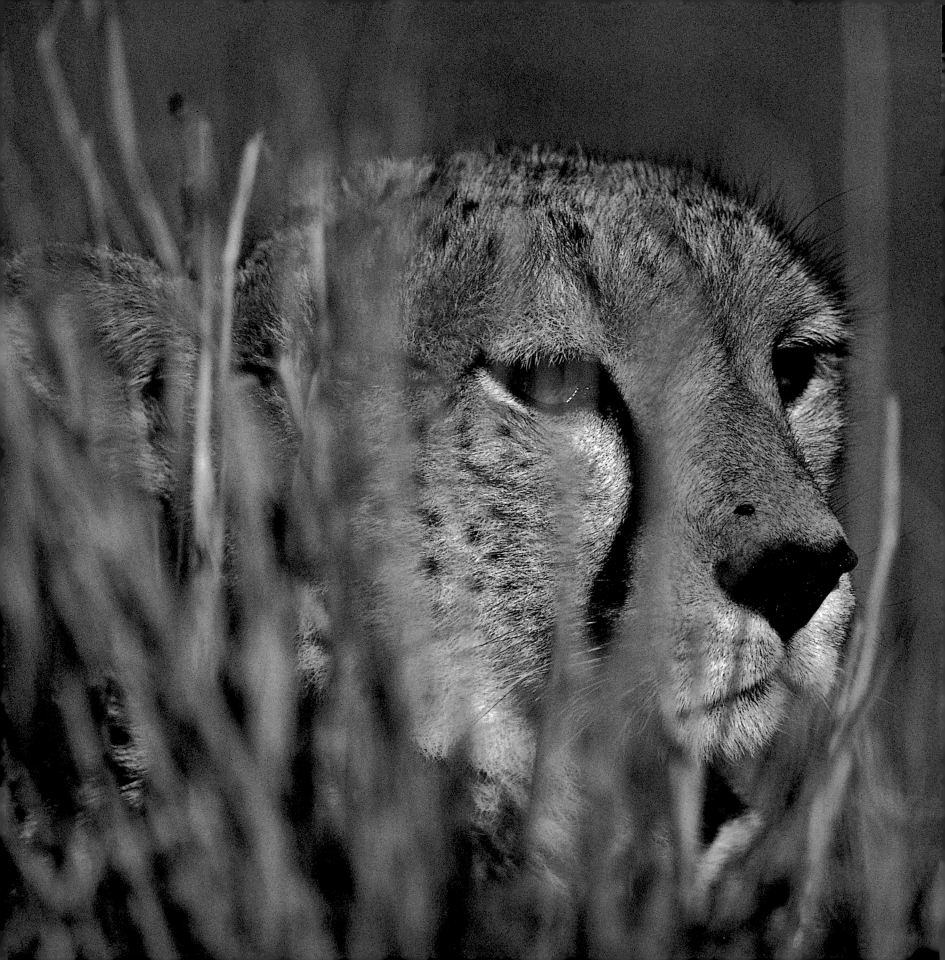

CHEETAH

A DAY IN THE LIFE

The cheetah walked along a ridge with definite purpose, not the "wander and pause" that cheetahs often move with. Suddenly, she froze, then began moving forward low, shoulders rolling, head and eyes locked on a target. This was going to be a hunt. With a smooth buildup of motion the cheetah gradually went from walk to fast walk to slow trot, rapidly closing in on something, yet not turning on the afterburners and keeping her whole body below the level of her rolling shoulders. She covered the ground fast, eating up a hundred yards in no time, but as of yet expending no significant energy!

The change in her gait occurred in a flash—she was suddenly running, accelerating almost instantly. She moved through a combination of tall grass and shrubbery that partially obscured her and totally obscured the target.

Suddenly there was a blur of tan, black, and white. It must be a Thomson's gazelle. A Grant's gazelle would stand taller and not show the black, and it was the wrong habitat for reedbuck or oribi. It just had to be a tommie, in spite of the tall vegetation.

A cheetah casts a discerning eye across the grasslands spread out before him, keeping watch for both predator and prey. Note the striking "tear" line extending from eye to jaw.

The gazelle broke clear of the grasses, running straight and tucked down, a death run. He flashed through a patch of short stubble and then back into the taller cover. The cheetah streaked through the same spot, a second behind. You could see them both now, still going straight, their heads just cutting across the green tops, like shark fins breasting the wave tops. But the trailing shark was rapidly gaining, the purpose and outcome clear.

As the two patches of tan rocketed across the blurry green palette, the cheetah, less than eight feet from the tommie's flashing flanks, suddenly pulled up, changing her stride to a high, bouncing, braking motion. The cheetah had been only a few strides from swiping out and cuffing one of the rear legs of the Thomson's, a light strike that would have sent the gazelle tumbling. The chase had eaten up less than two hundred yards, and it was a cool and gray morning—no reason to break it off. The terrain was perfect—it was neither slippery wet, nor dusty-slippery. With a success rate of 70 percent, almost all cheetah attacks end with a kill. But this strike was over almost as fast as it had begun.

As the Thomson's fled out of sight, another brown shape rose out of the head-high greenery very near the cheetah. The shape coalesced into a hyena, sitting casually and watching the cheetah as she decelerated to a walk. What lousy, rotten luck. The cheetah had been in the right

place at the right time, in the right cover, had closed the distance, had exploded with measured grace, had made the attack perfectly—only to be forced to give it all up to something stronger.

The cheetah turned and walked back in the direction from which she had come, not glancing back at either Thomson's or hyena. A hundred yards later, where the tall grass gave way to the short grass, the cheetah lowered her head and paused mid-stride. Two cubs, still gray-backed and all legs, bounced up to the adult. The cat kept walking, her two offspring in tow, and the three of them retraced the mother's path, steadily putting ground between them and the hyena. But the hyena didn't follow—at least, not yet.

The threesome descended into a shallow, wide basin and proceeded toward a cluster of granite that jutted up through the undulating plains. The cubs alternated between running ahead, taking turns attacking each other as they went, to falling behind their purposefully pacing mother.

The mother stopped at the base of one of the rock slabs, placing both of her front feet up on the rock face, thus giving her a better view across the plains. The cubs, on the other hand, charged up the four-foot rock without pausing, flew off it, and ran up the face of another rock before returning to their mother. The three seemed to pose, flawlessly sculpted statues in an endless sea of grassland.

The pause was short and Mom initiated the walking again, swinging slightly south of her original course, heading out across the depression, crossing it, and working her way at a slight tangent up the next gradual rise. Behind the rise was . . . nothing. Lots of nothing, endless nothing. But her stride didn't change, and she motored steadily on, crossing the next swale, ascending the next

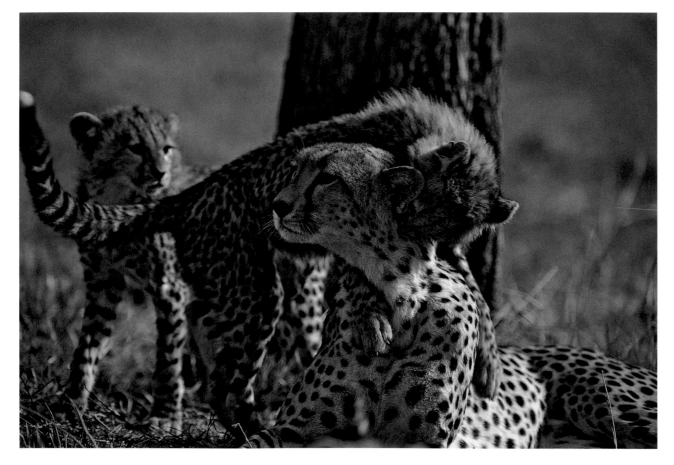

LEFT Cheetah mothers seldom get involved in their cubs' shenanigans, but they will remain patient nonetheless. This cub, the dominant of the three, continually leapt at its mother's face and neck, but she maintained her composure throughout.

OPPOSITE In an effort to get a better view of the plains and the game, a cheetah ascends an outcropping of rock.

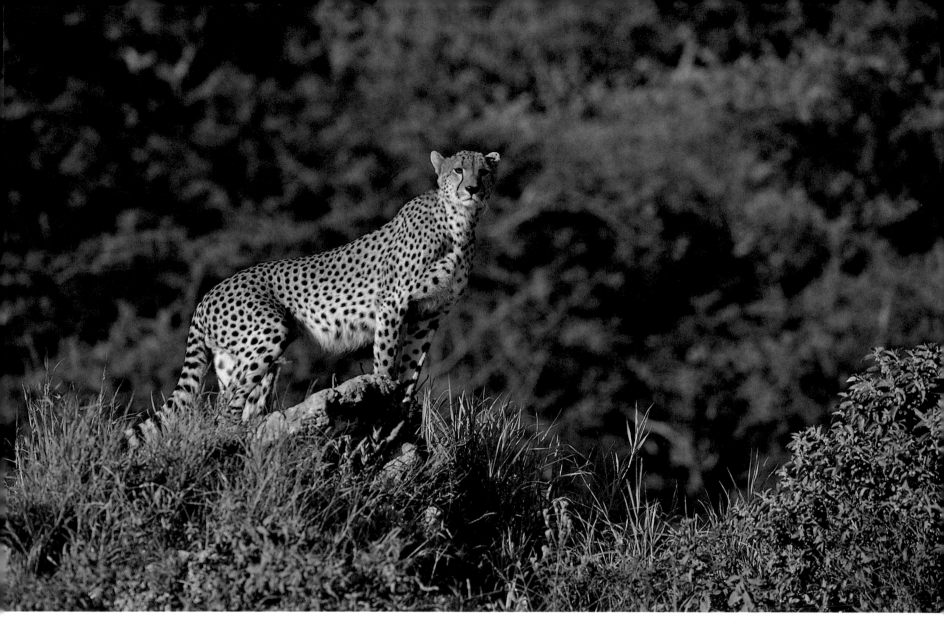

rise while her two cubs ran up ahead, mock attacking each other and anything that moved, and occasionally strolling beside her. The cubs, perhaps three months old, must have covered four times her straight-line distance at four times the speed, the by-product of youth and the excess of energy that goes with it.

Soon the cool of the morning was gone, having given way to the heat of the rising equatorial sun. It was seriously hot, too hot to carry on, and the threesome suddenly dropped out of sight. All was now nothing but endless green, clear to the Moru kopjes, gray and looming in the distance.

Suddenly, the mother's head was poking out of the grass. Nonchalant, her eyes casually took in the horizon all around. Her spotted pattern, tear-streaked face, and deep amber eyes melded into the surrounding grasses beautifully. But no cubs were to be seen. Then, there was a motion just behind the dappled head, and first one, then a second cub stood up and pushed through the stems to their mother, sliding right against her as they settled back in, three shapes melting into one.

After a nap, the mother was up again, casing the plains. Without warning, dark clouds moved in, obliterating the sun, and the temperature dropped. Mother

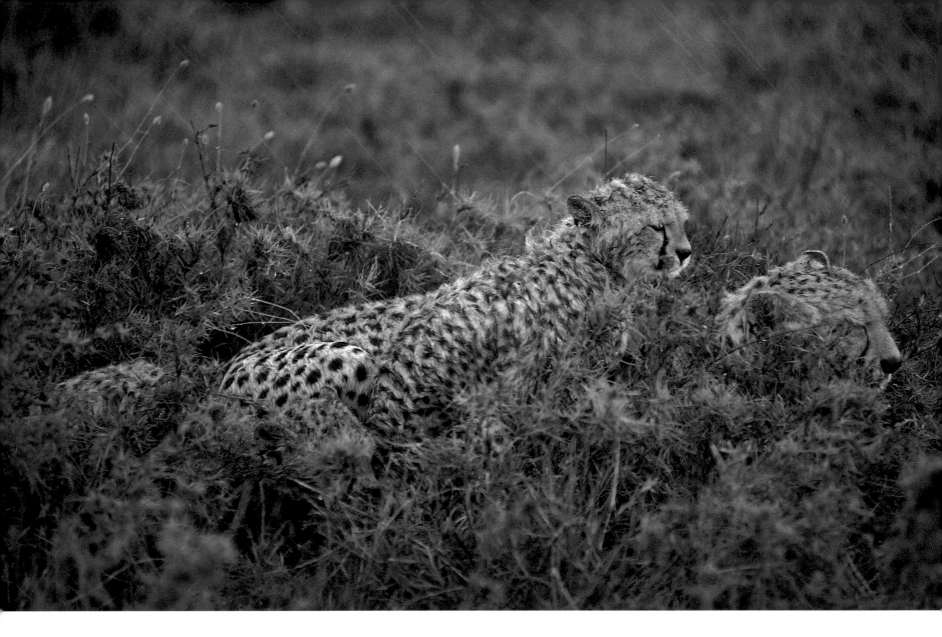

and cubs kept pacing, now out onto a broad section of shortgrass plain that was only occasionally interspersed with clusters of prickly shrubs. The rain came hard and fast, big-dropped and cold, from the sky, driving the cats to the little cover there was.

The mother found a small cluster of shrubs for protection and crouched with her back to the coming hail, legs pulled in underneath her, back slightly arched. One cub scrunched in by her right rear leg and the other against her opposite flank, almost halfway up her body. Within minutes the cub on her flank, more exposed to the cutting wind, was shivering hard and looking miserable. For twenty minutes the storm swept over the plain. The hail changed back to rain and the wind blew itself out; the rain changed to drizzle to mist to heavy air. With a shake and a stretch, the mother was up with the cubs, running hither and yon, chasing nothing and everything, and mostly one another.

Mom led the way with a stately and measured stride, not at all slowly, but still only walking. The cheetahs spotted a mixed herd of both Thomson's and Grant's gazelles some eight hundred yards ahead, grazing peacefully. The herd was not tightly packed, nor all facing one direction, the natural defense positioning of a herd.

The dominant of three cubs climbs onto its mother's back to stay warm while waiting out an afternoon dry-season rain shower. The other two cubs stayed near, but didn't receive the benefit of their mother's heat or protection.

In spite of the rambunctiousness of her offspring, the adult cheetah was able to close within three hundred yards of the herd and still remain undetected. And then suddenly she sat down, facing them and watching intently. In the herd were four small tommies, less than two weeks old, totally defenseless, their only hope lying in their mother's ability to spot danger early, while it was still far off, and lead the fawns away before the predator closed in. Yet this cheetah was already here, and stayed sitting.

But then the cheetah was up, moving with that purposeful trot that always means deathly business. Within fifty yards she was running. The cubs both dropped flat and motionless on the open plains as she accelerated away. She shot past the first tommie, then the second, passing within twenty yards of it. Suddenly she was right behind an adult gazelle and seconds later, after a few slight turns, she swatted out, sending the tommie cartwheeling end over end.

She was beside the gazelle long before it stopped tumbling, and the instant it stopped she had its throat clamped in her jaws, and soon it was all over but for the feeble kicking. The cubs trotted up, acting almost fearful as they closed the last seven or eight yards. But one cub moved next to its mother and actually took over the throat grip as the adult dropped the still-live gazelle onto the damp ground. Tiny, ivory-colored hooves protruded from the back end of the female gazelle. She had been in labor when the cheetah attacked! Now it made sense—the cheetah had ignored the smaller, easier-to-kill fawns for the more vulnerable but larger adult gazelle. She had noticed the birthing mother and had patiently waited for the right moment to streak in. She had proved her prowess as a hunter. The reward was more than enough food for herself and her rapidly growing cubs.

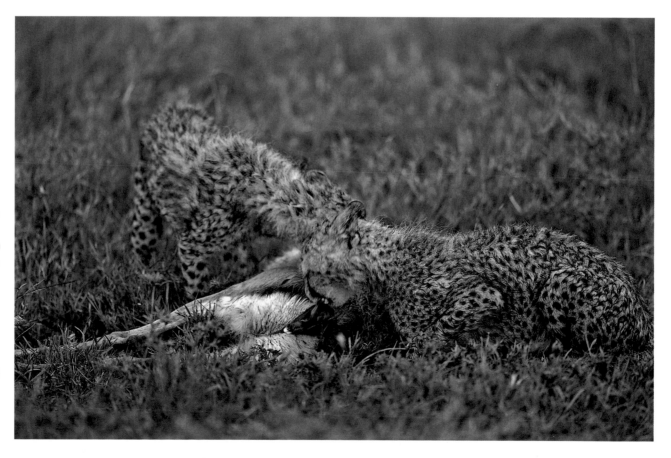

RIGHT Two three-month-old cheetahs tear into a Thomson's gazelle that was killed by their mother while the gazelle was in labor (the tips of its tiny hooves emerging from her are visible). The birthing mother actually managed to pull herself up and run, but she was no match for the adult cheetah.

OVERLEAF The rising sun eases up over the Serengeti and perches briefly on the back of a male cheetah who is already on the hunt.

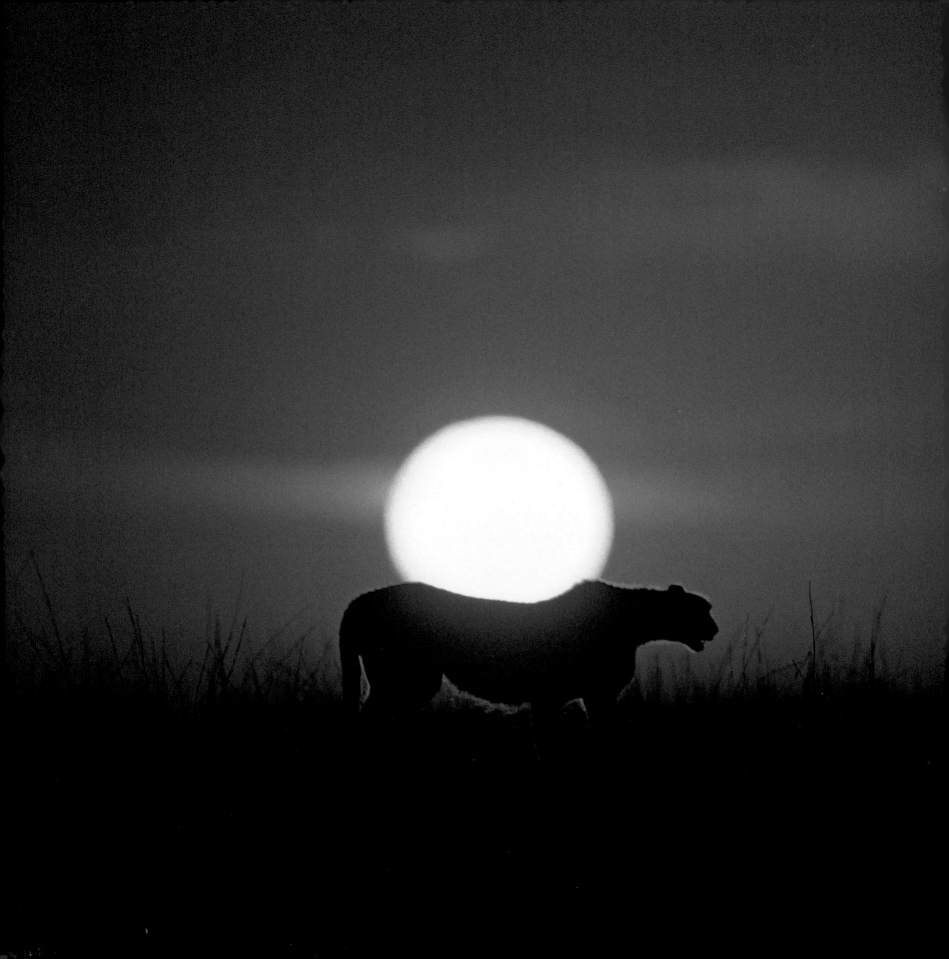

BIOLOGY AND BEHAVIOR

Cheetah Anatomy More than any other cat, the cheetah is the perfect embodiment of "form follows function." Every shape and curve of its streamlined body is designed for speed and hunting. There is nothing extra or superfluous. But as you examine a cheetah it becomes clear that speed is the cheetah's only weapon.

The skull of a cheetah is remarkably blunt when compared with that of a lion or a leopard, with no ridge, or sagital crest, on top of its head for anchoring strong jaw muscles. The jawbones are weak and narrow, lightly built, but the gape is wide, allowing the cheetah to gulp in large amounts of oxygen when running and to breathe in through the sides of its mouth while strangling prey.

A cheetah's honey-colored eyes are well recessed in its sockets, superbly protected under the eyebrow, or orbital crest. The sunken eyes are safe from both direct sunlight and the slashing of grass blades as it streaks across the plains at fifty-five to sixty miles per hour. Even in the earliest hours of dawn, or during the golden hour of an African dusk, one still sees only the lower half of a cheetah's shaded eyes.

Like all large cat's eyes, the cheetah's pupils stay round when they contract, instead of going elliptical as in all smaller felines. The eye also contains the *tapetum lucidum,* that special mirrorlike membrane behind the retina. Light that has passed through the eye hits this "mirror" of cells and bounces back through the retina again, stimulating the light receptor cells a second time, allowing the cheetah to see much better in low light conditions. But, sadly, it offers the cheetah no great advantage at dusk or night since it can use its speed safely only during the day.

Even the teeth of a cheetah are lightly built, with fairly stubby canines as compared to those of a lion or leopard. Like all cats (and many dogs), the cheetah has six incisors, one canine, two premolars, and only one molar, giving it a dental formula of 3-1-2-1 (on one half of one jaw, numbering the teeth by type, from front to back). The teeth of a cheetah aren't really designed for killing, but mainly for holding its prey's neck while it's strangling it. Thus, unlike leopards and lions, cheetahs really have only

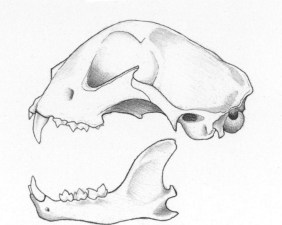

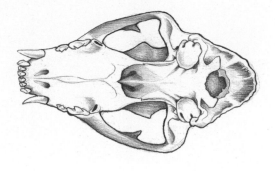

one way to kill once they have their prey on the ground. Whether the prey is a full-sized wildebeest or a still-wet newborn gazelle, a cheetah's prey will die by strangulation.

An animal with few molars, or none, like the cheetah, is not an animal that chews its food. The upper and lower molars and premolars are shaped a great deal like a shark's teeth, high-pointed and sharp—not at all like our grinding molars. Furthermore, the upper and lower premolars and molars shear across one another like a paper cutter, creating a perfect set of meat-cutting scissors (the carnassial shear).

A track runner can tell you that the secret to great speed is not just having muscles, but having the right kind of muscles along with flexibility. The cheetah has both. Amazingly, for reasons of flexibility, cheetahs have no collarbones. These cats cover more than twenty feet

SAFARI TIP

Look closely at a cheetah's head if you find yourself beside one. Watch a cheetah feeding or yawning and you'll see its carnassial shear.

ABOVE Cheetah skull, side and bottom views.

OPPOSITE This yawning cheetah reveals its stubby canines. The sharp premolars, used for meat cutting, and molars are also visible.

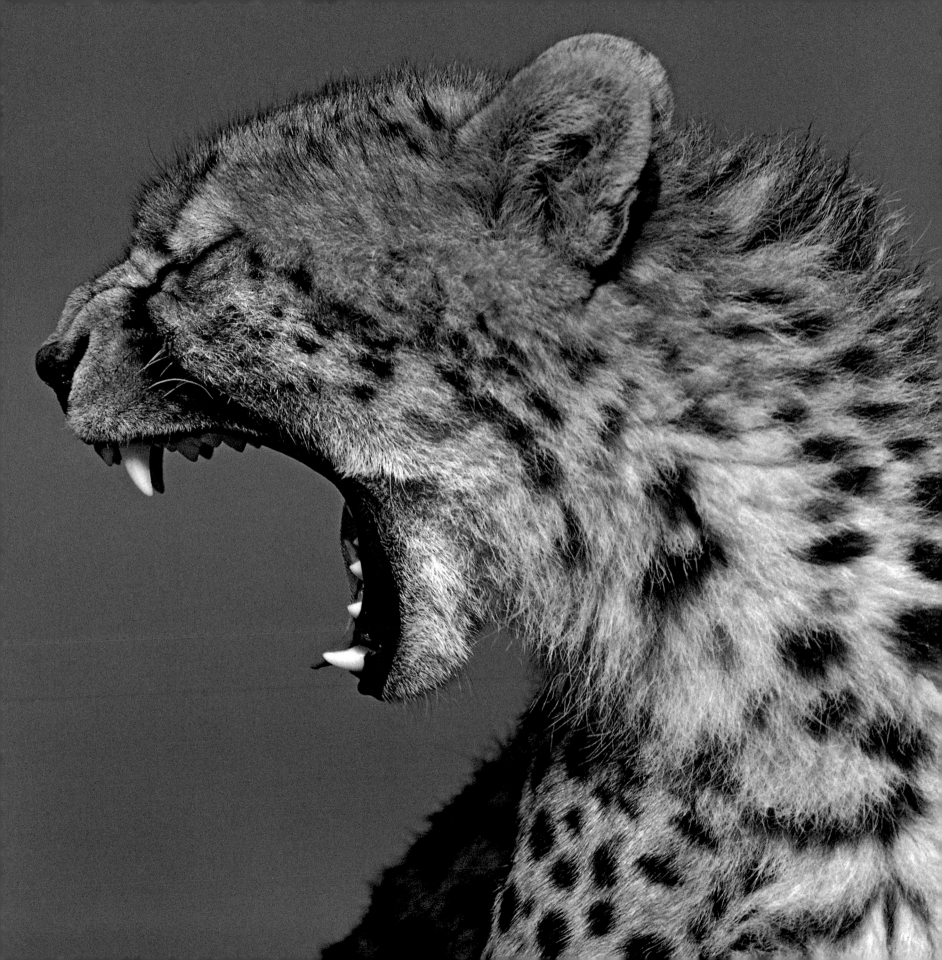

per stride when running full out; to have steps of this length requires that their front legs reach way up and forward, so much so that a collarbone would limit this extreme range of motion. Cheetahs also have massive pectoral muscles for those enormous strides.

The backbone of a cheetah is phenomenally flexible, yet highly reinforced with ligaments on both the top (dorsal) and bottom (ventral) sides of the spine. Thus, when the backbone is arched, as when the cheetah has reached its top speed, the ligaments on the top side are pulled tight. When the back is bent the other way the ligaments underneath the backbone are tightened. As with a child

in a swing, all the cheetah has to do is add impetus at the right moment and it rapidly accelerates.

A human running can impact the ground with about fifteen hundred pounds of pressure per square inch. Imagine the stresses that a cheetah must absorb tearing across an uneven plain, bounding at twenty feet per stride, motoring at sixty miles per hour! This requires an incredible foot and an extraordinary shock-absorbing system. It also requires great traction.

A cheetah's feet seem disproportionately large, huge actually, compared with the size and slimness of its overall form. The pads on both the front and back feet are

A mother cheetah chases down a young Thomson's gazelle, her flexible backbone and rudder-like tail clearly visible.

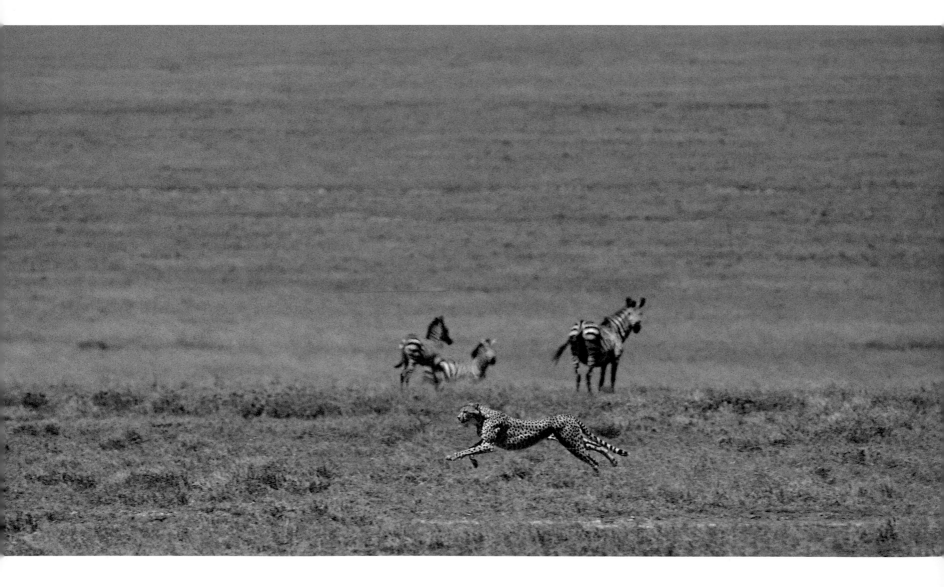

When you next see a cheetah lying down, take a good look at its feet.

sharply ridged and the claws are exposed. Contrary, however, to what we've all been told, the cheetah's claws are virtually non-extendable (protractile), but are permanently recessed, or retracted. They simply don't have the sheaths to cover them. The claws are thus always exposed, which makes them relatively blunted due to constant wear, but gives the cheetah solid traction on the ground. This also makes these cats terrible tree climbers. Cheetahs have notoriously weak ankles, so much so that there are numerous documented cases of young cheetahs seriously injuring themselves when jumping down from low tree branches.

The back foot of a cheetah is enormous, and quite long as well. In all other cats, the front foot is larger than the back foot, but the opposite is true in cheetahs. Larger back feet help them push off more effectively with each stride. The astounding acceleration of a cheetah, from zero to fifty-five miles per hour in two seconds, is supplied through its back feet, where it gets the traction it needs. These disproportionately large feet also help absorb the impact of running at such frightening speeds. A cheetah is not a power lifter like a lion or leopard, so it has a predominance of fast-twitch muscle fibers as opposed to slow-twitch fibers. A cheetah typically has only 2 to 3 percent body fat as well.

Evolution has seen to it that a cheetah's prey is not slow or ungainly. Thomson's gazelles, for example, don't run in a straight line. Watch those ungulates playing in the early morning. They cut and turn sharply as they cavort, much like a downhill skier. A cheetah has to match that slalom course as well as outrun the gazelle, hence the cheetah's strong and long tail.

ABOVE, TOP This cheetah's rear foot shows the ridges on the pad and the exposed claws, both necessary for traction during the cat's high-speed chases. Notice, too, the thin and somewhat short hair on the tail's tip, indicating that this is probably a cheetah getting well on in years.

ABOVE, BOTTOM A cheetah's print is easily distinguishable from those of a lion, leopard, or hyena. All cats have three lobes that protrude from the trailing edge of the pad while hyenas only have two lobes on the heel. The protruding lobes of a lion or leopard print are all the same length, while the middle lobe of a cheetah's print is noticeably shorter than the outside lobes. Cheetah prints also show the deep "v" of each heel lobe, not the gently rounded indentations left by a lion or leopard.

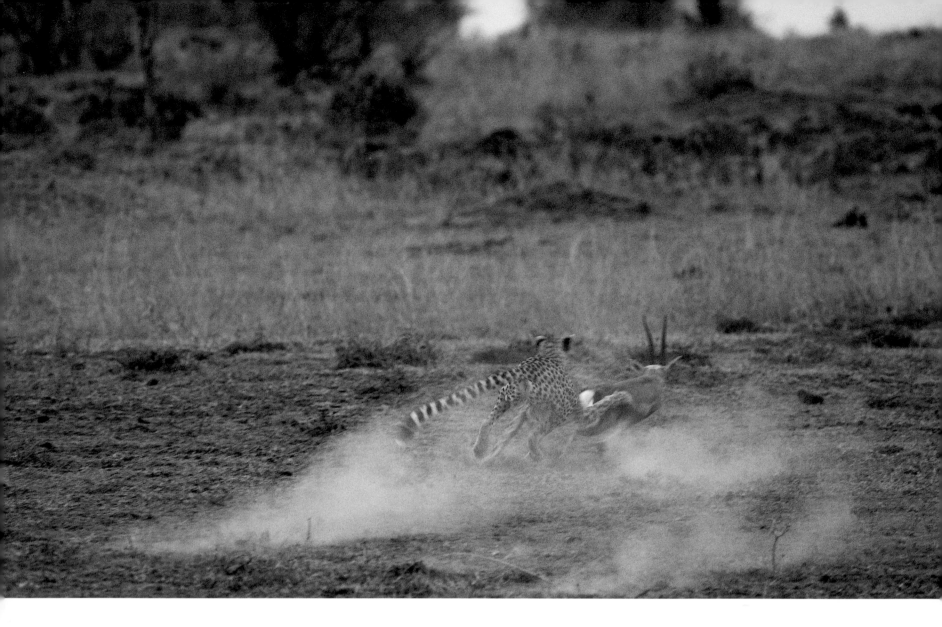

Even when a cheetah runs half-heartedly, you can see how its tail works like a counterweight, balancing out the running cat's every turn. And while you're looking at the tail notice how the cheetah's body spots turn to rings toward the end of the tail, which almost always ends with a white tip. You'll see that the tail rings differ in number and thickness from cheetah to cheetah and that the rings are deformed or even incomplete. No two cheetahs have the exact same tail pattern.

The cheetah's "weapons" can only come into play if it gets close enough to its prey to launch an attack, hence its coloration. A cheetah hunts almost exclusively during the day (diurnal), and generally hunts only in grasslands or open woodlands, so camouflage is important. A cheetah's spotted pattern blends in beautifully with virtually any grass of any length or color. The small rounded ears don't stand out, and even from the back the black on the back of each ear helps break up the head profile. The beautiful tear line on the cat's face along both sides of its nose also breaks up the outline of the head when it is low in the grass. These black lines do not, however, bend sunlight away from the eye, as has often been asserted. Rather, we are unsure of their purpose, although the lines are reminiscent of those of another speedster, the prairie falcon.

An adolescent cheetah, having been led on the stalk by its mother, streaks in and knocks over a male Thomson's gazelle. The cheetah easily slapped the gazelle to the ground, but it did not yet know how to kill it. The gazelle regained its feet and fled again, only for the process to be repeated. Finally, the cub's mother ambled over and killed the tommie, putting an end to the practice session.

Watch a cheetah run and keep an eye on its tail.

Identify cheetahs by their tail pattern.
Draw that pattern.

The irregular and distinctive tail-ring pattern of a cheetah.

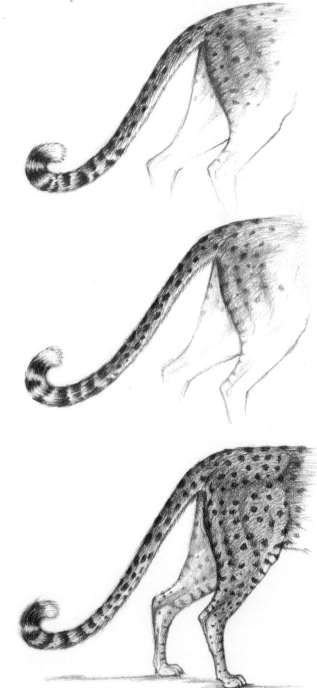

When you're within sight of a cheetah, take a minute to look at the varying lengths of the hair on different parts of its body; the spots are made up of slightly longer hairs, and the belly hair is substantially different from the hair on the back and face. You'll see that young cheetahs have long ruffs of hair, or manes of longer fibers, running down the backs of their necks. The old myth is that this ruff makes them look like a honey badger, a ferocious wolverine-like creature that not even lions will tangle with. The ruff certainly helps young cheetahs blend into the grass when they want to hide, but it's not going to fake out any lions or hyenas, predators that have, for survival necessity, evolved incredibly sharp vision. The answer to why young cheetahs have a ruff lies in a behavior pattern called "appeasement behavior." When an animal is threatened by another of its species, the submissive individual can diffuse the situation by presenting itself as vulnerable, not as a challenging threat. A submissive position includes exposing the neck and underbelly to the aggressor. Almost all felines, and many canines as well, have light-colored or white necks and bellies to accentuate this submissive positioning. A white ruff on

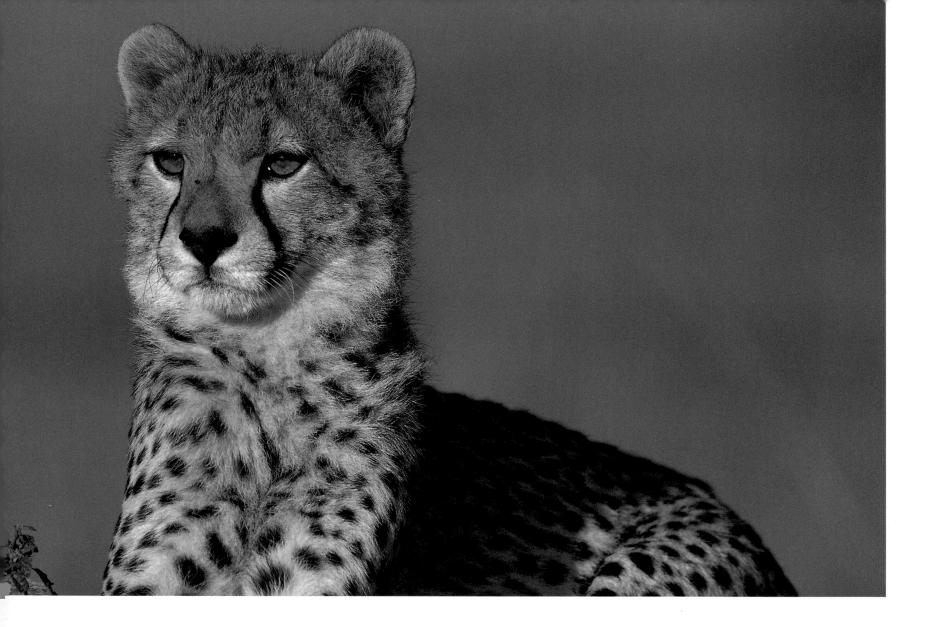

a small cheetah would suggest this nonthreatening and submissive status, thus diffusing any possible aggression in an adult cheetah.

If a cheetah family is just sitting with its individual members somewhat spread apart from one another, keep relatively quiet and listen. You'll have a good chance of hearing the mother call her cubs with that birdlike chirp that sounds so uncatlike. And if they are sitting close together you may even hear them purring. Cheetahs are the only large cats that can purr. The other large cats can growl very slowly, but not purr. Of the large African cats only cheetahs have tongue bones that are directly connected to one another, or ossified. This produces the purring vibration, the same as in house cats. Lions and leopards have a long cartilage connecting the tongue bones. This doesn't allow them to purr but it does give them the ability to project their roars loudly and over great distances. Cheetahs can't roar, hence they don't use sound to establish or maintain territories. In the vocalization department you might be fortunate enough to hear the cheetah moan, a call that has been well documented, but the motivations and reasons of which have yet to be understood (though it's thought to be a threatening or fear/stress call).

A five-and-a-half-month-old cub sits on a termite mound and warms itself in the morning sun. The overall fluffiness of the neck and chest, round ears, and the proportionately small, square head indicate the youth of this cat.

Territoriality and Habitat The life of a cheetah is a risky one, hence the startling statistic that 95 percent of all cheetahs in East Africa never live beyond the ripe old age of one. That mortality rate may be, on an evolutionary scale, a short-term phenomenon, but the few cheetahs that are out there must find each other and mate. So how do these cats meet?

Cheetahs generally lead solitary lives, unless it's a mother with cubs or a coalition of males. Cheetahs are not territorial per se. They most often live in so-called home ranges, areas that they consistently use but do not defend against other cheetahs. Both sexes stay within their home ranges as they roam, marking prominent landmarks, rocks, trees, and fallen logs within this area with urine and feces. There's a great deal of overlap among these ranges, so any cheetah can tell by smelling a urine post who has passed by, when they walked by, which sex it is, and whether or not it's a female in estrus. Hence, they can choose to leave the area and avoid contact, or stay in the locale in the hopes of bumping into one another for mating purposes.

Male cheetahs consistently break these solitary patterns and form groups or coalitions. The social structure of coalitions is a recently detected phenomenon, but obviously has its reasons. Males in groups of two, three, or even four, can kill larger prey certainly, but the amount of meat taken then has to be divided among the coalition members so the quantity of meat per cheetah stays about the same. Cheetah coalitions do not have a higher success rate on kills, nor do they kill more often, observations that left researchers puzzled for years. These groups of males do become ferociously territorial, vigorously and violently

This cheetah is not only sharpening his claws, he is also sniffing the log to see who may have marked it with urine, which would tell him who has stopped by and when.

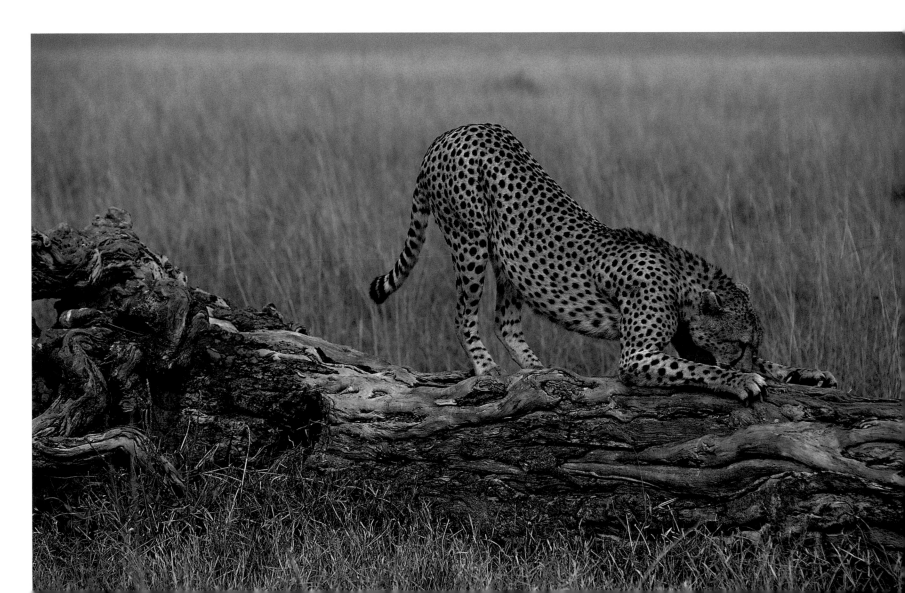

defending their small territories against other male cheetahs. These areas, however, are small, some nineteen square miles, as compared with the average cheetah's home range, which can easily extend five hundred square miles. It turns out that the location of these territories held by coalitions is the key to why they form such groups in the first place. The coalitions of males establish their territories in regions that are more frequented by females, thus giving these males more mating opportunities; having a territory gives male cheetahs a better chance of passing on their genes. No territories or coalitions have been recorded to last more than four years but the research continues.

It's fairly easy to identify a particular group as a mother and cub or cubs. Look for the ruff, or mane, on the neck of the youngsters. The younger they are, the longer and more prominent it is. Even if the cubs are nearing the size of their mother, the ruffs will be visible, if not obvious. If the group you happen upon all seems to be adults, check the sexes of the individuals and see if they are all male. If so, you are with a coalition. If one is a male and one is a female, you're looking at a mating pair. Sons do not stay with their cheetah mothers into adulthood, though they often stay with them for up to a year and a half. If the group is made up of multiple females, it's almost assuredly a mother and her near-grown daughters. The last possibility for your cheetah group is that you've come across a mating pair with another male trying to work his way in, or a female with a coalition accompanying her. If it's a coalition there shouldn't be any serious squabbling among the males, but if it's a mating pair and a solo male has stumbled upon them you'll see some aggression between the males.

BELOW A male cheetah, a member of a three-member coalition, sprays urine on a tree trunk to mark the territory.

OPPOSITE A male cheetah *flehmens*—he has just sniffed a urine post and is now mixing air with that odor to get a better taste of the urine.

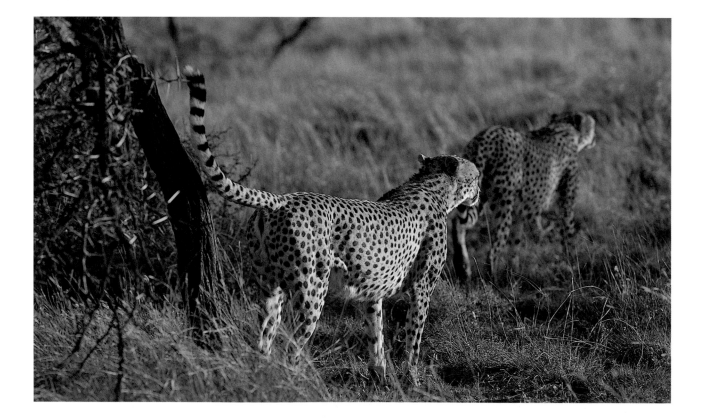

SAFARI TIP

Get out of your vehicle and sit down in the grass, your eyes about thirty inches above the ground. That's a cheetah's view of the world. You'll see how unlikely it is for cheetahs to encounter one another, even when they are seeking one another out.

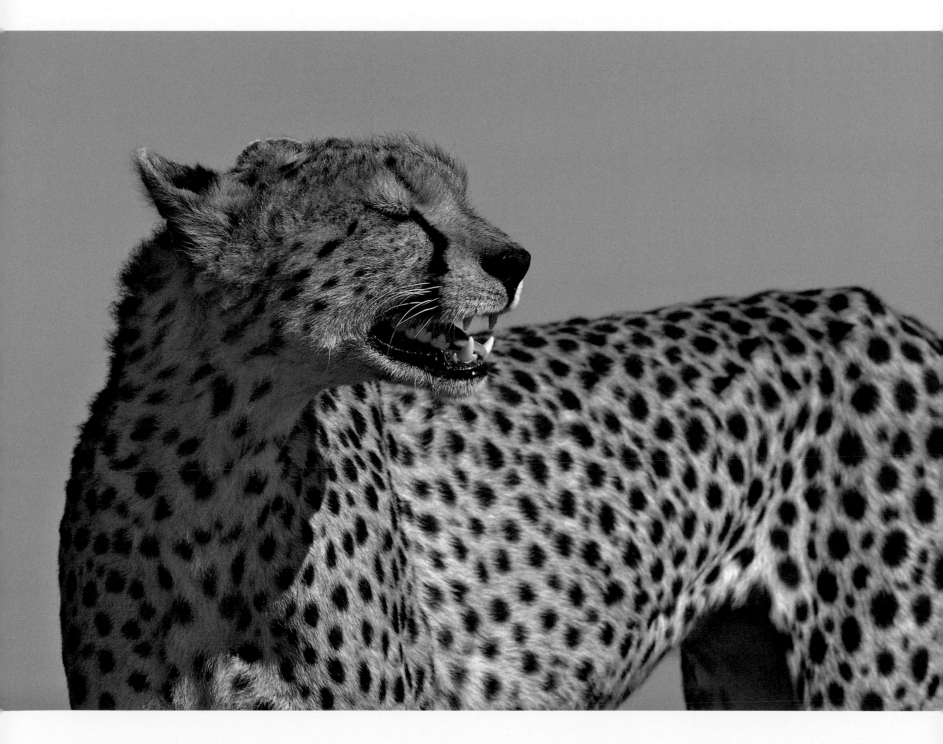

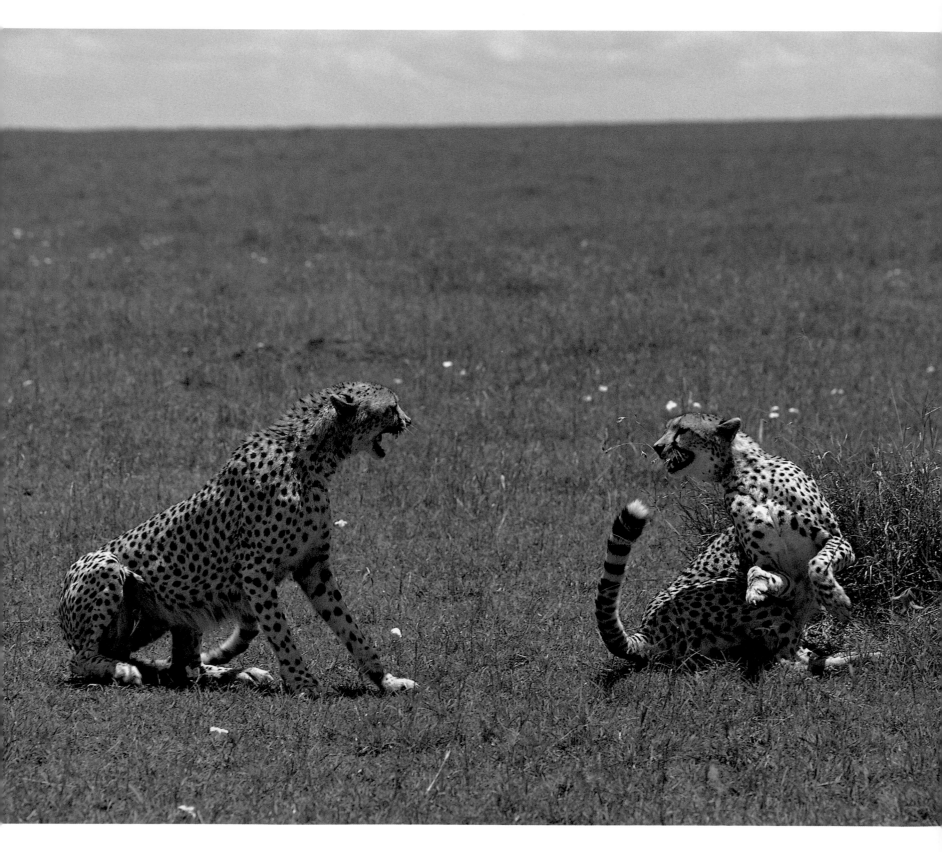

In a very rare encounter, two aterritorial male cheetahs meet and squabble over an estrus female. In spite of the spitting, growling, and posturing, the cheetahs do not actually fight, and the late-arriving male soon departs.

A pair of mating cheetahs mark a scent post as darkness falls. Cheetahs frequently mate at night and at less frequent intervals than lions. Their matings are such a rare and secluded occasion, in fact, that during one fifteen-year study, copulation was recorded only a few times. No photographs exist of cheetahs mating in the wild.

Seldom, however, will the encounter result in physical contact, much less fighting. The two males will hiss, snarl, and spit, with one taking a submissive role. That role can easily be seen by the low posture it takes, low to the point of sitting or lying flat on the ground while the dominating male struts around him.

These two males will soon separate, the interloper leaving the mating pair to their unfinished business. It's interesting to note that over decades of cheetah research, actual matings have only been seen a few times, and, to my knowledge, never been photographed. You do see brothers "false mounting" each other, but that's easy to recognize.

Female cheetahs increase the odds of mating by being in estrus four to ten days at a time with only ten to twelve days between cycles. Therefore, they can be impregnated about half the time they are awake! Unlike lions, cheetahs may only mate once in eight hours, as compared with as often as every four minutes for lions. Even then cheetahs often mate at night, which explains why so few have been caught in the act.

Youth and Growth The price of a cheetah's speed is fragility—its muscles and bones must be thinner, lighter, more streamlined—which means that a cheetah mother cannot do much at all to defend her cubs from lions, hyenas, or leopards. She's simply no match against these far more robust carnivores, and until the cheetah cubs can outrun a pursuit on their own, they are completely vulnerable to predators. Some 95 percent of all cheetah cubs are killed before they reach one year of age.

Cheetah mothers naturally do what they can to ensure cub survival. To start with, they give birth to a large litter, usually four to six kittens. For years scientists thought that two or three kittens was an average litter size, but it turned out that almost invariably some had already been killed by the time humans first observed a particular feline family.

Cheetahs select secluded locations in which to give birth, often utilizing rock outcroppings or kopjes, tall grass areas, swamp edges, or even small holes in the ground. I once spent nine hours discreetly following a lactating cheetah who I at first thought was hunting cape hares, but came to realize she was looking for her young and seemed to have lost them. She walked all day, continually sticking her head down one hole after another, finally finding her four-day-old kittens late in the afternoon just before a violent storm broke.

Mother cheetahs will move their young frequently during the first few weeks of their lives, thus reducing the risk of their being detected by another predator keenly watching the mother's consistent movements, or by a foraging hyena who has picked up their scent.

Unlike lions, hyenas, and leopards, infanticide has not been recorded in cheetahs, but since most cheetahs move solitarily and don't have territories this should come as no great surprise.

LEFT These tiny kittens, less than four days old, were misplaced by their mother. She spent an entire day searching miles of open plains until she finally relocated them at dusk. In the interim, one of the three kittens, whose eyes had not yet opened, was separated from the others. That kitten died within days, but these two survived to adulthood.

OPPOSITE A mother cheetah cares for her three-day-old kittens.

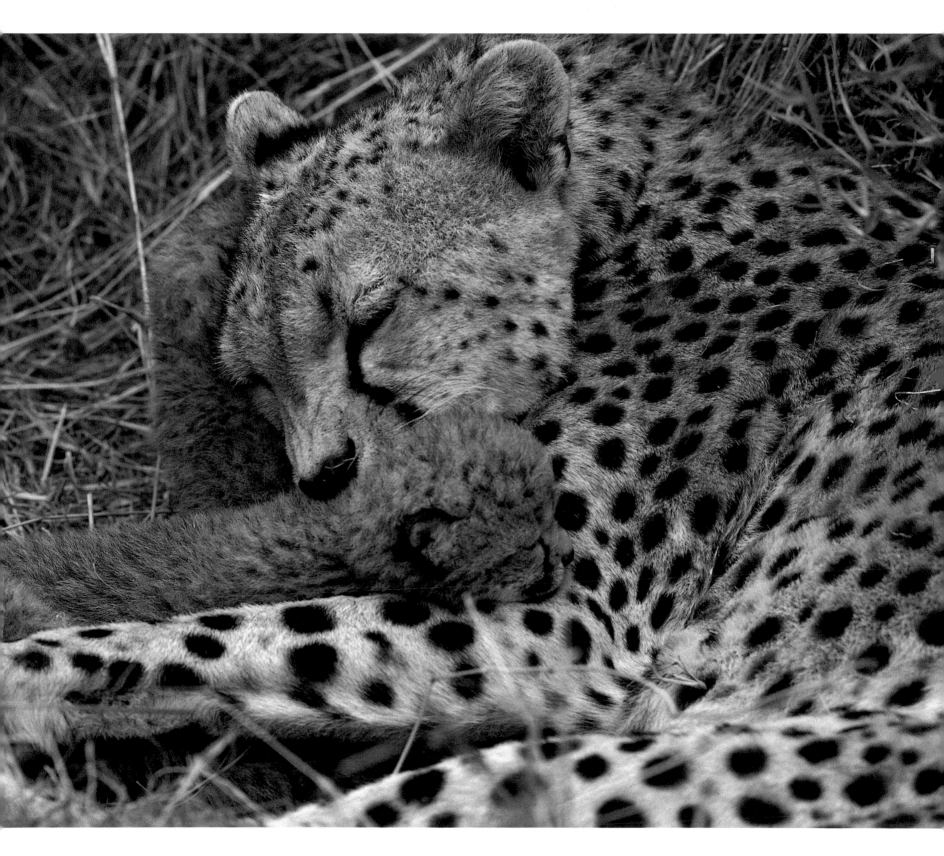

OPPOSITE A three-month-old cheetah hides in a clump of herbs on the Serengeti Plains. The cub, along with its two siblings, hid itself so well that when two safari vehicles drove up and spent ten minutes photographing the mother, no one noticed the well-camouflaged cubs only five feet away.

RIGHT These two cheetahs, only four weeks old, have squirmed their way underneath their mother before venturing to look out across the vast grassland.

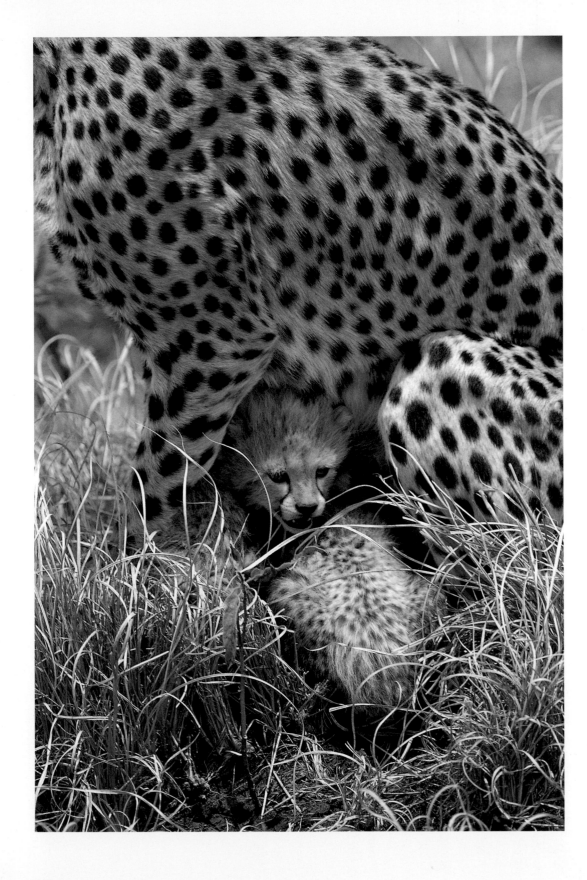

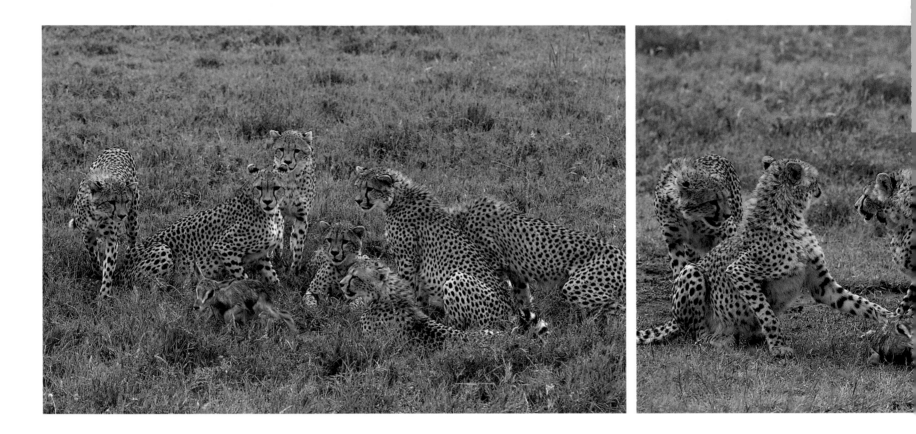

To further enhance their survival rate, cheetah kittens have evolved to develop faster than any other large cat. Surprisingly, female cubs are often the first to leave their mother, usually when they reach about sixteen months of age.

This fast development also means that the nursing period for cheetahs is short; the cubs are weaned by four months and eating meat by the early age of only six weeks. During this suckling period dominance is invariably established within the litter. Those cubs that manage to gain more access to either their mother's milk or attention end up stronger, healthier. Don't be surprised if you see cheetah kittens nursing not only while their mother is lying down, but even when she is upright and vigilant. Nursing time for the cubs is rather limited by their mother's mobile lifestyle so every second counts.

Incidentally, there are recorded cases of cheetah mothers adopting cubs from other litters. This has occurred when the adult has either stumbled across a lost cub, or when two mothers, each with a litter, have met up and the

THIS PAGE AND OPPOSITE The vast majority of cheetah cubs do not live to be even a year old. However, this mother managed to raise six cubs, an unusually large litter, to the age of almost one—an amazing success story. But the happy story ends there, for this litter turned out to be remarkably ignorant at killing. The mother cheetah brought the cubs this newborn Grant's gazelle—alive—and left it with them (seen here). They proceeded to lie down next to the fawn, clean it, and coexist with it. When the gazelle tried to run the cheetahs gave chase, but they would only knock it down and sit with it again. Finally, during the course of fighting for possession of the fawn, they accidentally killed it. For some reason, they had no clue as to how to kill it deliberately for food.

cubs have gotten confused in the excitement and ended up following the wrong mother. What's really interesting, however, is that, unlike lions, cheetahs will not suckle the cubs of another female, even if they've adopted them.

Even after six to eight weeks of age the cheetahs are still incredibly vulnerable to predation. The young cheetahs simply are not aware of the dangers and unless they are moving close to their mothers at all times, relying on her for the early detection of threats, they often walk right

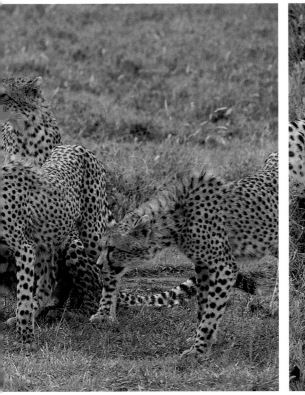

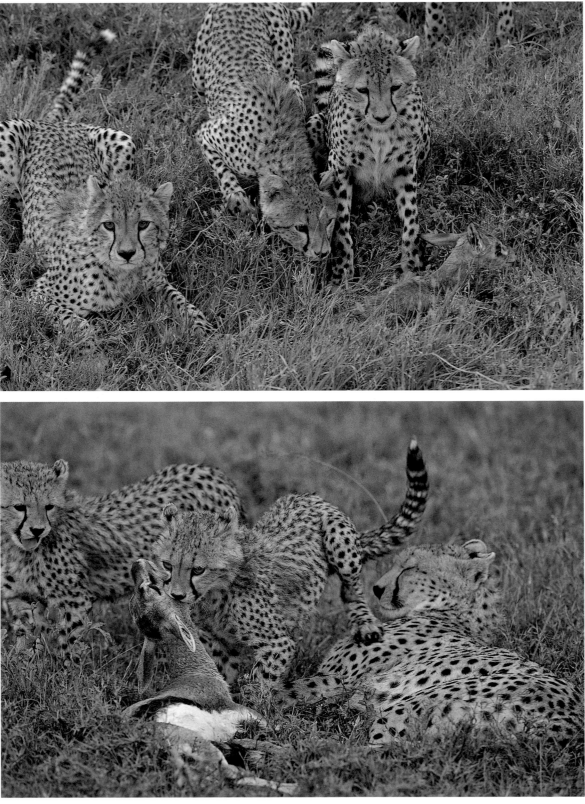

SAFARI TIP

When you meet a group of cheetahs, try to determine whether it's a mother with mature cubs or an all-male group. Also, notice that it's more often the female cubs that initiate either moving or hunting.

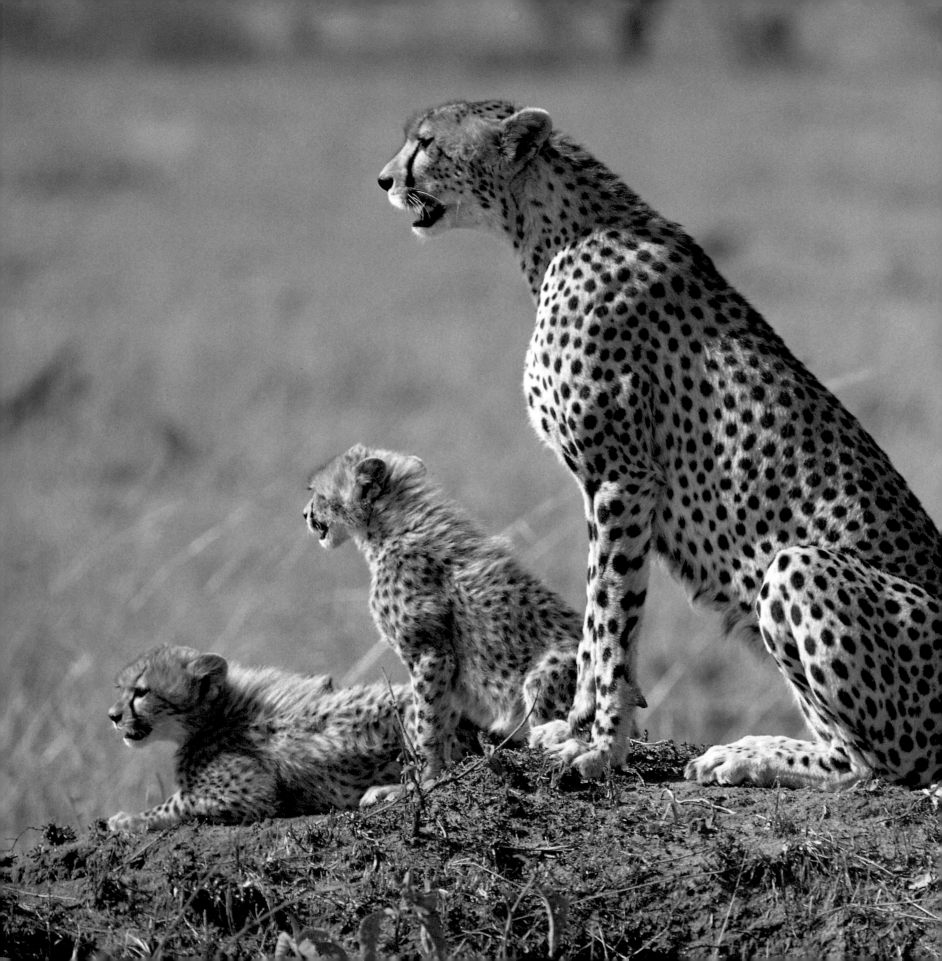

into danger. Lion cubs, for example, certainly seem to have a genetic fear of adult male lions and stay away from them from the start. Cheetahs, however, don't appear to have a genetically wired warning system tuned to dangers.

Luckily, cheetah cubs do have a few advantages on their side. The ruff of fur on their necks helps to hide them even in the shortest grasses. As with adult cheetahs, the ear and face coloration and body spotting are great aids in helping the youngsters blend into their surroundings.

Cheetah cubs, especially when they are less than six months old, stay extremely close to their mothers as they move across the open plains or through the open woodlands. They stray a bit farther when mother settles on a kopje or a fallen tree, but there is usually more cover available in these locations so the threat is reduced. It is during these long walking periods, when the mother cheetah is searching for prey, that the cubs first start to learn what to hunt and where, and what to avoid. This is a tough time for the mothers because the cubs tend to be a distraction and a nuisance when she is trying to hunt. Often they alert prey to their presence because the little ones either can't sit still, don't recognize that Mom is hunting and continue walking in full view, or try to attack the prey themselves from the most ridiculous distances. Hence, a mother cheetah's hunting success drops by 20 percent when she has cubs in tow. Still, the rambunctious cubs have to learn, and following their mother is the only way. Staying near their mother is a long-term survival trait in every aspect of life, from hunting to personal health to protection. During this stage of development the dominance order of the cubs, established during nursing, again comes into play. The more forceful young will get more of their mother's attention, more grooming, more warmth and protection, more milk, and later, more meat at the kills.

Two cheetahs, only nine weeks old, mimic their mother as she scans the horizon from her perch on a termite mound. Notice the prominent ruffs on the backs of their necks—these will recede as they age.

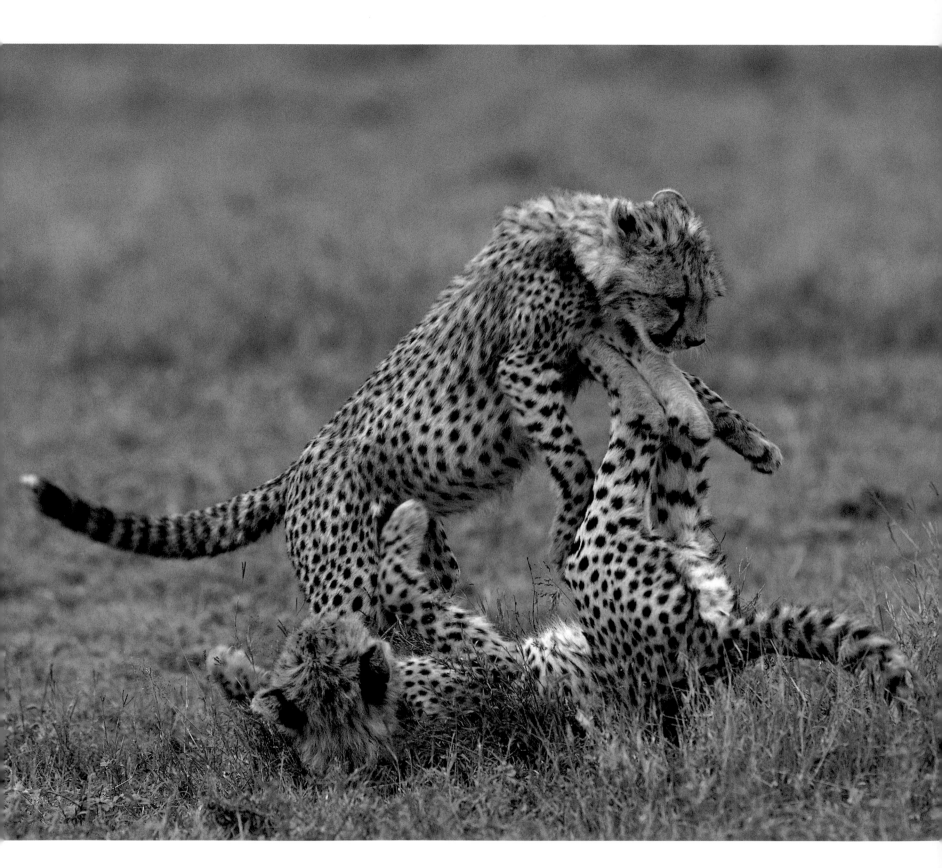

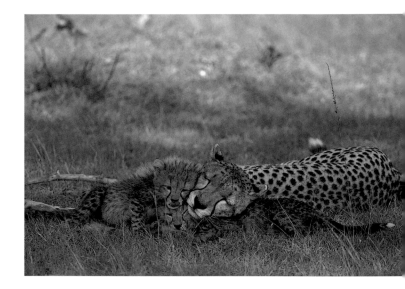

A mother cheetah, in an attempt to calm her playful youngsters, uses them as a pillow and tries to grab a bit more sleep before an afternoon of hunting.

Play Play is about much more important things than simply dominance, for when cheetahs reach adulthood they usually end up alone. But what's learned during that play must last a lifetime. Cheetahs decidedly do not play like lions. One of the delightful things about a morning spent with lions is watching them all play, and I do mean all of them. Adult black-maned males, weighing more than 450 pounds and adult females, particularly on chilly mornings, will spontaneously break out into a bout of full-on play; it's rough play to be sure, but play nonetheless. Play for cheetahs is almost exclusively confined to the cubs, with adult females rarely joining in. But cubs do seem to enjoy racing around and knocking each other over, and it's through this roughhousing that their bodies become conditioned and killing skills are learned and practiced. Running at sixty miles per hour and tackling a gazelle takes strength, speed, incredible coordination, timing, and flexibility. All these necessary survival skills are acquired during play, refined through time, but initially learned while the cheetah is still an enthusiastic and energetic youngster.

As a predator behavioralist, one of the big questions for me is, "What is genetic behavior and what is learned or taught?" Furthermore, how are habits "taught" to a predator? Does the adult take an active roll in the education of his or her offspring, or is it all some kind of Montessori School of Experiential Learning? Only by observing predator actions with an open mind can we gain some insight into these questions.

Genetically, it seems that cheetahs, much like a typical house cat, have the urge to chase anything that moves. That impulse seems built-in and can be witnessed in the youngest of cheetahs, long before they've had a chance to participate in any hunting at all. This desire can be considered a hardwired, or genetic, trait.

Very young cheetah cubs also seem to "know" how to swat a running target to send it sprawling.

A mother cheetah, for her part, seems to have an inherent desire to move her kittens, and appears to know just how to grasp them so as to be able to lift the kittens without hurting them. Sleeping, too, as funny as it sounds, is also a genetic survival skill. Cheetahs most often sleep in open grassland, totally exposed, yet they sleep in a deep, virtually comatose state, which I have witnessed myself. The advantage of sleeping so deeply is that as long as the cheetah remains totally motionless it will, more often than not, go undetected. Sleeping dead to the world is a genetically linked survival skill.

The distance that a cheetah pursues its prey is also genetically determined, governed by body physiology. Cheetahs have a resting body temperature of 101 degrees Fahrenheit. When their bodies reach 103 degrees Fahrenheit during a chase, they are forced to break it off, since they go into oxygen debt at this point. That temperature rise happens in seconds, depending on a number of conditions (slope of ground, ambient temperature,

OPPOSITE Cheetah cubs at play. One cub in a litter is always dominant over the others and usually the initiator of these playful attacks. Note their oversized legs and feet, characteristics of all cheetahs.

distance, or chase speed). But it is a physiological event, not a cheetah's choice.

Yet so much else that we see cheetahs doing, even grooming, seems to be taught behavior. As cubs follow their mothers during their daily forays, they learn the terrain, but their mothers also teach them to use vantage points, whether they be termite mounds, kopjes, a fallen tree, or even vehicles. She will also teach them, by example, what to hunt, where to look for it, how to stalk it, and how close to get before launching an attack. Experience, too, will teach the cubs this critical distance, but their mothers undoubtedly get them started.

As the cubs gradually participate more and more in chases and kills, they see how their mother kills the prey, how she avoids injury from horns and hooves as she strangles the day's selection. But the teaching goes well beyond that.

You'll notice that, even with a kill totally ripped opened, small cubs squeeze in right beside their mothers and feed cheek to cheek. As they do so they are learning what to eat of the kill and what to leave alone. Time is of the essence for a feeding cheetah due to pressures from lions, hyenas, jackals, and even vultures that often close in on the kill as well. New to eating meat, the cubs must learn what to eat first, what has the most food value, and then prioritize for that meat and work backwards as feeding time allows. The knowledge of what meat is best does not seem to be genetically known.

Notice that the cubs don't stop to clean themselves, even after they are finished eating. Mothers, during the cubs' early months, do the cleaning. As they grow, the cubs will do more and more of it themselves, including cleaning one another. A dirty cheetah is much more prone to disease and infection, so this cleaning is not only a social function, but also a survival tactic.

By her actions alone a mother cheetah teaches her young. For example, she is acutely aware of vultures coming down for the kill she has made. She will watch the birds and her cubs will watch her and learn to do it themselves. Experience (and the cubs' grandmother) have taught their mother that lions and hyenas follow descending vultures, thus giving away her presence and putting her cubs at risk.

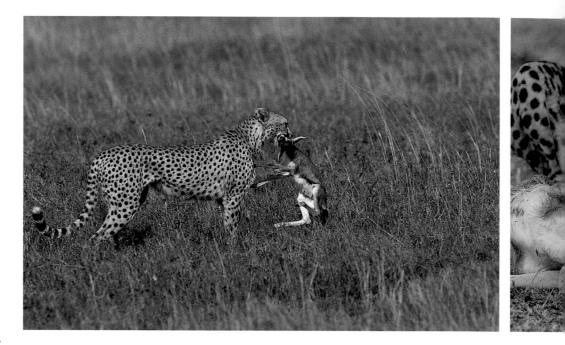

ABOVE A mother cheetah brings a live Thomson's gazelle fawn to her two waiting cubs. She will release it beside them, providing them not only with a meal but also with an opportunity to practice their killing skills.

In direct contrast to what we often read, cheetahs do scavenge—I've not only observed this but have photographed it as well. However, cheetahs rarely get the opportunity to scavenge and most often head in the opposite direction when they see vultures descending toward a dead animal. The risk of confrontation for cheetahs is simply too high, and they are too frail a predator to fight over a kill.

As they feed, cheetahs often raise their heads to look around them. They are watching for incoming predators that could either harm them or poach their kill. When a mother cheetah suddenly pops her head up and stares into the middle distance, watch how the cubs do exactly the same thing: "The more eyes I have, the better to see you with."

SAFARI TIP

As a cheetah (adult or cub) feeds, watch how often it raises its head to periscope the plains.

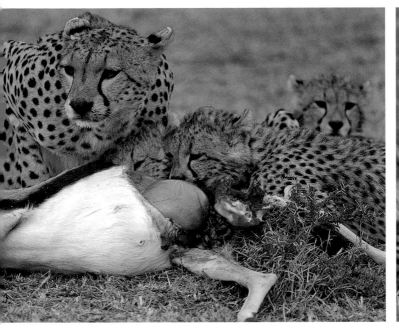

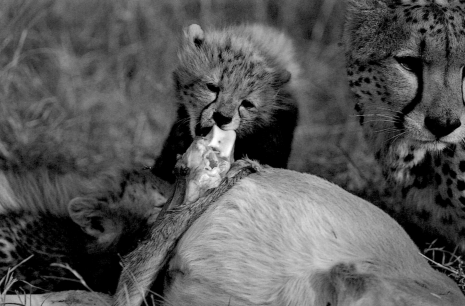

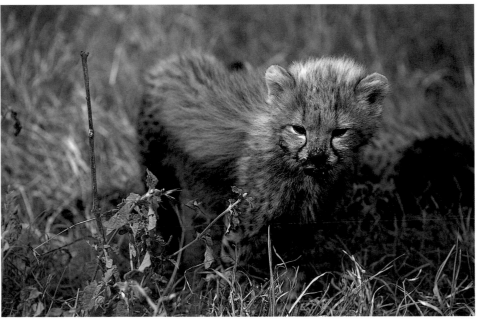

ABOVE A mother cheetah keeps an eye out for danger as her cubs settle down to feed. The least dominant of the three cubs is forced off the kill but will be able to eat after its two siblings have satisfied their hunger pangs and become more tolerant of his presence.

ABOVE, RIGHT At seven weeks, a young cheetah is already eating meat. Cubs have to learn from their mother what to eat of the kill, and the best way to do that is to sit beside her and mimic her. This particular cub has momentarily become sidetracked and is gnawing on a joint, passing up nutritious and digestible meat.

RIGHT Cheetah cubs are born with a ruff of blue-gray hair that extends down their backs from neck to rump. The ruff doesn't fade away completely until they are more than a year old. It is most likely an aid for the small cheetahs when they lie flat to hide in the surrounding grass.

SAFARI TIP
As you watch young cheetahs devouring a kill, notice how dirty and blood-covered they become.

Hunting Virtually every aspect of a cheetah's existence is designed for killing, and cheetahs do it far better than almost all predators, with a hunting success ratio of 70 percent (single lions only succeed 10 percent of the time, and leopards only 5 percent). Most cheetahs are not territorial but live in a home range that they have come to know well.

Cheetahs are far more successful hunting uphill, approaching the crest of a ridge, than they are working downhill into a broad valley or basin for the simple reason that they are more hidden approaching prey from below than they are after they've crested a hill.

Another common way for cheetahs to hunt, especially in the shortgrass plains, is to lie down in a small clump of vegetation and take a nap, a passive but successful method. The cat will wake occasionally, have a look around, and then often go back to sleep. The prey herds quickly forget that the cheetah is there, lose sight of it, and end up moving within the cheetah's strike range. This somewhat relaxed approach to hunting also saves the cheetah a long stalk and the energy of coursing across the plains looking for targets.

Cheetahs are extremely limited as to when they can hunt. Their weapon is speed, which can only be used during the daytime when they can see both prey and the ground. They are also limited by their body temperature and the ambient temperature of the day. So these speedsters are pretty much confined to hunting in the morning and late afternoon or evening hours. Running across the ground at sixty miles per hour is a risky way to kill. A wrong step, a rock, a hole in the ground, or even a stick could cause a crippling injury. A cheetah can't afford

A mother cheetah charged at this adult male Thomson's gazelle and hit it with her chest, which sent it flying. She made no move toward the stunned gazelle but instead allowed her cubs, seen here, to race in and make the kill. Finally, after much running around, the inexperienced young cats succeeded.

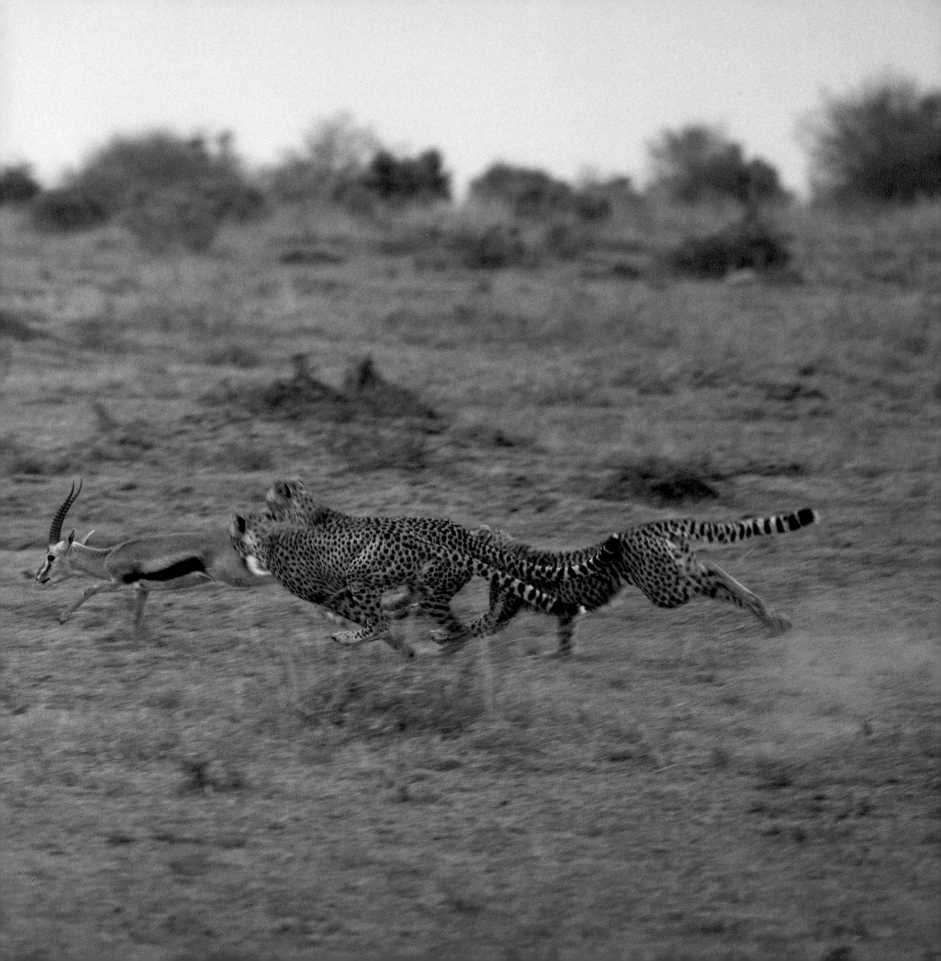

to run after every possible target—it must be sure of the hunt's outcome before it attempts to kill. Cheetahs don't attack herds. The same can be said of lions and leopards. Cheetah coalitions behave no differently. Invariably, a single cheetah from the group will initiate the hunt, select the target, and make the kill. Other members of the coalition come along, but seldom participate in the killing, although they are certainly present for the meat.

A pervasive myth is that predators hunt primarily old and sick individuals, thus strengthening the prey species' genetics by eliminating poorer specimens. Cheetahs hunt mostly healthy young gazelle fawns, depending on the region in Africa. The second largest group of animals that cheetahs kill is healthy adult male gazelles for the simple reason that they are more often alone than adult females, which congregate in herds.

Cheetahs were originally called "hunting leopards." They were even domesticated and trained to course after prey, much like hounds. And coursing, or searching the ground, followed by a careful stalk and high-speed chase is exactly how cheetahs hunt in the wild. Grasslands are the preferred hunting areas because they offer terrific visual protection for cheetahs, yet allow them to run at top speed.

A cheetah will often walk straight at a herd with low and measured paces, in plain view of the gazelles, which have probably spotted the cheetah. Eventually, a mother gazelle will turn and lead her fawn off at a run, and that's when the cheetah erupts into a chase. The cat will race in but won't turn on the afterburners until it is certain of a kill, usually when it is only two hundred yards or so from the fleeing fawn.

SAFARI TIP
Watch a cheetah as it intently studies a collection of gazelles; it always selects an individual.

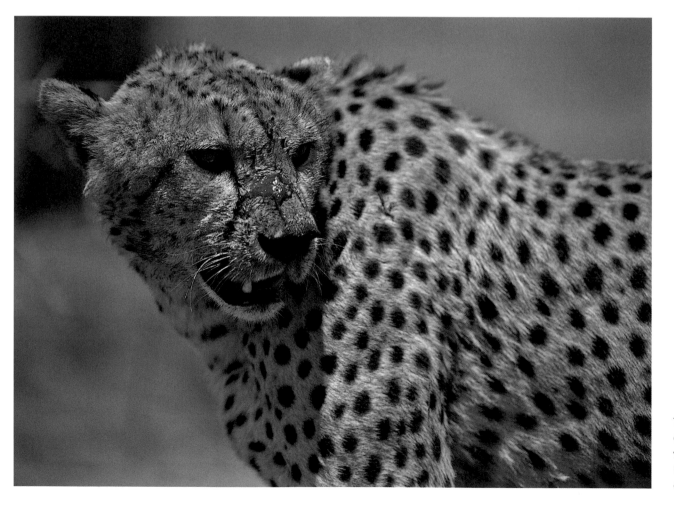

This female cheetah pauses during feeding to shoot a warning glare at two silver-backed jackals that have crowded too close for comfort.

The price of speed, a cheetah's only weapon, is loss of maneuverability. The cheetah's long and well-muscled tail helps it turn at high speeds, but the gazelle, though much slower, can out-corner the cat. A swerve to the left, then the right, and the cheetah has lost.

SAFARI TIP

To better understand what is involved in a cheetah hunt, get out of the vehicle and put your head down to a cheetah's head level (about thirty inches above ground). Now imagine moving at sixty miles per hour at that height, and while you're moving at that speed remember to keep an eye on the fleeing gazelle and watch out for any rock or hole that could twist your ankle and incapacitate you.

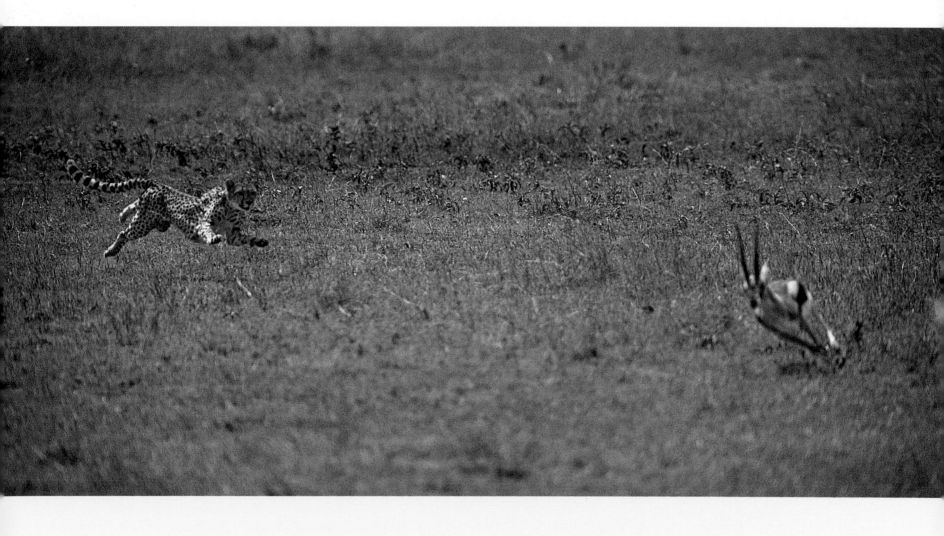

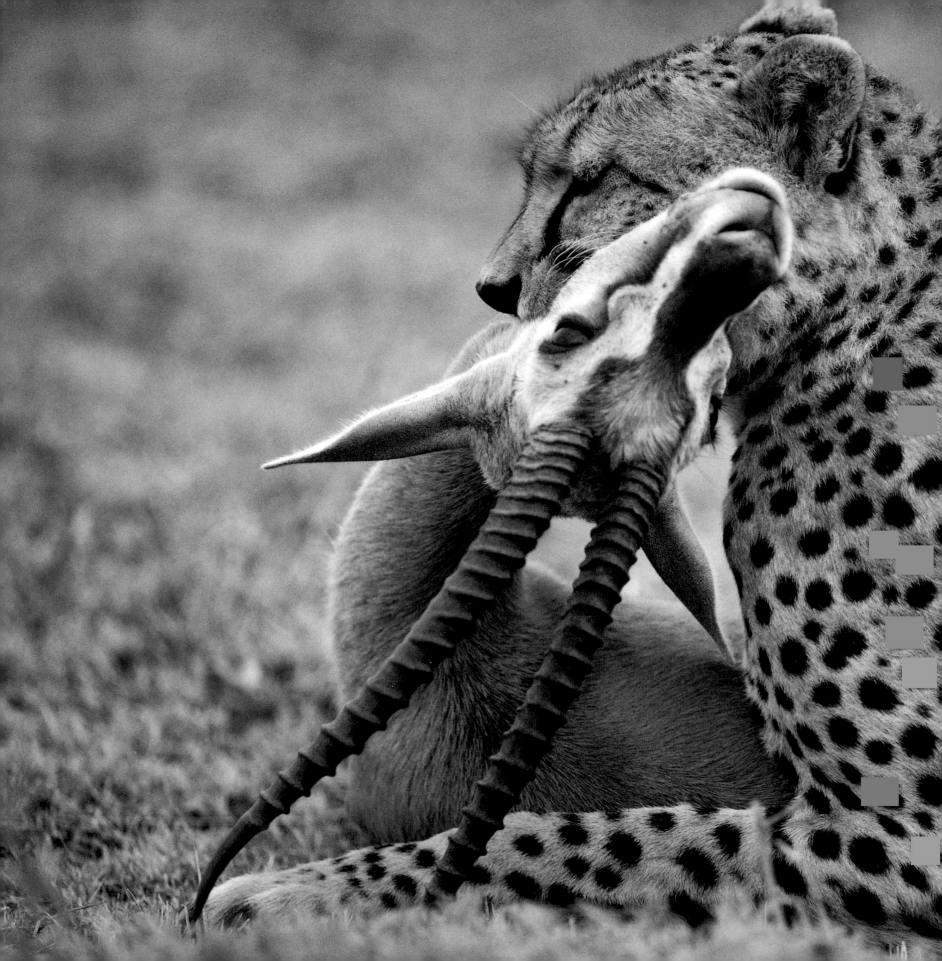

Measure the time spent walking between a cheetah's resting periods and estimate the distance covered, or measure the distance on your vehicle's odometer.

Since cheetahs have small, blunt canines, the only way they can kill their prey is by getting a grip on their victim's throats and strangling them. This mother cheetah has run down an adult male Thomson's gazelle and is patiently waiting out the gazelle's death throes as her cub waits for the thrashing to stop and her mother to release the kill.

When stalking adult gazelles in particular, the cheetah must get close, much closer than we observers may think is necessary. On average a cheetah initiates a strike from seventy yards, and even then it *must* remain undetected prior to initiating its attack. From that distance a cheetah can close the gap on its prey before its body overheats. The cheetah must be undetected prior to starting its chase so that it can use its explosive acceleration, and be thirty yards closer and already motoring at over fifty miles per hour before the prey sees it and can react.

A pervasive myth is that cheetahs and lions are aware of the wind direction when they hunt. This is most decidedly not the case, if for no other reason than that all the cats would eventually end up crowded together upwind in every game park in Africa. The cats hunt based on terrain and location of the prey, with total disregard to wind.

Cheetah kill success is also affected by how many previous attempts the cat may have made that day. It's important to minimize misses and not waste energy that would be expended by a failed hunting attempt. Recovery takes a long time for the cheetah.

A cheetah may break off a chase early if it sees that it will be unsuccessful. It's also quite possible that some other factor, like a hyena's presence, may make the hunt outcome not worth the effort.

Once the cheetah has closed on its prey it still has to kill it, of course. Bear in mind how fragile cheetahs are. They can't leap onto their prey and bring it crashing to the ground—way too risky. Slapping it is much safer. They do not use their dewclaw, the elevated fifth digit on the front foot, as we've been led to believe. They swat the rump or back leg of the running prey, trip it, or knock it off balance. The cheetah then out-brakes the prey and is ready to grab the throat as soon as the prey comes to a tumbling, cartwheeling stop.

The small and stubby canines give the cheetah a grip on the prey's throat, and the cat uses these to strangle it. The cheetah may, depending on what it is killing, also have to contend with the prey's hooves, horns, and kicking legs. These defense weapons can usually be neutralized by the cheetah laying its front legs across whatever is causing the problem. Cheetahs very seldom lose a kill once they have grasped its throat. I've never

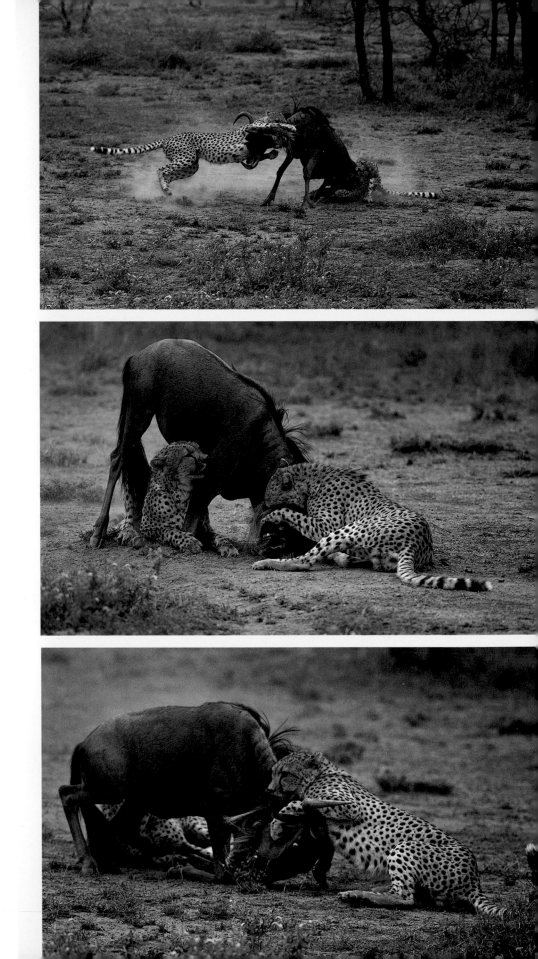

Two male cheetahs, a coalition formed in adulthood, take a great risk by attacking a full-sized wildebeest. The dominant cheetah led the chase, but it was the second cheetah that wrapped its paws around the wildebeest's back legs, slowing it down tremendously. The dominant cheetah took an unbelievable chance and leapt, fully airborne, between the sharp horns of the desperate wildebeest and grabbed the fighting animal's neck. Four times the cheetahs managed to get the wildebeest on the ground, but four times it managed to rise back up. Finally, on the fifth try, the cheetahs, exhausted now, were able to keep it down long enough to get a death grip on its throat. Almost immediately the two cats dragged their kill under the nearest tree to shelter it from the sharp eyes of vultures.

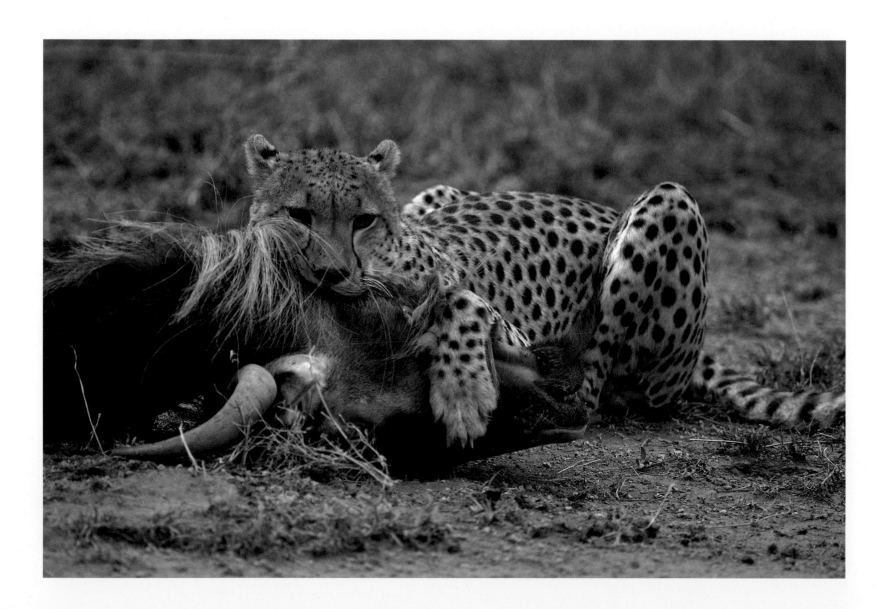

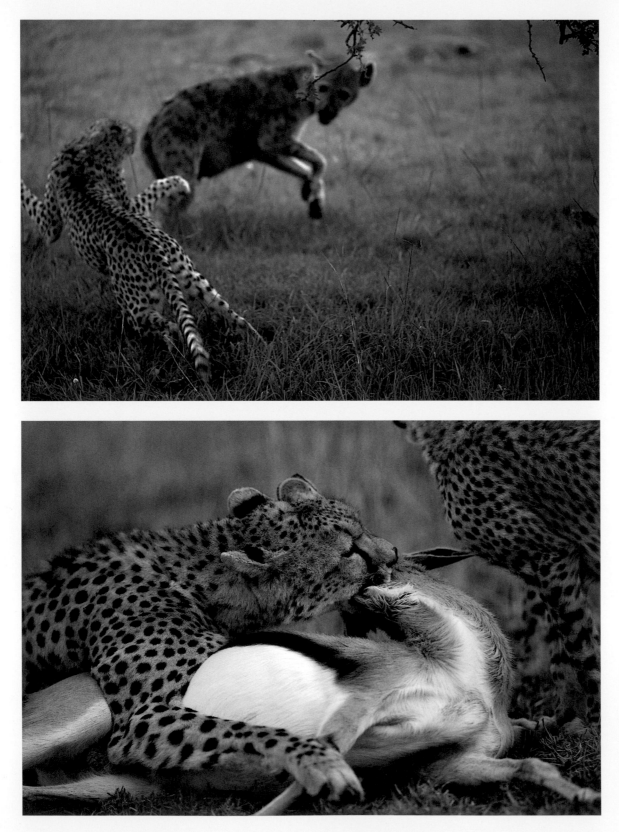

ABOVE A curious hyena comes in too close as it inspects a cheetah's kill. This cheetah became more aggressive than usual, since she had two cubs with her. She jumped repeatedly at the hyena, hissing and spitting. The bluff worked, and the much stronger hyena left the three cheetahs alone.

LEFT This young cheetah has learned well: It mimics its mother and has not only a good strangling grip on the gazelle's throat but is pinning down a dangerous front leg and sharp hoof with its paw.

A large female finishes off the remains of her kill. By the time she is done she will have consumed thirty pounds of meat in less than thirty minutes. The very real possibility that lions or hyenas, even vultures, might poach her kill forces her to strip the carcass and practically inhale the meat.

seen a Grant's or Thomson's gazelle mother come back to try to rescue its offspring—the risk isn't worth it. Better for the mother gazelle to abandon this fawn, produce another next year, and perhaps have better luck.

Cheetahs are usually most active in the mornings and late afternoons when they're searching for prey. If your sphinx stops during its ambling and has a drink of water consider yourself lucky, as this is a rare sight. Cheetahs can go almost indefinitely without water because they get all the moisture they require from the blood of their kills.

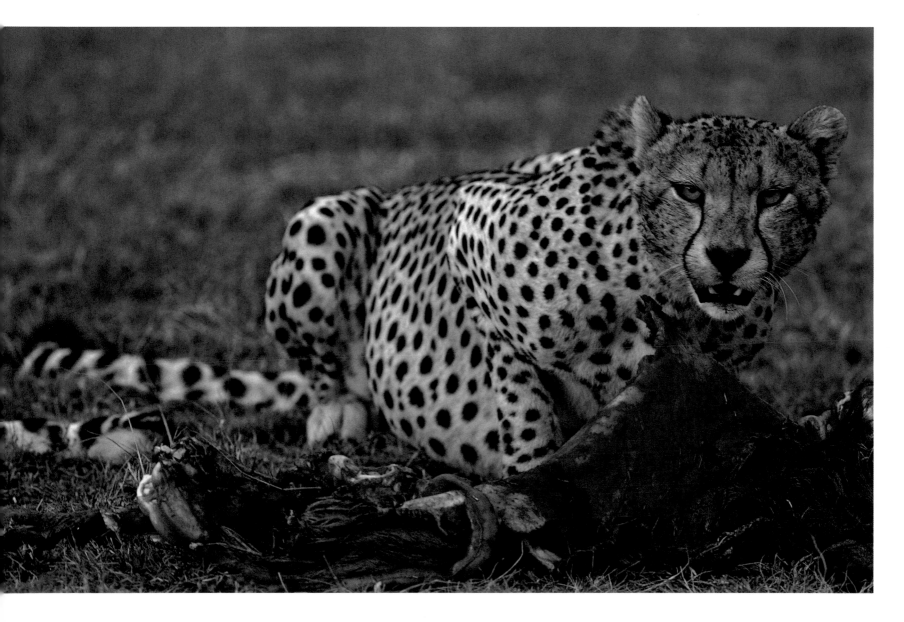

Prey Defense Prey animals, of course, do what they can to avoid being killed. Herds are a good defense against predation. A herd has a lot more eyes, ears, and noses watching out for predators. Even at night, at least one animal's eyes and ears are alert and watching out for the benefit of all. Coloration can also be a good group defense.

A prey animal may have body colors that help it blend into its surroundings, but many prey species live out in the open country where cover is scarce. These species have coloration that confuses charging predators by preventing them from getting a clear vision of what to attack or even where to hit it. Look at an impala, for example, and you'll see how confusing the black-and-white rump patterns and

flashing heel spots are as the prey bounds away, leaping high, cutting left and right, especially when there's a herd of them. Even if the predator is standing still and watching closely, the prey's coloration can be deceptive. Observe a tight-packed herd of zebras and try to keep your eye on one foal as the group ambles away.

Another way to avoid being killed is to be the biggest and toughest prey species on the block. Cheetahs won't attack Cape buffalo, which are huge. A Cape buffalo would provide an enormous meal, but imagine the risk in killing it, especially if you're a solitary cat. Hares and dik-diks, on the other hand, are tiny morsels, but the energy expended to capture these little hot rods may be

more than the calories captured. Somewhere in between these two extremes lies the answer. And even that answer will vary with seasonal availability. For example, when the Thomson's gazelles are giving birth, fawns become a cheetah's chosen food source.

A prey species' body might also determine what gets eaten. Short-legged dik-diks are easier for a cheetah to kill than a giraffe. Similarly, the leg length, speed, and agility of an adult tommie makes it much less likely to be selected for an attack than a fawn. A warthog flees in a straight line when pursued, but what a pity that the pigs have scimitar-like tusks. Furthermore, warthogs help make up for predation pressures by having large litters and giving birth at least once a year for years on end, thus maintaining the warthog population as they are being killed. Every prey animal has its anti-predator defenses.

The birthing process in prey species has a myriad of defenses built into it as well. A prey species, like wildebeest, can have a rut and drop all its calves during one peak season, thus "flooding the market" so that the predators, most of whom are territorial, simply can't eat all the newborns. Prey animals can also give birth almost instantly. From a prone or standing position, they can push out the offspring, eat the afterbirth, lick the blood off, and get it up and moving within minutes. The newborns, for their part, can cling so close to their mother's sides, even while running, as to make them indistinguishable from their surroundings.

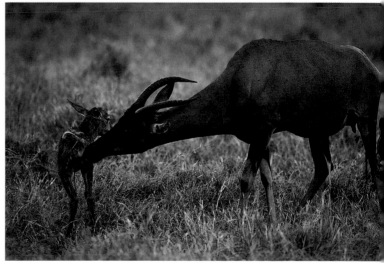

OPPOSITE A line of wildebeests keeps a wary eye on, and a proper distance from, a couple of prowling cheetahs. As long as the wildebeests are watching them, the cats will not attack.

RIGHT A topi drops her young on the plains. She will quickly lick it clean and eat the afterbirth to erase the odors that attract predators, and continually nudge the young one in an attempt to get it walking, even running, as quickly as possible. Topi, unlike so many ungulates, often stay and defend their offspring from cheetahs and jackals. Lions and hyenas, however, prove too strong for a topi, so she will make no attempt to fight those predators.

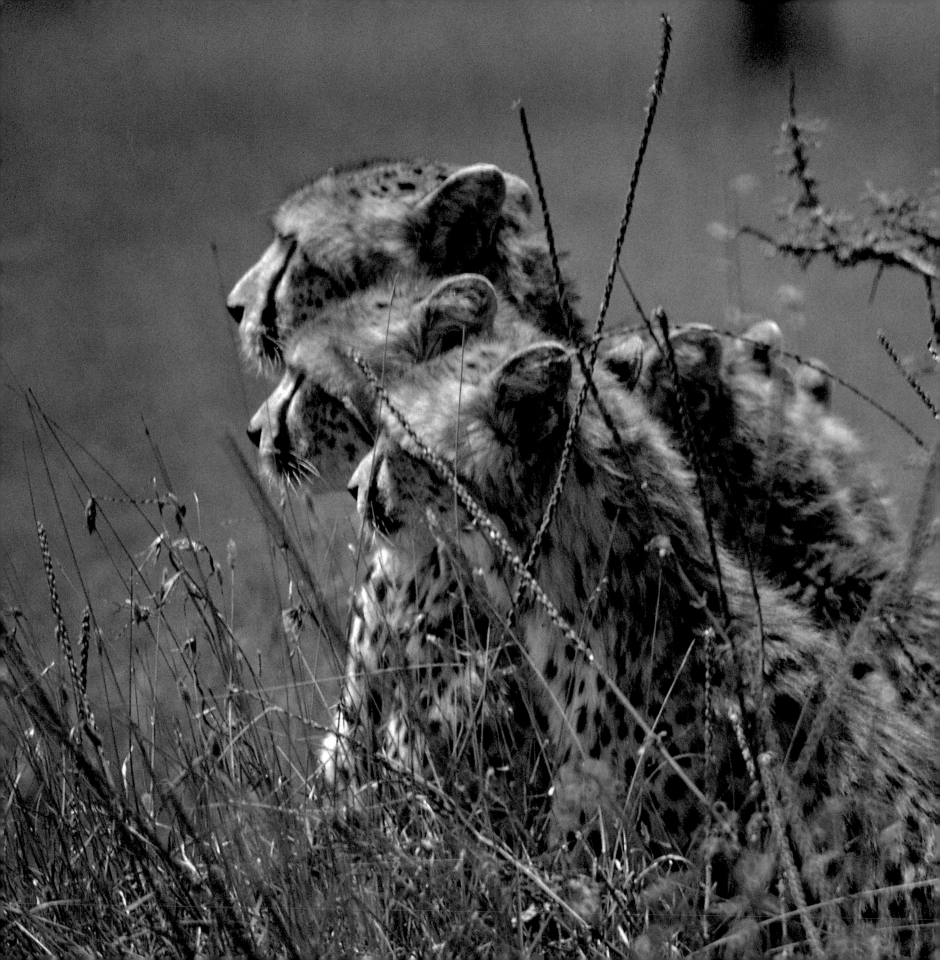

If, when you find your cheetah, it seems to
be doing nothing in particular, don't despair.
There is more to cheetah behavior than
just the killing. Be patient and be willing to
wait and learn a cheetah's daily rhythm. You
can count the respiration rate of a resting
cheetah to calculate how fast its metabolism
is working. Expect a respiration rate of about
120 breaths per minute, as compared to 18
per minute for a human. Time a cheetah's
breathing and see how long it takes to recover
after a medium speed, medium-length chase.

A mother cheetah and her cubs
(now of hunting age) sit in
the tall grasses and size up a
herd of Thomson's gazelles.
After staring for twenty
minutes, the mother led her
offspring elsewhere in search
of more suitable prey.

Debunking Cheetah Myths

MYTH: Cheetahs can run seventy-five miles per hour.

FACT: These cats have actually been timed on only a few occasions, dating back to l964. They've been clocked at fifty-five miles per hour, although at the time they didn't appear to be going at full speed. Sixty miles per hour is generally accepted as their speed limit.

MYTH: Cheetahs have nonretractable claws.

FACT: Cheetah claws are permanently retracted, and are only slightly protractile; they don't have the sheaths that cover retracted claws.

MYTH: Cheetahs are not the best hunters among big cats.

FACT: Cheetahs are, by far, the best hunters of the African felines. Their success ratio (kills per attempt) is six to seven times greater than lions and fourteen times greater than leopards.

MYTH: Cheetah cubs have blue-gray ruffs on their necks to disguise them as honey badgers, thus faking out lions and hyenas.

FACT: Lions and hyenas have terrific eyesight, and they are rarely misled by a cheetah with a ruff. It is believed the ruff helps younger cheetahs hide in the grass by blending in with their surroundings.

MYTH: Cheetah coalitions are more successful as hunters than solitary cheetahs.

FACT: Male groups of cheetahs have exactly the same hunting success ratio as single males and females. The coalitions can kill larger prey, of course, but they have to share it among more cats. Thus, the meat-per-cat amount is equal to that for single cats.

MYTH: Cheetahs are too specialized and thus doomed to extinction.

FACT: Cheetahs are highly specialized, but there isn't a shred of scientific evidence that suggests cheetahs are doomed. Their habitat is being destroyed in many parts of Africa, but that is also true for a lot of wildlife habitats worldwide.

How to Observe Cheetahs

1. Don't go for a night drive in the hopes of watching a cheetah kill. Cheetahs are diurnal hunters, which is determined, to a great extent, by temperature and light conditions.

2. If you've just left a lion pride feeding on a Cape buffalo or a clan of hyenas finishing off a wildebeest, you'll probably have to put some distance between yourself and those predators if you want to find a cheetah. The solitary cheetah has to avoid these more powerful predators.

3. Prey species have much sharper eyes and senses than you—use them and their signals to locate cheetahs. If they've spotted a cheetah, they often will follow them at a surprisingly close distance. Impalas, Grant's gazelles, Thomson's gazelles, topi, and wildebeests will snort alarm calls when watching cheetahs walk by. *Learn that alarm call.* Buffalo, giraffes, elephants, and eland won't be much help with sounds, but keep your ears open for the others.

4. Don't observe your cheetah from behind; get way ahead *and* to one side of a walking or hunting cheetah. Then try to select the herd or an individual that the cheetah might hunt. Try to figure out, based on local topography and cover, which way or ways the prey might flee and what cover the cheetah is going to use. Put this all together and you can create an attack profile for the cheetah.

5. In resting or feeding cheetahs there is quite a lot to observe. Notice how far back the eyes lie under the brow shelf, how well protected they are. Have a close look at the paws, front and back, and the claws, toes, and legs of the cheetah. Draw out the tail ring pattern of a cheetah. Hopefully you'll be in the same park for a few days and will have a good chance of seeing that cheetah again.

6. See how the cheetah's coat varies on different parts of its body, and not just in coloration or hair length, but in the texture of the fur itself. When you look at the fur and short whiskers on the face also notice the short canines and fine line of incisor teeth. Look at how wide the mouth is and remember how a cheetah must strangle its prey.

7. When you come across a group of cheetahs, determine if the group is a male coalition, a mating pair, large cubs on their own, or a female with cubs. Try to determine the sex of the cubs, which is impossible if they are just weeks old, but possible if they are more than six months of age. During your time observing the cubs you should be able to come up with a dominance order among the cubs, even if they aren't feeding.

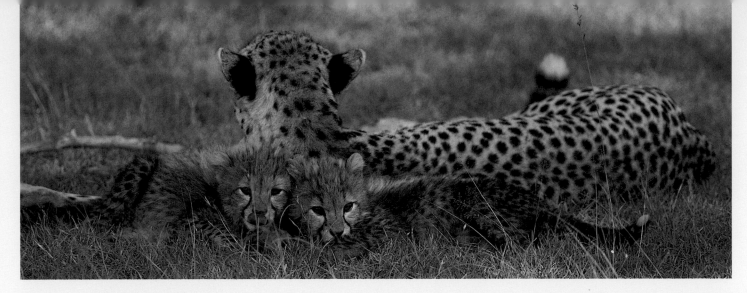

Facts on File

1. Mothers with cubs end up with less food for themselves, but with large cubs they benefit from the group's anti-predator awareness.

2. Over 90 percent of all cheetahs in East Africa do not live to be a year old. Lions kill over 70 percent of all the young cheetahs and hyenas take another 20 percent.

3. Young cubs develop their hunting skills slowly during the period they are shadowing their hunting mothers, which starts at four months of age.

4. Groups of cheetahs have higher hunting/foraging successes not because they collaborate during the hunting, but because as a group, they have the ability to hunt a wider variety of prey.

5. Cheetah's modern morphology is less than two million years old.

6. Cheetahs take less than 6 percent of the gazelle population, yet young gazelles and adult male gazelles are killed most often by cheetahs.

8. Female cheetahs reach sexual maturity at around fourteen to fifteen months, but don't give birth to their first litter until they are three years old.

9. Gestation period for cheetahs is ninety to ninety-five days.

10. Milk teeth are shed at about eight months of age.

11. Cubs often stay together for months after leaving their mothers.

12. Cheetah home ranges average five hundred square miles in the Serengeti, but coalition territories are only about eighteen to twenty square miles in the same areas.

13. Cubs leave the lair at about two months of age.

14. Litter sizes are the same in the wet season and in the dry season.

15. By four months of age cheetahs can usually outrun predators and thus have a much better chance of making it to adulthood from this point.

16. Infanticide in cheetahs has never been recorded.

17. Cheetahs will adopt cubs but will not nurse them.

18. Cubs stop nursing by the age of four months.

19. Lactating females have higher success ratios of kills than non-lactating females.

20. Mother cheetahs cover more ground and eat less food than females without cubs.

21. Cubs don't assume responsibility for initiating hunts until they are more than one year old.

22. Female cubs are usually the first to leave their litter.

23. Most, but not all, coalitions are comprised of brothers.

24. Over 20 percent of all adult males hold home ranges, but no adolescent males do.

25. Pair coalitions hold home ranges for just over half a year with trios holding ranges for up to two years.

26. The main benefit of males forming into coalitions is that they will have more mating opportunities than single males.

27. On average, cheetahs eat every one and a half days.

28. Cheetahs do scavenge but not often.

29. The average tourist vehicle stays with a cheetah for only about fifteen minutes—***don't be an average tourist.***

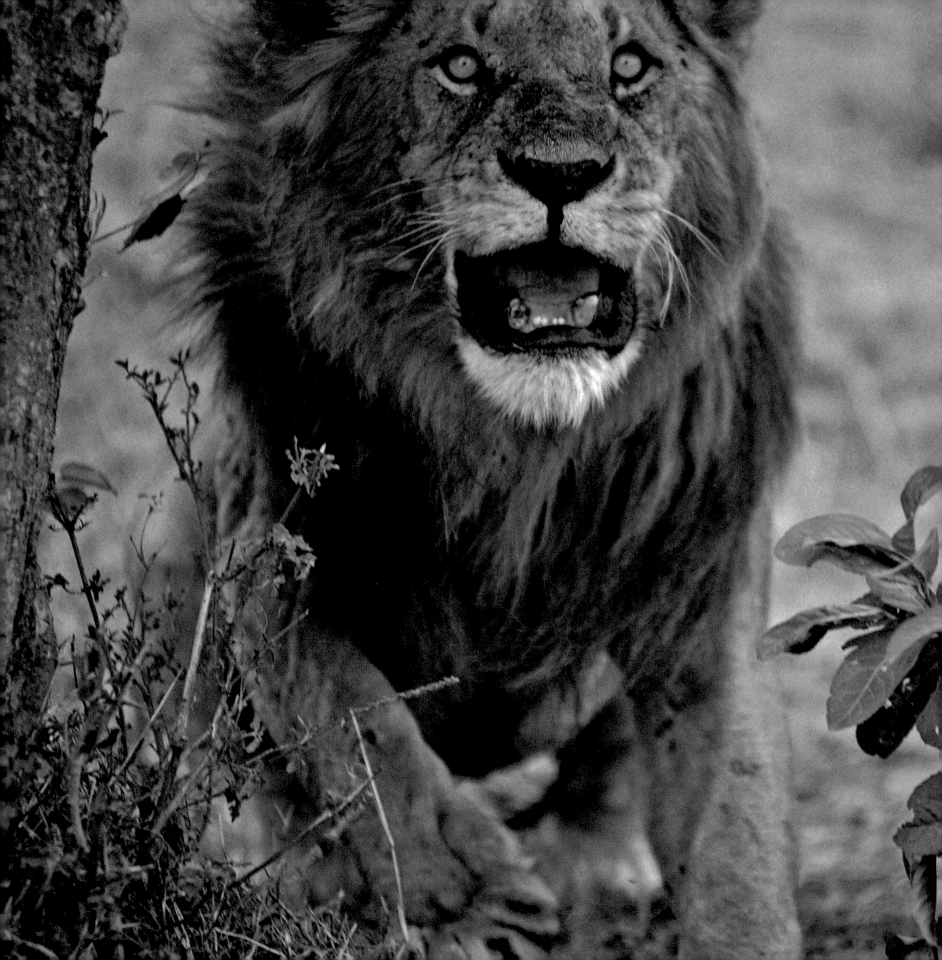

A male lion—very old, as can be determined by his well-worn teeth—runs out of patience and lunges for an attack.

LION

A DAY IN THE LIFE

It's late afternoon and for over an hour now five cubs have been batting at one another, chewing on one another's ears, and occasionally swatting and nipping at a mother's tail. Yet it wasn't until the sun shone on the low clouds sitting on the Isiria escarpment that the adult lions began to stir.

Within minutes movement spread through the pride. All members were now yawning, rolling onto their backs, pawing at a nearby cub, or stretching their muscle-bound legs. It still took another twenty minutes before the old female, the one with two deep slits in her left ear, sat up and ran her eyes across the plains.

The pride, minus its three resident males, lay haphazardly scattered among the croton scrub, with a few of its members still down in the *lugga*, where they had sought shade earlier in the day. As soon as the old female sat up, the other lions, cubs included, followed suit, keeping an eye on her every move.

Slit Ear rose and lumbered over to her sister and her sister's two male cubs and slid heavily to the ground, pawing a cub over with her as she collapsed. The two females lay on their sides, face to face, and licked one another as the other cubs came over, mewing noisily, and clambered up on top of their recumbent mothers.

95

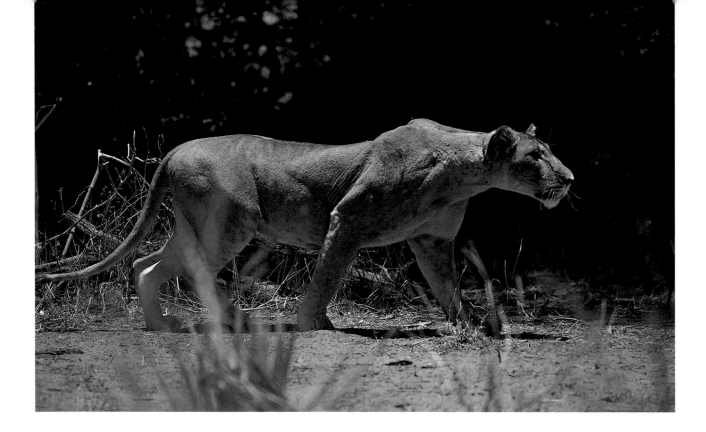

But Slit Ear regained her feet, tawny youngsters sliding off her as she rose. Sitting bolt upright this time, she faced the open grasslands once more and scanned intently. The four other adult females gazed in the same direction, as if there was something they had missed. But nothing was obvious and in less than a minute they relaxed and began assiduously licking their huge paws and heavy forelegs. The five cubs restlessly meandered from female to female, pushing under a chin here, receiving a strong lick there, and generally begging for attention, which they invariably received.

Another female rose to a standing position, stretched languidly, bowed and yawned simultaneously, and ambled out onto the plains. All members of the pride, young and old alike, followed her. Powerful, rounded shoulders rippling, loose paws flipping out, they strolled forward.

The pride walked for more than half an hour, the lionesses moving steadily, the cubs in fits and starts. They covered ground at a surprisingly fast rate and as darkness fell they were almost across the red oat grassland and approaching the swamp with its bordering forest of olive, Greenheart, and ficus trees. They skirted the south end of the swamp and lazed their way up onto two termite

A lioness has spotted her prey but closes the distance with measured paces, as she is not yet close enough to commit to an attack.

mounds just as nightfall enveloped them. The adults took the high ground on the mounds while the five cubs flopped at the bases, their three-month-old legs worn out from the long march.

No Thomson's or Grant's gazelles were in sight in the tall grasses, but buffalo, zebras, wildebeests, and waterbuck were all scattered out before the lions; a little herd here, a single male there, each species feeding in the grass type and length that suited it best. The prey options were plentiful.

Thirty minutes later the lionesses were moving again, the cubs less playful now. They sensed that the business of killing had begun. All nine felines descended into a small gulley, but only the four adults came low-crawling up the far side. The cubs stayed down in the datura-filled ditch. Both the vegetation and the cut in the earth gave the youngsters enough cover in which to stay safe and

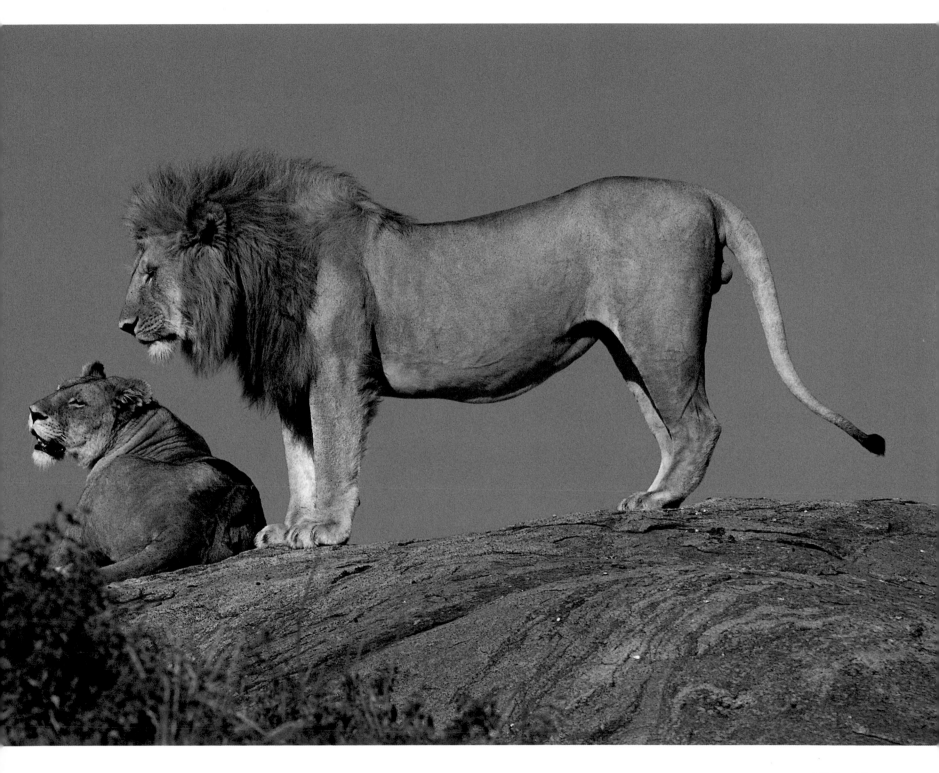

A magnificent pair of mating lions take a break from their procreating activities.

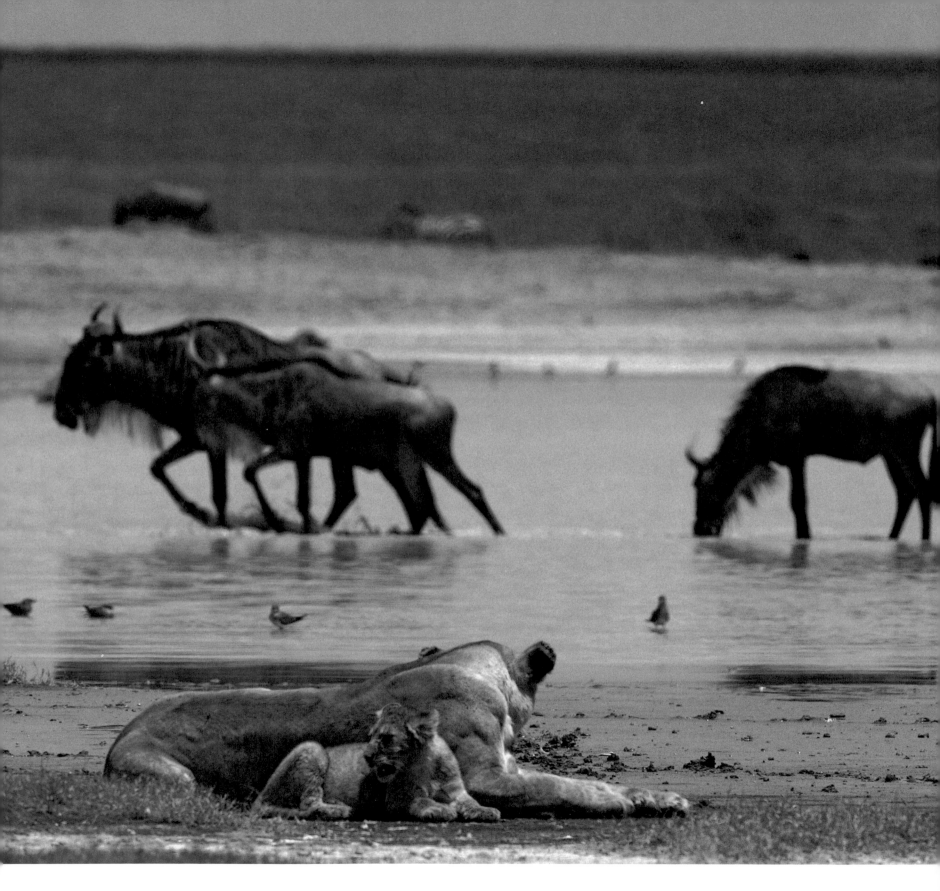

A lioness, her cub tucked in beside her, evaluates wildebeests that are coming down to drink the only water in the area.

out of sight. The fuzzy ones crammed close against one another, forming one indistinguishable lump of fur. Heads held low, legs and tails pulled in, the cubs went still and silent.

With their excellent night vision, the lionesses could easily see the small herd of wildebeests seven hundred yards in front of them. The gnus were feeding, facing different directions as they grazed. Most of the time their heads were down. The lions, four abreast, moved forward with measured strides, still upright and making no attempts at crouching.

Two hundred yards from the wildebeests, Slit Ear suddenly froze. The other three lions stopped, then turned and looked at Slit Ear. She remained motionless and staring ahead. Only when she resumed her stride did the other lions unlock and start closing the gap as well.

When the youngest lioness was only one hundred to seventy yards from the nearest wildebeest, she turned a sharp right, following an elephant path that led into the swamp and toward the feeding ungulates. Slit Ear moved straight ahead, now focused on a yearling wildebeest that had wandered some twenty yards from its mother. Slit Ear's sister had slid left and was belly-crawling up the vehicle track that circled around the swamp, edging herself steadily toward the herd at a different angle.

It took the lionesses more than twenty minutes to close the next one hundred yards and gain positions only sixty yards from the wildebeests. The herd, still oblivious, was grazing, though moving slowly away from the swamp. The cats seemed to ignore both the high half-moon and the slight wind that puffed sporadically from the east. They were aware only of the wildebeests and the grasses through which they were moving.

Slit Ear paused, moved quickly forward with six low slinking strides, and froze again. Silently, both Slit Ear and the female that had been following her exploded forward toward the yearling, and suddenly, panicked wildebeests were stampeding in every direction, some even rushing back toward the oncoming lionesses. As suddenly as it had begun, it was over, the thundering hooves of the fleeing wildebeests fading in the near distance. Slit Ear and her nearest accomplice both stood still, watching the wildebeests growing smaller as they fled to the plains.

A bleating sound came from the grasses about seventy yards to the right. Slit Ear was instantly off at a trot, her sister following. By the time they reached the source of the sound the other lionesses were already there, both lying full length across the wildebeest that Slit Ear's sister had brought down. The sister held the wildebeest by the throat, her long canines driven deeply into the neck on either side of the wildebeest's windpipe.

The arriving lionesses immediately attacked the downed wildebeest, one biting into a haunch and Slit Ear driving her canines into the back of the still struggling victim's neck. All the cats held their grip, motionless, for several minutes, until they sensed the inevitable end.

One lioness released her grip, clawed at the flank of the gnu, twisting it belly up, and grasped its rear leg. Her neat row of incisors began tearing straight into the lower belly, releasing a warm steam into the air. The lioness with her jaws still clamped on the throat maintained her grip as the two other cats released theirs and began raking open the wildebeest's stomach, snarling and swatting at each other as they fought for position.

Surprisingly, no lionesses went looking for the cubs, but within minutes all the little ones were there, growling and snarling with a ferocity way beyond their tender ages as they fought their way into a feeding space. The whole pride would soon settle down as they engorged themselves with meat and as the hype of the chase and kill wore off, but for now it was a highly vocal and physical contest as nine lions fed on one wildebeest. The hyenas had heard the squabbling and were on their way to the scene. Eventually the lion kill would belong to the clan, not the pride.

SAFARI TIP

Watch a lion pride feeding on a kill and take the time to study it, learn the order of dominance, and observe the learning processes taking place among the younger members.

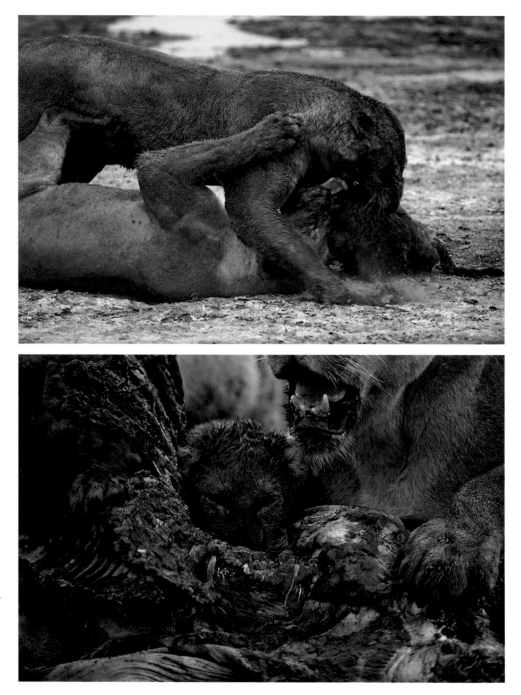

ABOVE Lions are not good at sharing, even among their own pride members. These two lionesses, sisters, fight vigorously over a wildebeest calf carcass.

RIGHT Lion cubs must fend for themselves at kills. Somewhat surprisingly, adult male lions are far more tolerant of their offspring during feeding than the females.

BIOLOGY AND BEHAVIOR

Lions are social cats. They live out their lives with a group, or pride, and everything revolves around that for one reason or another, from hunting style, food and habitat preferences, mating strategies, territorial systems, and vocalization. Even a lion's body has evolved to fit its various social roles.

Lion Anatomy A lion's skull is heavily built, with a large sagital crest for anchoring its powerful jaw muscles. A lion doesn't have the shear crushing power of a hyena's jaws, but their jaws are heavy and well-muscled, and the mouth is wide, though not proportionally as wide as a cheetah's gape. Yet it suffices, allowing a lioness to breathe while she maintains a suffocating grip on her prey.

The eyes of a lion are one of its tremendous hunting assets, principally because they are not only keen, but they also have a reflective membrane on the back of the retina called the *tapetum lucidum*. This mirrorlike layer of cells bounces the light back through the lion's rod and cone cells, doubly stimulating them, and thus giving a lion excellent night vision. It's no surprise, then, that 88 percent of all lion hunts occur at night.

A lion's teeth are far heavier than those of a cheetah or leopard, and they are capable of killing in a greater variety of ways. The canines are easily long enough and stout enough to pierce through the neck of smaller prey, severing the spinal column. When killing its smallest prey, such as a Thomson's gazelle or a newborn wildebeest, a lion can simply bite its victim's skull, and the long canines will punch through to the ungulate's brain, killing it instantly.

The premolars and molars are narrow and pointed, not designed for grinding at all. These teeth in the upper and lower jaws overlap, providing a paper cutter–like shear for slicing away meat called the carnassial shear. The six incisors, situated in a neat row between the canines, can also cleanly slice and strip meat from bone.

Lions often end up in brawls, and they're certainly brawlers when it comes to killing. The heavy frame and bone structure of these bullies anchors the incredibly powerful muscles they use for pulling down prey as large as buffalo and even giraffes.

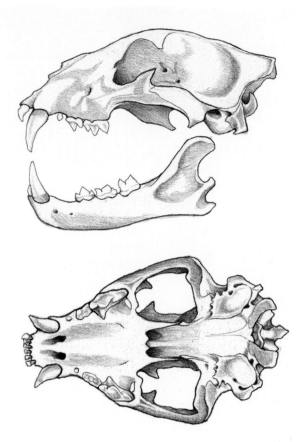

Lion skull, side and bottom views.

As with all the predators, except cheetahs, the front foot is larger, supporting the heavier front half of the body. Four toes show in the track, all claws retracted. The fifth toe, or dewclaw, is elevated, also with a retracted claw. The lion's rear foot is longer and more rectangular in shape than the front foot.

A lion's tail is strong, well muscled, and has a subcutaneous hook at its end. I once grabbed a male lion's tail (when it flipped through the Land Rover's window and ended up in my lap) and was absolutely amazed at the power contained there. The male lion merely flexed his tail and yanked it free of my grasp. This incredibly stout and strong tail serves as a counterbalance to the lion's heavy body, helping the cat turn and cut as it chases down its

SAFARI TIP

Compare the front and back feet when you find a resting lion. Notice the differences in the tracks when you find a set of prints.

A lion's massive front paw print dwarfs a human hand.

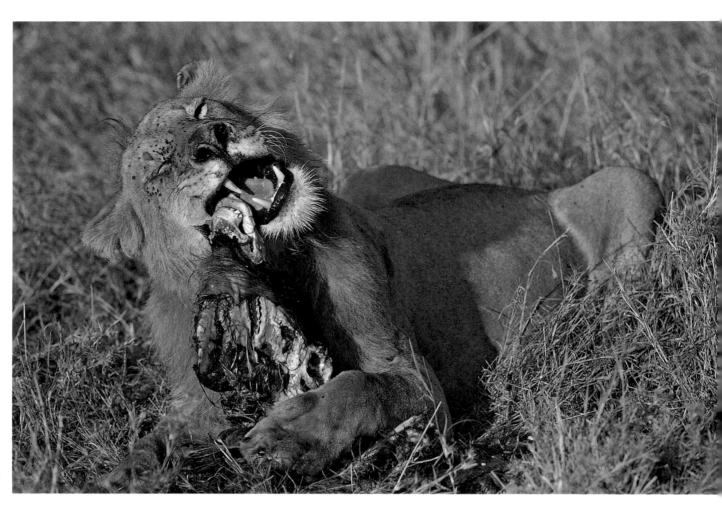

A young nomadic male uses his carnassial shear to cut the flesh from a wildebeest skull.

prey. It's not uncommon to see a tail without the pom-pom at the tip, but it's doubtful that this has any effect on the lion's ability to chase prey effectively.

Lion coloration, mane length and color, and light body spotting all vary tremendously from habitat to habitat and from individual to individual. Only the black on the back of the ears seems to be constant for lions. This blackness is a trait that lions share with all the large and medium cats, even the serval. Why this has evolved in most of the felines is still somewhat of a mystery, but it certainly helps break up the outline of the cat when viewed from behind and might be used for heat regulation as well, though no solid evidence has been forthcoming.

A lion's mane, however, is no mystery. Manes, which grow only on males, become evident very early in life and

an obvious ruff is noticeable by the time the male cubs are five to six months old.

By the time a male lion is a year and a half old, the mane is prominent. When these males are forced from the pride at around two years of age, the mane is already darkening in most cases.

What's the purpose of the mane? The answer is two-fold. A male lion's role in life is to establish and maintain a territory, and thus have access to the females that are contained within the territory. A male must both establish and defend this area and a mane serves as a visual sign, or sexual indicator, to other lions that a male is present. This huge and flowing mane, often very dark in older males, also works well as a warning sign to other male lions. Male lions frequently and ferociously fight over territories.

Study adolescent cubs carefully and
see which ones sport longer neck hair.

Male lions are often more tolerant
of small cubs than their own
mothers. During the heat of the
day, this cub is unable to contain
himself and continually mock
attacks his playmate, a two-year-
old male. Finally, the cub gets the
reaction he is looking for, and the
game begins.

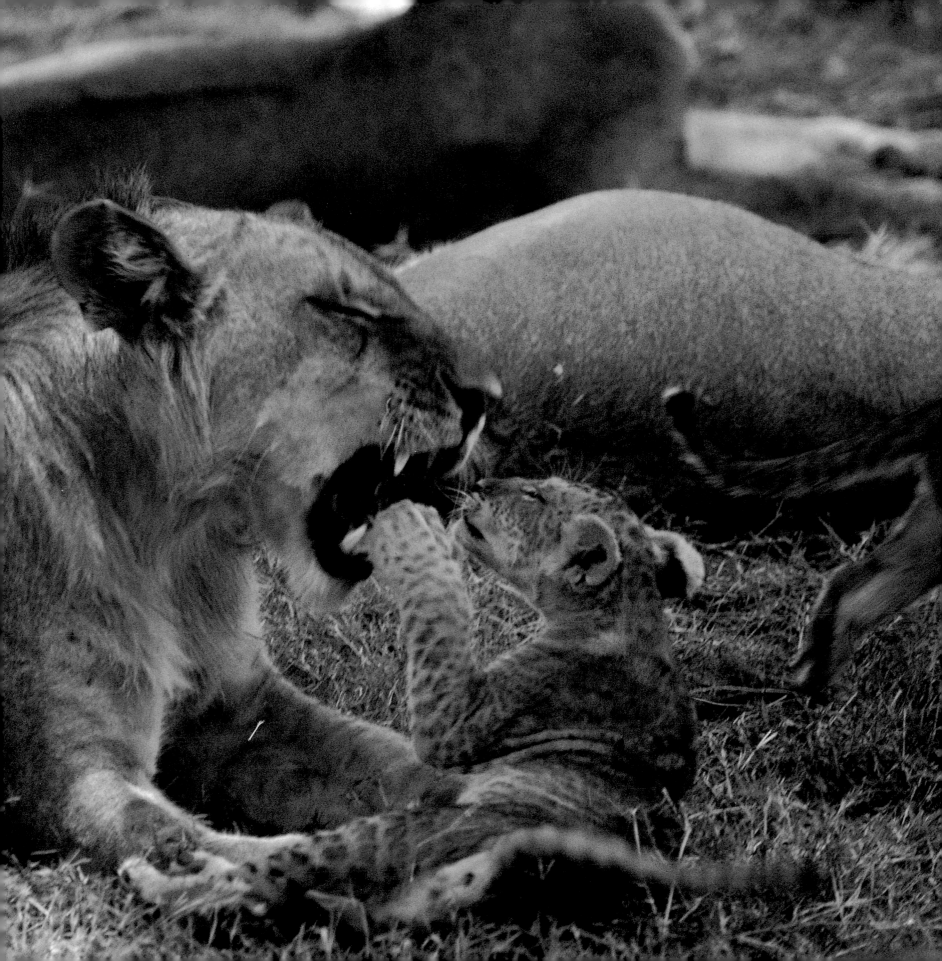

A thick mane of long hair around the neck serves as a protection during these violent fights by preventing an aggressor from gaining a throat grip. It is thought that longer manes may be linked to colder climates and higher altitudes. Recent research seems to indicate that lions with larger manes mate more often.

Not all male lions, however, have manes. In East Africa, it's not uncommon to find male lions in both the Samburu region of northern Kenya and in the Tsavo area of eastern Kenya that have no manes whatsoever. This could be temperature related, though that is doubtful. A lack of a mane in this case is probably caused by a hormonal imbalance, which has become genetically established in a population. These maneless males are not a separate species, or even a subspecies.

A lion's face is an expressive face. It's easy to recognize when a lion is angry, relaxed, focused, or about to charge.

You can also learn to identify individual lions quite easily by studying their facial features. A lion's whiskers typically grow in a series of five rows that run horizontally across the lower cheek. Each whisker, or vibrissa, emerges from a dark spot. Count the number of whisker spots in the top row and take note of their number and distance from one another. Then, look at the next whisker row down and again count the number of whisker spots. Notice where they are positioned in relation to the whisker spots in the row above. These top two whisker rows work like a fingerprint for identifying individual lions. No two lions have the same whisker pattern. It has even been observed that male lions with straighter whisker rows mate more often than males with uneven whisker rows. The straightness of the rows, therefore, could well be an indicator of a healthier individual with a more desirable set of genes.

A nomadic male hides in the grass as a herd of wildebeests ambles near. Notice the notches on his ear—these are his unique ear clocks, a handy way of identifying individuals.

Identifying lions by their whisker pattern can be done even on very young cubs. You have to get close enough to the cats so that you can clearly see the patterning with binoculars. Draw a lion's whisker pattern; do this for an entire pride. Draw ear irregularities and get to know individual lions. Add a drawing of the nose print to your whisker and ear-clocking patterns.

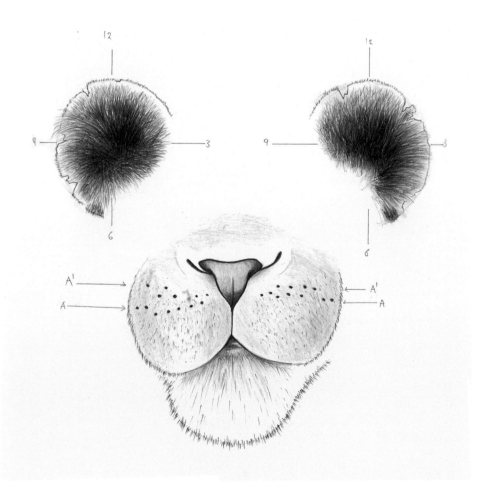

"Ear clocking" is another easy way to identify lions. Look closely at a lion's ears, and you will see that they are rarely perfectly round. Even on relatively young cubs there are cuts, splits, nicks, and tears along the edges. These so-called ear-clock patterns will not heal over and disappear, but new cuts and tears may be added during a lion's lifetime. If you return on safari a year or two later, you'll more than likely have to update the ear clocks you have already drawn.

Body scars and deep facial scratches can also aid in identifying lions. Because a lion has short hair on most of its body, these scars, especially those on the face and flank, are easily spotted. You'll notice that an adult lion's nose is seldom a solid pink or black, but is a combination of the two colors, formed in a unique pattern. Lions have clusters of spots on their lower flanks and bellies. This spotting is more obvious in cubs, but even adults retain these spots to various degrees. These spots, therefore, cannot be used to age a lion, but can be somewhat helpful in identifying individuals.

Similarly, some lions are more golden than others, while some individuals are darker, redder, or sandy-colored. All lions have lighter throats and bellies, as you're bound to observe when you stumble upon a pride during the day and they are snoozing in their typically undignified spread-eagle poses. These white areas have a purpose, as they do on cheetahs and leopards. To appease a dominant or threatening cat, the subordinate can cower and expose its white neck or belly, submitting to the threatening individual. This appeasement behavior can defuse the tension and reduce the risk of a physical fight, saving both individuals from possible harm.

Lions do not have the speed of a cheetah, for sure, but they do have the significant advantage of size and weight. Their muscles are correspondingly large, powerful, and incredibly well developed. Even during the fattest times of the year, when prey species are plentiful and killing is relatively easy and frequent; a lion will still have only 2½ to 3 percent body fat, as opposed to the average 20 percent body fat of a Western man.

A male lion rests after a violent fight with a territorial male. The claw marks on his belly show how badly he came off in the fight, which he lost.

A male lion marks his territory
by urinating on his back legs
and then scratching the scent
into the ground with his claws.

Territoriality and Habitat Unlike cheetahs, lions are fiercely territorial and will defend their areas, even to the death. For lions, no territory means no females and thus no offspring, which, of course, would mean a dead end for the species.

Territory sizes are determined by available prey in the area and can vary tremendously. In East Africa the average lion territory is fifty square miles, but they are smaller in mountain habitats, or in areas of denser vegetation such as Kruger National Park in South Africa. More specifically, territory sizes are determined by the least amount of prey species available during the worst time of year. These worst-case scenarios are *not* determined by prey migrations or movements, which are dictated by rainfall.

Lions exist in almost all habitats, from deserts to high, cold mountains. They are not as abundant in the plains as they are in the woodlands, though they are certainly easier to find and observe in the open country. This leads to the false belief that lions are predominantly a plains species. Even in such rich grassland environments as the Serengeti there is actually a net loss of lions, and it's in the woodlands to the north of the Serengeti where a surplus of these large cats is produced, forcing the overflow out into the open country to the south. Heavy forests, on the other hand, are less than ideal for lions, as prey species are usually more dispersed and harder to locate. But lions definitely occur in mountain habitats up to at least thirteen thousand feet. In these moorland environments they can make a successful living by hunting buffalo, eland, and reedbuck. But it is broken woodlands that are a lion's ideal environment. Prey is often in larger groupings, easier to spot, and there remains enough cover for stalking and attacking.

Maintaining a territory is no easy task, and it is a highly risky affair. Tenure for males in any given territory usually lasts only two or three years and is fraught with dangers, primarily from invading male lions. Lionesses are permanent residents in any territory, and they form the nucleus of the pride.

Male lions mark their territory in a variety of ways. These jealous landowners vocalize and patrol the perimeters of their land, leaving behind urine and feces to serve as boundary markers. When these signals are ignored, accidentally or otherwise, fighting will almost surely follow. A territorial fight between two males, or groups of males, is an incredibly violent, vocal, and ferocious affair. Quite often a lion will die in the fight or become seriously wounded, sometimes fatally. Males consistently try to bite the backbones of their rivals, which, if successful, will leave them paralyzed. The manes offer protection for the neck and throat, but the males can still kill one another by biting through a skull, or crushing legs, shoulders, or paws, any of which may leave a lion defenseless.

Females will fight too, though it usually amounts to little more than tangling with other nomadic females. These fights seldom inflict serious injury, and a wandering female is almost always accepted into an established pride. On occasion males will stumble onto nomadic females. At these encounters the males will posture and pose, strut, scent mark, and roar. They may even cuff the

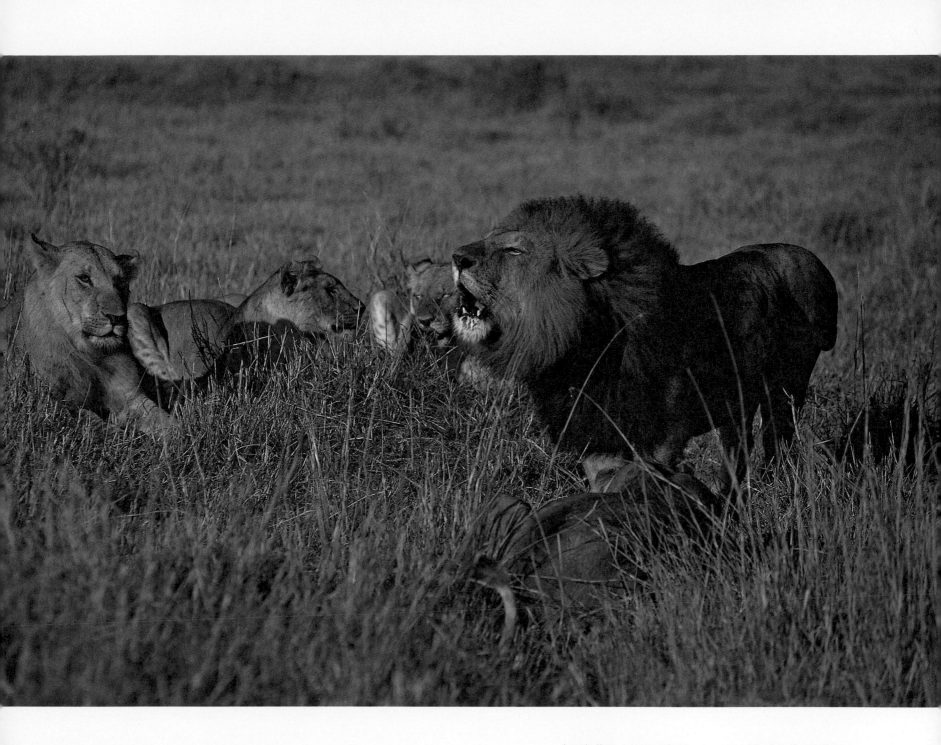

A male lion, accompanied by some of his pride females, confronts a female (low in the grass in the foreground) that has wandered into their territory. They roughed her up a bit, then the male proclaimed his territory and dominant position by standing over her and roaring loudly. They eventually allowed her to escape unharmed.

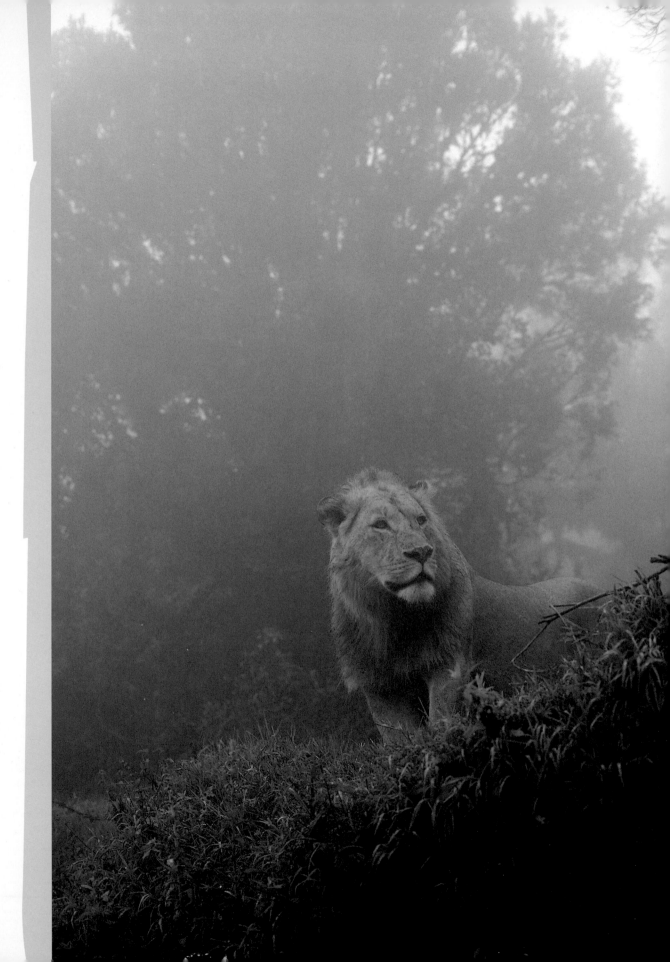

SAFARI TIP

Watch a lion or lioness saunter along. Notice the rippling muscles visible underneath the short fur of the shoulders and upper arms—the cat is walking in a completely relaxed state and isn't "pumped up." The power potential is obvious.

Lions live in a wide variety of habitat types, from bleak deserts to cold, high mountains. This five-year-old male, having just taken over this territory in the mountains, surveys his surroundings. He, along with his four age-mates, hunts Cape buffalo in the high forest—a risky way to survive.

intruding females around a bit, but the physical conflict will stop there.

Females, like males, roar and deposit urine samples. The roaring, which can easily be heard from five miles away, has two purposes. Lions of a pride often end up separated during the course of their nightly work, be it hunting or patrolling. Individuals of a pride know one another's roars, hence the roaring helps pride members to regroup. Roaring also lets other lions know that the territory is occupied. Lions roar more often when prey species are abundant, when life is easier for them. Although prey species recognize the sound of a lion, the cat's vocalizations do not help the hunted avoid predation.

Male lions, because they are larger and have deeper chest cavities, have louder roars that carry farther than those of females. Male lions typically let rip a series of twenty to twenty-five roars at a time, while female roars number fifteen or so to a set.

Africa is continually faced with sporadic droughts. Prey species' numbers plummet drastically during these dry years, and resources become thinly distributed. To adapt and survive under these conditions lions become aterritorial, abandoning both the land and their territorial maintenance systems. When the drought ends, and that could take years, lions fall back into their genetic routine of territoriality.

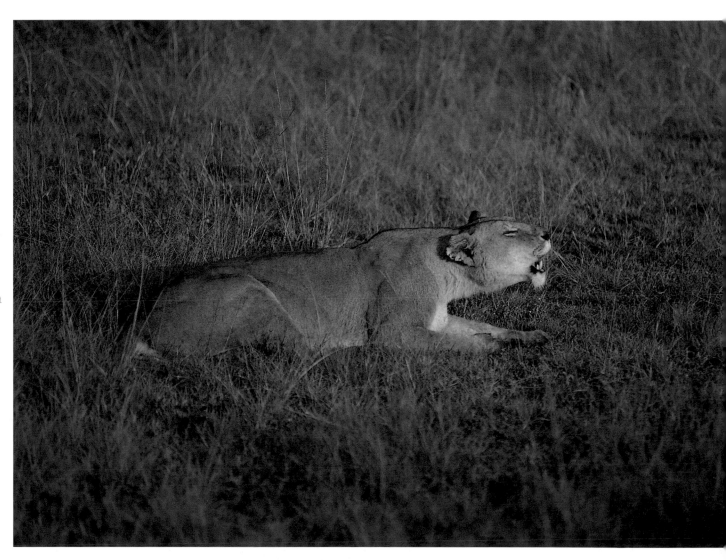

At sunset a lioness roars, proclaiming her territory and letting others in her pride know where she is.

A male lion, only four years old and no longer a nomad but a pride and territory owner, grimaces in the act of flehmen. He is tasting the urine that a female has sprayed on the bush in front of him to check if she is in estrus. If she is, he will track her down and spend a week or more mating with her. The mating lions, often accompanied by a third male, the "attendant," will mate as frequently as every four minutes. It takes as many as fifteen hundred matings to produce a litter.

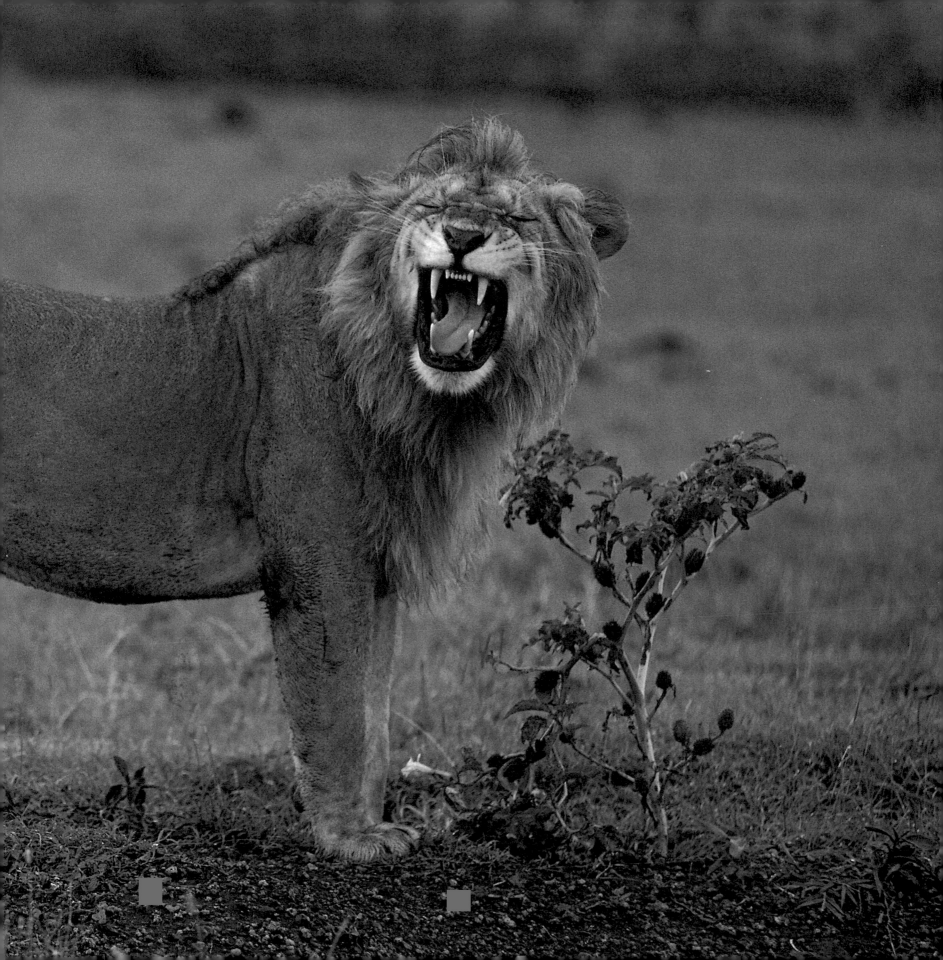

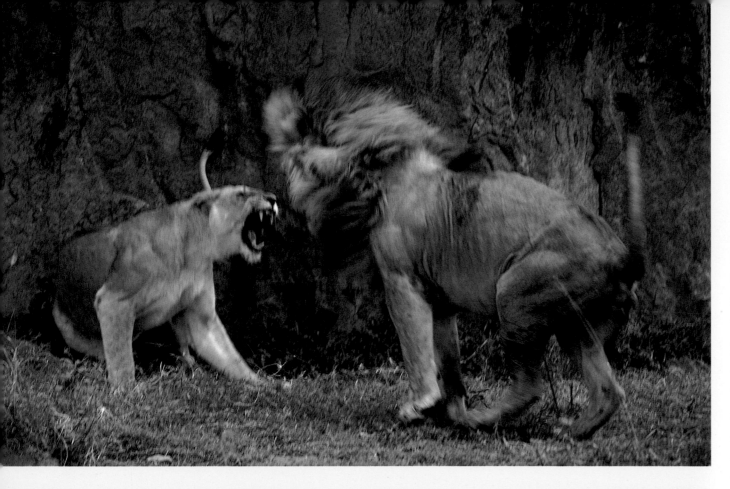

SAFARI TIP

If the mating intervals are far apart, half an hour or more, and the male's face bears no fresh cuts or scratches, the pair is early in the cycle, before her estrus peak. If the mating intervals are only ten or fifteen minutes apart, they are just before her peak. During the peak of her cycle, the matings will occur every four to ten minutes and the male's face will bear numerous fresh and bleeding scratches. Near the end of her cycle the mating intervals will be farther apart again.

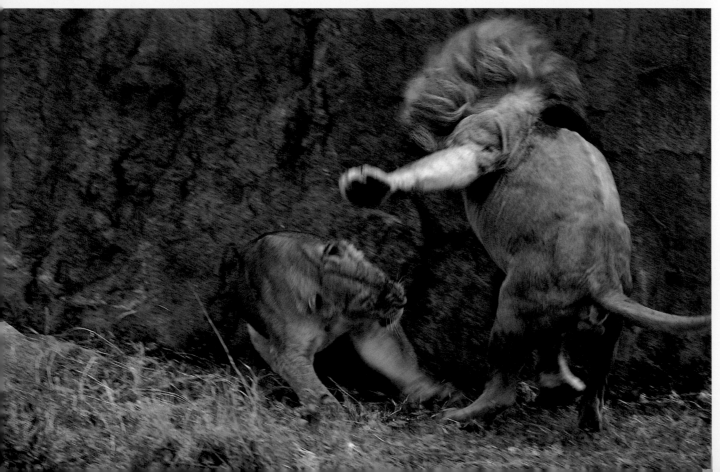

A male lion, having driven an estrus female from her pride, tries to start the mating cycle. It's a bit too early, and the lioness strongly rebuffs his attempts. However, in another day or so the female will initiate the matings.

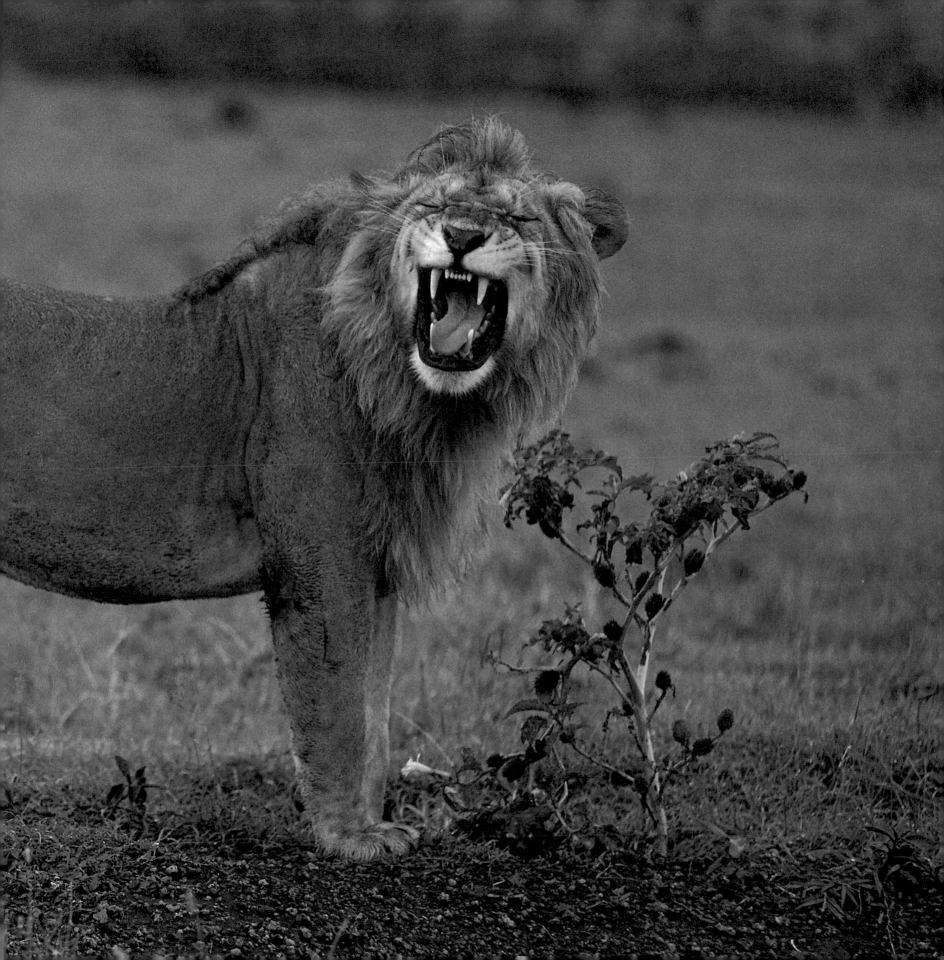

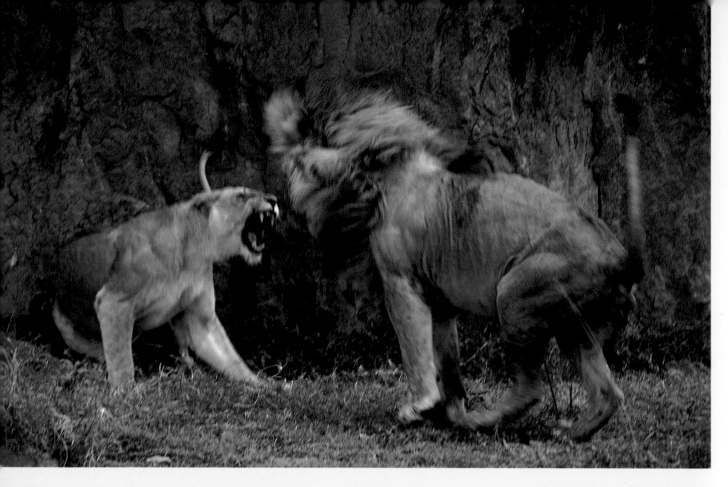

SAFARI TIP

If the mating intervals are far apart, half an hour or more, and the male's face bears no fresh cuts or scratches, the pair is early in the cycle, before her estrus peak. If the mating intervals are only ten or fifteen minutes apart, they are just before her peak. During the peak of her cycle, the matings will occur every four to ten minutes and the male's face will bear numerous fresh and bleeding scratches. Near the end of her cycle the mating intervals will be farther apart again.

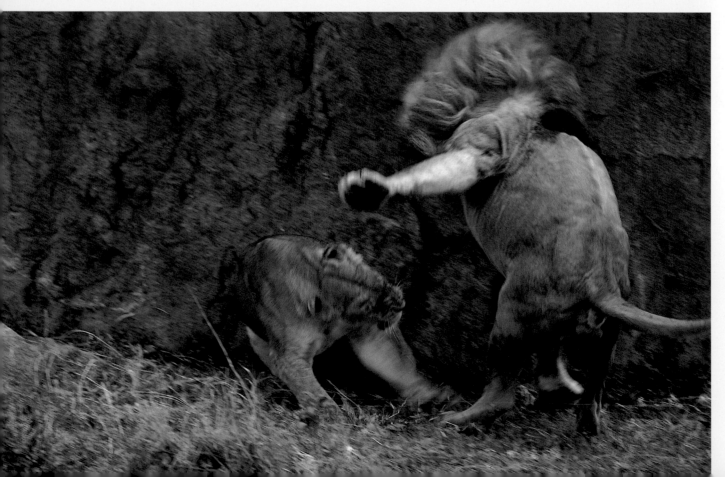

A male lion, having driven an estrus female from her pride, tries to start the mating cycle. It's a bit too early, and the lioness strongly rebuffs his attempts. However, in another day or so the female will initiate the matings.

Mating Single male lions are unable to establish, much less hold, a territory. Solitary males are either nomads or have an age-mate (or two or three) nearby. Territorial males—males that have access to female groups—live in coalitions of two to eight individuals, with two or three being the more typical number.

During the course of a patrol, males will come across urine samples deposited by females and will be able to tell by the scent if she is in estrus, or ready to mate. When she is ready, a female will be in heat for about seven days and will come into heat every six months unless she is lactating. If a female loses her cubs for any reason she will come back into heat almost immediately. If the litter consists of only one cub, the female will abandon or even kill it. Similarly, if a lioness gives birth out of synchronization with the rest of the pride, she will often abandon the cubs or let them starve. The result is that eventually all lionesses within a pride will come into estrus at approximately the same time, any time of the year.

One often sees a male lion sniffing the grass, a log, or a shrub, and then lifting his head up and opening his mouth slightly, grimacing. He is flehming, or mixing air with the urine sample that he has just inhaled, so that he can taste it more accurately and learn about the lion that deposited it. Urine carries with it a great deal of information. The flehming male will know whether the urine is from a male or female, whether it's an intruder or one of his own females, and if one of his own, which one and whether she is in heat.

If a female is in estrus, the males will track her down within the territory and the mating sequence will begin. Once the male lions have found the estrus female, which usually takes less than a day, they will force her away from the pride, isolating her from the other females. She may try and stay with her female companions but the males, by force of numbers and determination, will drive her out of the pride group. Once isolated, the female will make no further attempts to escape, yet every time she stands up, much less walks, the escorting males will be up in a flash and trailing her closely. It's interesting to note that neither males nor the estrus female will eat during the five or six days of courtship and mating. I have, on a number of occasions, seen either the males or female lion make kills during the mating days, but they never actually ate of the kills.

The situation now arises as to which male will gain access to the female. This makes for very interesting watching, and it's surprisingly easy to figure out which

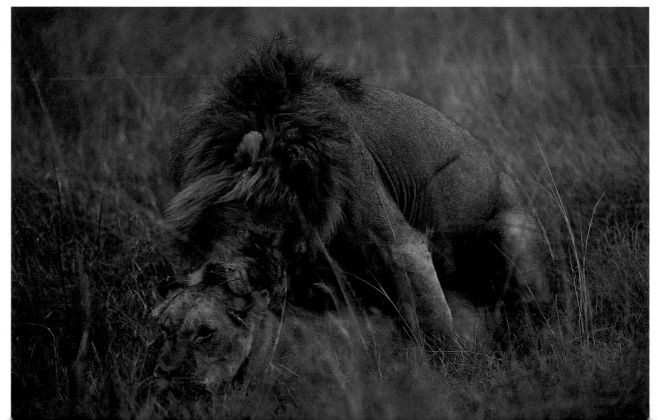

A male lion immobilizes an estrus female during copulation by grasping the back of her neck in his jaws.

is the dominant male and at what stage of the mating cycle the lions are in. Early in a lioness's estrus cycle, she typically resists male advances, often quite fiercely. A little later in the pre-peak period, she will allow a male to mate with her, usually one of the subdominant males. He will, after a day or so, start to succeed in his mating attempts, but as she approaches the peak of her fertility period, around day three, the subdominant(s) is forcibly displaced by the single dominant male. The dominant male will then stay with the lioness for the next four, five, or six days, mating with her more and more frequently as she approaches her peak fertility period.

At this point, a major change in behavior on the part of the female occurs. She will begin to initiate mating by rising and sashaying over to the male, belly crawling back and forth in front of him, even under his chin, and then turning, face away, squatting and "presenting herself" for mating. During the peak of her cycle the pair mates as often as every four minutes, which helps explain why it takes twelve hundred matings, on average, to produce a litter of cubs.

Copulation itself is a brief affair, lasting less than a minute. But it's dramatic. The male usually bites the female's neck and holds her, grimacing, then lets loose a snarl. The instant he is done he jumps back, she roars, spins around and usually takes a swing at him, often deeply scratching his face. It has been suggested that the penis has small hooks on it that hurt the female as he withdraws. But there is evidence to the contrary as well. Either way, she almost always gives him one hell of a shot across the face at the end of the copulation. The female then immediately flops over on her side, rolls onto her back, and stays that way for some minutes before falling

This lioness, after we had shared a campsite with her for almost a week, greatly surprised us one morning by bringing out into the open her two newborn kittens. They were so new, their umbilical chords were still attached. She placed them beside our vehicle, which she had become used to in the days we camped there, and walked off to the river to drink. Thirty minutes later she returned, picked up her wee ones and returned them to the forest. We were not to see them again for more than a month.

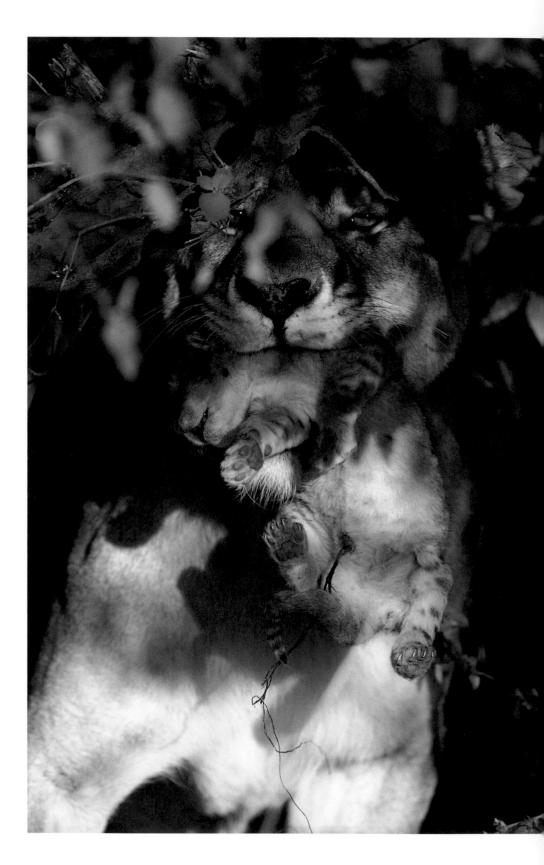

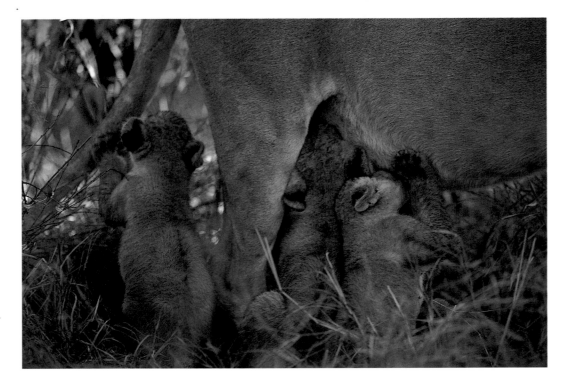

Hungry cubs cannot miss a minute's opportunity to nurse. These cubs, just seven weeks old, are unwilling to let go as their mother rises.

asleep on her side. It's quite possible that this action keeps the semen inside her longer, thus increasing the chance of fertilization.

The male, for his part, waits a minute or two and ends up lying beside the recumbent female. Toward the end of the cycle, like at the beginning, the female will become less friendly and will not allow him near her.

It's probable that more than one female within a pride will be in heat at the same time, so if you've found one mating pair search the area for others. Once the estrus cycle and the mating period are over, the females rejoin the pride and the males get back to the business of patrolling the territory. The females maintain their group social structure during pregnancy, separating, on average, one hundred and twenty days later, just prior to giving birth.

When male lions first take over a pride territory they will seek out and kill any young cubs (under three months of age) that are within their newly acquired territory. The mothers of these cubs will then come back into estrus and the new males will mate with them. Thus the new males will protect and maintain land for their own future offspring rather than those of the weaker males whom they have just displaced.

Because of this behavior, lionesses give birth to their litters, three cubs on average, in isolated seclusion, well away from both the pride males and the other females. They tend to choose thick bush, little caves, rocky areas, or even gullies in which to bear their young—better to risk this isolated existence than have the cubs killed by the males. It is thought, however, that male lions do recognize their own offspring, the proof being that in well-established prides, where males have held tenure for some time, the females are much more relaxed with the male's presence around her tiny offspring, sometimes even to the point of giving birth within the pride instead of isolating themselves.

Lion cubs, however, still suffer from a very high mortality rate, 50 to 70 percent. Surprisingly, the most common cause of cub mortality is that the youngsters are simply left behind, either abandoned or lost by their mothers. The wee ones must keep up pretty much on their own or suffer the consequences. Hyenas and leopards, as well as nomadic lions, also kill cubs, and certainly disease and starvation take a toll, though all these factors combined still account for fewer cub deaths than abandonment.

To figure out which cubs
belong to which female,
watch a nursing group and
observe which mothers
refuse which cubs and when.
Another way to tell is this:
A lioness will only carry her
own cubs.

A five-week-old cub yawns
after an exhausting yet
satisfying session of nursing.

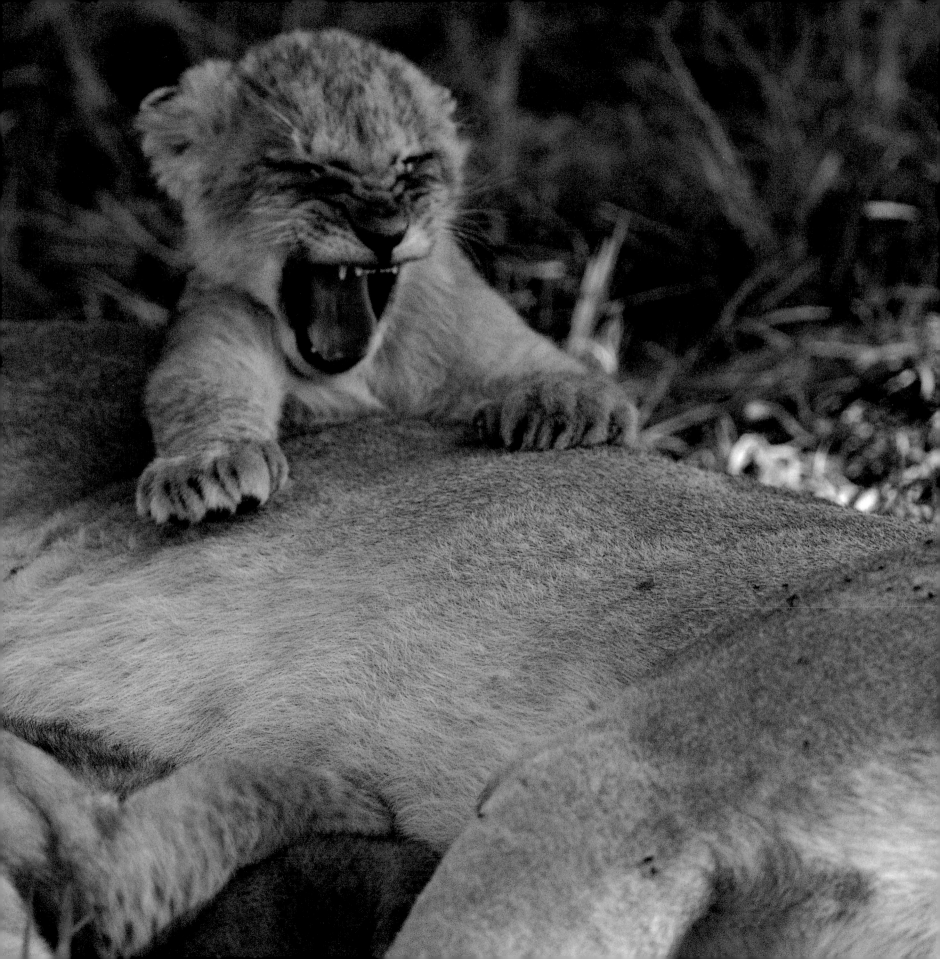

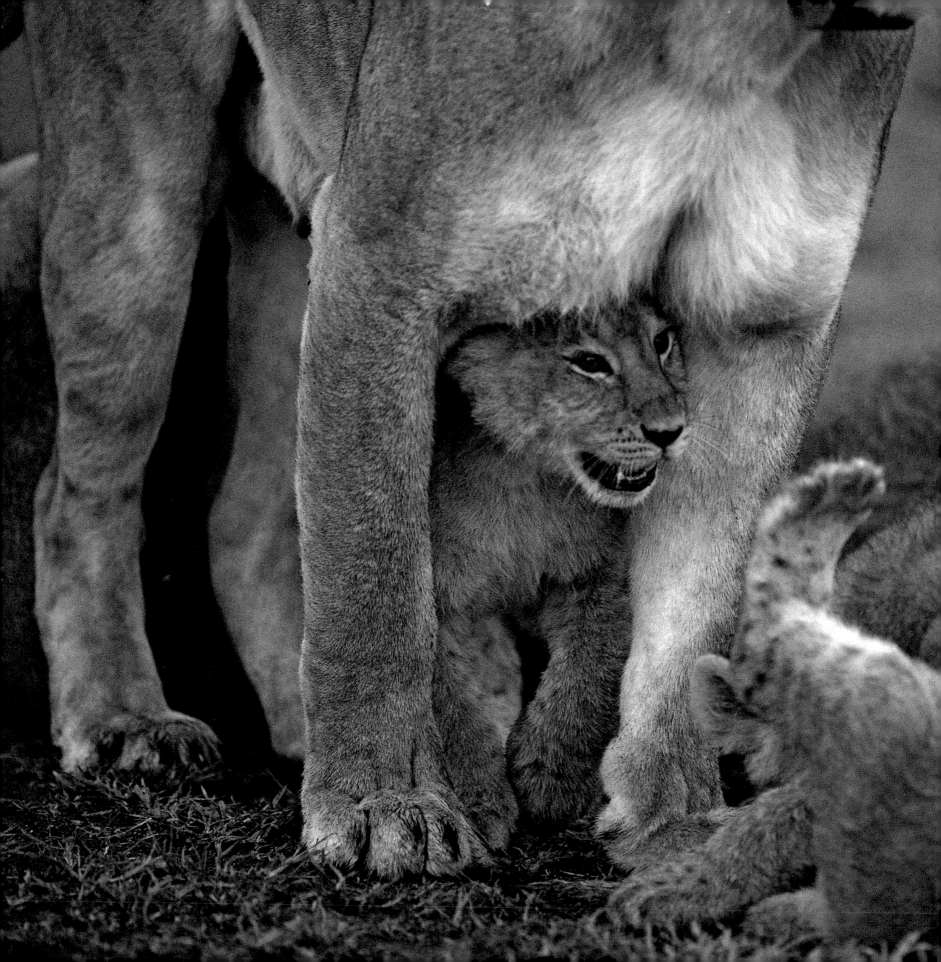

Youth and Growth Lion kittens are born helpless but extremely vocal. Within two to five days their eyes and mouths open. Lionesses are very attentive mothers at this stage, though they are forced to leave the cubs to feed themselves; if the lactating mothers aren't healthy the cubs will suffer. It is during these absences that the cubs are vulnerable to predators (remember, the mother gives birth in isolation). Hyenas and leopards both take a toll on very young lion cubs.

When the cubs reach four to seven weeks of age the mother will reunite with her pride females. Since the other females most likely have given birth, thanks to synchronized estrus cycles, the females will form a crèche of new cubs. The lionesses' behavior patterns now change drastically yet again. The mothers are social once more but are also far less mobile than they were before the cubs arrived.

The lionesses have a single major advantage: they live together in a cooperative group. Collectively they are much more capable of defending their cubs against nomadic males or the new male owners that have taken over their territory, or even against male lions of their own pride. Long-term lion research in the Serengeti has revealed this defense capability to be perhaps the overriding reason that lionesses form prides in the first place.

Thus, the advantages of synchronized birthing and cub crèches are obvious. A lioness or two can babysit while other females are off hunting. The babysitters can then go to the kill and feed, either bringing the cubs with them if they are old enough, or leaving them behind, but for shorter periods of time than if they had had to hunt. The cooperative behavior among the lionesses of a pride is always directed toward the protection of the gene pool and the acquisition of food.

The shiest cub in the litter hides in the safety of his mother's legs just prior to attacking his sibling, momentarily distracted as he cleans himself.

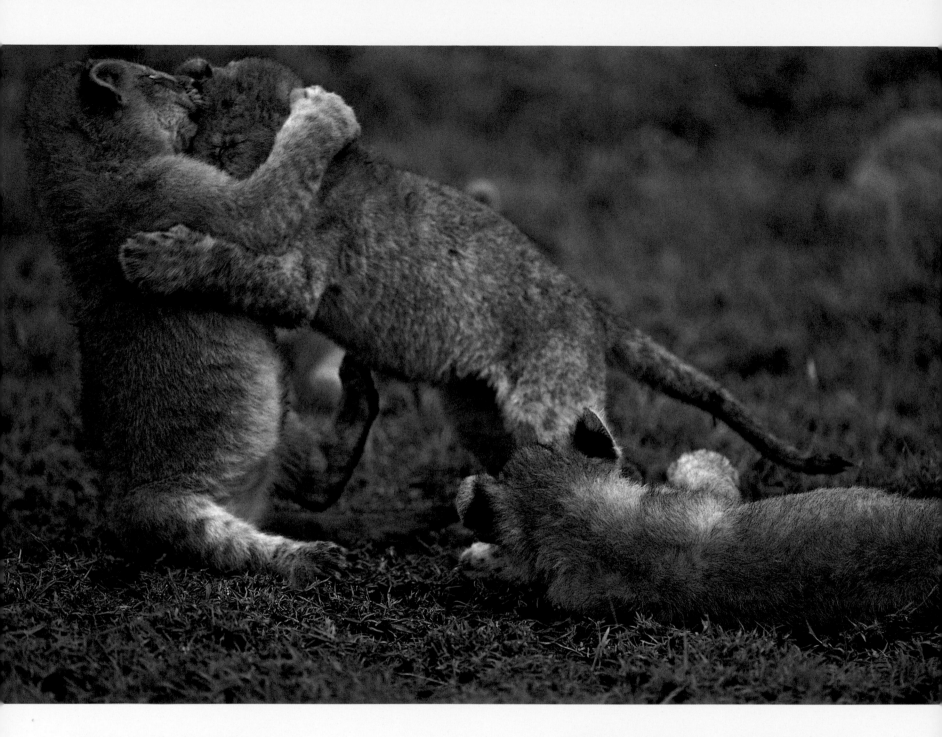

ABOVE Play is a form of learning for cubs.

OPPOSITE, TOP A cub pauses in its tussling with siblings to swat its mother right between the eyes. She endures the blow and then allows the cub to climb on top of her. Lions are far more tolerant of the playful activities of their offspring than the other big cats.

OPPOSITE, CENTER AND BOTTOM Two cubs squabble around their mother. One cub, in all the excitement, accidentally bit the lioness and got more response than he bargained for (bottom).

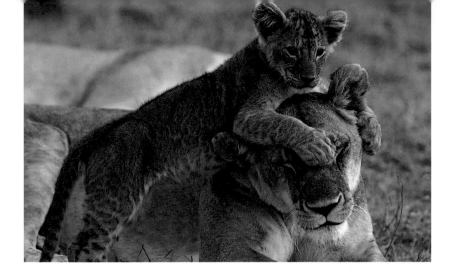

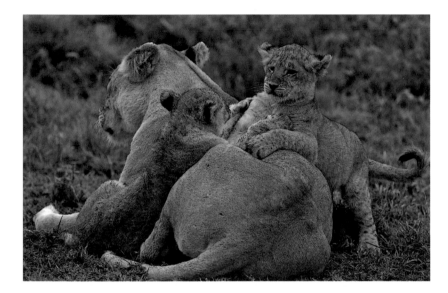

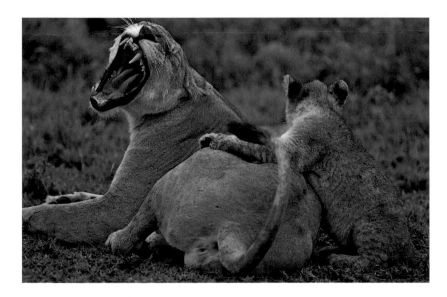

Lions communally nurse their young. Any lactating female will let any cub nurse, though when the mothers are awake they often repel cubs that are not their own. The lactating females, however, spend a great deal of time sleeping (some twenty hours a day) so some smarter cubs may wait until a lioness is asleep to sneak in and nurse unnoticed.

Play It's great being a lion cub most of the time. You are totally protected by your mothers, aunts, and grannies. You can sleep, eat, and play all day long; and play they do. From the moment they can crawl, at about three weeks, they are continually chewing, clumsily slapping, and tussling away with one another. This play is a disguise for serious development, however. It is at this early age that dominance begins to show, dominance that can mean the difference between life and death. It may look like a cub is gently chewing on another's neck, or that he is playfully pushing and pawing at his sibling, but he may actually be fighting for more nursing time, more of his mother's preening, cleaning, and attention, or gradually bulldozing his way into a position that offers better cover or security.

Play is a means toward greater physical development in cubs. As the kittens squabble, cuff, push, crawl, and chew one another, they are starting to develop the skills and physical abilities that they will need to survive as predators. As cute as this play is, all these actions have direct survival implications. As the cubs grow and become more mobile their play gets rougher and begins to involve their mothers more frequently. Adult lions, unlike cheetahs, never seem to lose their zest for play, either with the cubs or each other. By the time the cubs are three months old they are incredibly active (when they aren't sleeping) and will spend countless hours charging at each other, tussling with a mother's tail, or attacking anything that moves, be it branch, bird, or insect.

At three months, the cubs are also, en masse, beginning to follow their mothers out on hunting expeditions. The cubs tire quickly, which limits both the distance and the speed with which the mothers can move. But it does save the adults the work of fetching the cubs, and it drastically lowers the risk of the cubs being killed in their mother's absence. At this age they are also eating meat,

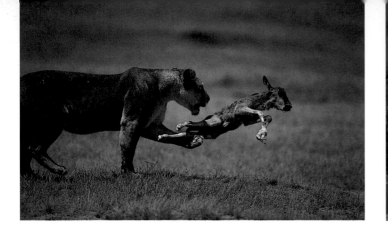

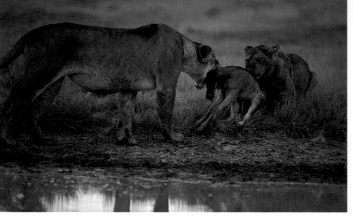

ABOVE Killing skills in almost all predators have to be taught to the young by experienced adults. With the casual sweep of her huge paw, a lioness sends a young wildebeest flying. She then picks up the still-alive wildebeest and carries it back to her half-grown cub. The cub plays with the wildebeest, not harming it at all. It is only when the lioness attempts to take her catch back that the cub manages to kill it.

and it is at the kills where the big struggle for dominance takes place. Mother lions, who do virtually all the hunting for the pride, do not give the cubs, even their own cubs, VIP treatment at a kill. At a kill, might makes right and every lion is out for him- or herself.

The pride males, by virtue of their size advantage (they can weigh 450 pounds to an adult female's 250 pounds), are given precedence at any kill, taking whatever they want, even appropriating an entire carcass. Somewhat surprisingly, however, male lions can be incredibly tolerant of the cubs at the kills, more so than the cubs' own mothers. But there is genetic impetus driving this behavior. If a mother allows her cubs to feed to the point that she herself suffers from lack of food she could sicken or even die. If she dies, the cubs would die as well. But if the cubs die from lack of meat, so be it, the female would go back into estrus, have another litter, and her genes will carry on.

A male lion has a different vested interest in his offspring. He has fought to take over a territory, perhaps killing cubs in the process, and has risked life and limb defending his acquired space. He has successfully mated, and months later his progeny has arrived. If those cubs die he may not be around for the next generation, since his position is always fairly tenuous and vulnerable to attack, so his best chance of genetic survivability is for those cubs to survive, even if it means that he himself will suffer. Thus, male and female lions exhibit totally different behavior patterns to reach the same genetic ends.

As with all predators, some behavior is genetic, some must be taught or learned. Young lions are no exception, and one could spend hours watching cubs at play while trying to figure out which actions are innate and which are not. Lion cubs as young as a month old know how to put a throat hold on another animal, though at this age that other animal is invariably another lion cub. By two months of age they are awkwardly stalking leaves, sticks, elephant dung, a mother's flicking tail, each other. The urge to hunt and chase is born in the youngster, but there is obviously not much to be gained from attacking a large pile of elephant dung. So we can deduce that they learn what to attack from their mother. It is also at this age that lion cubs are acutely aware of birds, vultures in particular, and for good reason. Lions locate a considerable number of kills by following descending vultures. This awareness of birds certainly seems genetically hardwired as the cubs have yet to have had any experiences with vultures at this stage of their lives.

Lion cubs are not weaned until they are nearly seven months old, but they eat meat and drink blood from the age of three months. They can learn what parts of a kill to eat in two ways: by trial and error and by feeding near an experienced adult and sharing what the mature lion is eating. This second approach is the method that is used most consistently by young cheetahs. The first

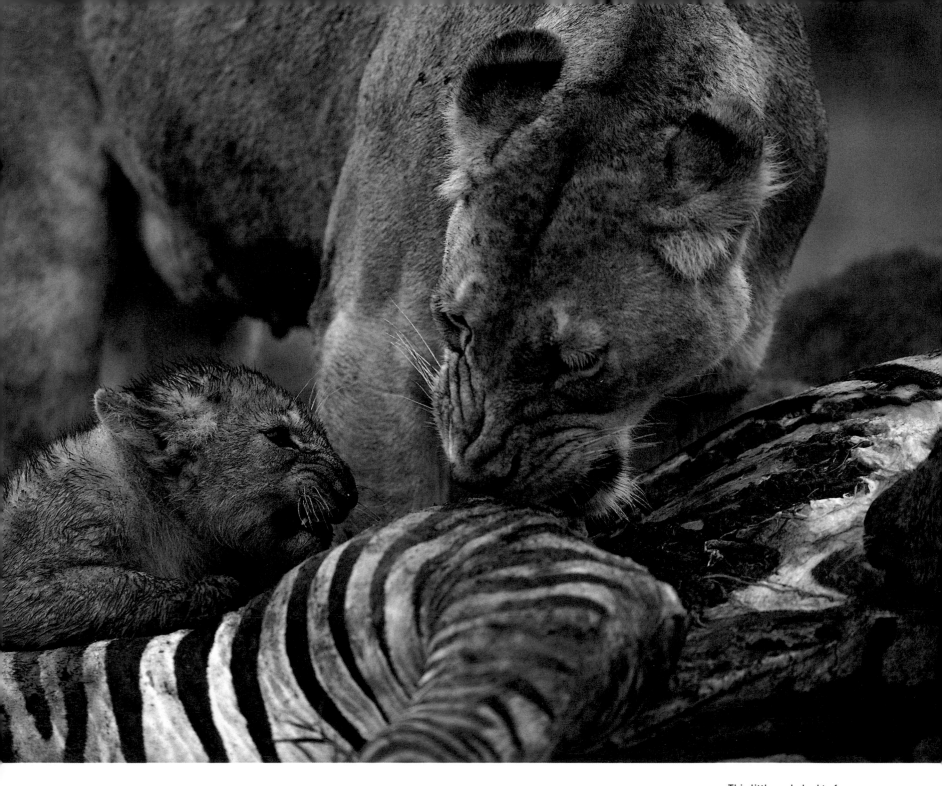

This little male had to face
down his own mother before
settling down to feed.

method will involve less fighting and conflict, but it also means the cub could be wasting time feeding on less than optimal parts of a kill. I've more than once watched a lion youngster make the mistake of trying to eat the stomach of a ruminant, only to have the sac literally explode in its face, spraying it with foul bile and gastric juices. It's a tough but effective way to learn what not to eat.

The second approach to nutritional learning, feeding near an adult, allows a cub to get the most food value in the shortest amount of time, but the cub will have to defend its position on the kill and will undoubtedly take a beating from any large lion that wants that feeding spot. It's during these interlion struggles at a kill that a lion's ears get torn and punctured, leaving the ear clocks we find so helpful in identifying lions.

Once the kill has been consumed the order of dominance and learning continues to play a role. Cleaning up after a bloody feeding isn't done for looks but to stay healthier and live longer. A bloody face and eyes, meat-crusted paws, and dirty cuts and scratches all pose a serious threat to a lion's health and longevity. Cubs, like young human boys, don't seem to understand the correlation between health and cleanliness so the lionesses must step in and clean their offspring. A dominant cub will be able to spend time close to its mother whenever it wishes—it has earned that right—and early in life received more milk than the less dominant cubs. Now that same cub will get more licking and bathing from its mother and thus be consistently cleaner and healthier. Cubs at three months old receive routine bathings from their mothers after feeding, but at this age they start to return the favor and clean the necks and faces of the adults as well. The mothers accept this and even seem to enjoy it.

At seven months of age lion cubs are fully weaned and extremely mobile. By now they have the strength and long legs to follow the adults on hunting forays, yet they desperately lack the patience required for hunting and

are nothing but a general nuisance at this age. Earlier in their development the cubs could be left behind during a hunt, but now their intense curiosity is coupled with their ability to keep up. Result: the cubs are a royal pain, blowing one hunting attempt after another. They attack all the wrong things, don't use available cover, and will often attack from distances as great as a quarter of a mile or more. Fortunately the mothers eventually manage to kill, so, in the end, the cubs, just by being present, learn what to attack, from what distance, and what cover to use. It's interesting to note that individual cubs, from very early on, start to develop their own unique hunting style, a style that they will employ for the rest of their lives. Just like their mothers, they will discover their own favorite type of cover, their favorite type of meat, and their favorite stalking method.

During the course of following along on the various hunts the young cubs learn the territory they occupy and which prey species can be found in the environment. This

An adolescent male has just finished feeding inside a Cape buffalo and emerges with his fur caked in blood.

When you find a group of lions comprised of only males try to figure out if they are nomads or residents. Study their faces for scratches and cuts—nomadic males have had no mating opportunities and generally have much cleaner faces.

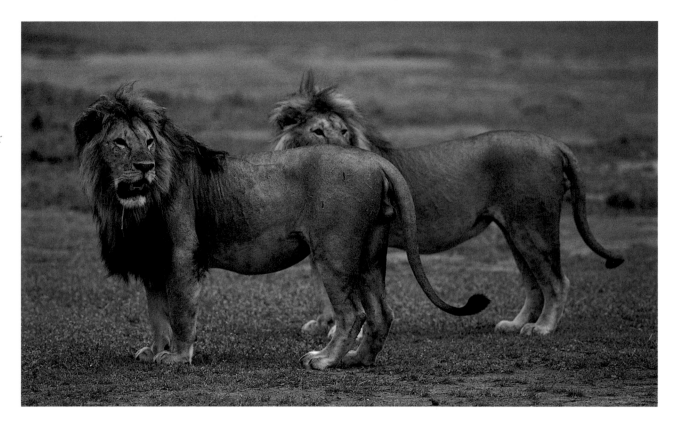

Two nomadic males, shy in spite of their size, pause before walking slowly off across the plains.

is vital to the survival of the pride. The male cubs will eventually leave their natal territory, but the female cubs will stay, becoming the core of the pride and learning the land, a vital necessity for their existence and the survival of the next generation.

What a lion can kill, as well as the mechanics of making the kill, has to be either taught or learned through trial and error. It is *not* genetic. I've watched four-month-old lion cubs put a death grip on a dead wildebeest's horns or back leg; you can watch them try to kill a dead zebra by engaging in a ferocious fight with the equine's tail. All of these incorrect actions would have fatal consequences were the prey actually still alive. Both experience and their mothers teach them.

Cubs can learn simply by watching their mothers kill. Mothers can also teach the small ones to kill by catching the prey and releasing it for the cubs to kill for themselves. There is huge risk in this as a released warthog or wildebeest, even an injured one, could severely wound or kill an inexpert lion cub. More than once, I have seen

lionesses release smaller prey in front of their offspring. Neither the lioness nor her cubs, in two of these incidences, was well fed, yet the lioness refrained from killing the helpless prey herself, so it's difficult not to interpret this action as a mother teaching her young. However, Jonathan Kingdon, one of Africa's leading zooligists, maintains that this is neither learning nor toying with the prey, but either the lions are well fed or they are killing in a low-risk manner. This is possible, but my observations seem to point toward a different conclusion.

At two to two and a half years old, the male cubs, now bigger than their own mothers, are forced out of the pride by the resident males. At this age, the fathers perceive the male offspring as competitors and still have the advantage of size, experience, and territorial imperative. Fortunately, due to synchronized birthing, it's highly doubtful that a male cub will leave a pride alone. A departing adolescent will almost certainly be accompanied by both his agemates and his brothers as he starts out on the riskiest stage of his life—nomadism.

Lionesses, like male lions, may be nomads, but only for brief periods. When a pride becomes too large in number, a female, usually accompanied by her sisters, will leave the pride to seek new country. Nomadic females often are not accepted by a resident male at first. This male roughly treats a lioness at their first encounter, but rarely is any harm done in these meetings.

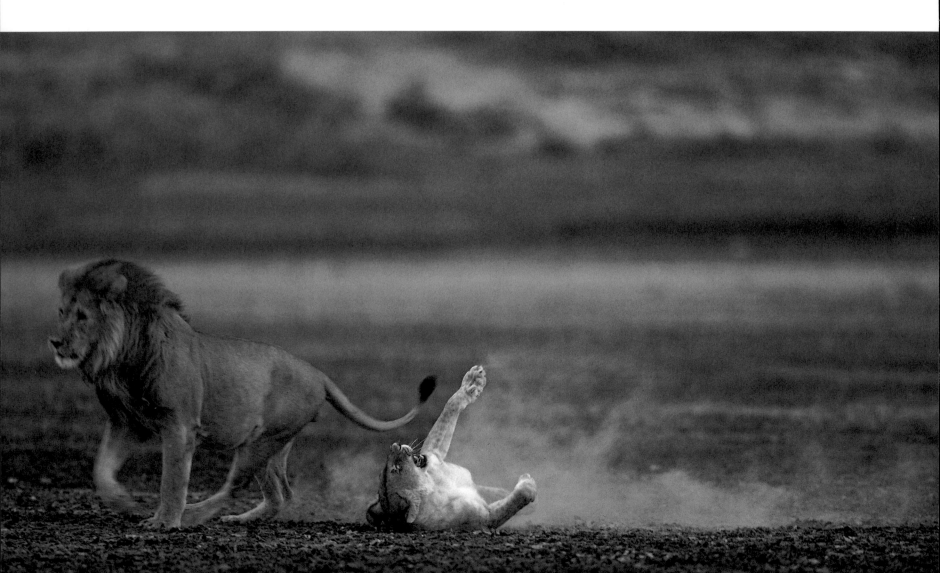

Nomadic Lions Male lions are far better designed for maintaining territories and looking majestic than they are for hunting. Their size and showy manes make it difficult for them to stalk unnoticed and they are generally slower and clumsier than the females. Combine these physical attributes with the fact that the young males just expelled from their pride are now aterritorial and inexperienced, and it's easy to understand why, on average, lionesses live 50 percent longer than male lions. Many males die during their nomadic years, when they are between the ages of two and five years old, but the males that survive this period may go on to live to be eighteen or even twenty.

Nomadic lions are fairly easy to recognize: They are young with large, gangly frames, and small manes. Nomads also behave differently from territorial males: they do not vocalize or scent mark. They stay alive by keeping a low profile, which can be observed by their reactions to the presence of other lions and their roaring. When these homeless males hear other lions roar they are attentive and, depending on how far the calling lions are, often start moving away from the sound, frequently stopping to look anxiously over their shoulders. They will use more cover, move more stealthily, and give up their kills far more easily to hyenas or to approaching lions.

Eventually, by the age of five or six years, the group of nomads (individual nomads often form groups or join existing groups) will be physically strong and socially bonded enough to challenge pride males. There is an order of dominance within the nomadic group, but the members will fight as a group; a collection of young, large, and healthy nomads is a force to be reckoned with.

Sometimes, though infrequently, territorial males will abandon their territories and the pride females when challenged, and become nomads again. These males seldom take another pride and territory, preferring to live out their existences as nomads. More often, however, territorial males will remain in their territory when it is challenged to make a stand and fight. These battles are frighteningly ferocious and often deadly, with the nomads winning more often than not. This is probably due to the fact that the nomads won't challenge pride males until they are physically capable of winning the war.

These fights can last for hours, leaving corpses or badly wounded lions in their wake. The winning males usually allow the losers to escape, but they will pursue them from a distance, pausing often to roar. The victors will then invade their newly acquired territory. More importantly, they will search out and confront the pride females and kill any young cubs they find. Most important of all, the new owners will begin marking and vocalizing within their new territory. Those females that lost cubs during this change of ownership will soon be back in estrus again. Life carries on.

The fear in pride females and their cubs of large males is great and very well-embedded. I was once sitting with five lion cubs, all around four months of age, when a large male lion came strutting over the hill, head erect and mane flowing splendidly in the early morning sunlight. The cubs and their mothers immediately took flight and put more than half a mile between themselves and the boldly approaching male. Only when the male paused and roared repeatedly did recognition start to register in the cubs and lionesses. They stopped running and hid, letting the male come on. At a distance of one hundred yards or so, the group finally recognized him and came bounding out to greet him, jumping all over him exuberantly. Survival may hinge on this instinctual fear reaction.

Female cubs go through minimal social change as they come to sexual and social maturity. They grow up surrounded by their mothers, aunts, and grandmothers and become part of the pride, eventually carrying on the genetic line. But there are times when the number of females within a pride becomes too great. When a critical pride number is reached, which is probably determined by the amount of prey available, some of the adult females may simply splinter off and start a new pride. During the course of their wanderings these nomadic lionesses may encounter either territorial males or nomads, who may intimidate and even box them around a bit, but they rarely suffer serious injury. If they're unfortunate enough to stumble upon females from another pride, they may be run out of the territory and even severely mauled in the process. If the nomadic females are few in number they could, conversely, be accepted into the pride.

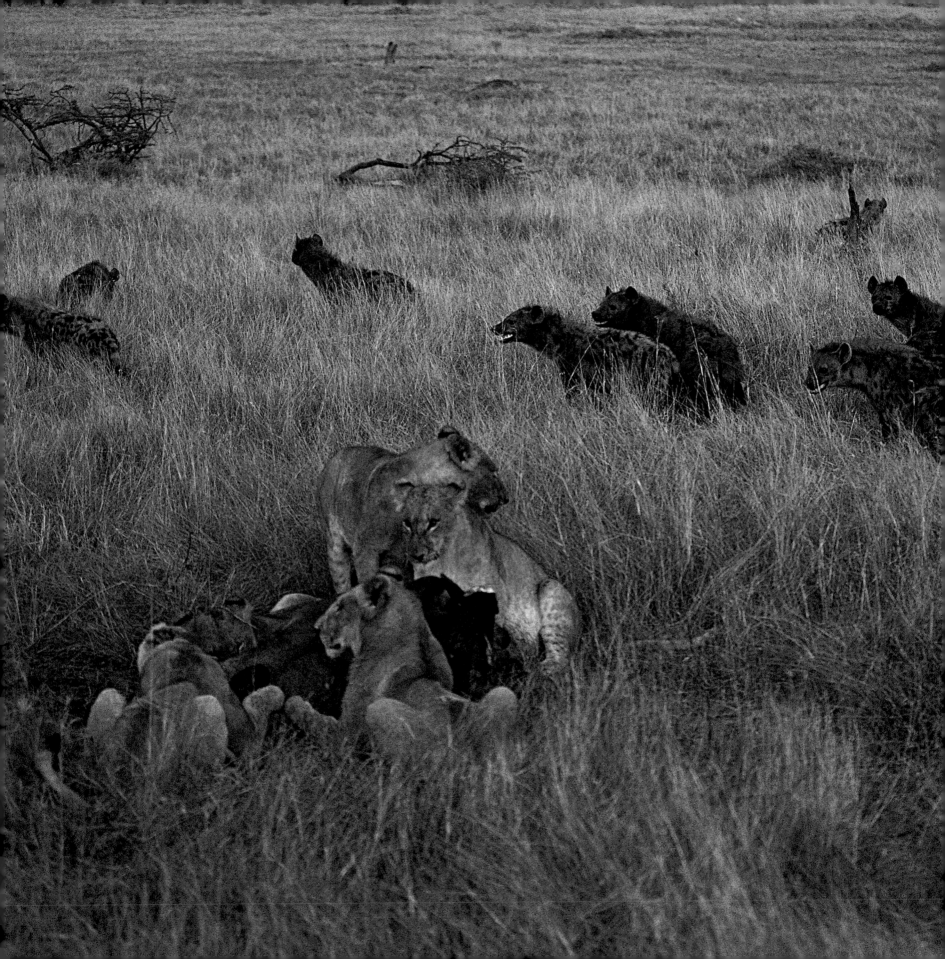

Hunting Lions are powerful predators. They are also intelligent and, therefore, are quite adept at scavenging. Lions will not hesitate to poach kills from hyenas, particularly in places where the hyena density is high, such as in Ngorongoro Crater. In the crater, lions steal 22 percent of all carcasses. In open plains country, lions still steal about 15 percent of their meat from hyena clans. Hyenas are highly vocal and become excited when they feed in a group, making it easy for lions to locate them. But if the hyenas outnumber the lions, they won't approach them. Hyenas also poach lion kills when the numbers are in their favor. Any predator, cheetahs included, will take risk-free meat if the opportunity presents itself.

The prey species that lions take and the methods used in hunting are almost infinite, varying with the habitat, seasons, number, and sex of the lions hunting. But the truism holds: Bigger predators can kill bigger prey. Lions, for example, seldom hunt dik-diks—it's simply not worth the effort. Hunting is always a balance of risk and reward.

Lions employ different hunting methods, depending on the prey. There are a few commonalities, however. Lions must be within approximately fifty yards of their chosen prey before they launch an attack. Lions also have a much better chance of succeeding at capturing their prey if the attack is carried out by two or more lions. That is not to say that lions hunt in coordinated groups, with decoys or herders. That lions hunt with a coordinated and premeditated plan is yet another pop-science myth. Neither does the same lion or lioness lead or initiate a majority of the hunts. Lions hunt with total disregard for wind direction, also contrary to popular myth.

Hyenas and lions are arch enemies, competing for the same prey, in the same environment, and often hunting at the same time. These hyenas managed to drive the lions off and steal their kill.

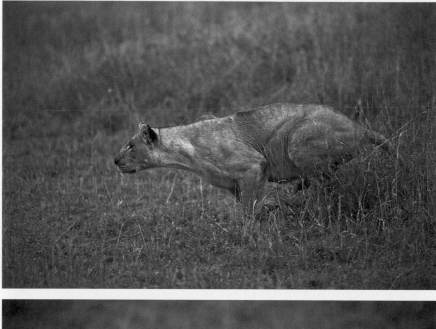

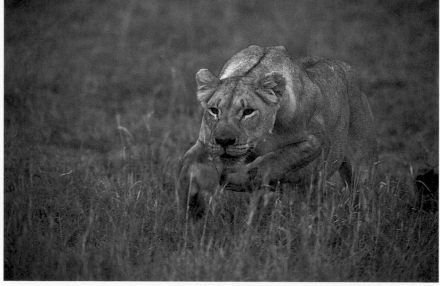

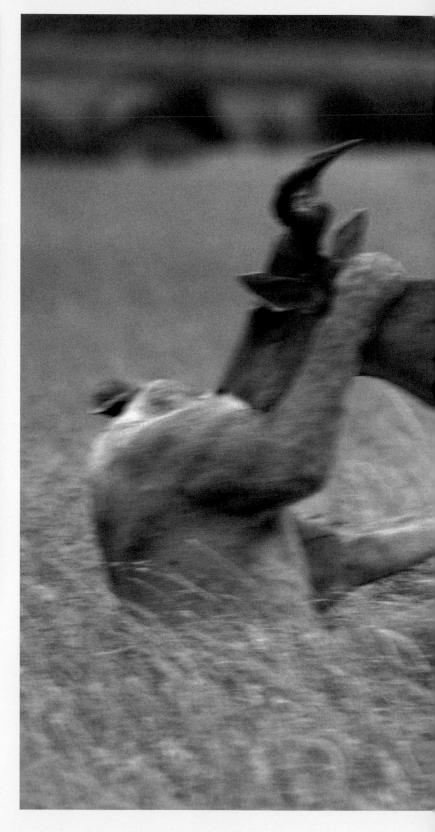

ABOVE Muscles tensed but already uncoiling, a lioness that is close enough to her prey is poised to unleash her frightening strength and power (top). Moments later, frozen midair for a mere fraction of a second, she explodes out for the attack, every nerve and fiber in her body focused on the kill (bottom).

RIGHT Two lionesses pull down a running hartebeest—one lion slows the prey by biting its haunches while the other bites it across the mouth to suffocate it.

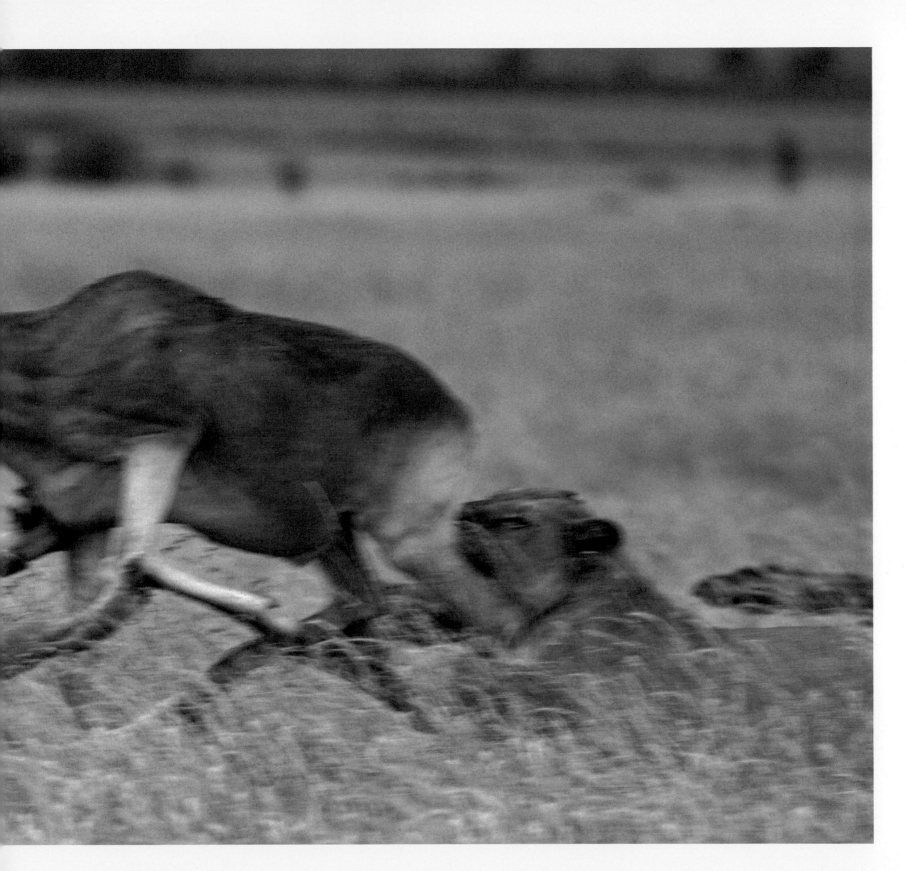

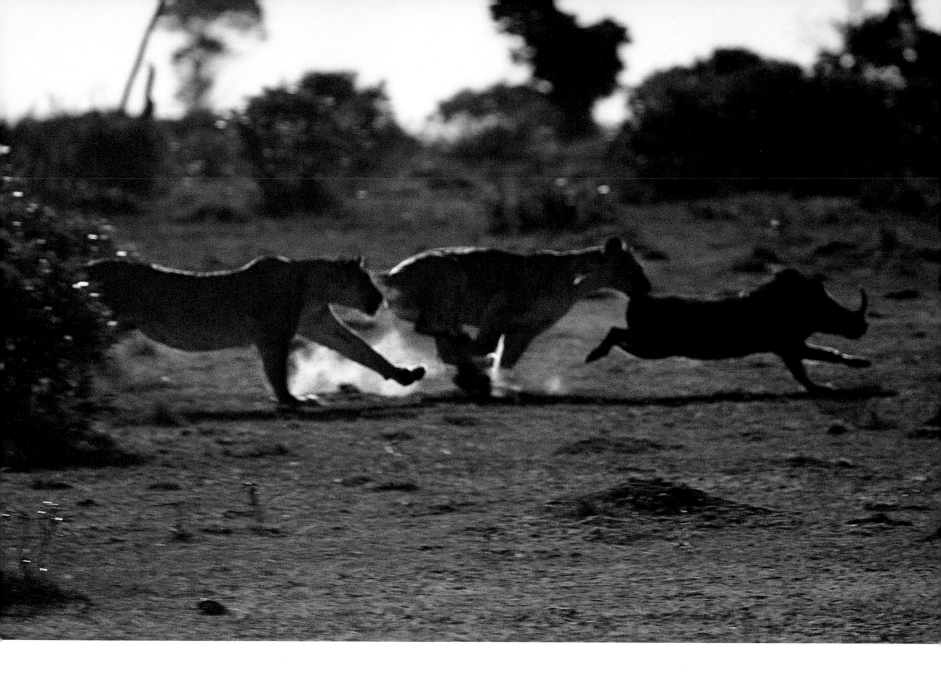

All that said, lions are not nearly as good at hunting as one might expect of the King of Beasts. Single lions succccd at 10 percent of their hunting attempts, while groups of lions enjoy success ratios of 15 to 30 percent (varying with habitat). Each lioness, over the years, has developed her own style and method of hunting, her own preferred cover choice, location, and stalking method. However, lionesses will often end up hunting the same herd, maybe even the same individual target, the result being that while running away from one lion the prey may accidentally stumble upon the other. The proof that lionesses do not coordinate their attacks lies in the fact that any one female, regardless of whether she is hunting alone or with her pride, hunts in her own unique way.

On smaller prey, such as warthogs or Thomson's gazelles, the hunt is usually carried out by only one lioness, even if other lionesses accompany her. It is only when the prey target is larger, such as a wildebeest, zebra, or buffalo, that the other lionesses join in the attack—when one lion makes a hit on the prey the other felines can

When you find lions on the move at dawn stay with them. Keep well ahead of the moving pride, and well to one side. Try to locate their prey even before the lions see it and then position yourself beyond the prey species or herd. You might see a daytime lion kill if you're extremely patient.

In rare daytime attacks, these lionesses, in separate incidents, successfully kill adult warthogs. Lions generally will give adult warthogs a wide berth, although they will attack them on occasion.

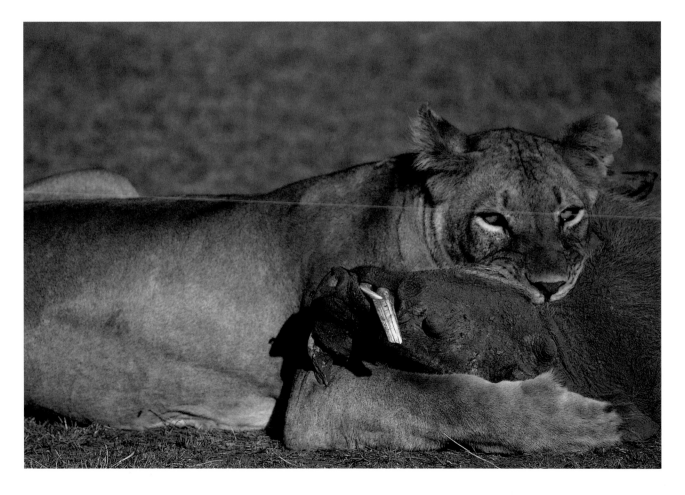

quickly rush in and help subdue the struggling animal. The sooner the predators can kill the prey the less their risk of injury and the less the chance of the prey escaping. Large prey will feed all the lionesses so it is in their best interest to help kill the animal. Smaller prey provides a small amount of food so there's little motivation to expend the energy or take the risk.

Lions and lionesses are supremely adaptable and modify their killing techniques for the environment and the targeted prey. Warthogs are a consistent food source for lions when migrating herds have left the area. The pigs can be chased down, or, more often, dug out of their burrows at night. Lionesses will usually sit at attention and watch one cat do the digging while they wait for the warthog to either make a break for it, or be pulled from its den by the digging female. In open plains country during the rainy season, lions will position themselves in such a way that a driving rainstorm will push an ungulate herd

into the waiting pride. In Kruger National Park in South Africa, lions know how to hunt impalas, fleet runners that live in tight social herds. The lions of East Africa, however, are seldom able to pull down this extremely fast and agile prey.

Though lions generally don't like water, they are able to use it to their advantage when hunting. In the Okavango Delta lionesses swim quite readily, and in the Great Rift Valley, where lakes are seasonally abundant, lionesses will drive their prey into shallow water, which slows them down. The lions won't hesitate to charge in and make a kill in the water; they won't, however, feed in water.

Buffalos, in spite of their size, are not at all beyond a lion's capabilities, and become an important food source when migratory wildebeests are absent. Yet buffalo herds won't hesitate to charge at prides, much less single lions. Older bulls, however, are often in smaller groups, moving in twos or threes, which makes them more vulnerable.

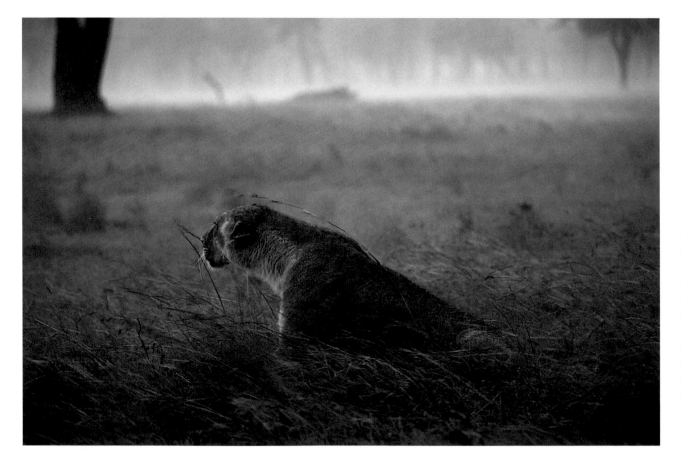

LEFT AND OPPOSITE All predators are opportunists, and, much as they dislike water, lions will wait patiently in a violent rainstorm, knowing it will more than likely push a herd of potential prey in their direction.

OVERLEAF Lions nevertheless consistently chase prey into water, where it will become slower and easier for the lion to overcome. Here, a lioness returns from a lake with her wildebeest kill.

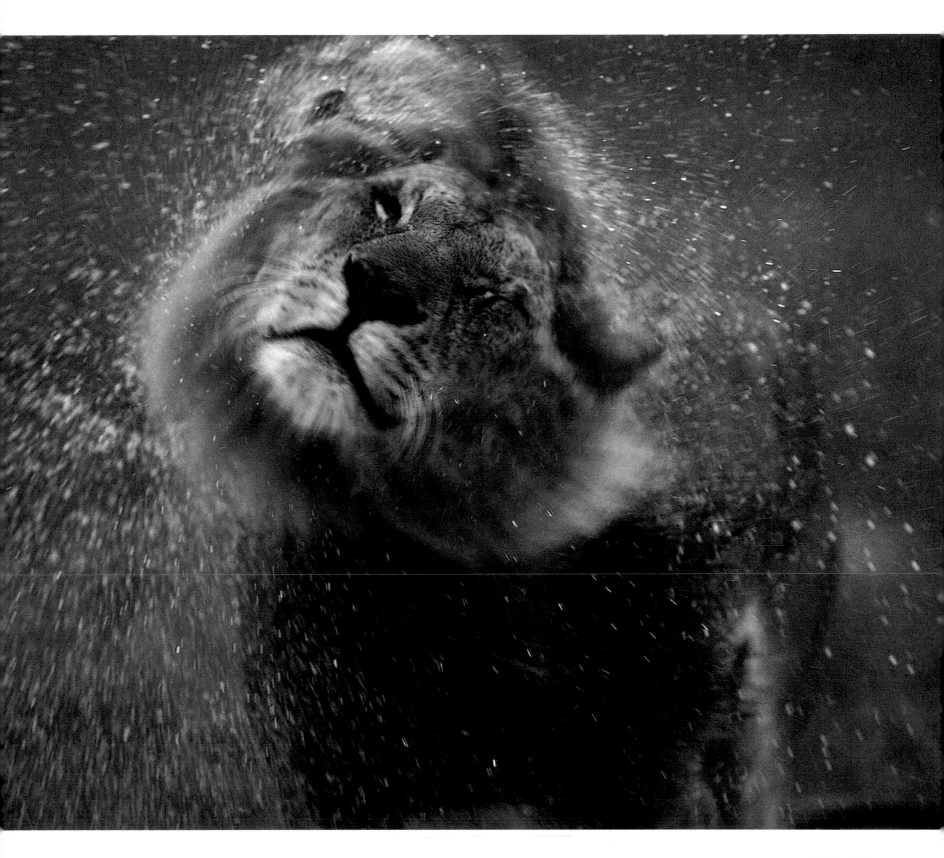

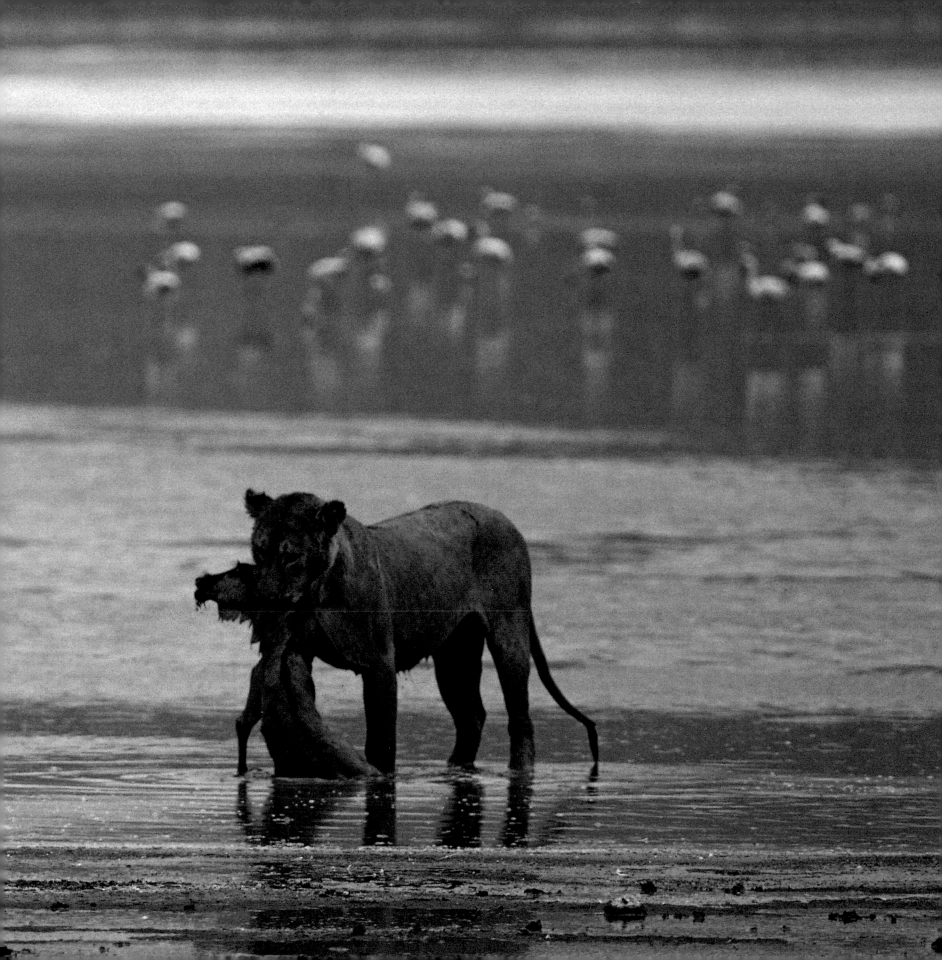

Particularly in mountainous habitats, as on Mount Kenya, Ngorongoro Crater, or the Aberdare Mountains, lions have adapted and buffalo often end up as their primary food source.

With all large prey, the lions must somehow get the prey off its feet, either by tripping it or tackling it, and wrestling it to the ground by brute strength. Once it is down, or stationary, the predator can control it better, eventually obtaining either a strangle hold on the throat, or biting the prey across the mouth, squeezing down, and thus suffocating it. You can imagine the damage a buffalo or wildebeest could inflict on a lion were the cat unable to mobilize. Four times during my thirty years in Africa, I have seen lions feeding on elephants that they themselves killed. In each case the lions managed to separate a young elephant from a herd and get it off its feet. An elephant herd is a tightly knit group with a sophisticated system of communication among its members. But if the lions are able to cause pandemonium and separate the herd, they can succeed.

Adult lions generally need just under eleven pounds of meat a day, but since they are able to consume up to sixty-six pounds of meat at one feeding, they don't have to hunt every night. Lions will remain with a wildebeest kill for an average of eighteen hours, and stay with an impala for five hours on average. Killing every four or five days is fairly typical for lions but that can change depending on the size of the pride, the number of cubs and their ages, and the number of prey animals available.

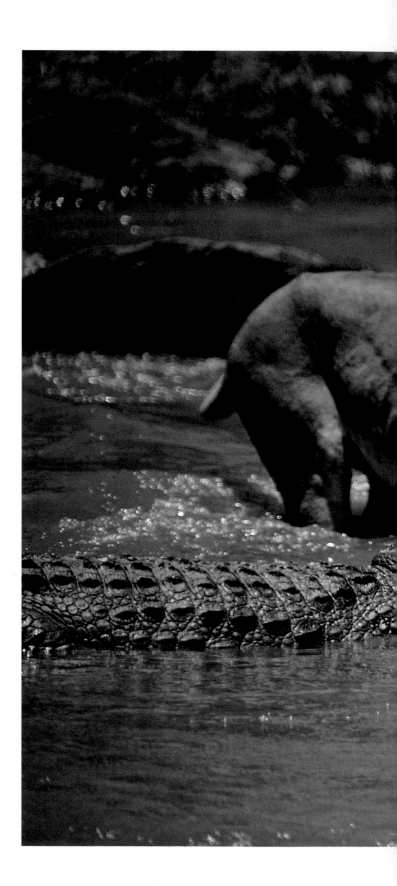

This hippo was trampled to death by thousands of crossing wildebeests, and in spite of his abhorrence of the water, this lion floundered out to the kill. Further problems arose when four crocodiles approached the same kill. The crocs refused to be intimidated by the lion—this was their territory, after all—and after a bout of hissing and growling all round, both lion and crocs settled down to consume the hippo in harmony, a rare sight, indeed.

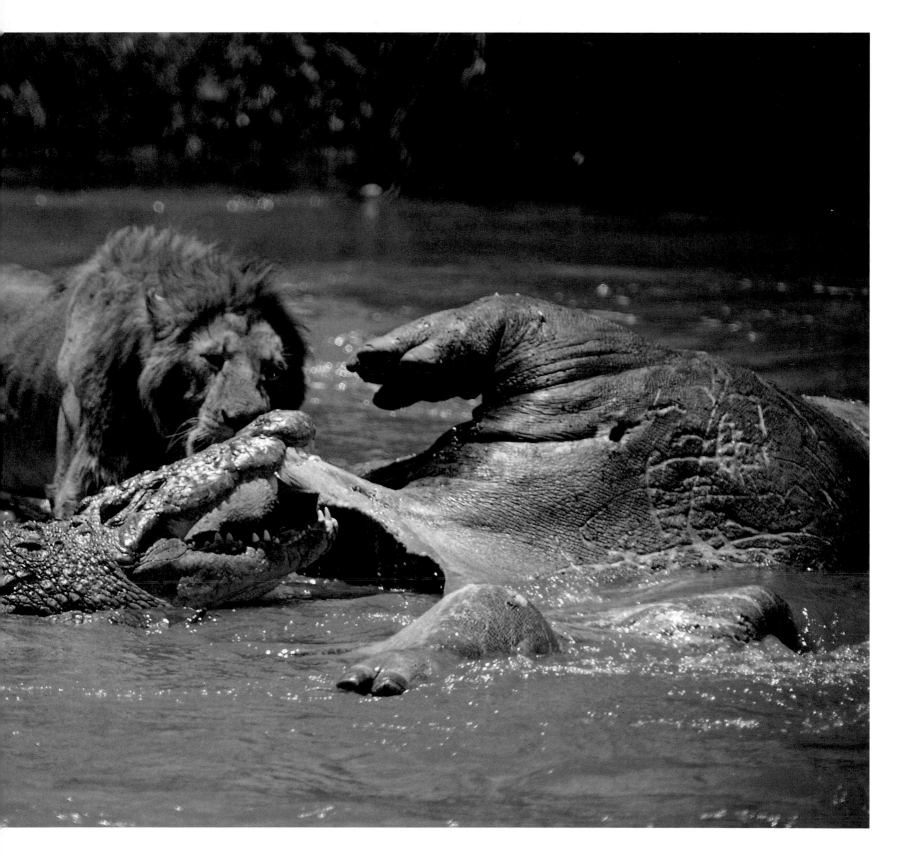

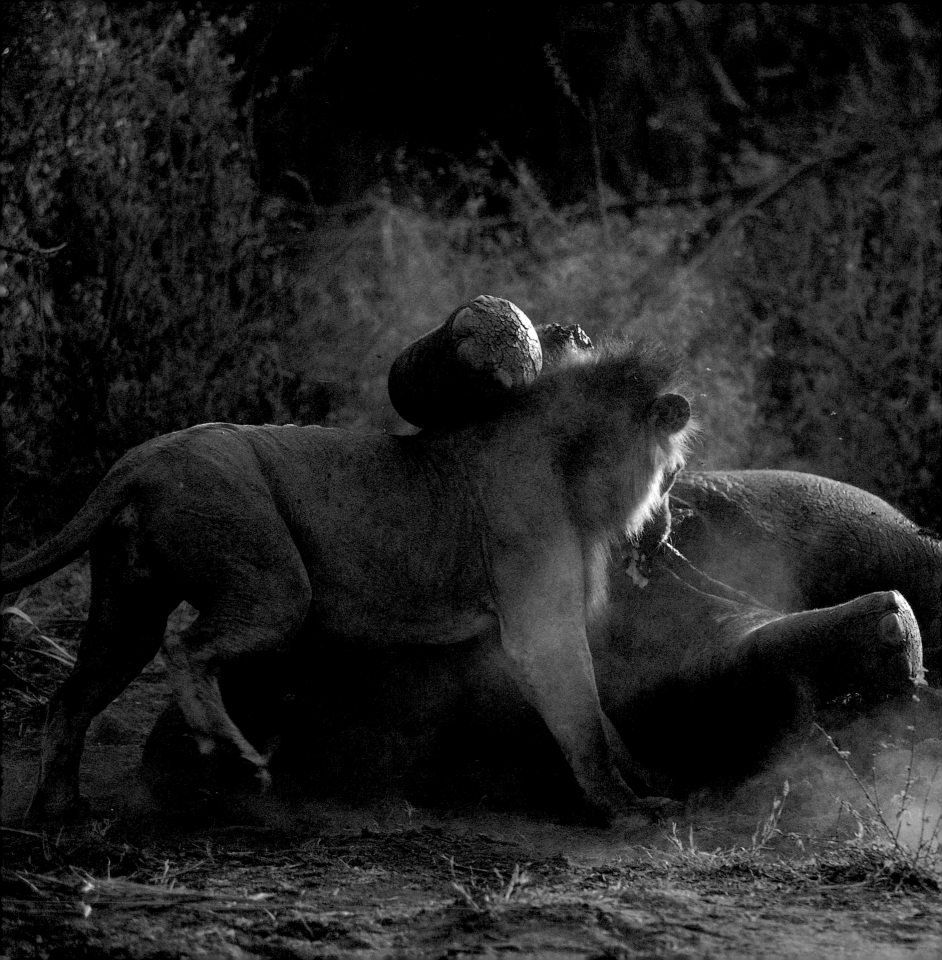

Eighty-eight percent of all lion hunts occur at night, and somewhat surprisingly, moonlight has no affect on the success or failure of these hunts, or even on the number of hunting attempts. All predators are opportunists and lions are no exception. On more than one occasion I've watched feeding lions leave a fresh kill to make a second or even a third kill. Opportunity seldom knocks twice in a row.

Once a pride has a kill they start feeding right away on most occasions, particularly if the pride is large in number. Lions are not under nearly the same pressure from other predators as a cheetah when it comes to consuming a kill, but there is intense competition within a pride. Resident males are often not on the scene when a pride of females makes a kill, and it may take them hours or even days to locate it. But when they move in there is little hesitation. Lionesses and cubs simply must yield or suffer injury. The struggling that occurs is left among the females and cubs. If a female, however, tries to displace a cub, even her own offspring, from a good spot on the kill the cub will resist vigorously and perhaps even manage to maintain his location. Once again, might makes right.

This male killed this elephant entirely on its own, an impressive and extremely rare feat of daring. It will be difficult for him to break into the tough hide, however. In almost all encounters between elephants and lions, lions will walk the other way.

Debunking Lion Myths

MYTH: Lions hunt upwind.

FACT: Lions do not use the wind to hunt. The direction of the hunt is determined by the location of the prey, nothing more.

MYTH: Lions hunt in coordinated group attacks.

FACT: It's easy to misinterpret what takes place during a hunt, and this myth is deeply embedded. But individual lions are consistent in their hunting methodology, whether they are hunting singly or in groups.

MYTH: Lionesses are terrific mothers.

FACT: The single highest cause of cub mortality is abandonment or being lost by their mothers. On several occasions, however, I have been more than impressed by a lioness's willingness to defend her cubs. Male lions, contrary to popular belief, do seem to be quite tolerant fathers, especially if the cubs are their own offspring. Males will kill the cubs that already exist in a pride they have just taken over, but not their own or those of their pride.

MYTH: Lions are great hunters.

FACT: Lions have a hunting success ratio of ten percent singly and 15 to 20 percent as a group.

MYTH: Male lions are lazy.

FACT: Establishing and defending a territory is riskier than hunting. In a pride, there exists a division of labor, a diversity of roles, and males and females contribute relatively equally. All lions, however, do sleep an average of twenty hours per day.

MYTH: Lions are the King of Beasts.

FACT: Watch a buffalo herd charge young lions or single cats. Observe how lions, even large prides and old males, respond when confronted by an elephant herd. They run away. They also have no problem stealing kills from hyenas. This is not, in my opinion, kingly behavior.

How to Observe Lions

1. As always, be patient and take your time when observing predators.

2. Work on noticing detail. For example, are these lions females or maneless males? Are these males nomads or territorial owners? Look at their "attitude"; study their faces for telltale mating scars and scratches.

3. Make identity records of the lions you encounter. Draw out the whisker patterns and ear clocks. Sketch in any prominent body scars or deformities that you notice. You'll almost certainly see the lions you have sketched a second time.

4. Find out which lions are dominant. Just watch them feed, clean up, fight for a "toy," or compete for their mother's attention.

5. Determine which cubs belong to which female. Watch them nurse when the lionesses are fully awake; see which cubs a lioness carries.

6. Watch the behavior, particularly of cubs, and sort out which actions are genetic and which might be taught. A cub "strangling" a piece of wood shows that strangling might be genetic, though what to strangle has yet to be learned.

7. Listen to lions roar and identify the sex of the caller. Fifteen to twenty roars in a sequence indicates that it's probably a female, while twenty to thirty roars would most likely be a male roaring.

8. Study a lion's tracks. Compare them with cheetah, hyena, and leopard tracks.

9. If you come across mating lions, time the intervals between matings, notice if there are any other male lions around, and study the mating male's face for fresh or old claw scratches.

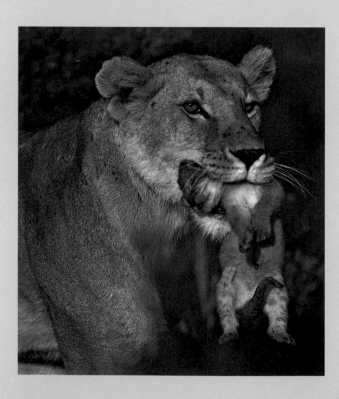

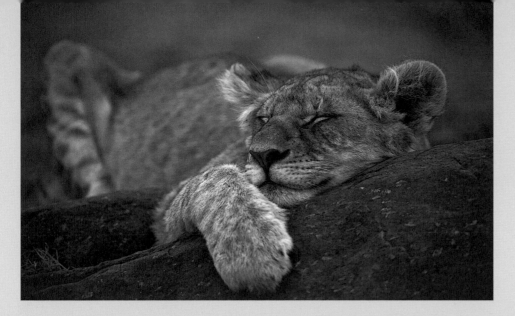

8. The average lion pride consists of twelve lions, in both East Africa and Kruger National Park.

9. Males transfer out of their prides, becoming nomads.

10. Males fight ferociously for territory, even to the death. Biting and severing the backbone is a common fighting technique among lions.

11. If a lioness loses her litter she can produce another within four months.

12. Lionesses give birth in isolation and keep the cubs away from the pride until they are four to eight weeks old.

13. Male lions will kill small cubs, under three months, that are not their own offspring.

14. Birthing intervals for lionesses are two to two and a half years.

15. Lionesses will communally suckle cubs but will carry only their own offspring in their mouths.

16. Cub mortality rate is 50 to 70 percent, the chief cause being that the cubs are abandoned or lost by their mothers. Disease and starvation also take a toll, as does predation by hyenas and leopards.

17. Lions, proportionally, have a smaller braincase than either leopards or cheetahs.

18. Lion populations do not regulate prey species numbers in any environment. The prey species are limited by their food sources.

10. If the opportunity presents itself, watch lions hunt. Stay well ahead, well clear, and to the side of the walking/ stalking lions. These cats have a strike distance of only fifty yards and pursue their prey for only two hundred yards on average. Your chances of seeing a daytime kill are slim, but certainly not impossible. Make the effort— be patient.

11. Sit with a pride of lions as dusk falls and just enjoy them as they wake up, greet one another, and set out on their night's foray.

Facts on File

1. Male lions can weigh up to 450 pounds, while lionesses average 250 pounds.

2. Gestation period for lions averages 125 days, with an average litter size in East Africa of 3.4 cubs, with an average birth weight of two to four pounds; they are born blind.

3. Lions are not dependent on water but do drink after eating if water is near.

4. Lion distribution is determined by prey availability; they need medium to large prey, not water.

5. Lionesses are the nuclei of the pride, not the males.

6. Lions are capable of climbing trees but are clumsy. They climb trees to avoid flies and sometimes even to steal leopard kills if the kill isn't too high up.

7. Lions rest twenty hours a day on average, but switch from sleeping to wide awake in the blink of an eye.

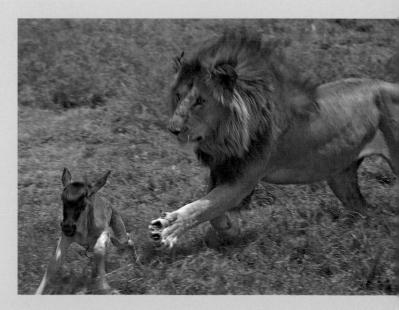

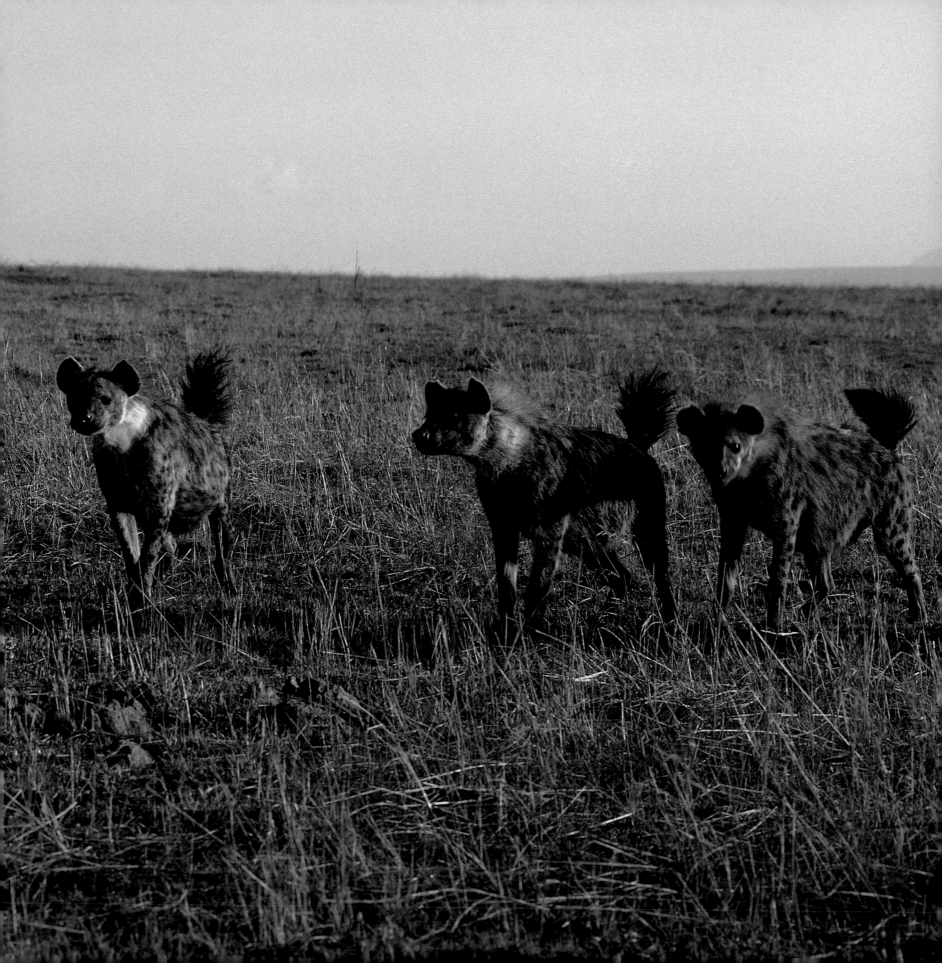

HYENA

A DAY IN THE LIFE

The ragged-eared female, caked with dried mud, her head and neck stained brown from last night's bloody kill, lay on the packed dirt at the base of a termite mound. Two small black eyes peered tentatively out from the darkness of the nearby hole, gazed at the female, and blinked slowly. The hyena pup blinked again, raised his head, and sniffed the air repeatedly, unsure of the smells that were wafting across the den entrance on the early morning breeze.

The cub took a few tentative steps forward and stood in the den entrance, his doglike head in the soft sunlight, low-slung rump still in the darkness. He turned his head toward his lounging mother and continued twitching his nose, chin held high, ears forward. He ventured out into the day and slowly and heavily cantered the ten feet over to his tattered mother, stopping twice to sniff some old bones that lay scattered on the ground.

The female opened her heavy-lidded eyes at the pup's approach and rolled slightly, turning her belly toward the weak but warming sun. The young pup immediately flopped down and began to nurse. The milk, incredibly rich in fat and protein, and the mere action of tugging on a swollen nipple began to calm the little one, but the sounds didn't go unnoticed and another pup's head emerged from the den hole.

This second pup boldly stepped out from the safety of the den. She cantered directly over to her mother, growling as she approached. As soon as the second pup reached the recumbent pair it grabbed the male cub ferociously by one ear and violently yanked him off the nipple, tossing him aside. He yelped, landed on his side almost three feet away, gained his feet, and started right back toward his mother.

Immediately after throwing her brother aside, the female pup flopped down and begun to nurse but as her sibling approached she stopped and savagely turned on him, grabbing him again by the ear, and dragged him off as he screamed in protest. The adult hyena didn't even raise her head as the female pup pulled her brother fully ten feet away.

Both of the male's ears were tattered and bleeding, mere stubs compared to the ears he had been born with. The male cub lacked the size of his sister, even though they had been born together, and there was little he could do to defend himself. Since the pup's birth seven weeks ago the female cub had dominated completely, nursing at will, and terrorizing her brother. The beatings and the lack of milk had taken their toll on him and now he could

As the hyenas move in on a feeding lioness, their elevated level of excitement is evident in their raised, fanned tails and their stiff-legged walk; they are whooping as they press forward en masse.

only sit on his haunches and yowl softly, hoping for attention. Mother and daughter lay together peacefully, the adult hyena's leg casually thrown over her pup. The young one tugged and pulled as she nursed.

The adult female had gotten plenty of sleep the previous night. She had not participated either in the territorial patrol or the hunting, stirring from the communal den only when she heard the distant sound of the excited clan as they giggled and whooped. The sounds told her that the group had made a kill, and she had risen heavily to her feet and trotted off toward the calling clan. It took her more than twenty minutes at a steady lope to arrive at the sight of the kill. Thirty-four hyenas were darting helter-skelter, tails arched up over their backs as they charged excitedly around the carcass. Seven hyenas, mostly females, were already tearing into the wildebeest when she arrived, and she herself bore straight in, ignoring her clan-mates milling around in the tall grass.

The new arrival was snapped at by a few of the feeding females, and she snarled and bit back in response, but no damage was done. The eight hyenas fed as if they hadn't eaten in weeks, tearing out huge chunks of flesh with their sharp molars, crushing bones and cutting hide. It was a frenzy. One male managed to bite completely through the wildebeest's back leg and tear it free. He immediately galloped off with his prize, strong neck muscles holding his bounty high as he fled. Two hyenas gave chase but both gave up after a hundred yards. There was still so much meat on the kill that fighting for a bony leg wasn't worth the time.

The cubs' mother, largest of all the females, stood with one front foot on the carcass as she ate. She was calmer now, methodically working away on the wildebeest's left shoulder. The other hyenas fed beside her but respected her space and didn't crowd her. Gradually, all the hyenas, even the smallest males, established themselves on the kill. The excited giggling faded, the moist night air only occasionally punctuated by a yelp when one hyena snapped at another. The meat disappeared at an incredible rate.

LEFT Hyenas are predominantly nighttime hunters, as are lions. Also, like lions, hyenas often pass the hot daytime hours tucked well into the shade in some secluded spot within their territories.

OPPOSITE Two cub siblings lounge outside the nursery den as their mother keeps watch.

SAFARI TIP
If you find an adult hyena lounging near a den
entrance, come back to the den at dawn or sunset
and watch the cubs nurse and tussle.

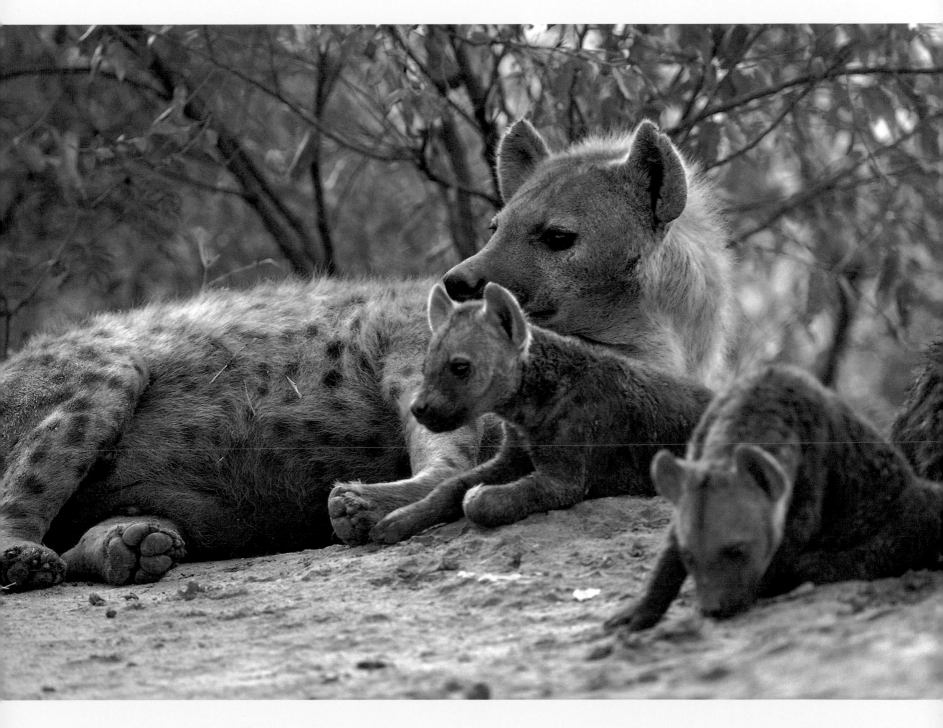

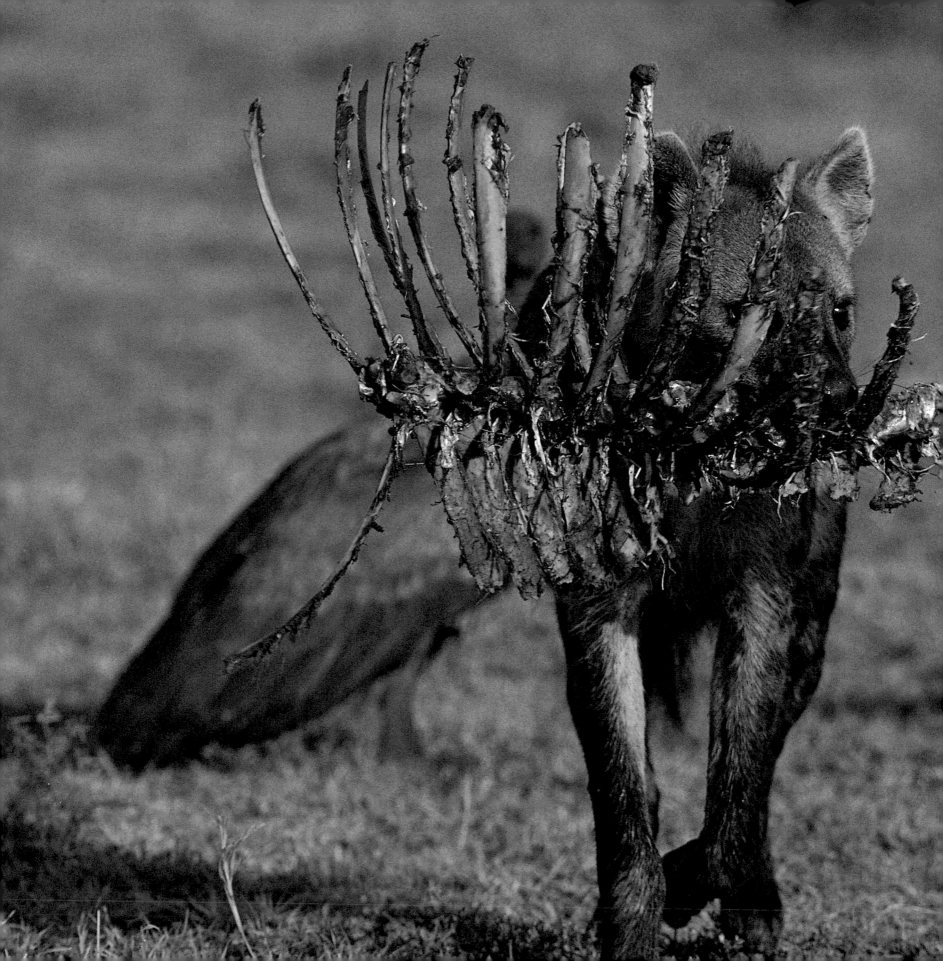

In less than an hour a skeleton with a black head was all that was left of the wildebeest. Half the hyenas had torn away pieces of the kill and had cantered off with their prize to feed in peace. Other hyenas lounged near the kill but had ceased eating, more were still working on the bones.

The mother hyena crushed the lower neck vertebrae, separating the skull and neck from the carcass. She bit the hair-covered skull, lifted it free, and started for the den. Immediately, two hyenas came at her and her booty. She dropped the skull and charged first one and then the other in quick succession, never running far from the skull. The two yelped, tucked their tails up under their bellies, and rapidly retreated. The old female again picked up the skull, turned, and started walking east toward the communal den.

The heavy skull and connected vertebrae posed no problem for the mother as she waded through the thick, long grass. She held the skull high and the neck bones flopped against her shoulder as she walked, the last few vertebrae dragging on the ground as she moved steadily homeward. It took her over an hour of monotonous pacing before she reached the worn ground and converging paths near the den. Finally she dropped the wildebeest neck to the earth.

A month from now the wildebeest herd will have moved on and her commuting out to the distant herds will take her days and days to return to the den again. But by then the cubs will be older and because of her rich milk she will be able to leave them alone for four or five days at a time. Now, however, with the hundreds of thousands of wildebeests and zebras within her clan's territory, the hunting is easy. The clan has been killing

A hyena casually lifts up the entire spine, skull, and rib cage of an adult wildebeest. A high front end, frighteningly powerful jaws, and bulky neck muscles allow hyenas to carry these carcasses for great distances.

nightly, and individuals walking during the day have been able to scavenge something wherever they wandered. For the moment, at least, the hyenas all had full bellies.

The rest of the hyenas gradually made their way back to the communal den, the focal point of the clan's territory and social lives. They picked their way carefully around the mother hyena as she worked on the wildebeest skull. They were all well fed and it wouldn't be worth disturbing her, especially since she was near her pups, which always made her frightfully aggressive. She eventually picked the part clean and bit down on the bony dome just below the horns. Her premolars, powered by massive jaw muscles, easily crushed the wildebeest's braincase, at which point she began slurping up the exposed contents. When that was done she awkwardly turned the skull with her blunt-clawed paws, crushing the bridge of the wildebeest's nose with a single bite. Soon only the horns and the section of skull to which they were attached were left. Shards of bone were scattered around her like bleached and broken pottery from some ancient archaeological dig.

The female rose heavily, walked to the base of the familiar termite mound and plopped down against it. A pair of eyes peered tentatively out of the darkness of the nearby hole, gazed at the female, and blinked slowly.

SAFARI TIP

Look into a hyena's mouth when it yawns and see its toothy weapons.

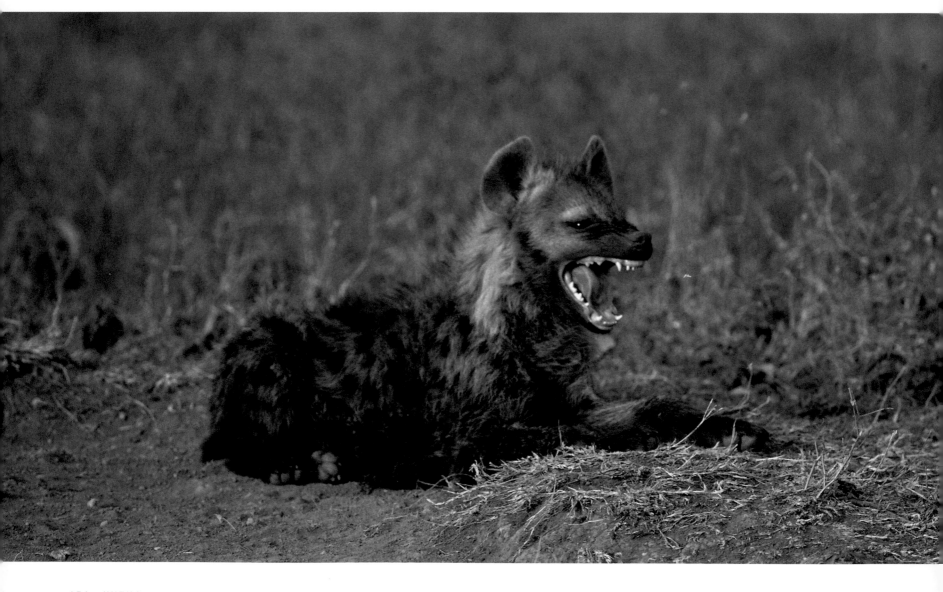

BIOLOGY AND BEHAVIOR

Hyena Anatomy Hyenas have the strongest jaws of any predator on the African continent. They can easily crush flat a giraffe leg bone or a wildebeest skull, something that a lion or leopard could not possibly manage. This requires strong teeth, of course, and massive jaw muscles. A hyena's skull has a tremendously large sagital crest, which is the bony ridge on the top of the skull. No African predator has a larger sagital crest than a hyena. The larger the bony protrusion, the larger the jaw muscles that are attached to it. Furthermore, the jaw muscles are anchored far forward on the jaw, making the jaw slower to open and close, but giving it great leverage and strength. The teeth have evolved for splintering bone and can stand up to the power supplied by the jaw muscles. The premolars are the bone-breaking teeth for hyenas, specifically the second upper premolar and the third lower premolar. Not surprisingly, these teeth are subject to tremendous wear over time and researchers are able to determine a hyena's age by how worn these teeth are.

A hyena's teeth also serve as superb meat cutters. The sharp incisors are set in neat rows between the canine teeth, a great position from which to cut meat from between bones, but it's the molars that can be really devastating. In both the upper and lower jaw these teeth are pointed and sharp: when the jaws crunch together the upper and lower molars slice past one another. This creates a wickedly clean and razor-sharp cutting surface, much like a powerful paper cutter. This cutting face, or carnassial shear, powered by a hyena's heavy jaw muscles, can cut through the toughest meat as if it were butter and remove huge chunks of flesh from a carcass with incredible speed.

Unlike its teeth, the eyes of a hyena are more canine than feline. Their eyes do not possess the reflective layer on the back of the retina, the *tapetum lucidum*, that gives lions and leopards such extraordinary night vision. But hyenas see well enough at night, so well that they do almost all of their hunting under the cover of darkness.

Similarly, a hyena's nose is more doglike than catlike. This nose plays an enormous role in the life of a hyena. Hyenas mark their territories with paste from their anal and interdigital glands and recognize one another's scent

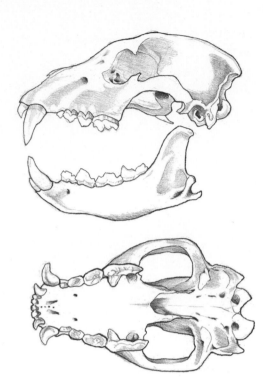

Hyena skull, side and bottom views.

marks. They use their noses when greeting one another as well, reaffirming who is who.

The skeleton of a hyena is marvelously adapted for a number of its peculiar predatory traits and habits. Hyenas are mislabeled as cowards and scavengers and are maligned for slinking around the plains forever looking guilty. That slinking around is a very economical way to cover ground. Any slope-backed mammal, hyenas included, moves with far greater efficiency than a flat-backed mammal. It's a hyena's shoulders and front legs that power the animal. The front legs are long and the shoulders high, so a hyena's back legs are effortlessly pulled forward when the front end of the animal is lifted and moved. This gives a hyena three advantages. First, it gives them the ability to lope for long distances with very little expenditure of energy, allowing them to chase their prey for great distances and wear them out. It also makes it possible for a hyena to commute for days to get

OPPOSITE An adolescent hyena relaxes next to the communal den and yawns, revealing its razor-sharp teeth and a jaw that has more crushing power than a lion's. Hyenas are the ultimate predator in Africa and have more influence on prey numbers in any given environment than all other predators combined.

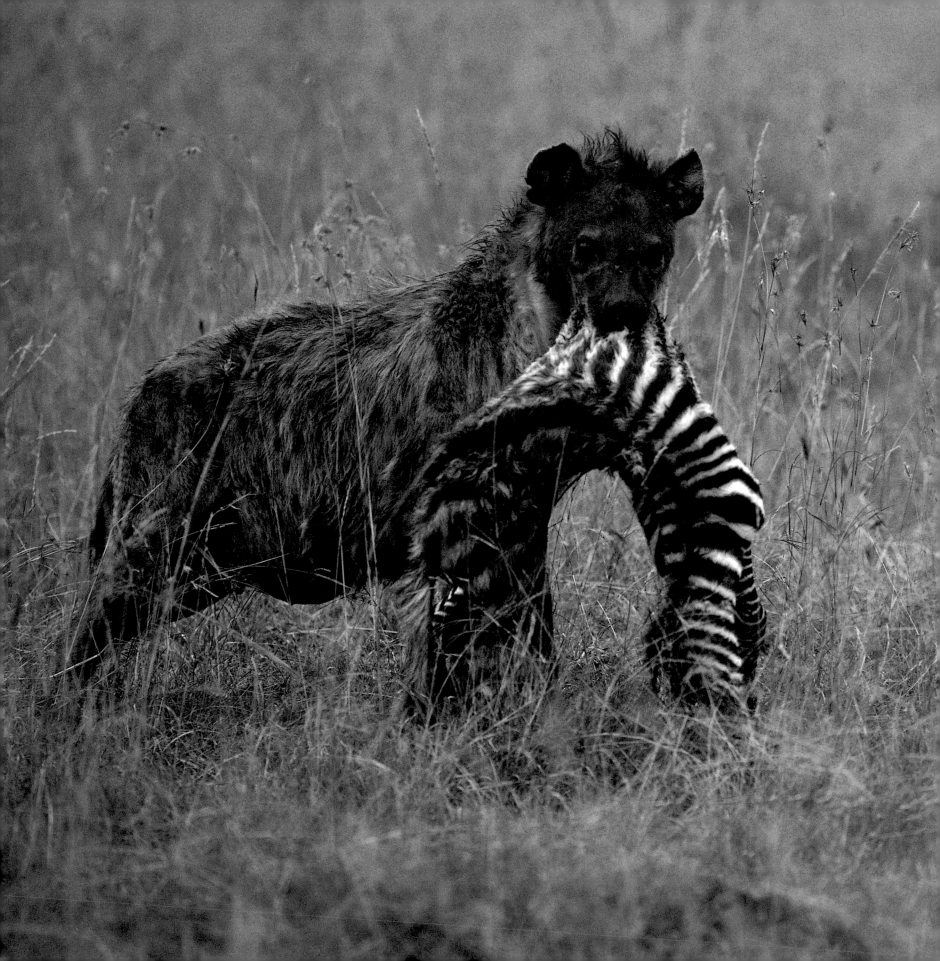

A hyena's track is the easiest of all predators' to learn. Just look for a duck-footed doglike print with claws showing and two lobes across the back of the heel pad.

to migrating herds of wildebeests and zebras. Second, the jaw and neck muscles are incredibly strong, making it easy for a hyena to lift huge weights in its jaws. Third, the hyena's high front end gives it the necessary ground clearance to walk or canter without dragging the meat or skeletal chunks it is carrying.

Since the front half of a hyena is heavier than the back end, the front feet have larger supportive surface areas as well. A hyena's foot is much like a dog's: its claws are blunt and exposed, with two lobes across the back of the pad (as opposed to the three lobes of a cat's). Hyenas, like all slope-backed mammals, walk or canter but never trot. Furthermore, hyenas walk duck-footed, with front and back feet turned outward.

The tail of a hyena is an extremely expressive appendage. Its position, when combined with the hyena's stance, communicates a great deal to other hyenas. Under normal conditions the tail hangs angled down and backward, but when it is positioned straight up with the hairs bristled, it usually signifies that attack is imminent. This

high tail, however, can also be erected during greetings, when one hyena approaches another, so body stance is factored into the equation.

Ear position, too, must be considered. When a hyena flattens its ears against its skull the hyena is ready to flee; ears cocked forward tells you the animal is approaching, probably boldly. When you combine ears flat with tail under the belly, the signal is one of submission, which is often accompanied by retreat or rolling over on the ground.

Two or more hyenas working together communicate using these methods, but their body positions can carry even more significance. When two hyenas parallel walk—striding boldly side by side with their heads and tails held high—it can be downright intimidating. You will see this walk when hyenas approach members of a different clan, and when they approach lions (usually with the aim of stealing a kill). When these carnivores are excited like this it can be difficult, if not impossible, to dissuade them from their plan.

OPPOSITE Hyenas have an elevated front end and a powerful neck for good reason: to lift its kills clear off the ground and to canter away with them. This hyena is carrying her fresh kill back to the den where her cubs are waiting for her. She effortlessly canters across the tall-grass plains for many miles at approximately twelve miles per hour.

RIGHT A hyena track, showing the two-lobed pad and the claws.

Territoriality and Habitat Hyenas, like lions and leopards, are highly territorial. To maintain their territories, hyena groups regularly patrol their borders. During these border patrols the clan doesn't hunt but is single-mindedly concentrated on territorial maintenance. The patrolling hyenas vocalize, lowering their muzzles to the ground when they whoop (thus bouncing the sound off the ground), and leave so-called paste markings from their anal glands along their territory boundary. They also defecate in established latrines and paw at the earth, depositing scent marks from the glands between their toes. Both hunting packs and border patrol groups are composed mostly of males, despite the fact that hyenas live in a matriarchal society.

It's quite possible that a pack on a territorial outing might encounter another clan carrying out a similar patrol. When the two clans meet, they will line up opposite each other, much like a rugby team, and rush toward one another like two howling phalanxes. The two lines of hyenas seesaw back and forth with a great deal of whooping, yowling, growling, and darting about. Very seldom does any hyena get hurt, and more often than not both clans end up faced off and staring at one another. Then, they simply turn and walk away. Any violent and self-defeating conflict is usually avoided, even if the territory boundary line shifted during the conflict.

Unlike lions, hyena territory sizes are not limited by the amount of resident prey, since hyenas will consistently hunt outside their home areas. Hyenas can commute to find their prey, often venturing as far as fifty miles in search of migratory species. When prey is plentiful, a clan will hunt within its boundary, and its territories will be very well maintained. But when prey becomes dispersed by dry conditions or migration, hyenas will leave their territories in search of meat. These wandering trips can easily last three or four days for a lactating female and twice that long for males and females without pups. The time away from the home territory is limited by how long females can leave their cubs alone without nursing them.

In East Africa it has been determined that sufficient resident prey is in any given hyena territory only 26 percent of the time, meaning that hyenas must travel outside

Learn to read a hyena's tail and ears. Watch a hyena canter and notice how the back legs appear to move stiffly.

Hyenas regularly chase vultures off kills. I've never seen a hyena catch a bird, but the threat must be real because the vultures fly off at each hyena charge.

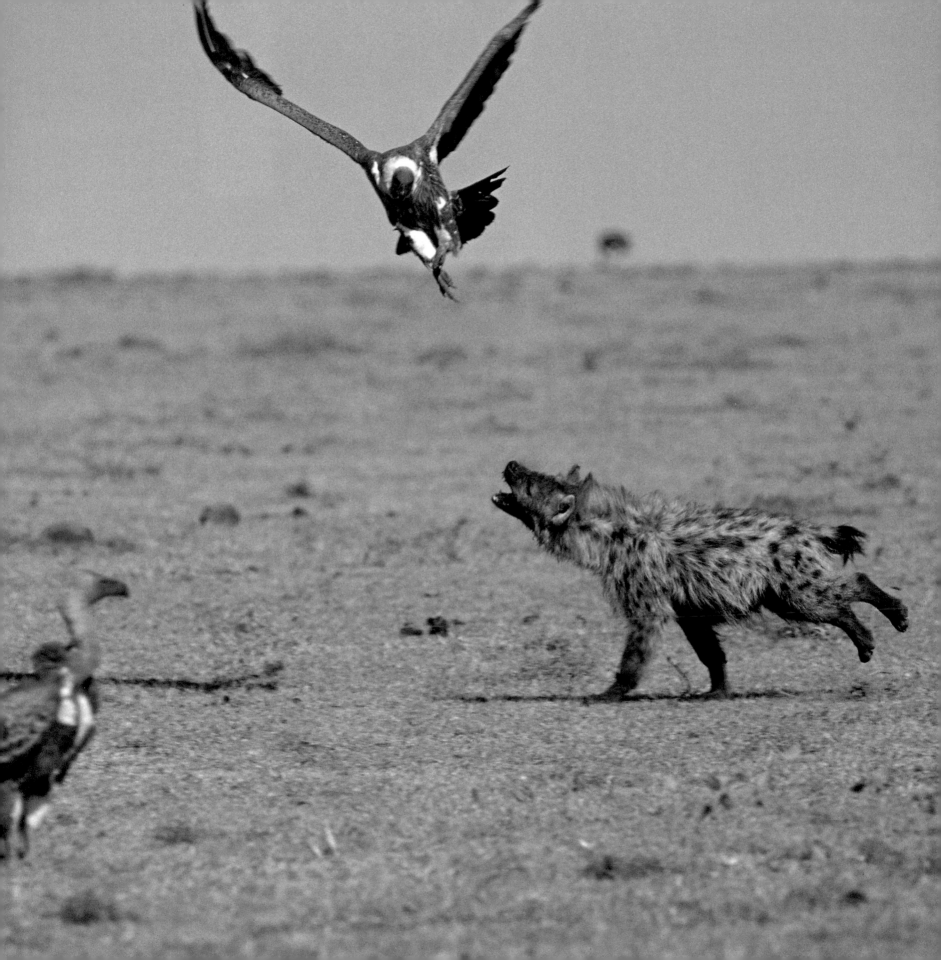

their territories for three-quarters of the year. There is a direct association between hyenas and wildebeest numbers but not between hyenas and zebras, indicating that hyenas depend most heavily upon wildebeests for food.

Territory sizes vary throughout Africa, ranging from twenty-two square miles in the Serengeti down to less than half of that in Kruger National Park. Clan sizes vary as well, and can reach eighty individuals in Kenya while a clan in South Africa typically is composed of only eight to twelve members.

There are some commonalities, however. Hyenas need water, and though they can go for days without it, all territories include water sources. All spotted hyena territories also have a communal den as its focal point and social center. There will be other less important dens contained within the area, and the communal den location will vary every few years, but one den will always function as the apex of activity.

In spite of the fierce territoriality that hyenas exhibit, certain individual hyenas, more often males, consistently sneak into the territories of other clans. These individuals, if persistent in their invasions, may eventually become accepted by the other clan and can even take up residence there.

A hyena's typical hunting style is to wear down its prey and exhaust it with a long-distance pursuit. Sometimes the pursuing clan will give up the chase when they reach their territorial border, though at other times they will continue running the prey and make the kill in another clan's area. If the territory owners detect the hunting invaders they will come to do battle. Invariably the hunters will leave their kill and return to their own territory without putting up a fight.

Youth and Growth In a variety of mammals, mating and false mating may serve more than one purpose. False mating is used to establish or reaffirm dominance between individuals, with the subdominant individual mounting the dominant one. Don't be surprised to see two male lions, cheetahs, or hyenas false mating.

With hyenas, mating for reproductive purposes almost always occurs at night, so if you see hyenas mating during the day it is most likely false mating.

A strict hierarchy, or dominance order, exists within a hyena clan, and while any female of any rank can be impregnated, it is usually the alpha or dominant male that mates with the estrus females. Hyenas come into heat for fourteen days at a time, at any time of the year, though there are peak birthing seasons. In South Africa most hyenas are born in late summer, while in East Africa the majority of pups are born in the months of March and May.

Despite the fact that the communal den is the center of clan activity, or maybe because of it, hyenas give birth away from the communal den. One hundred and ten days after the mating, two pups (usually) are born. At birth their eyes are already opened, they have thick, dark brown to black body hair and weigh in at three pounds.

When the pups are two weeks old the mother will carry them to the communal den and deposit them in one of the many entrances. The den holes are too narrow for the adults, which makes the den even better protection for the pups.

Unlike lions, hyenas do not communally suckle their young, but there still is a group approach to raising hyena pups. All females with youngsters transfer their pups to the central den at the same time and all the females will help defend that area. These females are primarily defending their young from lions, which are the main cause of hyena cub mortality, and even other hyenas. Male hyenas will cannibalize their own pups, which is the primary reason that females have evolved larger bodies than males and have genitalia that look exactly like those of a male (though only females have large nipples).

Interestingly, females of higher rank produce more male cubs than female cubs. Similarly, the cub survival rate of high-ranking females is two and a half times greater than the cub survival rate of lower ranking females. Lastly, high-ranking females reach sexual maturity sooner and have shorter birthing intervals than lower ranking females.

All hyena studies, in both South and East Africa, have shown a stable linear social hierarchy among females. A pup's social standing may change as life goes on, but it originates wherever the mother's standing is within the clan. Hyenas most definitely live in a matriarchal society.

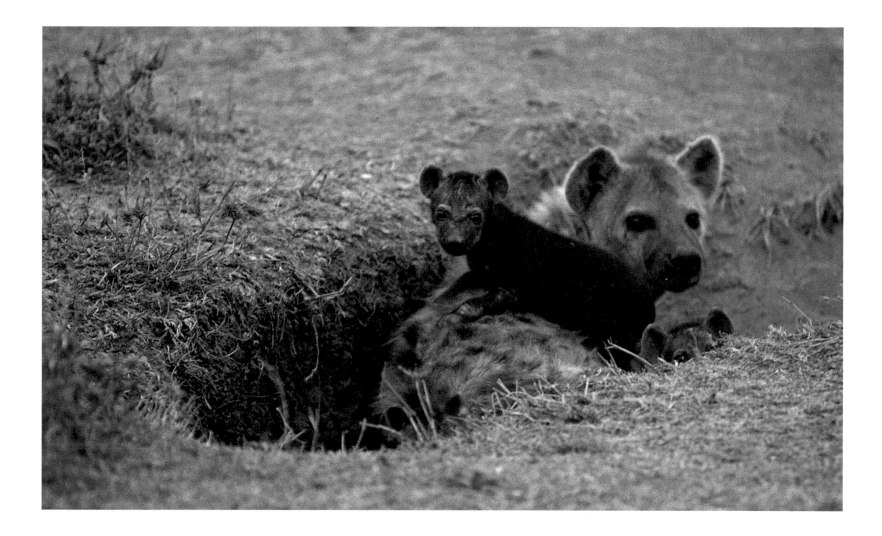

A tiny hyena pup, only five weeks old and still black, peers tentatively out at the world from the safety of its mother's back.

Siblicide is common in hyenas, it is generally safe to assume that when you see a single pup it is probably because that pup has killed its sibling. Female pups in particular kill their littermate brothers before the males are even a week or two old. A mother hyena has a far better chance of raising a single pup to adulthood than two. Since male hyenas are smaller than females (only 88 percent as large) it is the males who suffer most. Most of these death battles take place underground, where the hyenas spend the first six weeks of their lives, but they can be witnessed outside the den as well.

Hyena milk is incredibly rich, much like the milk of a polar bear or a marine mammal. This milk sustains the pups while their mothers commute away from the den for days at a time in search of migratory prey. When prey species are within the territory the mothers nurse their offspring in the early morning and at dusk aboveground.

Hyenas start eating meat that the mothers have carried back to the den by the time they are six months old. Hyenas, unlike wild dogs or leopards, do not regurgitate meat for their offspring. The switch from milk to meat is a gradual change, and even if meat is available, the pups will continue to nurse until they are a year old.

Almost 50 percent of all hyena pups live to be a year old, a much higher infant survival rate than that of lions, leopards, or cheetahs. This is because hyenas are reared in communal dens and spend so much time underground

SAFARI TIP
When you are watching small hyena pups play, be aware that one may actually be trying to kill the other, or at least to establish a dominance order.

The dominant of two hyena pups roughly plays with his submissive younger brother. Hyenas live in a female- dominated society, and female pups, even at birth, rank higher than their brothers.

early in their lives. Fully 36 percent of all hyenas reach sexual maturity, with female hyenas reaching it in three years and males in two.

Hyenas reach maturity slowly, but they have fairly short life spans, generally living to only about twelve years of age. Furthermore, 80 percent of all hyenas die a violent death.

Play No predator young are as playful as lion cubs, nor does any predator remain as playful as lions do in adulthood, but hyenas can kick it up a bit in their own subtle way. For hyenas, play is limited to squabbling over a bone, perhaps, or a stick or a wildebeest tail. Even adult hyenas

will partake of this kind of play, as mild as it is. This play also serves to establish and maintain the social hierarchy within the clan, even if it doesn't sharpen the pups' hunting skills as it does for young lions and cheetahs.

Adult hyenas, like pups, will use a scrap of meat or bone and play keep-away with it. When a clan is near the end of feeding on a kill, an individual may grab some unimportant scrap from what remains and run around with it, enticing other hyenas to give chase. The chase is not about dominance or gaining possession of some limited resource; it's only a game, one that helps establish a bond.

Adolescence Contrary to popular belief, hyena pups are timid creatures, not cowardly, just shy. Getting used to the world aboveground is a gradual process for these cubs, which may be one reason why spotted hyenas have such a high cub survival rate. At first, young ones come up only to nurse, scampering back underground at the slightest noise or disturbance. Gradually they learn to stay up longer, spending more time playing aboveground, chewing on scraps of meat and bone, and following their mothers around the den area. It will take a full year, however, before the cubs begin accompanying the adults on their hunts.

At six months of age the cubs still face the threat of trespassing lions but the threat of cannibalizing hyena males has passed. Surprisingly, these young hyenas don't seem to recognize lions by sight, even at close range, but when the cats walk upwind of the juvenile hyenas or the pups amble downwind of a lion, the cubs instantly recognize the smell and bolt for cover.

Social Life Hyenas spend twenty hours a day lying down and are predominantly nocturnal animals. This can make observing their social life a bit challenging, but not impossible. The first step in understanding the social lives of hyenas is the realization that they live in a matriarchal society and are extremely aggressive predators, not cowardly scavengers.

To begin with, rank directly relates to survival in a hyena's world. A high-ranking female mates more often than a low-ranking one, reaches sexual maturity sooner, has better access to meat on a kill, her female offspring inherit her status, and she is able to better defend her pups. A society with ranks necessitates that individuals in the group know and recognize one another. Hyenas recognize each other in a number of ways.

If two hyenas that have noticed each other choose to approach rather than avoid, they will close in on each other, and the dominant one usually will circle downwind and approach the lower-ranked individual from that angle.

Hyenas love water. This one takes a cooling, cleansing afternoon bath in a pool of fresh water that was created by a hard rain that fell during the middle of the dry season.

They will sniff each other's faces, mouths, and necks. Next they will stand side by side, head to tail, and sniff each other's genitals. Submissive hyenas will raise their legs and expose themselves first. The dominant female hyena may not even offer her genitals for inspection at all. Each hyena knows its rank, its place in the hierarchy.

Cubs as young as six weeks old are already sniffing and greeting other hyenas. They are also paste marking and pawing to put down their scent. Since a pup starts its life with its mother's rank, these greetings and marking behavior carry great significance.

Hyenas use communal toilets within their territory as a way to pass on and gather information. These communal toilets transmit so much data about who was there and when that a hyena may visit one even when it doesn't need to use it. On the approach, a hyena will first take a few minutes to sniff around the latrine, smelling the information available; only then will it defecate. Urine and urinating carry no special significance for the hyena; only the feces carry valuable information.

A hyena's ranking can change throughout its lifetime. Dominance is tested, established, and adjusted during squabbles for food and access to mating partners. Greeting ceremonies often follow in the aftermath of such fights and serve to both calm the individuals and firmly establish who is the winner and the loser. These dominance struggles begin when the pups are just days old, when they first start fighting for their mother's nipple.

Bonds between spotted hyena clan members are vital to the clan's survival. They are strong and are continually being reinforced. They are strengthened during border patrols as the clan members of both sexes walk their

SAFARI TIP

Watch a meeting between two hyenas and determine which is dominant, which submissive.

A hyena chases away a brazen black-backed jackal that hovered too close to its kill.

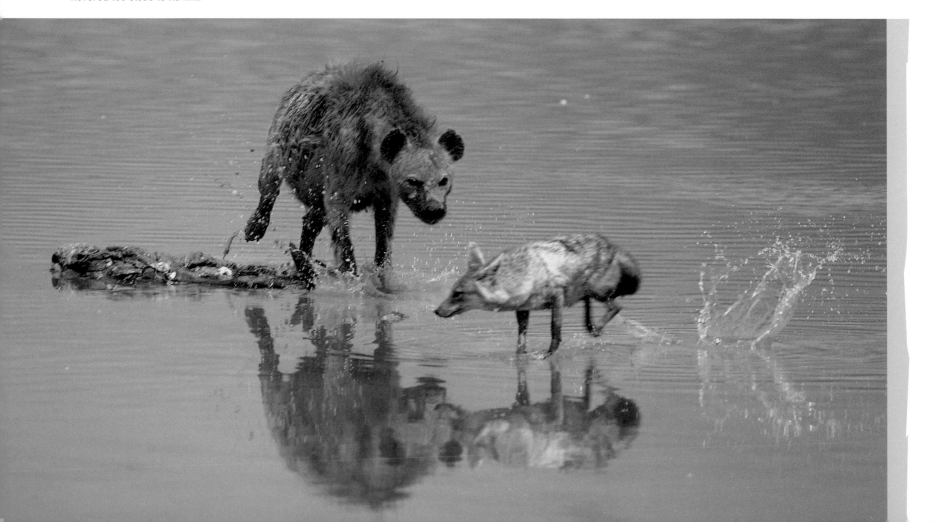

Look at how a hyena
uses its nose; see how it
is constantly quivering,
smelling, and assessing
the world with its nose.

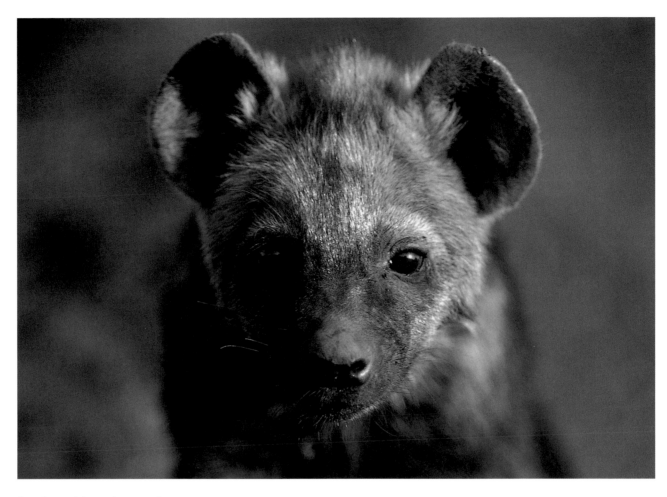

A curious adolescent approaches
the photographer.

territory perimeter, paste marking, pawing, and vocalizing together. Hunting parties, which invariably contain more male hyenas than female, also call, deposit paste marks, and paw during their outings. They also maintain territory boundaries through these activities. These communal ties within a clan are also strengthened when a clan either chases away intruding hyenas or when they repel another clan during a border war.

Hyenas forge individual relationships as well. Certain hyenas hunt together more often while other hyenas never hunt at all (and scavenging is a solitary activity). Some individuals seem to prefer each other's company and can be found lounging and sleeping together constantly, while others stay more separate from the group or are solitary.

Spotted hyenas, unlike lions, do not wash their faces with their paws, nor do they wash the faces of other clan members. This washing within a lion pride is not only done for health reasons but is also a bonding activity within the pride. Hyenas miss out on the opportunity to forge relationships in this way. However, hyenas don't fight with their paws and claws the way lions do, but rather use only their teeth, so they inflict far less damage during scuffles among themselves.

Dominant female hyenas spend most of their days near the communal den area, even when they don't have pups. For other hyenas the den carries less significance, but this significance changes when pups are born.

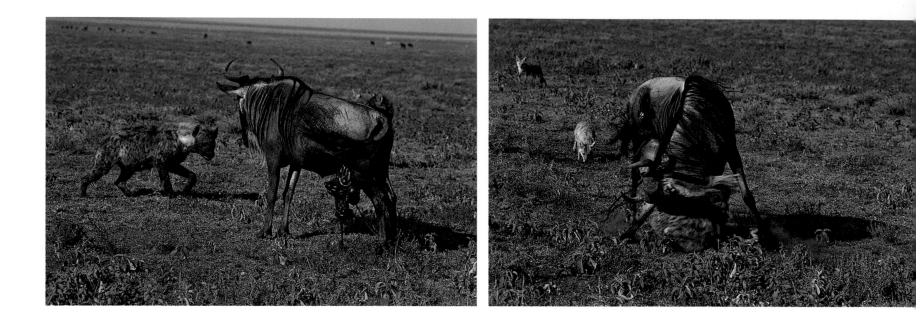

Hunting Until 1964 spotted hyenas were thought to obtain their food entirely through scavenging. We now know better, but hyena hunting data is still relatively new and still being compiled. Hyenas do, of course, scavenge, but it makes up only about a third of their diet, and even less in some regions, such as Ngorongoro Crater, where they kill 90 percent of their meat. When hyenas do scavenge, it is most often a solitary activity during the day when they can visually locate old kills or meat scraps and use descending vultures to help them find carcasses.

Lion, cheetah, and leopard populations and distributions are dictated by the amount and location of prey species in their environments. This is not true for hyenas because they will range far and wide in search of prey. Yet hyenas have more effect on prey species numbers in the habitats they occupy than do lions, leopards, and cheetahs combined.

In southern Africa, impalas and gazelles are the major prey species hunted by spotted hyenas, while in East Africa wildebeests and zebras are the most important food sources. When hyenas hunt wildebeests, zebras, or impalas, they do so at night in packs. Hyenas have two peak activity periods, between 6:00 p.m. and midnight, and then again between 4:00 a.m. and 6:00 a.m. Thomson's and Grant's gazelles are not taken at night

THIS PAGE AND OPPOSITE These two hyenas simply charged into a wildebeest herd, singled out an adult male, and ran it for over five miles before the exhausted wildebeest turned to face them. With one slashing bite, one of the hyenas tore open the doomed wildebeest's flank, partially disemboweling it. The ensuing struggle lasted forty-five minutes, a remarkable feat of strength and endurance on the wildebeest's part, before it finally succumbed.

but hunted diurnally and opportunistically by individual hyenas who more or less have stumbled upon them.

Spotted hyenas are blessed with a sloping back, which makes them terrific long-distance runners. Most hyena hunts involve a long pursuit, and the longer the chase the higher the chances of success for the predator. When a hyena chase lasts two-thirds of a mile they succeed in killing 15 percent of the time, but when a chase lasts one mile or longer, they make a kill 55 percent of the time.

Hyenas live in many of the same habitats as lions, but they hunt slightly different prey. Lions hunt in areas where more cover is available and tend to go for more old and sick individuals than hyenas. Hyenas more often take healthy individuals, and though they do kill more

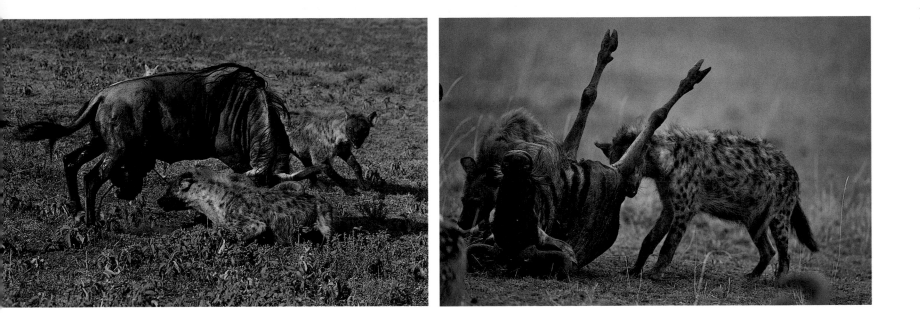

female zebras than males and more male wildebeests than females, this relates to those prey species' social structures, not their health conditions.

Packs of hyenas attack herds of animals, rushing at them to scatter them apart, with an individual hyena then selecting an individual prey target from the fleeing group. Other hyenas in the pack will then join in running down the selected prey. Spotted hyenas are fast—their average chase speed is thirty miles per hour, and at that speed even wildebeest tire fairly quickly.

It comes as no surprise that wildebeests and zebras ignore sitting or sleeping hyenas, and pay little attention to solitary hyenas. Both species, however, flee from groups of hyenas, even if the predators are walking. They also can tell the difference between a hungry hyena and a full hyena. Wildebeests can read a hyena's body language. At times they will let the carnivore walk within five yards of them, but at other times the herd will flee when the hyena is still more than two hundred yards away.

Hyenas initiate hunts as individuals even when they are moving as a hunting pack. A hyena of any rank, or either sex, may be the one that selects the individual target animal in the herd, though a hunting pack is composed of more male hyenas than female. The rest of the hunters rapidly join in once they realize that one

hyena has chosen a prey animal. But even at this point in the hunt hyenas abandon their chases 20 percent of the time for no apparent reason. Still, spotted hyenas succeed in killing in two out of three tries, a much higher success ratio than prides of lions enjoy, and are seven times more successful per hunt than leopards.

When they do continue a chase and make a kill, hyenas do not have any particular killing bite or grip. With a wildebeest, they will usually rip it open and then simply start eating it alive—not an easy thing to observe or photograph.

It seems to take ten or more hyenas to successfully hunt zebras. When they target these equines, they hunt them from a crescent-shaped attack formation and chase them at a much slower speed than when they hunt wildebeests. Once grabbed, a zebra puts up no fight whatsoever, and the killing is usually over in seconds.

Rhinos and buffalo are not off a hyena's hit list, but the risk of hunting these massive animals is great, and therefore seldom occurs. Similarly, the little warthog also appears too risky to be worth hunting. Lions have no trouble simply swatting a running pig or digging one out of a burrow, but hyenas hunt only with their teeth, putting them at a huge disadvantage when it comes to hunting warthogs. These pigs can mount a spirited defense

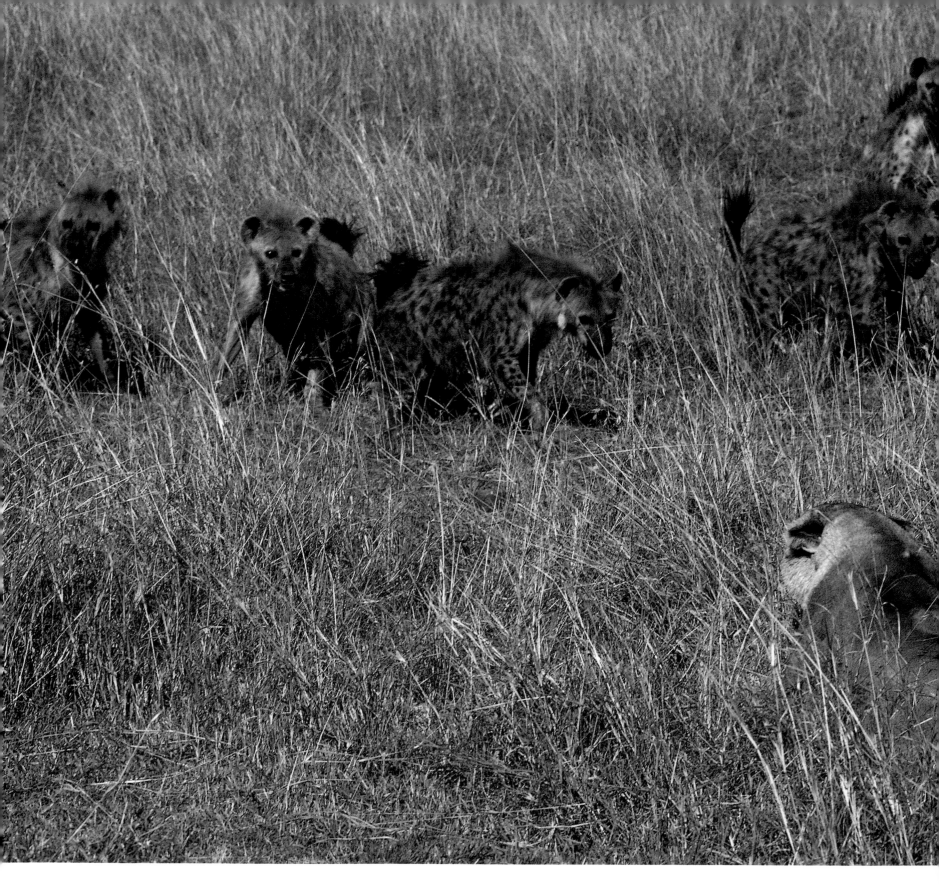

against hyenas, and hyenas actually seem so afraid of warthogs that they seldom hunt them.

A single hyena can consume thirty pounds of meat at one sitting, and the heavier the fallen animal, the more hyenas you will find feeding on the kill. With one eland, which can weigh eighteen hundred pounds, you can find an average of twenty-five hyenas feeding at one time. Seventeen is a typical number of individuals found feeding on a zebra, and twelve hyenas is the norm on a wildebeest.

An amazing and unique habit of hyenas is that they use bodies of water to cache food. A kill stashed underwater can neither be smelled nor seen, so it is safe from lions, vultures, and even other hyenas. Hyenas must know precisely where the meat is located, for even a shallow lake will not give a clue as to where to scavenge. Hyenas will actually dive under water, staying down for as long as twelve seconds, to feed on carcasses and sections of kills that they have deposited beneath the surface.

Hyenas are blessed with cast-iron stomachs and can digest the toughest of bones effortlessly. They can eat virtually anything, from airplane tires to pythons, though medium to small ungulates are their favorite prey. They also seem to be immune to disease as well. These doglike/catlike predators have antibodies against rabies, canine herpes, distemper, *canine brucellosis, canine adenovirus, canine parvovirus, feline calisi, leptospirosis, rinderpest, anaplasmosis,* and *bovine brucellosis.*

In many ways the spotted hyena is the superpredator.

This encounter began when a single hyena moved in on the feeding lioness. The hyena whooped loudly, calling in other hyenas to help drive the lioness off her kill. The lioness must relinquish the kill or suffer at the jaws of the hyenas.

Take the time to watch a pack of hyenas feeding on a kill. Hyena dominance in these situations does not take the form of fighting as it does in lions, but by who can eat the most fastest. Hyenas are seldom hurt during a feeding frenzy, in spite of all the nervous giggling and loud whooping. Lions can hear this ruckus from miles away, and they will investigate. If you approach lions feeding on a kill during your early morning game drive, see if the hyenas standing around have bloody heads and necks. If they do, it is the hyenas that most likely made the kill, got in some feeding time, and then were pushed off their quarry. Wait around for a bit, and you'll most likely see the hyenas mobilize as a group and reclaim the kill they made.

A hyena wastes no time tearing into a kill. Organs and entrails are higher in nutritional value than muscle meat, so the hyenas often eat those parts of a kill first.

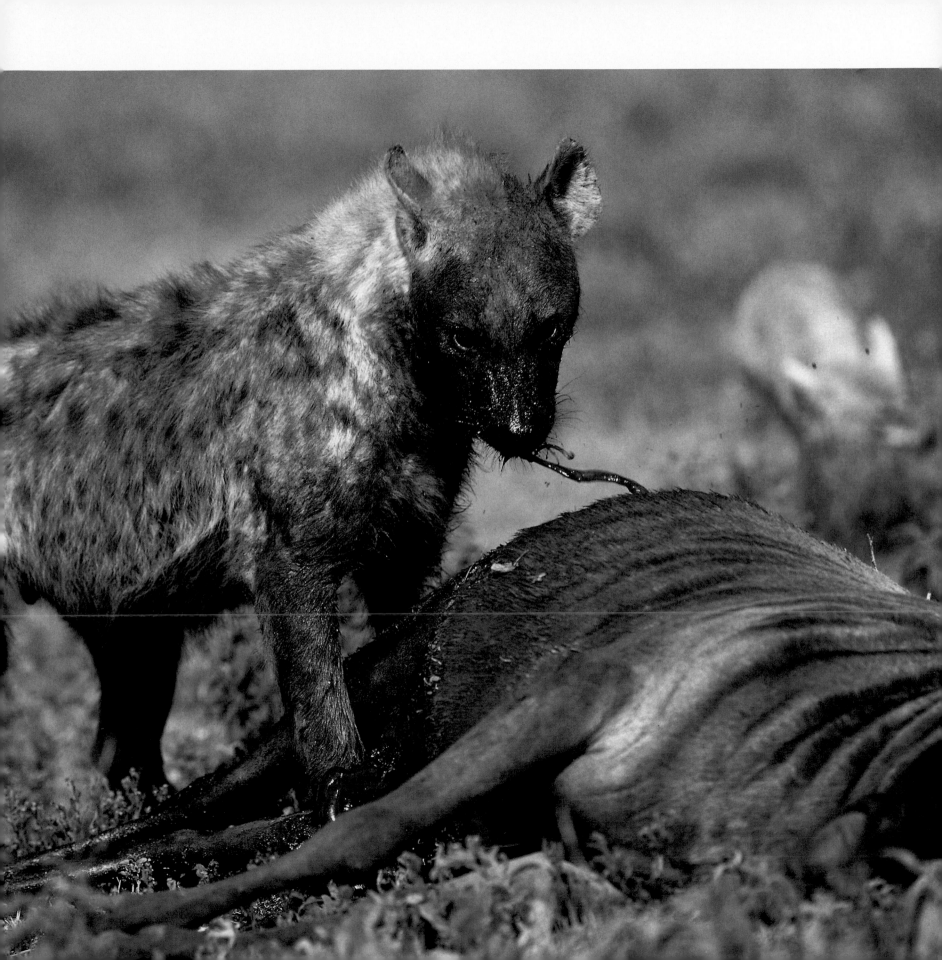

Debunking Hyena Myths

MYTH: Hyenas are dogs.
FACT: They are certainly doglike, but they are not dogs.

MYTH: Hyenas are scavengers.
FACT: Hyenas are predominantly hunters. They kill approximately two-thirds of the meat they eat.

MYTH: Hyenas are poor hunters.
FACT: Hyenas have a hunting success ratio (kills per attempt) that is 700 percent greater than leopards, 350 percent greater than single lions, and have more influence on the prey species in a given habitat than all the other predators combined.

MYTH: Hyenas are cowardly.
FACT: Hyenas, in numbers, easily chase lions off of kills, can kill rhinos and buffalo, and in one-on-one encounters, will chase off or even kill leopards. I was once dragged away from a campfire by hyenas, and a friend of mine who was napping by his truck had both his legs crushed by a single bite from an investigating hyena.

MYTH: Hyenas regurgitate food for their young.
FACT: Hyenas do bring back meat and bone to the communal den but do not regurgitate.

MYTH: Hyenas are hermaphroditic.
FACT: The external genitalia of female and male hyenas look identical, but only females have enlarged nipples. The organs have evolved to look the same probably to allow the females to defend the communal dens from cannibalistic males.

MYTH: Witches ride hyenas and drink hyena milk (a commonly held belief in Africa).
FACT: Witches ride brooms, and hyena milk is one of the richest of all mammals, but no research indicates that witches enjoy that milk.

How to Observe Hyenas

1. Hyenas are predominantly nocturnal so search for them early in the morning or just when it's dark.

2. Use your ears to locate hyenas. You can often hear giggling and whooping hyenas far from your camp. These sounds usually indicate that a kill has been made; get going.

3. If you find lions on a kill and a number of hyenas milling around, wait! The hyenas will, when their numbers are right, drive off the lions in a most exciting changeover of kill ownership.

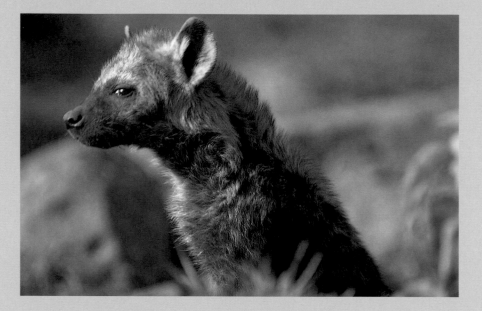

4. Hyenas are long-distance chasers. If you see hyenas running after prey, get well ahead of the chase—even half a mile will not be too far. Stay to the side and don't get between the hyenas and their targeted prey. Be patient.

5. Learn where the water is in your area of whatever game park you are visiting. Go to those water sources at dawn and/or dusk and wait for hyenas.

6. Study old bones, notice how they've been broken and chewed, and see if you can figure out if hyenas fed on the kill at some point.

7. Locate the communal dens in your area of the game reserve and discreetly park near them at dawn or dusk. You'll be able to watch dominant females interact with their pups, each other, and with any males that wander near.

8. Drive, walk, or ride toward any major hyena noises that you hear. Something is definitely going on.

9. Watch hyenas meet and figure out who is dominant over whom.

10. If you see a group of hyenas moving, follow them at a distance. It could be either a hunting party, which will be made up of mostly small males, or it could be a border patrol group, in which case you'll see them mark, defecate, and paw the earth.

11. Watch a hyena yawn and try to photograph it. If you have a digital camera you can instantly study their amazing dentition.

12. Look for hyena tracks, which are easy to identify, and learn to recognize them. Hyena tracks show claws, only two lobes across the heel pad, and from the tracks, you can see that hyenas walk duck-footed. Their front feet are larger than their back feet.

13. Watch hyenas "whoop" and you'll see that as they call their muzzles come right down to the ground, bouncing the call off the earth. They don't put their heads up and yowl like wolves.

Facts on File

1. Male hyenas weigh only 88 percent of a female hyena.

2. Female hyenas can weigh 180 pounds.

3. Gestation period for hyenas is 110 days.

4. Pups weigh three pounds a birth.

5. Pups are not born in the communal den; when they are fourteen days old, they are moved to the communal den from the den where they were born.

6. Hyena pups are born with black hair and their eyes open, and are immediately mobile.

7. Hyena litters usually consist of two pups.

8. Siblicide occurs at a very early age, and is common in hyenas.

9. Hyenas eat meat by six months of age, but nurse for a year or more.

10. Hyena milk is as rich in protein and fat as the milk of most marine mammals.

11. Hyena young don't join in hunting activities until they are a year old.

12. Hyena pups are born with the status of their mother, though that may change.

13. Male hyenas reach sexual maturity at two years of age, females at three years of age on average.

14. Spotted hyenas live in a purely matriarchal society.

15. Males transfer away from their natal clan more often than females.

16. Clan sizes average forty-five animals in East Africa and twelve animals in South Africa.

17. Hyenas maintain their clan boundaries by marking them with secretions from their anal and interdigital glands, using communal toilets, and vocalizing.

19. Hyenas will urinate anywhere, and it has no special significance.

20. Clan territories in open plains country average twenty-two square miles, but are much smaller in woodland environments.

21. Hunting packs are made up of mostly males, but some females go along.

22. Hyenas use only their teeth when fighting.

23. Hyenas have non-retractable claws, like a dog.

24. Hyenas hunt within their own territory when prey is plentiful.

25. Hyenas commute days away, and up to fifty miles, in search of migratory prey.

26. Hyenas need water, but can go days without it.

27. Hyenas spend twenty hours a day lying down.

28. Hyenas cache food under water.

29. Hyena groups can displace lions from kills.

30. Single hyenas will attack and chase off leopards.

31. Hyenas chase wildebeest at over thirty miles per hour for up to five miles.

32. Hyenas kill their prey by immobilizing it and eating it while it's still alive.

33. Hyenas have the strongest jaws of any predators on the African continent.

34. The average life span for hyenas is twelve years, though life spans of up to twenty-three years have been recorded.

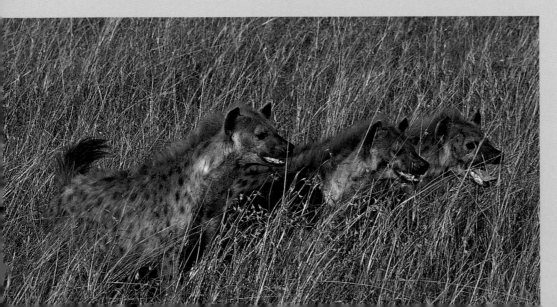

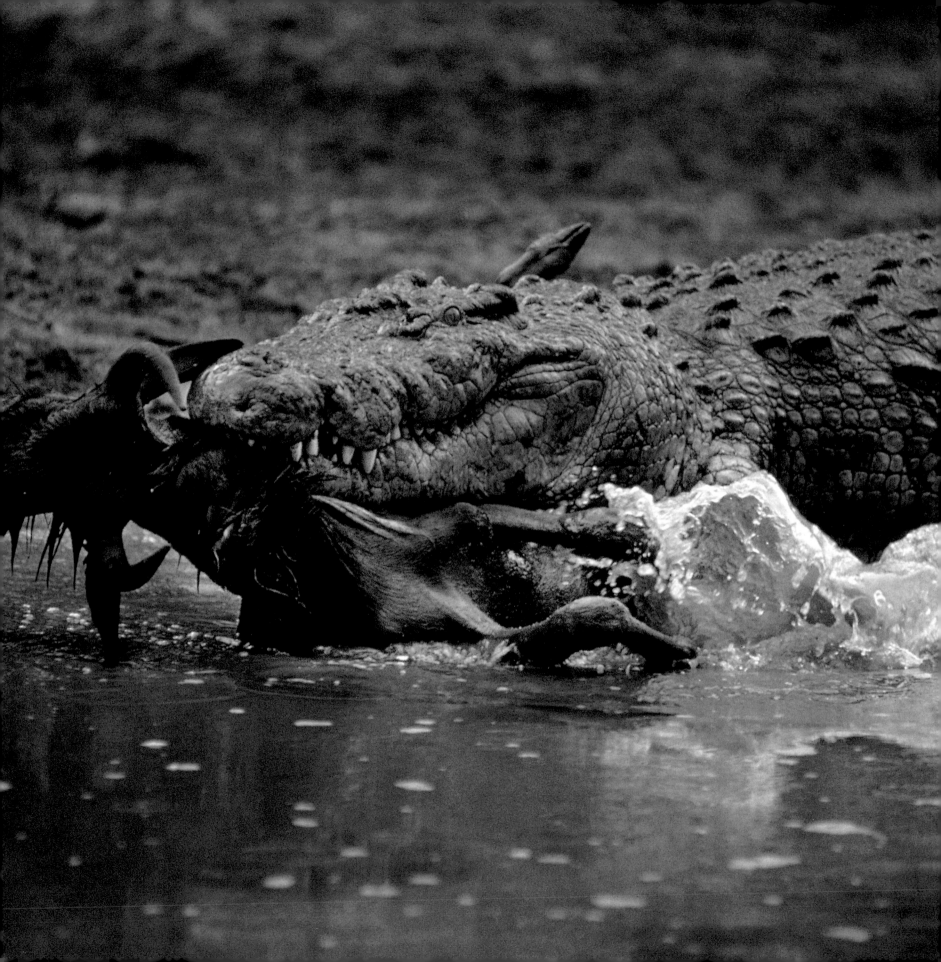

A fifteen-hundred-pound crocodile effortlessly carries a wildebeest carcass across the sand from one pool to another along the Grumeti River in Tanzania.

CROCODILE

A DAY IN THE LIFE

The wildebeests stretched for miles across the tawny grassland, moving single file in so many lines like long black threads spread wide, curving gracefully closer and closer until they joined at the riverbank. Those threads had to cross a croc-filled river in order to reach the green, succulent plains beyond the horizon.

A brown cloud of dust, visible for miles, hung between the two parallel lines of trees that hemmed the Mara River. Vultures circled in the same eddies of wind that spun the dust, and herds of zebras, also in single file, plodded toward the dust. The green borders were broken occasionally, the trees unable to grow in the places where zebras and wildebeests had thundered through for thousands of years on their yearly migration north and south. Millions of hooves per year had packed the dirt rock-hard at these crossing points, and the few seedlings that managed to take root during the animals' absence were trampled flat upon the herds' return.

Now, thousands of zebras and wildebeests were congregated near the river and stood still a hundred yards back from the water's edge, for the moment safely out of reach of either the crocs before them or the lions behind. As more and more animals reached the river, however, the pressure began to build against the zebras and wildebeests closest to the river. They balked at being forced nearer the water, but it was only a matter of time before the tide of the incoming ungulates would overwhelm them.

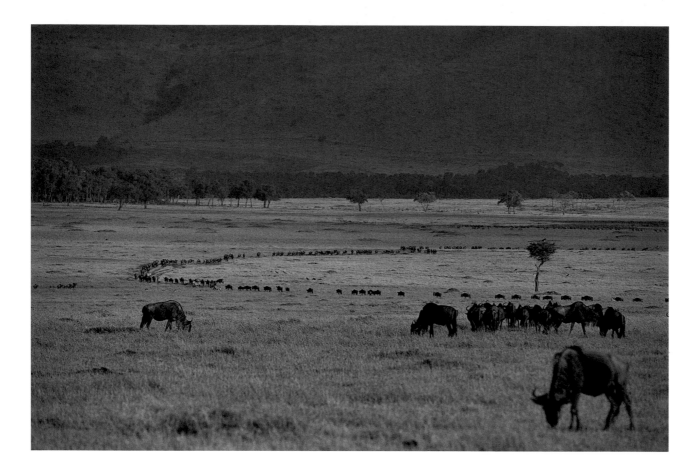

For over an hour the drumming of hooves filled the air as the never-ending threads of dark gray and black and white moved inexorably toward the water. The wildebeests waited in silence as they stood on the hard-packed earth near the water. The zebras, on the other hand, never stopped "talking" to one another, sometimes braying loudly, sometimes muttering to themselves. The ones near the river stood alert and studied the waters from their vantage point fifteen feet above. The wildebeests seemed to be leaving the scouting to the equines and merely waited patiently, heads hung low.

Occasionally a zebra would move purposefully toward the water, head high, ears pricked. The individual would be followed by half a dozen other zebras. Invariably, the lead zebra would balk, kicking backward at the zebras following it. Then, suddenly, the leader would bolt, running

hard back away from the river, only to be stopped by the oncoming hordes.

Every time a zebra broke away from the river, it spread panic among its neighbors. Without warning, an entire section of the gathered animals would break into a run, and just as suddenly they would stop, turn, and face the river. Again and again this action was repeated, almost always initiated by a zebra herd leader, with the wildebeests dumbly following their example.

As the numbers crowding the bank grew, so did the noise and dust. Zebras were constantly calling out alarms, relocating separated members of their family groups and vocalizing their impatience. The dancing continued, growing faster and more urgent.

The river in front of the clustered animals flowed smoothly and deep, with a band of rocks creating a set of

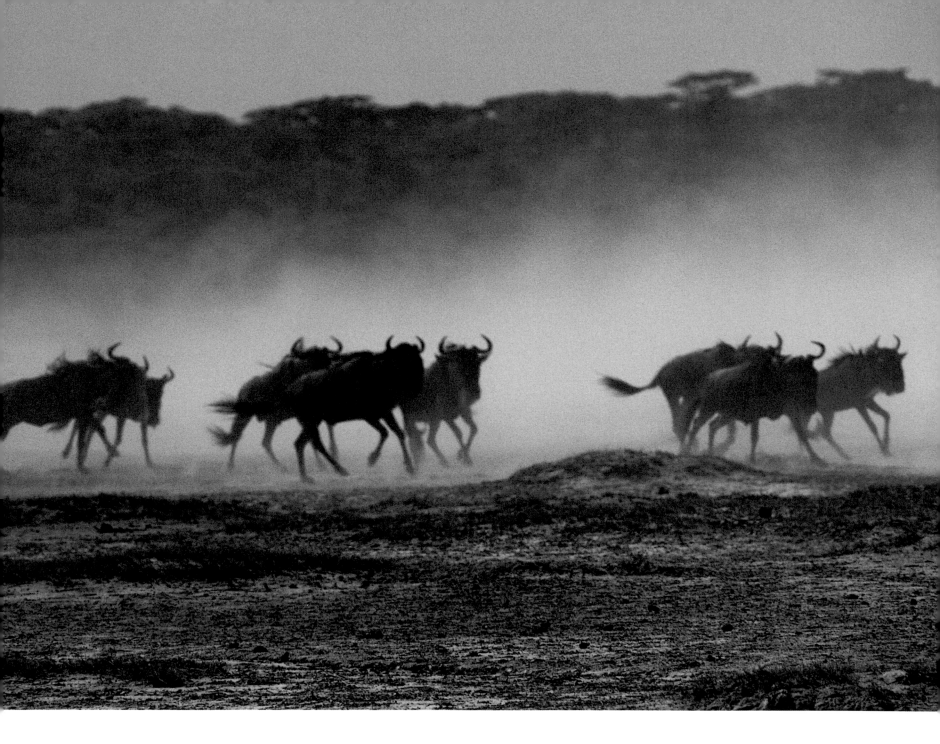

OPPOSITE Migrating is dangerous, exposing the wildebeests to tremendous pressures. To minimize the exposure to predation, wildebeests migrate in single file where terrain permits.

It's much like moving through a mine field for them—only the lead animals are exposed to a possible mine, or the waiting predator. As long as the lead wildebeest makes it through, the others follow.

ABOVE A cluster of migrating wildebeests cavorting across the alkali flats.

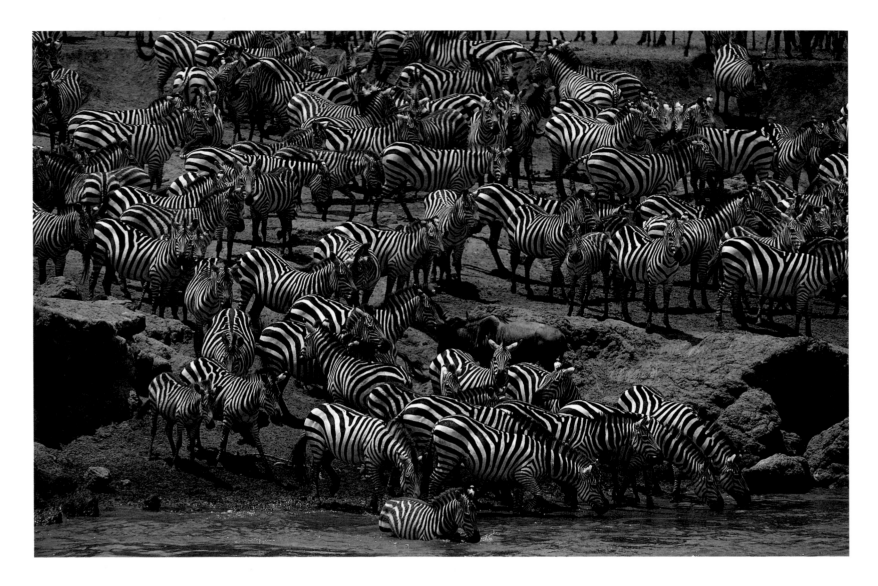

shallow white-water rapids that stretched for thirty yards, flat water above and below this stretch. But the river wasn't as peaceful as it appeared. It wasn't only rocks that poked up through the dark brown water. Yellow-green eyes and blunt nostrils also rested on the surface of the water, watching, breathing, waiting. Half a dozen crocodiles lay stretched flat and motionless on the river banks, some above the gullies that ran down from the herds to the water, others below.

The crocs had felt the vibrations generated by thousands upon thousands of hooves. The reptiles knew the wildebeests were coming, and as the vibrations in the earth grew into an audible sound, a number of crocs shoved heavily off their sandbars and eased into the cool current. The crocodiles were in no hurry at all. They would feed—in fact, their prey would walk or swim directly into their open jaws. And if they didn't feed today they would most assuredly feed soon enough. In the meantime, they treaded water, waited, and watched, not a single motion betraying their presence. The crocs on the shores were motionless as well, looking like so much driftwood.

Suddenly, an old mare zebra trotted quickly down toward the river, maneuvering between the wildebeests. She walked to the very edge of the water, drank briefly, then waded purposefully into the deep river. Eight other

OPPOSITE Even when zebras mix into the wildebeests' migration, the equines stay somewhat separate, moving together as both a family unit and as a species. It is easy to see how the stripe patterns of the herd protect individual zebras by making a visually confusing target.

RIGHT A crocodile lies motionless waiting for the right moment, as wildebeests and zebras cross on either side of it.

BELOW A family of zebras, calm but alert, starts crossing the Mara River. By entering and crossing with little splashing, they draw less attention from the crocs than the crashing wildebeests.

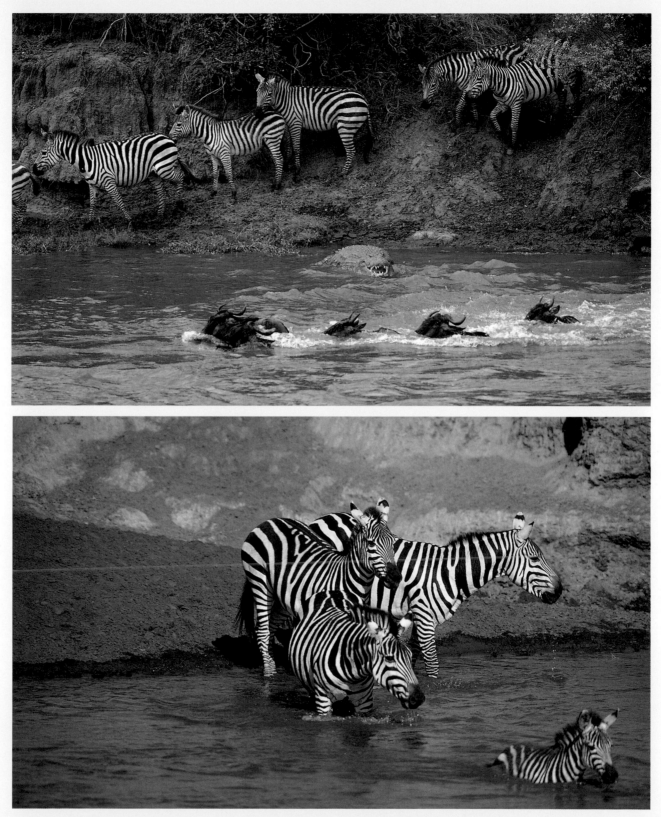

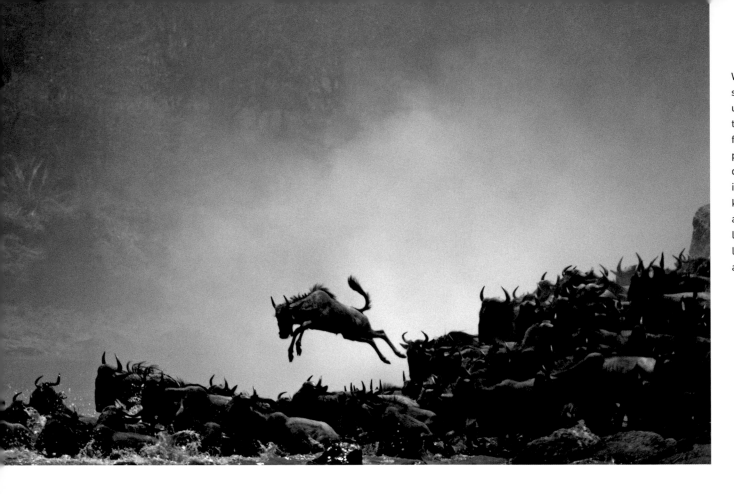

zebras followed her. There was no splash, no leaping, just a steady progression. The zebras began to swim when the water became too deep. The crocodiles hovering in the river downstream of the zebras began to move, their massive, thick tails sashaying gently left and right, propelling them forward.

The wildebeests nearest the zebras suddenly broke and ran charging down to the river, not stopping when they reached the beach. Unlike the zebras, the wildebeests cantered right to the water's edge, then took flying leaps as far as they could into the river. As each heavy beast landed in the river, the water exploded.

The crocodiles that had been lying on either bank shoved back with their fat, short legs and reversed into the river. Instantly they sighted the source of all the chaos and began moving at an angle toward the crashing and swimming targets in the middle of the river. The zebras kept quietly swimming and soon the first mare gained

the far shore and waded out, running away from the water as soon as her hooves gripped solid ground. She neither waited nor looked back, but the other zebras were trailing her tightly and the first herd gained the far bank unscathed. The wildebeests were not as lucky.

A massive crocodile, seventeen feet long and weighing fifteen hundred pounds, angled down toward the crazed line of swimming wildebeests. He cut almost lazily across the current until he was twenty feet upstream from the crossing line. Then the croc rocketed forward, creating a massive wake as he plowed into the wildebeests. He wasted no motion, and as he reached a two-year-old calf his immense jaws swung open, his head rolled sideways, and he slammed down on the young wildebeest's head and neck. The croc arched his back, driving his weight down onto the hapless swimmer, completely engulfing the calf's head and neck between his jaws. With a violent subsurface twist, the croc yanked the calf out of the

swimming line and pulled it back upstream, away from the crossing. As suddenly as it had begun, it was over and all that was visible was the croc motoring quietly upstream, a black mass wedged between his green-scaled jaws. No blood, no kicking or splashing, no fight.

Now panic spread through the wildebeests. Even the ones in the very back of the congregation somehow knew that the crossing had begun. They pressed forward, forcing those at the edge to jump in. The noise of bleating wildebeests, exploding water, and braying zebras was deafening. Thousands and thousands of hooves thumped the earth and the dust reached hundreds of feet into the air, forcing the swirling vultures to circle wider, free of the choking air above the stampeding and diving animals.

Three crocodiles came swimming up from downstream, driving hard and fast like torpedoes aimed at the crossing swimmers. The line of animals was three abreast now, with more leaping, sailing, pouring off

the embankment into the murky water. The younger wildebeests, weaker swimmers than the adults, drifted downstream from the main line, exposing themselves to the advancing crocodiles. The first of the three inbound crocs plowed his way right into the line and slashed, open mouthed, at the first wildebeest that swam into his jaws. Savagely, he yanked his head and neck back, wildebeest firmly grasped, and shot back downstream.

As fast and as furious as the wildebeests and zebras were charging into dangerous waters, it wasn't fast enough. The urge was so great, the drive so impulsive, that the herds a quarter of a mile from the river were cramming in. The momentum and pressure continued to build. Zebras were forced to fan out and find new places to charge down the embankment, and within minutes there were four separate lines of migrants flailing across the choppy waters. The line of animals crossing above the rapids soon bowed dangerously downstream, and a few

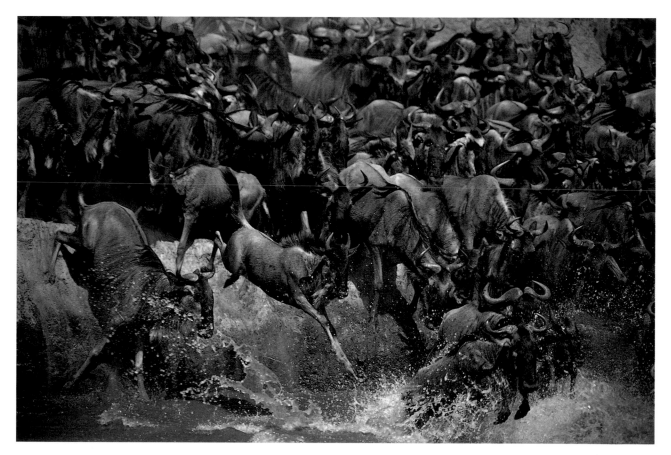

RIGHT Panicked wildebeests pour into the river during their annual migration.

OVERLEAF Thousands and thousands of wildebeests jam the crocodile-infested Mara River as they cross into Kenya.

were swept into the white water and sent crashing against the rocks, ricocheting through the boulders like a pinball. Floating bodies were spat out at the bottom of the rapids and swept on downstream into the wildebeests that were crossing there. Black corpses were now beginning to gather in the backwaters and pools of the river, forming a floating mat of water-slick hide and horns. But the crocs ignored the bodies and continued to ambush the moving prey.

The next croc held short, waiting as animal after animal swam just past his nose. He stayed motionless, eyes open, nostrils pulling up jets of water as his breath mixed with the river. He hung in the current, with only a slow motion of his tail from side to side indicating that he was indeed a living predator. Suddenly, he saw what he wanted, and his gape swung wide, showing a deep, pale yellow palate surrounded by a bow of ivory-colored teeth.

With one thrust of his tail he catapulted up and out of the water, crashing down on an adult zebra. He hit the zebra just behind the head, and the zebra shot upward, propelled by the violent thrust. The croc's grip slipped and the zebra was free, thrashing through the water for a few feet, and then swimming steadily again. There were only a few shallow scratches that testified to the near-death miss.

But the croc quickly repositioned and hovered, watching the wildebeests swim by less than two feet from his jaws. Ten, fifteen, and then twenty wildebeests made it safely past him before he slashed in again into an adult. Again he hit late, biting down on the neck just above the shoulders. The wildebeest went berserk, jumping, spinning, and kicking, but the croc held on for the ride. Two more crocodiles now came swiftly forward with deadly intent. The reptile to arrive first closed the last five feet to the wildebeest with its mouth open, water gushing in and spilling out at the corners. Its jaws snapped down on the wildebeest's rump, tearing and gashing into the black hip. Now the wildebeest was held front and back when the third croc smashed into it. The final crocodile also attacked the front, but with more skill than his cohort. This last crocodile effortlessly, silently, took the entire head of the doomed beast between his jaws and slammed the vice shut, crushing the wildebeest's skull. The water erupted around the dead animal. One croc violently

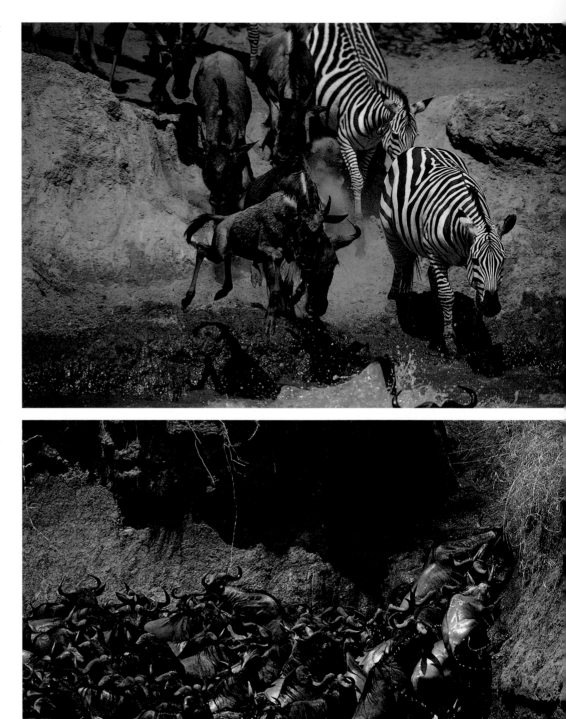

OPPOSITE, ABOVE Zebras, in a quiet and organized fashion, walk down to cross the Mara River while the wildebeests, in panic, sail out into the water. Their huge splashes telegraph the waiting crocs that they are crossing.

OPPOSITE, BELOW Wildebeests do not evaluate the far shoreline where they will have to climb out of the river. If the embankment is too steep, the wildebeests end up piling on to one another in their desperate attempts to find dry land, often causing death among themselves.

BELOW A crocodile grabs a young wildebeest by the leg as it crosses the Mara River.

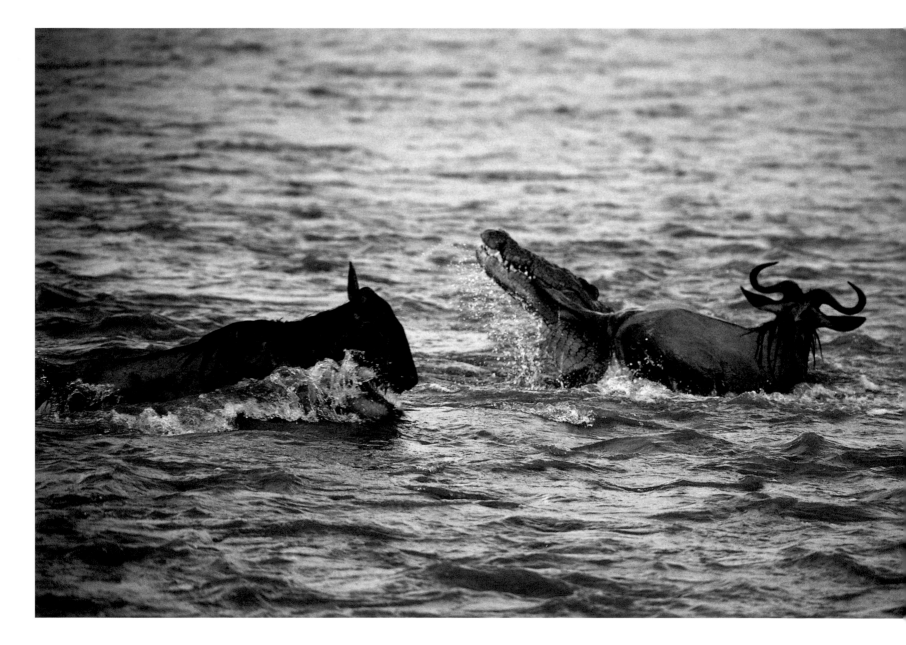

twisted the carcass one way while another tried to twist the other way. The third croc slashed its tail with horrible violence, sending an arch of water ten feet into the air as he forced his way right up on top of the carcass. Two smaller crocodiles swam in and tried to get a grip, but the carcass was being jerked left and right as the crocs fought over it. Suddenly, the brown water burst red, and a croc started swimming rapidly away from the dead animal, one front leg and part of a shoulder clasped in its jaws.

Two hundred yards downstream from the chaos, the corpse of an adult wildebeest drifted into the territory of a bull hippo. The hippo responded to the intruder by attacking it. Again and again the bulky bull attacked the body, raising it clear of the water and smashing it down again. The two animals, one alive and one dead, continued to drift downstream. Finally, when the two reached the bottom of the bull's territory, he shoved the wildebeest violently with his broad nose and let it drift downriver.

And still, the wildebeests and zebras came on, perhaps ten thousand yet to cross. They were driven to cross that river no matter the danger. And they could be their own worst enemy. In their absolute panic, wildebeests would often leap onto one another as they descended into the river, driving the luckless ones under water. If a wildebeest delayed getting into or out of the river, it was trampled to death. The noise of the crossing had reached a deafening crescendo. Zebras on the far shore were calling and calling, trying to locate herd members that had become separated in the mass chaos and confusion. Water exploded continually as animal after animal sailed out and crashed down. The drumming of the hooves made a monotonous backdrop, punctuated by bleats, brays, and splashing water.

For forty minutes they crossed, for forty minutes the crocs moved in to make their kills, instinct driving them all.

Zebras are incredibly strong animals—so strong that cheetahs seldom attack them and even lions will think twice before attempting to kill one. This Grevy's zebra, an endangered species, managed to get away from a crocodile that had held it completely enclosed in its jaws. As horrid as the bite looks, it will probably heal well, the deep cuts being kept clean of flies and parasites by the oxpeckers with bright orange beaks on the zebra's back.

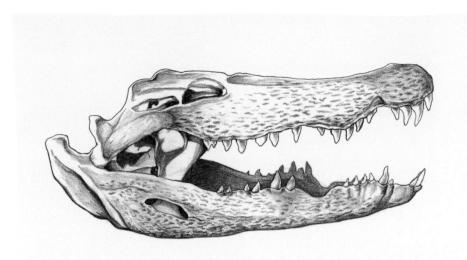

A crocodile's skull, side view.

SAFARI TIP

Look at a crocodile's jaws and notice the "bumps" that run in a line around the edge of their jaws and down their body.

BIOLOGY AND BEHAVIOR

Crocodiles are living dinosaurs. They were waddling across the earth more than two hundred million years ago, and they've evolved little in over sixty million years. These massive reptiles sunning themselves along the banks of the Zambezi or Mara rivers coexisted with the brontosaurus and stegosaurus exactly as we see them today. As with sharks, nature hit upon an evolutionary form that needed little to no modification.

Yet the Nile crocodile, the species found in East Africa, is far from a brainless lizard driven merely by instinct and habit. Crocodiles are alert, curious, incredibly aware of their surroundings, able to adapt to many situations, and are even somewhat social.

But first and foremost, the Nile crocodile is a fast and efficient killer. To a crocodile, a human in the water or along the shoreline is merely one more warm body, no different from its usual prey. A crocodile can outrun, out-hear, out-see, outswim, out-sense, and outfight even the strongest human.

Crocodile Anatomy I once watched as a so-called problem crocodile was shot with a .375 caliber rifle. The bullet ricocheted off the animal as it slid into the water. The croc stayed submerged and swam away, not to be seen by us again for weeks. A crocodile's scales are incredibly tough, but underneath these scales is an even more formidable defense: osteoscutes. *Osteo* (bone) and *scutes* (scales) combine to form a set of "bone scales" underneath the green and yellow scales visible on the surface of a crocodile's body. These bone scales are keeled, giving them more strength, and overlap one another to form a flexible and practically impenetrable protective layer, much like chain mail, that covers a crocodile's entire body.

You can see how strong and effective this shield is when you watch a herd of wildebeests charging into a river during their annual migration. It is not uncommon for a crocodile lying on the riverbank to fall victim to the wildebeests' stampeding hooves. But the ungulate's sharp hooves, slamming down on the reclining crocodile, have not the slightest effect. An external scale may be scratched or broken, even knocked loose, but the crocodile will remain unscathed.

Crocodiles are immensely powerful creatures. The muscles and bones of their stubby legs are stout and respond instantaneously. The tail, which equals about 40 percent of a crocodile's total body length, is so strong that it is frequently used as a weapon. A croc's heavy tail can break the legs of a zebra or wildebeest, leaving them helpless and vulnerable on the shoreline. There are two rows of scales that run along the outer edge and dorsal side of the tail that extend upward. These sharp scales can inflict horribly deep wounds when accurately aimed.

A crocodile is an ectothermic, or cold-blooded, animal. However, they have an efficient, four-chambered heart much like a mammal's (other reptiles have three-chambered hearts), which allows them to respond and move far quicker than most cold-blooded reptiles, even on the coolest and cloudiest of days. These reptiles can further fine-tune their body temperatures by lying either in the sun, the shade, or the water; they open their mouths to dissipate heat. They will do whatever is necessary to achieve the precise body temperature necessary to function optimally, often moving back and forth between different environments during the course of a single day.

Naturally, a crocodile's teeth are designed for killing. The fourth tooth of a croc is exposed when its jaw is closed, unlike an alligator's, and the canine teeth of the top jaw slot neatly into a socket located in the lower jaw, allowing the crocodile to "lock" its jaws together in

Try to sneak up on a crocodile while you're in a
boat, walking along a shoreline, even tiptoeing
through a riverine forest in an attempt to catch it
basking unaware.

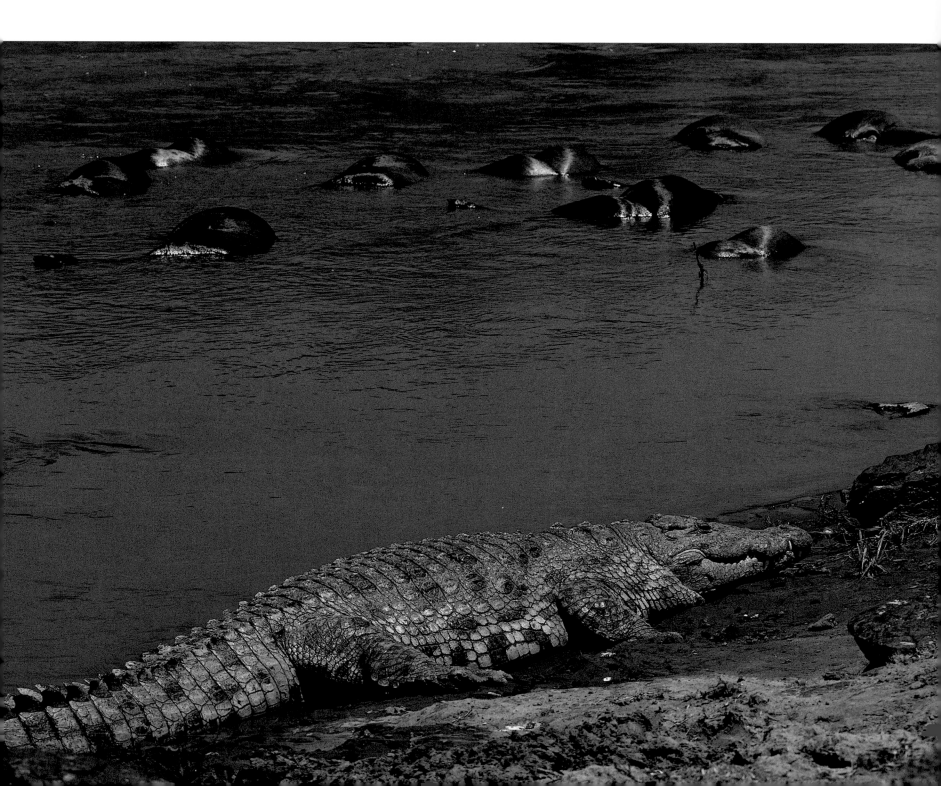

a closed position. Despite the fact that most teeth in a crocodile's jaw do not interlock, a croc can still shear meat from a carcass or tear limbs off by twisting its jaws and often its entire body.

Crocodiles have evolved phenomenal immune systems, a system so strong that the medical community has taken note and is conducting studies to determine how its properties might be utilized in humans. Crocodiles generally live in fairly warm, muddy, slow-moving water, ideal conditions for a myriad of microbes. These waters are made filthier by the rotting flesh of crocodiles' kills. In this environment it is not unusual to see crocodiles with large open wounds, the calling cards of their violent lives, and yet suffering from no infection or disease.

Crocs have such keen senses, it's nearly impossible to sneak up on them. You'll be detected every time, your presence known to the reptile long before you get near it. A crocodile's acute awareness of its surroundings, and all that is going on within its world, is perhaps its most impressive trait. Very rarely does anything, from a bird walking along the shore to a wildebeest herd a mile away from the river, go unnoticed by these seemingly primitive animals.

A crocodile has excellent vision, as well as a nictitating membrane, or second eyelid, that is transparent, allowing some vision when the membrane is pulled across the eye, but also offering greater protection to the eye when this membrane is drawn across the pupil. This membrane closes over the eye when the croc's jaws are opened to clamp down on prey, or while they are fighting. The eyes of a crocodile, like its nostrils, are located high up, close to the top of the skull, allowing it to breathe and see while most of its body remains submerged in the muddy water. The eyes are also set out on the side of the head and positioned in such a way that a crocodile can see, with binocular vision, both above itself and behind.

Crocodiles do have ears, though with no external flap that helps funnel sound into the organ. It is presumed that their ears also work like a pressure sensor underwater, helping them locate splashing or swimming prey. But their most remarkable sensory organ has only recently come to light.

The pigmented nodules that surround a crocodile's jaws and that run along its body work like the lateral

lines on a fish. They are extremely sensitive pressure sensors. The nodules are nerve bundles that respond to the slightest pressure changes on the surface of the water. They can also detect hoofbeats of approaching herds. It is no surprise that the crocodiles along the rivers of the wildebeest migration route are often already in their concealed ambush positions in midstream long before the herds reach the riverbank. The crocs can literally "feel" the herd coming.

Similarly, it is not surprising that a swimming wildebeest, even one that's hundreds of yards away from a croc, can be detected by these archaic predators and rapidly pursued. Weighing in at close to a ton, and as long as eighteen feet, a crocodile certainly has no problem finishing off any prey that it has sought out.

As Dr. Soares, a neurologist at the University of Maryland who is studying crocodiles, says, "They're very curious, very alert, and want to know what's going on." The crocodile is certainly well equipped for it.

Territoriality and Habitat Crocodiles operate through a combination of decision making and pure instinct, though the decision-making component of a crocodile's daily life accounts for a far greater percentage of his actions than was once believed. For these reptiles, even mating, the most instinctual process of all, also involves an evaluation and decisions.

Crocodiles do not live in groups per se but are very tolerant of group situations and actually do need other crocs to a degree. A single crocodile has a difficult time tearing apart food because they can't really cut and chew meat, but multiple crocodiles can make short work of a carcass since they unintentionally "hold" it for one another, allowing each croc to tear off chunks of meat.

When crocodiles do congregate in groups, and groups can number twenty or more, they do so because they want the same feeding areas and beaches. They tend to sort themselves into groups, with similar-sized individuals staying together. This is probably a defense against being picked upon, even fatally attacked, by much larger crocs. It also has the secondary advantage of allowing the younger, smaller crocs to grow up together. When it comes time to mate, chances are they'll already be

A crocodile, for reasons unknown, waddled up this track, resting occasionally, and left its unique prints in the sand.

familiar with their partner. Still, crocodiles are essentially solitary creatures.

Only the larger males will mate, and they control this not only by attacking and driving away smaller crocs, but primarily by controlling the breeding beaches. Crocodiles are only territorial when they breed. Males don't hold permanent territories like lions and leopards, but merely have section of rivers or lakes that they prefer. These home ranges are selected based on the quality and availability (or lack thereof) of food, shade, water current, and beaches. Windy and exposed beaches are avoided, but calm beaches, and beaches with vegetative cover are

ferociously defended, even defended against boats (for instance, my kayak—the kayak lost).

Nights, almost invariably, are spent in the water, even though the colder temperatures are a disadvantage for an exothermic crocodile. But the safety it provides from nocturnal predators is worth the price of being colder. Even at altitudes of more than five thousand feet, crocs spend virtually all their nights in the water. Somewhat surprisingly they still retain a certain level of activity, much higher than, say, a cold snake. Beware! A cold croc is far from a helpless one.

Desirable beaches, sunny and with well-drained sand, are used year after year for mating. The males that control these beaches will allow the females to approach. The male will then puff up his body, and slowly and audibly blow out air for five or six seconds at a time. These vocalizations can become quite loud. Both females and males "shiver" their scales, which generates an odd noise and ends up spraying water upward somewhat like a garden sprinkler. The male will then position himself on top of the female and rub the underside of his lower jaw on the back of the female's neck and head. This releases a chemical stimulant in the male, which is probably necessary for her to allow him to mate.

During copulation, which lasts only a minute or two, the pair usually sinks to the bottom of the lake or river. The male will clasp the female's neck in his jaws, surprisingly gently, and will growl softly while they mate.

In South Africa mating most often occurs in August, and the eggs are laid in November. In East Africa the mating season is a more drawn out affair, with couplings occurring anytime between August and November, with eggs being laid as late as February.

All eggs that are laid on the ground are extremely vulnerable, be they ostrich or grouse, snake or crocodile eggs. Crocodiles' nests are heavily preyed upon by Marabou Storks, monitor lizards, baboons, and ratels (honey badgers). Still, there are a number of precautions that female crocodiles take to increase the odds of those eggs hatching. To start with, crocodiles lay their eggs at night, away from the prying eyes of monitor lizards, baboons, and vultures, all of whom are daytime hunters. Secondly, they lay a lot of eggs so that it's not a great loss if some

SAFARI TIP

Sit quietly by a croc-filled pool or stretch of river and listen. You can hear crocs peeping, gurgling, hissing, and grunting low in their throats, and even roaring.

SAFARI TIP

Look for shallow, crescent caves along the riverbanks. Using a flashlight (a strong one that allows you to keep at a safe distance), see if these recesses are occupied.

never hatch. Crocodiles lay anywhere from twenty-five to ninety 3.5-ounce eggs, which usually takes three to four hours. After the eggs are laid and buried in the sand, females stay with, or near, their nests, and are ferociously defensive of them until the eggs hatch. The eggs of a Nile crocodile require three to three and half months to incubate, and just prior to hatching, the tiny crocs, still within the eggshells, begin squeaking and chirping. These sounds stimulate the mother to dig up the eggs, using short and powerful strokes with her front legs.

Youth and Growth For decades it was thought that mother crocs cannibalized their own young when they were observed taking their new hatchlings into their wide jaws. But research has since shown that very much the opposite behavior is taking place. The mother crocodile does indeed take the just-hatched offspring into her jaws, but she is gently carrying them down to the water, like a lioness carries her cubs, where she will release the little ones into a safer environment.

Crocodile mothers better the chances for their offspring by carrying them to the water instead of forcing them to scramble to safety across land where they would be extremely vulnerable. Once they are in the water, they form into crèches and stay in a group, often for six weeks or more, before they disperse. Sometimes the mother stays with her numerous offspring for weeks, calling them to her by vibrating her scales whenever she perceives danger. Her offspring feel this high frequency vibration and either hide under cover or swim back to her.

It's interesting to note that the temperature of the sand is what determines the sex of the embryos. If the ambient sand temperature is between 79 and 86 degrees Fahrenheit, you have more females than males; if the temperature range is between 88 and 93 degrees Fahrenheit, more eggs become male. The opposite is true for American alligators, and even with gharials, caimans, and saltwater crocodiles.

In spite of all the precautions and care, only about one percent of all crocodile hatchlings reach maturity, which is six years in northern Kenya, and twelve to fifteen years in South Africa. Fish, herons and egrets, mongooses, pythons, leopards, birds of prey, and even other crocodiles all prey on the tiny ones. Those few crocs that do reach old age often live seventy years or more. As adults, their only predators are humans.

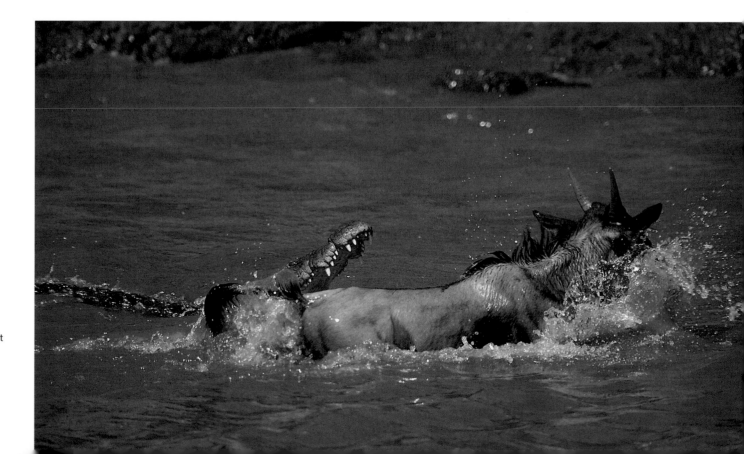

A crocodile's jaws slam shut on a crossing wildebeest.

Notice how nervous ungulates are when drinking
in lakes and rivers that crocs inhabit.

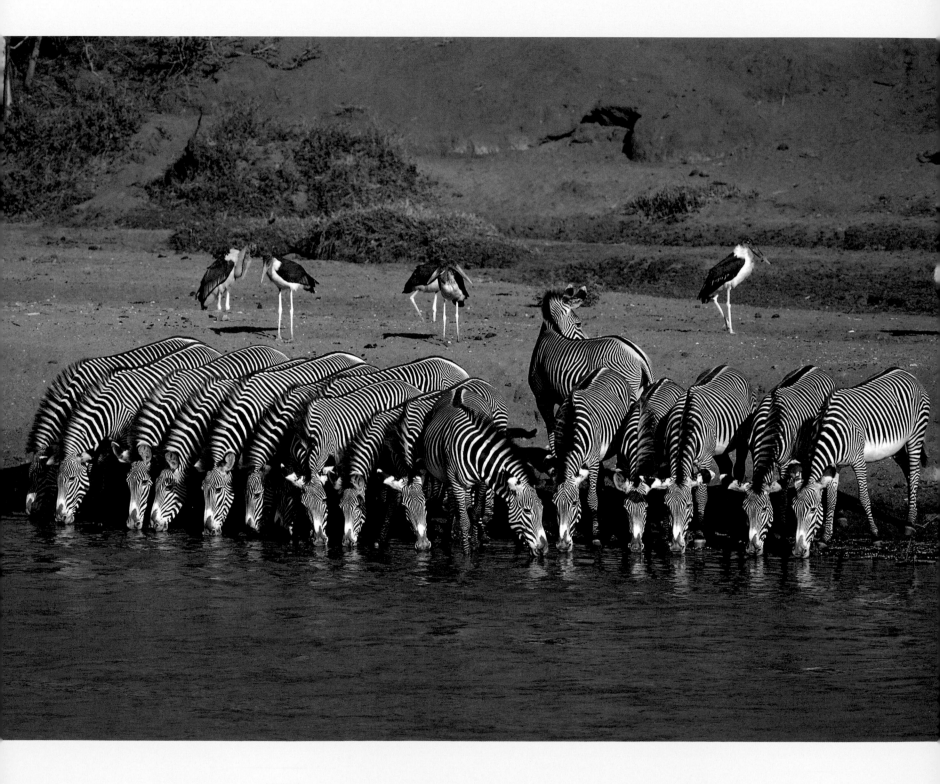

Hunting Anything and everything is on a crocodile's menu. I know of two cases in which a crocodile stalked and successfully killed a male lion. And in both cases it wasn't much of a fight once the crocodile got the lion into the water.

Having said that, crocodiles do seem aware of the fact that baby elephants, which they would have no problem killing, are accompanied by a herd. Time and time again I have watched as tiny elephants have come to the shoreline and stood literally beside a recumbent crocodile, giving it easy access. Yet I have only ever seen the reptiles either ignore the pachyderm altogether or slide slowly into the safety of deeper water.

With crocodiles, survival is genetically hardwired. There is no evidence at all of crocs being taught how to hunt and kill. As with all predators, it comes down to a question of risk and reward. For crocodiles, the decision is an intuitive one. Lions and cheetahs can be enormously patient when it comes to killing, waiting a seeming eternity before exploding out to kill. A crocodile can hold its breath for forty-five minutes or more, can even slow its heartbeat to a few thumps a minute.

The crocodiles in the Grumeti River in western Serengeti National Park have evolved to eat during only one period a year, when the migrating herds cross the river. The rest of the year they will fast, or subsist on a

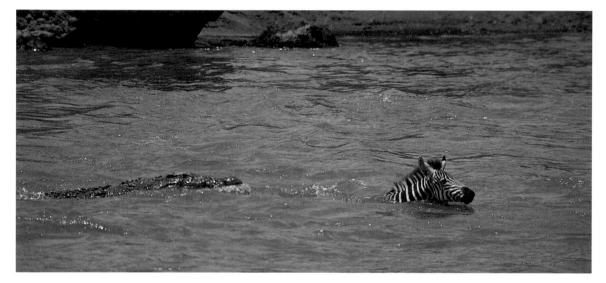

OPPOSITE This crowding behavior at the river is a good defense against crocodile attacks. More eyes watching make it harder for a croc to slide in undetected, and the myriad black-and-white patterns are visually confusing, making it more difficult for the croc to target just one zebra.

ABOVE AND RIGHT A crocodile motors out and swims down a crossing zebra. With a roll of its elongated head and a thrust with its tail, the croc runs over the zebra, grasps its head, and pulls the equine silently under the waves.

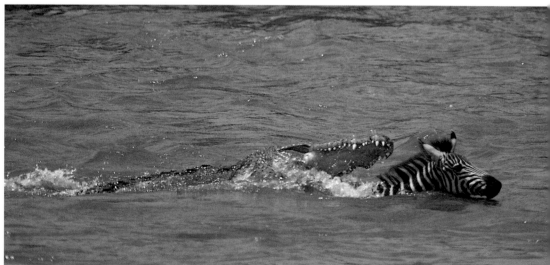

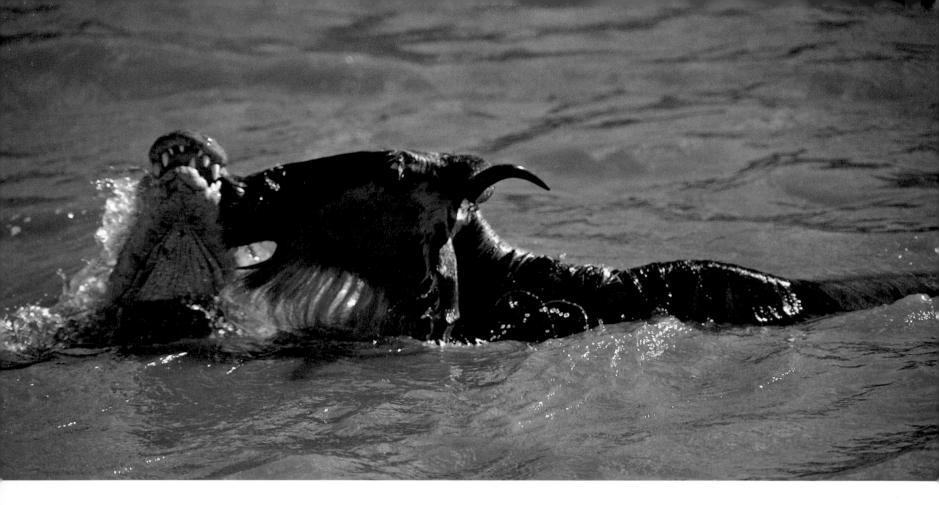

ABOVE A crocodile rears up and grabs the snout of a wildebeest. It will then either pull it under or wait until the animal has suffocated.

RIGHT A massive crocodile thrashes a wildebeest carcass against the riverbank to break it down prior to swallowing it.

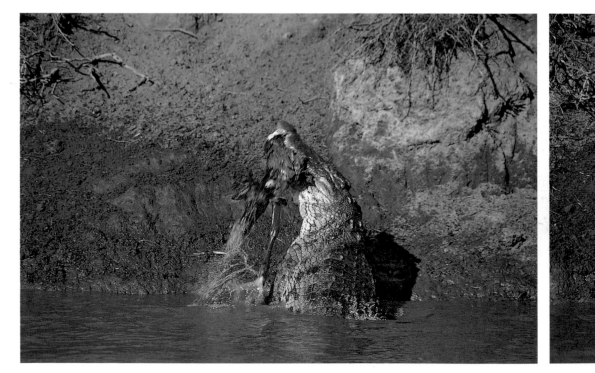

Keep filming or watching after the prey has been taken underwater. The killer and the victim will resurface and more action is bound to follow.

few fish and the occasional mammal kill. During these times of dearth, a croc's vital organs shrink in size, reducing the calories needed to stay alive. The leviathans can then make caves for themselves in the sandy embankments with their tails, crawl inside away from the sun, and estivate until the season changes.

Crocodiles are fast runners on land, and can swim as fast as sixteen miles per hour, much faster than a swimming zebra, gazelle, or wildebeest. The sunning reptiles can launch, torpedo-like, off the shore, or slide slowly into the water without causing a ripple. Anything in or near the water, humans included, is fair game to a large crocodile.

In East Africa, the two most common ways crocs kill are by ambushing a herd as it crosses a river or by waiting quietly, with infinite patience, at a location where the croc has learned mammals will come to drink.

With the first hunting method, the crocs, often half a dozen or more at a time, will "feel" the herds approaching the river long before they reach it, giving the crocs plenty of time to prepare. Usually long before the skittish herds

of zebras and wildebeests are at the river's edge the crocodiles are already off the shoreline and positioned in water that is deep enough to allow them to drown their prey. The migrating herds have no choice but to enter the water, though the zebras tend to do so more carefully, creating very little splash or panic, while the wildebeests charge into the river, leaping as far out as possible and then crashing down into the water. Yearling wildebeests are not as strong as the adults and often end up drifting slightly downstream away from the rest of the herd. Crocs have learned this behavior, so most croc kills are made from a downstream approach, the scaly killers using their immensely powerful tails to propel themselves upstream toward the swimming animals. The crocodile selects who is to die, and will often spend minutes hovering in the current nearby before moving forward to take the chosen thrashing wildebeest. The croc swims in, rolls slightly sideways, and powers itself up and onto its swimming prey. The partial roll allows the croc to bite down on the victim, and the crocodile's massive body weight drives the prey under, where it quickly drowns. Rarely is there

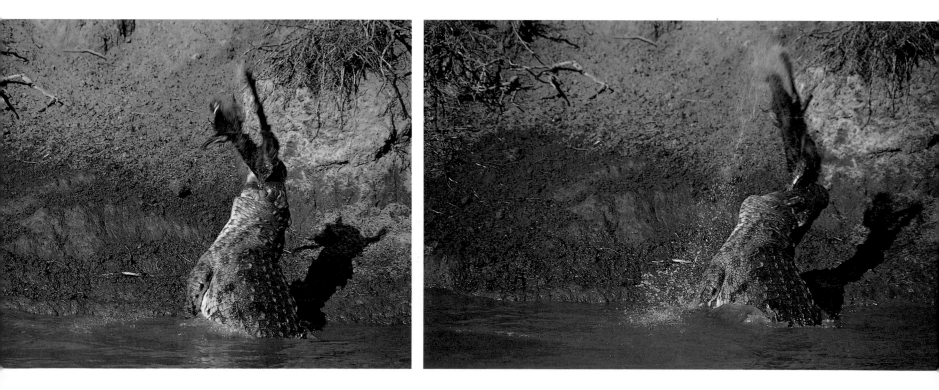

a fight and seldom does the prey escape once it is bitten. A member of the herd is rarely grabbed from the shore (though this has been known to happen).

Once a crocodile has killed its prey the situation often becomes even more violent. Due to the structure of a crocodile's jaws, it cannot shear off, or cleanly cut away chunks of meat. Instead, a crocodile has to either wedge the carcass in underwater tree roots or rocks and spin so violently that it savagely rips an appendage loose, or allow another croc to get a grip on the floating kill and feed together. The two crocodiles together will anchor the carcass as they bite, twist, and roll in their attempts to tear flesh away. The water fairly explodes at these times and blood and flesh goes flying. The feeding crocodiles can swallow while underwater, thanks to a flap of skin that closes the gullet, and valves that close their nostrils while they are swallowing.

Crocodiles do not jam their kills into underwater roots and leave them there for days to rot. No croc would go through the energy and risk of making a kill just to leave it for another croc to find and eat. Crocs possess an acute sense of smell, so great that they can tell the difference between putrid or poisoned meat and merely rotted kills.

The other major way that crocodiles kill is to position themselves at a place where prey species come to drink. It's a terrible dilemma for prey animals, as they must drink to survive, yet they risk their lives to get at that necessary water.

Crocodiles can, with one powerful stroke of their muscular tails, propel themselves two-thirds of their body length onto the shore. They can then rapidly scramble up the bank another nine yards, plenty of distance in which to grab a panicked gazelle.

Once it has something in its jaws, the croc will then quickly turn and drag the prey back to the water, where it can finish it off if it's not already dead. Hyenas and lions will not attempt to poach the kill of a croc if that kill is in water. On land, however, both of these opportunistic predators may be brazen enough to steal a crocodile's kill.

BELOW An adult wildebeest is grabbed by a crocodile, but the wildebeest defends itself, shakes free, and eventually climbs out of the shallow river. Very few victims escape the jaws of a crocodile.

OPPOSITE At the last second, a crocodile rolls its head sideways, jaws open, and crashes down on a swimming wildebeest.

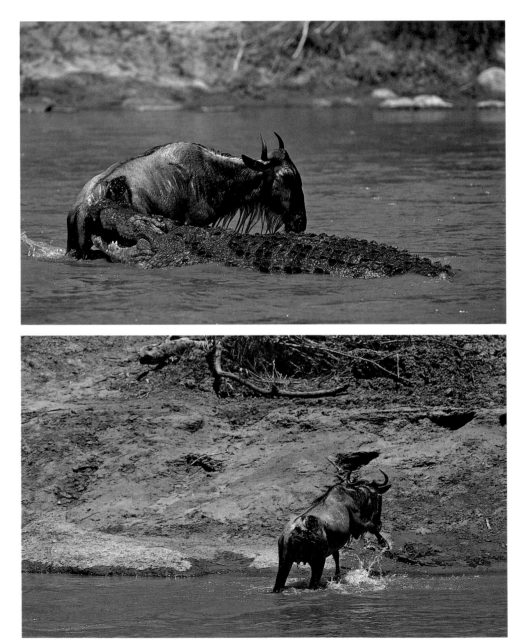

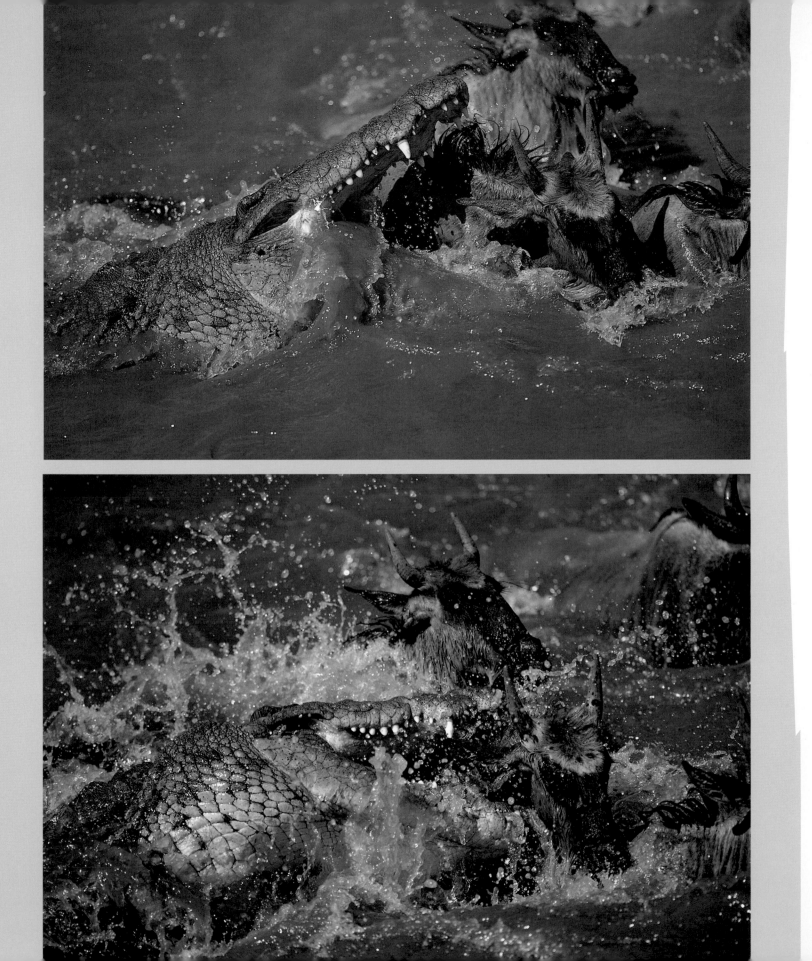

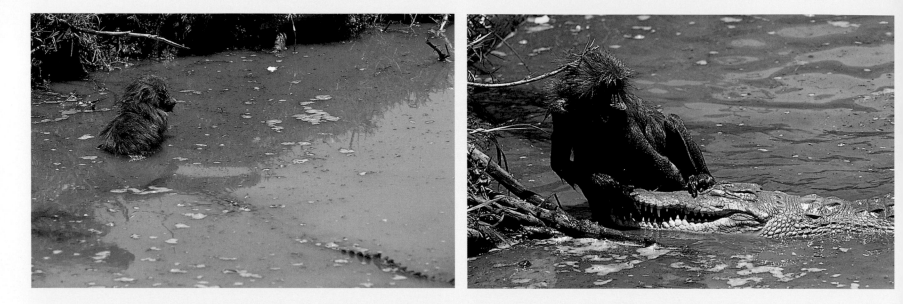

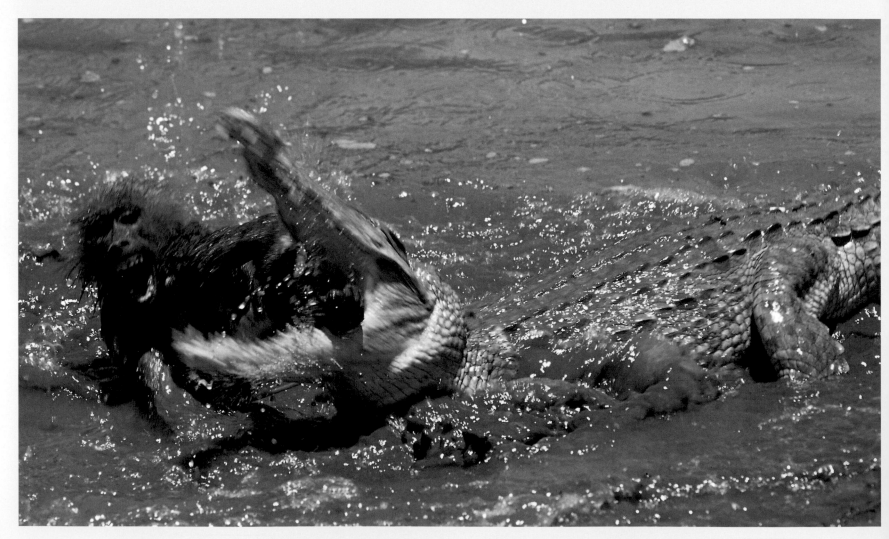

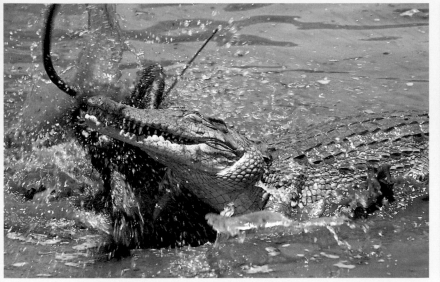

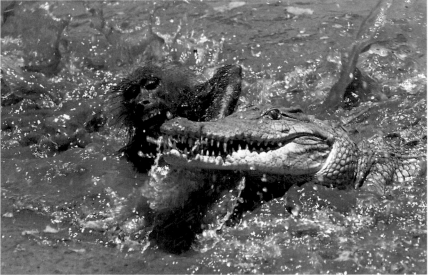

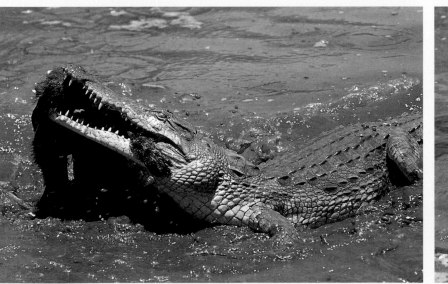

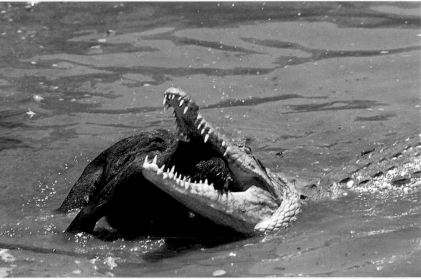

Every day this baboon, a member of a territorial troop, came down to the same spot in the river to drink. An observant crocodile noticed the pattern and began "parking" himself near this spot. One day, about noon, the baboon strayed farther out into the river than usual because the water level had dropped. In a flash of flying water, the croc had him by a back foot. Screeching at the top of his lungs, the baboon managed to grasp some roots on the river's bank and hang on. Hearing his cries, the dominant males of his troop came racing, and actually tried to pull their comrade free, but to no avail. The epic battle between baboon and croc went on for almost an hour—the agile baboon repeatedly tried various escape tactics and would manage to loosen the croc's grip but only for a moment. At one point, the young baboon, a foot and a hand trapped on the jaws of the crocodile, was sitting on the reptile's snout, as if casually riding on a deadly raft. But eventually, this croc won the battle.

Debunking Crocodile Myths

MYTH: Crocodiles are brainless lizards.
FACT: Crocodiles are extremely responsive, curious, and adaptable predators.

MYTH: Crocodiles stash their food underwater to let it soften and rot.
FACT: Crocodiles do not leave food to rot—they eat it right away. They cannot chew food off a kill so something must be used to anchor the prey while the croc tears off chunks of meat.

MYTH: Crocodiles do not have good senses, and operate purely on instinct.
FACT: Crocodiles have an excellent sense of smell, hearing, and sight, and can sense pressure changes in the water.

MYTH: Crocodiles kill for the fun of it.
FACT: Crocodiles, at times, certainly kill more than they can eat, but it's because the opportunity has arisen and, being opportunistic killers, instinct takes over and they kill more than they immediately need.

MYTH: Crocodiles are man hunters.
FACT: Crocodiles do not look for humans in particular. A human is just another soft, warm-blooded animal.

MYTH: Crocodiles are thirty feet long and can weigh two tons.
FACT: A large crocodile is eighteen feet long and can weigh up to a ton.

MYTH: Crocodiles, because they are cold-blooded, are slow and lazy.
FACT: Crocodiles can swim as fast as fifteen miles per hour, and are lightning quick on land and in the water, even on cloudy and cool days.

How to Observe Crocodiles

1. Know when and where the various migrations and animal movements occur in eastern and southern Africa, and when these herds will be crossing the various rivers on those routes.

2. Take your time and study crocodile-inhabited rivers and lakes. Look for their tracks and slide marks on the shorelines. Learn where crocodiles rest, hunt, and feed.

3. Wildebeests, zebras, and other animals cross rivers in well-worn, age-old locations. Ask around to find out where they are, go to them, and study the lay of the land.

4. If you're a photographer, think where the sun will be when, which direction the ungulates will be crossing, and which way the current flows (thus which way younger animals will get pushed downstream).

5. Pack a breakfast and a lunch, and have afternoon tea with you. Waiting for a wildebeest or zebra crossing can be a long and drawn out affair. But to witness a crossing taking place and to see the drama surpasses all description. Allow enough time—a full day or two—in your safari for waiting out a crossing. Once you have positioned yourself, be prepared to wait all day.

6. Crocodiles are shy and sensitive. Dress to blend in, not to be seen. Be quiet and slow. If you can legally and safely get out of your vehicle, do so smoothly and quietly and find a place out of sight from both crocs and the crossing animals. Never get out of the vehicle unless your guide says it is safe to do so. All too often these days one sees film crews and safari guests driving right in among the crossing herds, selecting a spot right on the shoreline, and terribly disturbing both predator and prey. Always be sensitive to the ways of wildlife and never interrupt or disturb their ways. A crossing can be easily observed and photographed without disturbing the wildlife.

7. When trying to capture a croc kill on film, follow the croc as it swims in, NOT the crossing wildebeests and zebras. Stay on the predator.

8. Listen: crocodiles are vocal predators. Be quiet enough to hear these reptiles' sounds.

9. As always, be the first one there and the last one to leave. There is no substitute for being patient and taking your time when observing wildlife.

Facts on File

1. Crocodiles are living dinosaurs—they have changed very little over the last sixty-five million years.

2. Crocodiles are ectothermic animals, meaning they are unable to generate significant body heat.

3. Crocodiles have a four-chambered heart, allowing them to stay active longer.

4. Crocs have a nictitating membrane that works like an extra eyelid; it cleans and protects the eye.

5. Articulated limbs in crocs allow them to run, even gallop.

6. The fourth tooth in crocodiles is visible, not recessed in a socket as it is in alligators.

7. Crocodiles can reach eighteen feet in length and weigh two thousand pounds or more.

8. The tail of a croc is 40 percent of its total body length.

9. A crocodile's back feet are webbed to aid in crawling in mud and swimming.

10. Crocs have valved nostrils that rest on top of the nose bridge, which allow them to breathe while their bodies are fully submerged.

11. Underneath the body scales is a set of interlocking bony plates, called osteoderms, which offer the croc excellent protection from impact.

12. Crocs bask in the sun to absorb heat but open their mouths to allow for evaporation if they get too hot.

13. Crocs are active both day and night.

14. Crocodiles can stay underwater for forty-five minutes.

15. There is also no hard evidence that crocs hunt by disabling prey with slashing strokes from their tails.

16. Crocodiles have eighty teeth.

17. The pigmentation spots around a croc's jaws are nerve endings, which are highly sensitive to pressure changes in water, allowing them to detect swimming prey.

18. Crocs have a superb antibody system, which allows them to recover from terrible wounds, even dismemberments.

19. Male crocodiles are highly territorial only during mating season, and females are very protective of their nests.

20. Females dig out nests in sunny, well-drained sandy areas and lay fifty to one hundred hard-shelled eggs.

21. Incubation lasts eighty-five to ninety days.

22. Hyenas, baboons, monitor lizards, and Marabou Storks all prey on the eggs.

23. Females carry their hatchlings to the water in their mouths, where they will remain as a group, in a crèche, for up to eight weeks.

24. Sex of hatchlings is determined by temperature of the sand during incubation. Cooler sand produces more female crocs and vice versa.

25. Crocodiles eat virtually anything, from rhinos and giraffes to people and birds. All is fair game when it's in or near the water.

26. Crocodiles can live from sixty to ninety years of age.

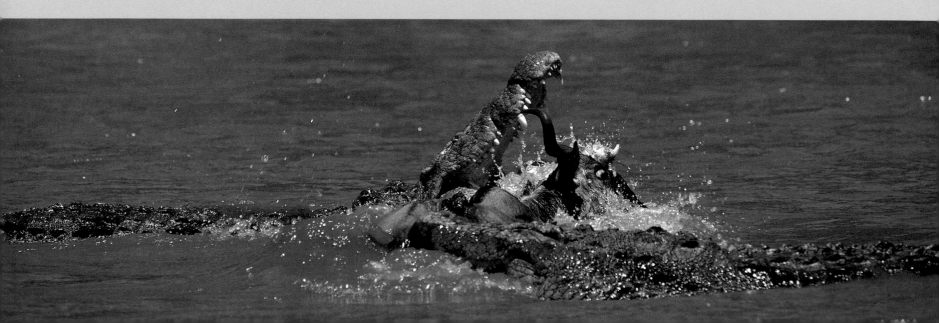

PHOTOGRAPHING AFRICAN WILDLIFE

First and foremost, you need a camera that is reliable, durable, and accurate. David and I have been shooting with Nikons, exclusively, for decades, all around the world, in the worst conceivable conditions, and have never had a problem (knock on wood).

Second, to capture wildlife behavior you must allow that behavior to take place, which means not crowding the animals—give them space. There's plenty out there! Use longer lenses, 300mm or more, which allow you to stay back a bit, giving the animal space to breathe and live its life, while still being close enough to get a good shot.

I shoot with Nikon F4's and F5's, while David prefers digital, and thus shoots with the Nikon D2x. Our lenses tend to be long, 300mm and 400mm, but no longer. We also carry 80-200mm F2.8 lenses, which we have found superb in their versatility and sharpness. A Nikkor 20mm is also a tremendously versatile lens for shooting nature.

Before you embark on your own safari, think long and hard about what you need, what you can afford, and what kinds of animals and environments you'll be shooting. One of the advantages of shooting digitally is that you can change your ASA as you go, even from shot to shot. The Fuji Provia series and the older Kodachromes are good films to use. You'll also need to consider if you want to print and enlarge the photos yourself, whether you hope to publish, or if you are doing pure research. Answering those questions will help you determine what camera you should use and what medium to choose for capturing and storing your images.

Even with digital photography there are no shortcuts to photographing wildlife in a natural setting. Below are a number of tips that can greatly increase your chances of capturing some great images.

1. Be the first person out of your lodge or camp and the last one to return. You can, no matter what anyone tells you, bring along both breakfast and lunch, as well as drinks and snacks, and stay out the whole day if you like. Your driver and your guide work for you, so talk to them and get them to arrange for you to stay out there.

2. Go out no matter what the weather and lighting are. We've photographed lion kills taking place at high noon on the equator. If some prey wanders into a predator's range they will try for it, regardless of when the books say their normal hunting hours are. Storms can make for dramatic photographs. In other words, you never know what may happen, so best to be prepared, to be in the right place at the right time. Try not to shoot straightforward, front-lit portraits of animals. Early morning and evening sun provide some of the best lighting—side-light and backlight both work extremely well and can evoke a greater sense of mood or atmosphere. Dust and an animal's breath, for example, show up better when backlit.

3. Shoot at a low angle from the safari vehicle window, rather than from the roof. The wildlife will look more to scale and not so distant. If possible, lie on the ground or even crawl under your vehicle—do anything to change the angles for variety.

4. Be very wary of autofocus cameras. Many focusing systems scan back and forth across the field of view before locking onto something. They work well when the subject is large or not moving rapidly but can fail at critical times when the animal is moving fast, such as when it's hunting, swimming, running, or fighting.

5. If you follow wildlife too closely or from behind, do not expect to get good behavioral or action shots. The mere proximity of your vehicle will inhibit them, even if they seem to be oblivious to your presence. Anticipate their actions, keep a good distance (use long lenses if necessary), stay well in front and ahead of your subject, and let it come to you. Head-on or broadside photographs are usually far more interesting than rump shots of a retreating predator.

6. You—or your guide or driver—simply must know the animal you're trying to shoot. This cannot be overstated. If you are familiar with an animal's behavior, daily rhythm, or even its personal preferences, you'll be far more likely to capture an image that accurately depicts its true nature and essence. Read up on the animal(s) you want to shoot before your trip, watch videos, check out other photographic books—do your homework.

7. Monopods and tripods are highly overrated for African wildlife photography. You'll most likely be shooting from a vehicle and the pods will only magnify any movement. A beanbag, or even a folded jacket or sweater, will work just fine.

8. Bring lots of spares: spare batteries (they may not be available in many parts of Africa), spare film or flash cards, spare protective filters, and even an extra camera body if you can manage it. You may only be on safari once, or see a particular action once in your lifetime. Don't miss it because of dead batteries or lack of film/cards.

9. And most importantly, remember:
 START EARLY, END LATE, BE PATIENT, BE READY!

Photographic Equipment List (digital and film)

The following equipment should cover about 95 percent of your shooting requirements on a safari. Know your equipment, know the animals you're shooting, put in your time, and most of all, be patient, and you'll get what you're after.

CAMERA
Nikon F5 camera body
Nikon D2X Digital camera body
EH-6 A/C adapter
Lexar Compact Flash cards, 1 and 4 GB memory
Epson P-4000 Memory Storage (80 GB)

FILM
Kodachrome 64 film
Fuji Provia 100 ASA film

LENSES
400mm F2.8 ED-IF II AF-S, with silent wave motor
300mm F2.8 ED-IF AF-S, with silent wave motor
80-200mm F2.8 ED-IF AF-S zoom lens
24-120mm F3.5–5.6 ED-IF AF-S zoom lens
50mm F1.4
20mm F2.8 wide angle
TC-14-E II AF-S teleconverter
TC-20-E II AF-S teleconverter

CARRYING CASES
Lowepro Pro Trekker AW II camera pack
Pelican hard case (size varies)
lead film bags

BIBLIOGRAPHY

Caro, T. M. *Cheetahs of the Serengeti Plains*. Chicago: University of Chicago Press, 1994.

Estes, Richard. *The Safari Companion*. White River Junction, Vt.: Chelsea Green Publishing Company, 1999.

Jewell, P. A., and G. M. O. Maloiy. *The Biology of Large African Mammals in Their Environment*. Oxford: Clarendon Press, 1989.

Kingdon, Jonathan. *East African Mammals: An Atlas of Evolution in Africa*. New York: Academic Press, 1977.

Kruuk, Hans. *The Spotted Hyena*. Chicago: University of Chicago Press, 1972.

Ross, Mark C. *Dangerous Beauty*. New York: Hyperion Press, 2001.

Schaller, George B. *The Serengeti Lion*. Chicago: University of Chicago Press, 172.

Shah, Anup, and Manoj Shah. *The Circle of Life: Wildlife on the African Savannah*. New York: Harry N. Abrams, Inc., 2003.

Sinclair, A. R. E., and Peter Arcese. *Serengeti II*. Chicago: University of Chicago Press, 1995.

Sinclair, A. R. E., and M. Norton-Griffiths. *Serengeti: Dynamics of an Ecosystem*. Chicago: University of Chicago Press, 1979.

Smithers, Reay H. N. *The Mammals of the Southern African Subregion*. Pretoria, South Africa: University of Pretoria, 1983.

Spawls, Stephen, et al. *A Field Guide to the Reptiles of East Africa*. New York: Natural World, 2002.

Stuart, Chris, and Tilde Stuart. *A Field Guide to the Tracks & Signs of Southern and East African Wildlife*. Cape Town, South Africa: Southern Book Publishers, 1994.

Walker, Clive. *Signs of the Wild*. Cape Town, South Africa: Struik Publishers, 1992.

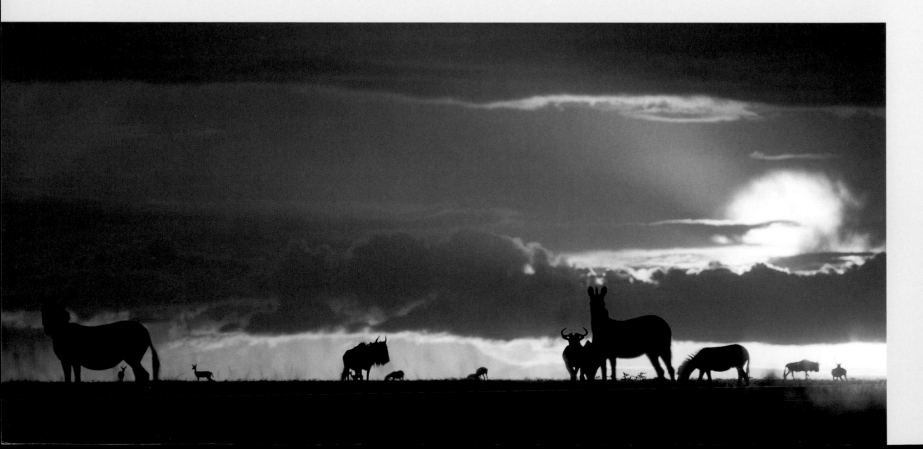

INDEX

ACKNOWLEDGMENTS

Without safari guests willing to explore the African bush with me, for weeks on end, spending hour after hour each day in the field, I'd never have had a chance to see what I've seen and learn what I've learned. Surely it is to all my guests over some thirty years to whom I owe my biggest debt of gratitude.

More than fifteen years ago I was sitting on a Land Rover roof, as usual, with a driver I had never met—most unusual. Today, that driver and I are still together. John Koskei long ago became a vital, integral part of all my safaris. Not only does Koskei keep the vehicle running and the coffee hot, he takes great care of our guests, smiles when elephants rush at us, and never blinks an eye when leopards, lions, and cheetahs are on or under our vehicle. My safaris are much richer, and go far smoother, because of Koskei's friendship and participation.

I would also like to thank Manoj Shah, who, with his brother Anup, have "done it the hard way" in terms of wildlife photography and publication. They've helped me immensely, and have always found the time to care.

A host of Kenya professional guides have been so supportive over the years, answering my endless stream of questions and helping direct me when I lost my way. In particular I would like to thank Phil West, Don Young, James Robertson, Alan Binks, Peter Silvester, Nigel Dundas, and certainly Will Craig.

I spent countless hours bent over the light tables at The Slide Printers/Denver Digital Imaging, in Denver, Colorado, and neither Suzy Matthews nor Andrea ever chased me away. Thank you for the access to your store. It helped me to no end.

Thanks to Mike Mkena of Red Sky for the wonderful skull, cheetah tail, and lion ear-and-whisker drawings—they add a dimension above and beyond my photos.

When I walked into the Abrams office in New York, senior editor Andrea Danese not only did not throw me out but instantly saw the book's potential. Without her greater vision and patience this book would never have made it to press. Thanks also to designer Brady McNamara for bringing all the elements together on the page so beautifully.

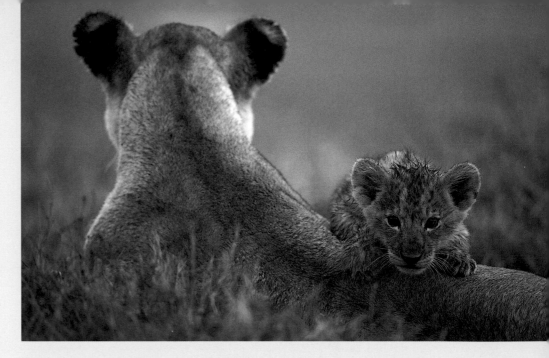

My longtime friend, Daphne Baker, also saw the possibilities and concretely supported the book effort, as did Joy and Dennis Pinto of Micato Safaris.

David Reesor has been a willing accomplice from the start, and without his backing I'd never have been able to afford the time off to research and write the text for this book.

Last and most important, I want to thank Helen, my wife, who believed in both me and the book from the very start. With her encouragement I took time off from guiding to edit some 29,000 images, write the text, and get the book organized. Helen helped me whenever it was needed, diverted our attentions when it was the healthier alternative, and worked tirelessly beside me over many glorious months while the book took shape. My Murit.

—*Mark C. Ross*

I owe a debt of gratitude to Mark Ross for the knowledge he has imparted to me about the wildlife of East Africa and for inviting me to participate in this book, my first. We've become great friends over the course of fifteen years of safaris together.

Thanks also to Birgit Bateman, who has shown me "there can be art in photography."

The biggest thanks goes to my wife, Diane, who has added so much to my life and travels.

—*David Reesor*